June 2002

Thank you, Shozo – for a great 2002 workshop on Sasshu & Another memorable year and looking forward to next year – Your 25th –. Best wishes – Elizabeth G. Baker

THE ART OF
TWENTIETH-CENTURY
ZEN

AUDREY YOSHIKO SEO
with STEPHEN ADDISS

with a chapter by Matthew Welch

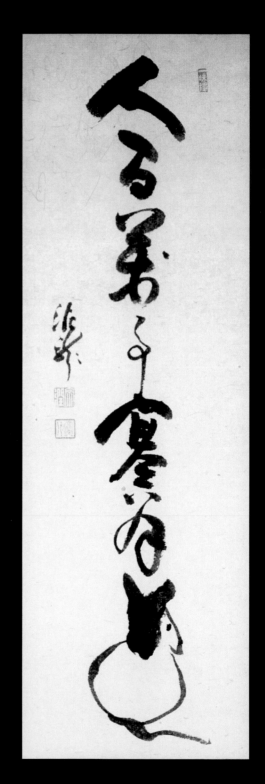

THE ART OF TWENTIETH-CENTURY ZEN

Paintings and Calligraphy

by Japanese

Masters

SHAMBHALA

Boston & London 2000

Shambhala Publications, Inc.
Horticultural Hall
300 Massachusetts Avenue
Boston, Massachusetts 02115
http://www.shambhala.com

9 8 7 6 5 4 3 2 1

First Paperback Edition
Designed by Dede Cummings Designs
Printed in Hong Kong

∞ This edition is printed on acid-free paper that meets the
American National Standards Institute Z39.48 Standard.

Distributed in the United States by Random House, Inc.,
and in Canada by Random House of Canada Ltd

The Library of Congress Catalogues the hard cover edition
of this work as follows

Seo, Audrey Yoshiko.
The art of twentieth-century Zen: paintings and calligraphy
by Japanese masters / Audrey Yoshiko Seo; with Stephen
Addiss; with a chapter by Matthew Welch. — 1st ed.
p. cm.
Published in conjunction with a touring exhibition first
shown at the Japan Society, New York.
Includes bibliographical references and index.
ISBN 1-57062-358-9 (cloth: alk. paper)
1-57062-553-0 (pbk.)
1-57062-561-1 (L.A. County Museum ed.)
1. Painting, Zen — Japan — Exhibitions. 2. Calligraphy,
Zen — Japan — Exhibitions. 3. Painting, Japanese —
20th century — Exhibitions.
I. Addiss, Stephen, 1935– . II. Welch, Matthew.
III. Los Angeles County Museum of Art. IV. Title.
ND1457.J32L63 1998
755'.94327'0952 — DC21 98–22210
CIP

This book was published in conjunction
with a touring exhibit, curated by the authors:

The Japan Society
New York, New York
November 19, 1998–January 10, 1999

Marsh Art Gallery
University of Richmond
Richmond, Virginia
January 29, 1999–April 10, 1999

Los Angeles County Museum of Art
Los Angeles, California
September 1999–January 2000

Spencer Museum
University of Kansas
Lawrence, Kansas
January 29, 2000–March 11, 2000

Dedicated to Hilary T. Seo

CONTENTS

LIST OF ILLUSTRATIONS

Figures

IN THE SPRING of 1989 the Spencer Museum at the University of Kansas held an exhibition called "The Art of Zen," curated by Stephen Addiss. It was the first major exhibition of brushwork by Japanese Zen Masters of the Edo Period (1600–1868) to be shown in the United States. As a graduate student, I was amazed to see in one place so many important examples of Zen brushwork—the personal and direct expressions of some of the most noted Zen Masters of that period.

As part of the public programming for the exhibition, the Spencer Museum invited Fukushima Keidō, Zen Master of Tōfuku-ji Monastery in Kyoto, to visit the university for ten days as an artist in residence giving calligraphy demonstrations. Beyond seeing the works in the galleries, the chance to see the actual activity of Zen brushwork was astonishing. Through his many Zen lectures, meditation sessions, and calligraphy demonstrations, Fukushima Rōshi was able to reach the American audience with his humor, dedication, and Zen experience. In turn, the Americans also impressed Fukushima Rōshi with their enthusiasm, pointed questions, and sincere interest in Zen.

Despite the historic and culture-specific associations that permeate traditional understanding of Japanese Zen, interest continues to grow in the West, and Zen continues to adapt itself to new cultural forces. Fukushima Rōshi's continuing visits to the United States have reaffirmed that Zen is a vital, living experience, not an archaic practice. *The Art of Twentieth-Century Zen*—and the exhibition of the same name—reveal the dedication and determination of Japanese Zen Masters through one of the most turbulent periods of Japanese history. Through political upheaval, numerous social and cultural changes, religious oppression, and growing non-Japanese influences, twentieth-century Zen Masters have persevered in passing on their Zen teachings. Many of them have also produced ink paintings and calligraphies of great spirit, charm, and visual impact. As a result, Zen not only reestablished its role in Japanese culture during the twentieth century but also found a new and eager audience in the West.

Although the role of lay Zen students and scholars in the twentieth century is discussed in the introduction, the focus of the book is on the actual Masters of the period, their experiences, teachings, and art. Also, although this book mentions the experiences some of the Zen Masters had in the West, it is not a study of Zen in the West or in America. These two important aspects of Zen in the twentieth century have already been studied extensively.

The Art of Twentieth-Century Zen in no way represents a complete exploration of the field. Many important figures, such as Shaku Sōen, Ashigaka Shizan, Furukawa Taikō, and Hashimoto Dokuzan have not been included owing to lack of space. Instead of presenting a general survey of twentieth-century Zen Masters, we have chosen to focus on the work of a select group of fourteen Zen Masters, opening the door to an area of Zen art which has been largely overlooked.

This book and the exhibition would not have been possible without the help of many people. I would like to thank Stephen Addiss for his constant help and encouragement; Natsuko Oda, Norman Waddell, Jonathan Chaves, Akira Suzuki, J. Thomas Rimer, Fumiko and Akira Yamamoto, and Kinuko Jambor for their help with translations; Tanaka Daisaburō for his hospitality in Numazu and for sharing his affection for Yamamoto Gempō;

Joseph Seubert of Geibundō, and Naomi Maeda, librarian at Hanazono College, for helping to locate difficult-to-find research materials; Tsuneda Sen'ei and Paula Arai for their assistance in studying Kojima Kendō; Eiichi Maezawa and Belinda Sweet for their constant enthusiasm and appreciation of *zenga*; Jeff Shore of Hanazono College, for his advice; Fukushima Keidō for his kindness and assistance with Zen questions over the years; Kendra Crossen Burroughs for her meticulous editing; Peter Turner and the staff at Shambhala for their commitment toward this book; Richard Waller of the Marsh Art Gallery for enabling the exhibition to take place; the owners of the works in the exhibition for their generous loans; Diana Vincelli at the University of Richmond for her time and energy in helping to prepare grant proposals; and the National Endowment for the Humanities for its generous planning grant.

A.Y.S

THE ART OF
TWENTIETH-CENTURY
ZEN

THREE MAJOR ELEMENTS distinguish Zen in the twentieth century. The first is the growing importance of lay Zen, which includes the influence of major Japanese philosophers in spreading and reconfiguring Zen ideals to the public. The second is the spread of Zen to the Western world, led by such scholars as D. T. Suzuki. Both of these factors have been written about extensively elsewhere and will be discussed only briefly here. The third major element, however, has been largely neglected and undervalued in discussions of Zen in the twentieth century. This is the increased strength of monastic Zen in Japan during a period of great change and disruption in Japanese history. It is this religious strength, in which the role of the Zen Master is vital, that has provided the bedrock for both Japanese philosophers and the spread of Zen to the West.

INTRODUCTION

A Dragon gives birth
to another Dragon.

—*Hekiganroku*,
CASE 65

Zen Masters, referred to as Rōshi (revered teacher), are those monks who have achieved enlightenment as recognized by their own Zen teacher. Furthermore, they have received the "transmission" of their Master's Zen teachings, thereby enabling them to continue their Master's lineage through further transmissions to the next generation of disciples. This recognized ability to carry on the teaching is the backbone of monastic Zen. Unlike Buddhist priests, who are allowed to marry and are often expected to serve at small hereditary temples, Zen Masters do not marry and usually serve at large teaching monasteries. As Shibayama Zenkei (1894–1974), former Zen Master of Nanzen-ji in Kyoto, wrote:

> *The real life experience of Zen is in the religious experience attained by each individual. In Zen it is transmitted directly from mind to mind and not by writing or rituals such as prayers or chanting of mantras and sutras. While its tradition and transmission are maintained solely by the religious experience of each individual, the genuineness of the experience of the disciple must be identified with that of his teacher. In other words, while Zen insists on the one hand that the religious experience of the individual is the fundamental requisite, at the same time, Zen holds that the teacher's verification of his disciple's attainment is absolutely necessary. The mind-to-mind transmission in Zen thus has to be teacher-student identification.* [1]

ZEN BUDDHISM IN JAPAN

Zen was introduced to Japan in 1191 when the Japanese monk Eisai returned from a trip to China, bringing with him both the doctrines of Zen and the drinking of whisked green tea. Encountering a certain amount of hostility from Japanese monks of established sects who resented the new religion, Eisai left Kyoto, the cultural capital of Japan, and went northeast to Kamakura, where the new military government was establishing itself. In a country in which rulers must demonstrate not merely political prowess but also cultural sensibilities, Eisai soon gained the support of the Kamakura government, which saw the new religion, as well as the new forms of aesthetic that it introduced, as a means of demonstrating its cultural awareness and thus its ability to govern.

Underlying the support of the Kamakura government's patronage of Zen were the values of self-discipline and self-reliance, on which Zen was based. Zen does not rely on the saving powers of Buddhas or bodhisattvas, or

dependence upon books, scripture, or doctrine. Instead, the practitioner is told to look into his or her own self to discover the inherent Buddha-nature; seeking Buddha outside oneself is useless. This pragmatic sense of self-reliance and directness greatly appealed to the military, many of whom were not highly educated.

Through the Kamakura (1185–1333), Muromachi (1333–1573) and Momoyama (1573–1600) periods, the military governments continued to patronize Zen Buddhism. Zen Masters served as administrative counselors for *shōguns* because of their knowledge of and experiences in China. In the fourteenth century, the Ashikaga Shōgun Yoshimitsu (1358–1408) established trade relations with Ming-dynasty China, and from that point until the end of the sixteenth century, every Japanese delegation overseas was led by a Zen monk.

Beyond political affairs, Zen monks also strongly influenced the scholarship and art of medieval Japan. Among the few opportunities for education were the *terakoya* (temple schools) run by Zen monks. Through these schools and through their influence in government, monks were able to introduce aspects of Zen-influenced poetry, literature, painting, tea ceremony, and martial arts to Japanese culture. Furthermore, isolated from the Kyoto courtiers, the influence of Zen aesthetics was largely uncontested.

Japan, torn by civil wars during the sixteenth century, was reunited during the Momoyama period by Oda Nobunaga (1534–1582), Toyotomi Hideyoshi (1537–1598), and Tokugawa Ieyasu (1542–1616). Subsequently, Zen was replaced by neo-Confucianism as the dominant social and ethical code of the Tokugawa (or Edo) period (1600–1868). Neo-Confucianism provided the rigid social structure and sense of moral duty and filial piety upon which the Tokugawa shogunate planned to base its authority. As a result, Confucian scholars took over education, as well as serving as scholar-officials in the government; Zen monks were gradually displaced from their governmental, intellectual, and cultural roles. However, despite the loss of official favor, Buddhism still remained an important social tool for the Tokugawa regime. In an attempt to abolish Christian influence, the government required all Japanese to register at Buddhist temples, making membership in a particular temple, as Robert Bellah points out, "a matter of political obligation rather than religious conviction."[2] This governmental interference in spiritual matters encouraged a general sense of apathy and lack of social activism for which Buddhism during this period has been criticized.

Although the Edo period has been described as a period of religious decline by many early-twentieth-century writers, more recently scholars have reassessed the role of Buddhism in daily life. Masahide Bitō commented:

> *Religion came to penetrate the lives of the general populace, not just as a primitive faith, but also as a system of beliefs that had undergone considerable intellectual refinement while sustained by the teachings and rituals of Buddhism and Shinto. The same period saw the establishment of a common religious institution throughout the country. And it is the spread of a common pattern of religious practice both geographically and socially that can be cited as evidence of the establishment of a national religion.[3]*

For Zen monks, the loss of political favor also meant the loss of artistic patronage. *Daimyō* (feudal lords) as well as the Tokugawa shogunate preferred supporting the secular, professional artistic ateliers of the Kanō and Unkoku schools. As a result, Zen monks were free to turn their attentions to creating art for more personal purposes—as expressions of their own Zen experiences, as teaching guides for pupils, or as visual reminders and encouragement for lay followers. From this transformation of patronage, purpose, and expression, the term *zenga* has emerged, denoting the artwork produced as an expression of the Master's Zen mind.

The art created by Zen Masters of the Edo period revealed a new freedom of spirit and a joyful new way of looking at life and conveying Zen teachings. The works were often humorous and charming, but at their core lay a direct and inner intensity that revealed years of dedicated training on the part of the Master. Moreover, free from the confines of official patronage, Edo-period Zen Masters such as Hakuin Ekaku (1685–1769) looked for new ways of revealing Zen teachings to their growing audience of lay and monk followers.

In Hakuin's case in particular, painting and calligraphy were also Zen texts, simply in a different format for a new audience. But they were still teaching tools—some directly relaying Zen or Buddhist messages, others utilizing images of familiar folk figures to convey Zen teachings. Most significantly, they all had the ability to relate to people on different levels. By making himself approachable through art, Hakuin could more easily encourage followers to understand his Zen teachings.

Hakuin is credited with revitalizing Zen teaching and training during the Edo period, when Zen was still trying to discover its new role in society. His rejuvenation of Zen, along with his powerful and highly imaginative works of art, provided the impetus to carry Zen into the modern age.

THE OPPRESSION OF BUDDHISM
IN THE MEIJI PERIOD (1868–1912)

The abolishment of the Tokugawa shogunate in 1868 marked the end of feudalism in Japan and the restoration of Imperial rule. In a move to reaffirm the authority of the Meiji Emperor, the government officially endorsed Shinto as the state religion, establishing the Department of Shinto. At the same time it declared a policy of separating Shinto from Buddhism (*shinbutsu bunri*) in which Shinto gods (*kami*) were removed from Buddhist temples where they had coexisted with their Buddhist counterparts for almost a millennium. In 1870 the government issued the Proclamation of the Great Doctrine (*daikyōin*) restoring the "way of the *kami*" as the guiding force of the nation. The government also reversed the Tokugawa edict that required registration at Buddhist temples, instead requiring all Japanese to register at a local Shinto shrine. This act of governmental promotion of Shinto met with particularly strong opposition, however, and as a result it was rescinded in 1873.

Despite the government's claims that it was not attempting to eradicate Buddhism (*haibutsu kishaku*), the fervor with which it imposed many new regulations began to look like a concerted effort to destroy the religion. Beyond the aggressive promotion of Shinto as the state religion, the Meiji government also sought to negate Buddhism as an institution. Within weeks

of the Restoration, new regulations emerged, including one stating that all Buddhist priests associated with Shinto shrines were required to be reinstalled as Shinto priests or return to secular life. In 1870, for example, the Toyama district included 1,730 Buddhist temples; they were instantly reduced to seven. Although some of the temples were consolidated, most were dismantled.[4] Temple bells and statues were smelted and converted into weapons, and many artworks were plundered or destroyed.

The attack on Buddhism occurred throughout the country; in 1869 the *daimyō* of the Matsumoto domain abolished all his family temples, which numbered more than one hundred and forty. Similarly, immediately following the *shinbutsu bunri* edict, the local official on the island of Sado declared the number of temples on the island as excessive and the monks as lazy and ignorant.[5] In 1875 all seventy-one temples on the island of Oki were abolished, and monks either returned to the laity or left the island.[6]

Attacks on Buddhist temples were not limited to the countryside. In the cultural and religious centers of Kyoto and Nara, the anti-Buddhist movement was also strong; in the Kyoto court, Buddhist services were prohibited, and Buddhist texts were removed from Imperial storage. In Nara, the monastery Kōfuku-ji was destroyed; only its five-story pagoda survived destruction because the dealer who intended to burn it to the ground (to salvage its metal fittings) was forced to abandon his plans out of fear of fire spreading to other areas.[7]

Inaccurate records make it impossible to determine how many temples were closed or destroyed in the first years of the Restoration. However, according to the census data, between 1872 and 1876 about 18,000 temples were closed, and 56,000 monks and 5,000 nuns returned to secular life.[8] Some sects of Buddhism were harmed more strongly than others; temples that relied on the support of *daimyō* for patronage were severely affected, including many Zen monasteries. In contrast, temples of Pure Land Buddhism, which had greater support from the general population, fared better.

In 1871 many temple lands were confiscated by the government, and the performance of Buddhist ceremonies in the Imperial household was abolished. In 1872 the ranks and privileges accorded the Buddhist hierarchy were revoked, monks were forbidden from going on traditional begging rounds, and each sect was required to appoint an abbot (*Kanchō*) to supervise and administer it. At this time the Zen temples were divided into major subsects, with numerous subtemples falling under the abbot's jurisdiction. Beyond the physical and legal restrictions placed on Buddhism, the government also mounted a campaign of anti-Buddhist sentiments toward the general population, based on the idea that Buddhism had become increasingly corrupt under the protection of the Tokugawa government and had largely lost its spiritual purpose and social relevance.

Buddhists responded to these governmental actions varyingly. On the one hand, there were strong reactions against the anti-Buddhist movement, against Shinto, against Western influence, and against Christianity. For instance, in 1873 Buddhists in three counties of Echizen (present-day Fukui Prefecture) staged a protest, marching to the prefectural government offices carrying banners reading *Namu Amida Butsu* (Praise Amida Buddha). The protesters demanded that local government (1) prevent Christianity from entering the prefecture, (2) permit the preaching of Buddhist doctrine, and

(3) prevent the teaching of Western learning in schools. This protest grew into a large-scale peasant revolt.[9]

On the other hand, there were a number of Buddhists who were more concerned with the detrimental effects on Buddhist spirituality. A movement toward religious reawakening was led by men such as Shaku Unshō (1827–1909) and Fukuda Gyōkai (1806–1888). Explaining their efforts, Gyōkai wrote:

> *Buddhists regret the* haibutsu kishaku, *but not because temples have been destroyed. . . .It is not because we have lost our government stipend. We grieve before heaven and man that we have lost the Way of the greatest Good. In order to regain the lost Way, and for this reason only, priests should pray for the extension of dharma (Buddhist Law) and the prevention of* haibutsu. [10]

This spiritual awakening led many Buddhists to search for new scholarship, particularly outside Japan. Buddhist priests such as Shimaji Mokurai (d. 1911) and Nanjō Bunyū (d. 1927) traveled abroad in the 1870s, exploring new aspects of Buddhist study. Shimaji Mokurai, on one of these trips abroad, advocated a separation of "worship" and "government," a position that was supported by several government officials. Some Buddhists joined Shinto, Confucian, and nationalistic leaders in a campaign against Christianity, which was viewed as threatening to introduce dangerous elements of "modernity."[11] And many Buddhists planned to gain support for their own faith by siding with the increasingly strong nationalistic views that marked the era.

BUDDHISM IN THE TWENTIETH CENTURY

Beginning with the Sino-Japanese War (1894–1895), many Buddhists aligned themselves with the Imperial system. In 1916 the Buddhist Society for the Defense of the Nation (Bukkyō-gokoku-dan) was established to support nationalism and the authority of the Emperor, and to "help protect the world and benefit the people."[12] In 1937, as nationalistic sentiments reached their peak with the invasion of China, the "Buddhist Movement of the Imperial Way" also increased its activities, promoting slogans such as "Serve the State through Buddhism" (*Bukkyo hokoku*).[13] Prayers were offered for soldiers and ceremonies were conducted in support of the war, although these were a reflection of secular political associations, not Buddhist doctrine.

In early Buddhism there is a sutra that relates the legend of the destruction of the Shakya clan (the clan of the historical Buddha) in India when the Buddha was about fifty years old. King Virudhaka, insulted by a racist remark by one of the Shakyas, set out to destroy the Shakya kingdom. Receiving news of this, the Buddha sat under a dead tree directly in the path of the approaching army. According to Indian tradition, an army must retreat if it encounters a holy man during its advance. King Virudhaka asked the Buddha why he was sitting under a dead tree instead of in the shade of a live one. The Buddha replied that his clan was like a dead tree, an allusion to the impending attack. The king, in keeping with custom, retreated in frustration.

King Virudhaka mounted a second attack but encountered the Bud-

dha under the same tree. Three times he encountered the holy man and was forced to retreat. But when the Buddha heard that a fourth attack was being prepared, he refused to intervene. As a result, the Shakya clan was slaughtered and their capital destroyed. The tale reveals the rejection of war in ancient Indian Buddhism, not on the basis of humanistic values, but for reasons of *karma*; the Buddha realized that fate cannot be changed by human design, so he maintained an attitude of nonbelligerence, understanding that his people would ultimately be punished for their insult to the king. The sutra relates that karmic retribution also occurs: the king's people were all drowned in a huge storm, and the king fell into the lowest hell realm.[14]

Robert H. Sharf has noted that despite demonstrating some despair at the horrors of war and the desire to promote Zen as a "universal religion," some Zen Masters, including Shaku Sōen (1859–1919), still reflected considerable nationalistic sentiment. Sōen wrote in "Sermons of a Buddhist Abbot" on Japan's role in Manchuria:

> *War is not necessarily horrible, provided that it is fought for a just and honorable cause, that it is fought for the maintenance and realization of noble ideals, that it is fought for the upholding of humanity and civilization. Many material human bodies may be destroyed, many humane hearts be broken, but from a broader point of view these sacrifices are so many phoenixes consumed in the sacred fire of spirituality, which will arise from the smoldering ashes reanimated, ennobled, and glorified.* [15]

Furthermore, many Zen Masters were associated with the military, either as chaplains to the troops or as personal acquaintances of officers. For example, Nantenbō (see chap. 1) instructed General Nogi Maresuke (1849–1912) in Zen and oversaw his *kōan* training. The Zen Master Furukawa Taikō (1872–1968) also strongly discussed Buddhism's recognition of "just wars" in his "Rapidly Advancing Japan and the New Mahayana Buddhism" (*Yakushin nihon to shin daijō-bukkyō*).[16] However, despite this trend toward nationalism, there were also Zen Masters who voiced some dissent.

In 1936 fourteen hundred troops stationed in Tokyo attempted a coup d'état on February 26. Business leaders in the Kansai area, worried that increased militarism would leave them cut off from the West, asked Seki Seisetsu (see chap. 6) of Tenryū-ji to write a letter to Terauchi Hisaichi, an acquaintance of Seisetsu's who served as minister of the army, and encourage him to take action against the reactionary elements of the military.[17] The following year, however, militaristic elements in government prevailed, leading to the invasion of China.

Other monks who spoke out against war included Yamamoto Gempō (see chap. 4), who gave antimilitaristic talks to soldiers in Manchuria, and Taneda Santōka (see chap. 5), who wrote poems about the tragedy and futility of sending troops abroad.

With the inception of World War II in 1941, however, the official relationship between the Buddhist church and the government was reinforced. All Buddhist sects were required to renew their allegiance to the Emperor and were considered transformed into "societies for the protection of the state." Slogans such as "Act as a loyal subject" (*shindo jissen*) and "Help and support the Great Policy" (*taisei yoku-san*) were posted on temple walls.[18] Orders were disseminated from the government through the Great

Japan Buddhist Association (formerly the Buddhist Association) to the Buddhist sects. According to these orders, the abbot of each sect was required to travel and preach throughout Japan in support of the Emperor and the war effort.[19] Again, the ideas being preached were purely political and had no Buddhist doctrine associated with them. In general, the support of most Buddhist monks for the Emperor and the nation was complete and unquestioning, as it was with all other major elements in Japanese society.

Ultimately, many Zen Masters found themselves in a difficult position. Although they may have personally, morally, and spiritually opposed violence and aggression, their traditional role was not one of political activism. Instead, their task was to continue the monastic training of monks and administer to the needs of their lay parishioners. If duty required men to fight and suffer the physical consequences, then condemning their actions would be both futile and insulting. Instead, many Zen Masters attempted to support the human endeavors as a means of social unity while objecting to the political motives behind them.

After the war, Buddhism was left largely untouched—unlike Shinto, which faced an enormous amount of political criticism and restructuring because of its association with the Imperial family. However, in the face of massive national devastation, political uncertainty, and human suffering, the Buddhist church also faced a difficult future. A large number of Buddhist clergy had been killed or wounded in the war, and 4,609 temples had been destroyed or heavily damaged.

In a country trying to rebuild, money for the reconstruction of temples was scarce. As a result, many priests were forced to find part-time jobs to help support themselves and their temples, or to leave their temples completely and find secular employment. In Fukushima Prefecture, 800 of 1,700 temples had no resident priest.[20] Other temples had to sell off or lease land to raise money, and many of them established nursery schools or kindergartens for parish children to provide additional income.[21]

Despite these dire circumstances, the Buddhist church managed to rejuvenate itself after the war. Most vital was the continued strength of the Zen Master tradition. However, another significant contribution to this rejuvenation was the emergence of numerous lay Buddhist organizations (*zaike kyōdan*), which broke away from traditional institutional Buddhism.

THE LAY ZEN MOVEMENT

The lay interest in Zen following the war was spurred on by a new enthusiasm for Zen as a philosophy, even though Zen Masters have spoken vehemently against conceptual and rational thinking. Heinrich Dumoulin noted in his book *Zen Buddhism in the Twentieth Century*:

> In this very period, a new attitude toward philosophy and its problems established itself within the Zen movement. Philosophical thinking—partly rooted in the Zen tradition and partly stemming from the contemporary philosophical climate—has given a boost to Zen today.[22]

Yet it is important to note that this "boost to Zen" had little if any influence on actual monastic training and practice; most of it was more closely related to intellectualizing in the Western philosophical tradition.

Lay Zen philosophical approaches to Zen concerned themselves mainly with two of the three Zen subsects, Rinzai and Sōtō, which had been imported from China in the late twelfth and early thirteenth centuries. The Rinzai sect emphasizes intense *kōan* training, while the Sōtō sect stresses *zazen* as a means to enlightenment.[23] Philosophical approaches to these Zen sects were promoted by several key figures in the twentieth century. Regarding Sōtō Zen, not only did the monk Nishiari Bokuzan (see chap. 5) write extensive commentaries, but the scholar Watsuji Tetsurō set out to reveal the cultural and spiritual relevance of the writings of Zen Master Dōgen (1200–1253), such as the *Shōbōgenzō*, to current issues.[24] Watsuji's work of the 1920s was followed by a long essay, "A Personal View of the Philosophy of the *Shōbōgenzō*," written by Tanabe Hajime (1885–1962), and *Studies in Dōgen* by Akiyama Hanji in 1935, which provided a systematic approach to Dōgen's work. The first comprehensive study of Dōgen in English appeared in 1975 in *Dōgen Kigen: Mystical Realist* by Hee-Jin Kim. Since then numerous books have appeared in English and other Western languages, providing translations of the *Shōbōgenzō* and critical commentary on Dōgen's works.[25]

Concerning the Rinzai sect, lay philosophy was most greatly affected by scholars of the Kyoto school, who sought to infuse the systemized framework of Western philosophy with the spirit of Zen. The school, which was associated with Kyoto University, was founded by Nishida Kitarō (1870–1945), who strove to assimilate Western philosophical methodologies with Eastern spiritual traditions, particularly Zen. In 1927 he produced "From the Acting to the Seeing," in which he presented his idea of the "place of absolute nothingness" where the true self could be found. Here the individual reality of all things could be derived from the self-identity of "absolute nothingness."

Shin'ichi Hisamatsu (1889–1980) was a pupil of Nishida who, while maintaining his philosophical studies at Kyoto University, also participated in Zen training at Myōshin-ji monastery. As a result, he reflected a unique coupling of deep philosophical scholarship with firsthand Zen experience. In his essay "Atheism," he declared himself an atheist as a natural result of Zen enlightenment: "The modern age has developed in such as way that human beings increasingly free themselves from the law of God and submit to their own law."[26] In 1958 Hisamatsu founded the F.A.S. Society, an informal group of scholars and intellectuals intent on promoting Zen as a universal truth. He also wrote an influential book, *Zen and the Fine Arts*, in which he tried to systematize Zen aesthetics.[27]

Nishitani Kenji (1900–1990), also a student of Nishida, did much to promote the work and ideas of the Kyoto School through his numerous lectures and publications, bringing the work of the new Japanese philosophers to the attention of their European counterparts. In particular, he was interested first in establishing a dialogue between Buddhism and Christianity, and second in the theme of self-discovery or self-awakening as a means to overcome nihilism.

However, the best-known member of this circle in the West has been D. T. Suzuki (1870–1966) (FIG. 1). Although not a professional philosopher, Suzuki was close friends with Nishida, and the two influenced each other's ideas greatly. Like Nishida, Suzuki wanted to introduce Eastern spirituality, especially Zen, to the West. While studying at Tokyo University, Suzuki also began Zen training at Engaku-ji in Kamakura under Shaku Sōen, who had been the first Japanese Zen Master to visit the United States, when he

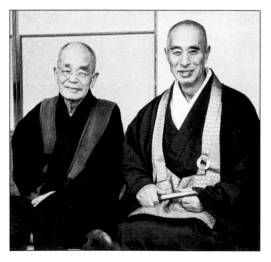

Figure 1.
D. T. Sukuki (left) and
Shibayama Zenkei

spoke at the World's Parliament of Religions held at the Chicago Exposition in 1893. In 1897, at the age of twenty-seven, through an introduction from Sōen, Suzuki traveled to La Salle, Illinois, to assist Paul Carus in the translation and publication of a series of books on East Asian philosophy and religion. He remained in the United States for eleven years, translating Buddhist texts.

In 1909 Suzuki returned to Japan and began teaching, first at Gakushūin University and then at Ōtani University in Kyoto, where he founded the journal *Eastern Buddhist*. In the 1920s he published a series of articles that would eventually form the core of his three-volume work, *Essays in Zen Buddhism*, the first major treatise on Zen in a Western language. He continued for the next decade producing numerous works on Zen, culminating in *Zen Buddhism and Its Influence on Japanese Culture* (1938), which caused a sensation in the West and was also widely read in Japan after being translated into Japanese in 1940.

In the 1950s Suzuki began traveling abroad to lecture on Zen more often. He soon became a visiting professor at Columbia University, where he witnessed and contributed to America's rapidly growing interest in Zen. Through his numerous books, articles, and lectures, Suzuki helped promote understanding of and appreciation for what had once seemed an abstruse, incongruous, and enigmatic foreign religion to Westerners.

In part as a result of Suzuki's contribution, Zen, along with Buddhism in general, has become one of the fastest growing religions in the West; hundreds of books have been published, providing translations of important original texts, as well as elucidating personal experiences. American Zen centers can be found in all parts of the country, affiliated with both Japanese and Korean sects, and American Zen teachers now transmit the *dharma*. Despite these developments, Sharf states:

> *While Suzuki, Nishida, and their intellectual heirs may have shaped the manner in which Westerners have come to think of Zen, the influence of these Japanese intellectuals on the established Zen sects in Japan has been negligible. At this point it is necessary to affirm that Japanese Zen monasticism is indeed still alive, despite the shrill invectives of some expatriate Zen missionaries who insist that authentic Zen can no longer be found in Japan.*[28]

The vital importance of the monastic tradition is affirmed by the understanding that within the ever-changing currents of Zen, and the increasing enthusiasm for a philosophical approach to Zen, there remain Zen Masters who carry on the vital Master-student transmission in the traditional monasteries of Japan.

MONASTIC ZEN IN JAPAN[29]

The Zen monastic system in Japan is represented by three major sects: Rinzai, Sōtō, and Ōbaku. Since the Edo period, these sects have been organized into twenty-two divisions denoting head temples, followed by hundreds of subtemples. Of the twenty-two divisions, the one representing the Sōtō sect is the largest, encompassing two head temples overseeing 14,718 temples and twenty-six monasteries. The Rinzai sect is represented by fifteen head tem-

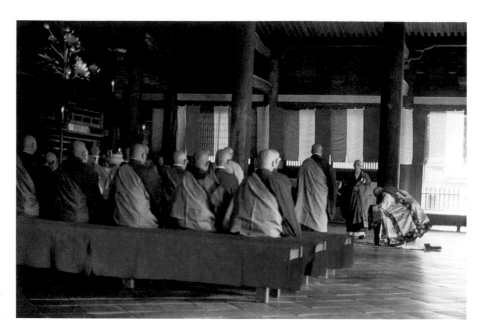

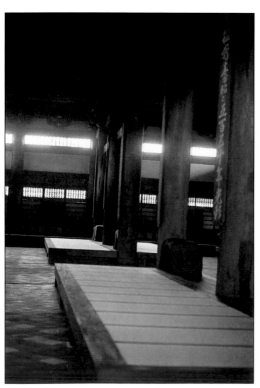

Figure 2.
Founder's Day ceremony
at Tōfuku-ji, 1995

Figure 3. Tōfuku-ji Zendō

ples administering 5,754 temples and thirty-eight monasteries.[30] The Ōbaku sect, with 460 temples and two monasteries, represents its own division, as do five other smaller organizations. Six further monasteries are for the training of female monastics, who in 1984 represented about 10 percent of the total Zen Buddhist clergy.[31]

The head temple functions as an administrative center over the numerous smaller subtemples, from whom they collect annual fees. The chief abbot, or *Kanchō*, is in charge of the regulation and ordination of clergy as well as clerical rankings within the temple. Many of the larger temples also operate schools, research centers, or other public services. The head temple also provides a year-round schedule of ceremonies for the Japanese public, generally beginning with a New Year's ceremony and including rituals marking the Buddha's Birthday on April 8, the Bon Festival (Ceremony for the Dead) in July, a Founder's Day ceremony (FIG. 2), and a ceremony to mark the date of the Buddha's Enlightenment on December 12.

Included among the temples supervised by the head monastery are training centers (*sōdō*, usually located within the grounds of the head temple, but in several cases also located elsewhere), which formally train clergy.[32] There are seventy-two Zen monasteries in Japan today, the larger monasteries training up to twenty-five monks at a time.[33] Within the monastery, the *zendō* (meditation hall) is where the training of monks is centered. This is outfitted with long, low wooden platforms separated by aisles (FIG. 3). Each monk is assigned a section of platform where he sleeps and does *zazen*. Sutra chanting and Zen lectures are also sometimes performed in the *zendō*.

While in the monastery, novices are under the supervision of a senior monk, who usually oversees their daily responsibilities of *zazen*, labor around the temple grounds, begging rounds (FIG. 4), and the study of scripture and monastic practices. However, their individual study of *kōan* (riddles or conundrums) is supervised by the Zen Master. He is responsible for guiding each monk along his spiritual journey to enlightenment. Often using Zen *kōan*, the Zen Master helps the disciple penetrate beyond rational, logical thought until both the ego and the reliance on dualistic thinking are transcended. In the Rinzai tradition, there are 1,700 *kōan*, the most famous gathered in collections such as the *Mumonkan* and the *Hekiganroku*.

Shibayama Zenkei recounted how his own teacher described the role of the *kōan* in Zen training.

The task or role of the kōan *is to help a student open his Zen eye, to deepen his Zen attainment, and to refine his Zen personality. It is a means in Zen training, but in actual practice the* kōan *does not lead a student along an easy and smooth shortcut, like other ordinary means. The* kōan, *on the contrary, throws a student into a steep and rugged maze where he has no sense of direction at all. He is expected to overcome all the difficulties and find the way out himself. In other words, the* kōan *is the most difficult and rough means for the student to go through. Good* kōan, *called* nantō, *are those that are most intricate, illogical, and irrational, in which the most brilliant intellect will completely lose its way.*

Suppose there is a completely blind man who trudges along leaning on his stick and depending on his intuition. The role of the kōan *is to mercilessly take the stick away from him and to push him down after turning him around. Now the blind man has lost his sole support and intuition and will not know where to go or how to proceed. He will be thrown into the abyss of despair. In this same way, the* nantō kōan *will mercilessly take away all our intellect and knowledge. In short, the role of the* kōan *is not to lead us to satori easily, but on the contrary to make us lose our way and drive us to despair.*[34]

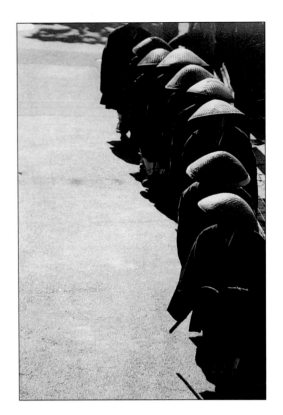

Figure 4.
Begging monks

Today, most monks enter the monastery after spending four years in college. The majority of them will inherit the position of chief priest of a temple from their fathers. In order to succeed their fathers, however they are required to spend a minimum of three years at the monastery. During this time, the monks will not only learn the formal rituals and services need to serve as priest of a temple, but also the proper way to perform ordinary daily activities such as bathing, eating, and even going to the toilet, which are dictated by specific Zen etiquette.

The manual labor performed at monasteries is not only a necessity for maintaining the large temple grounds, many of which serve as tourist attractions, but also serves as a way to promote self-sufficiency, humility, and the practice of meditation within activity. Hakuin wrote:

What is most worthy of respect is a pure kōan *meditation that neither knows nor is conscious of the two aspects, the quiet and the active. This is why it has been said that the true practicing monk walks but does not know he is walking, sits but does not know he is sitting. For penetrating to the depths of one's own true self-nature, and for attaining a vitality valid on all occasions, nothing can surpass meditation in the midst of activity.*[35]

A typical monastic schedule is as follows:[36]

3:30 A.M.	get up
3:45	morning service
4:15	*zazen*
5:00	morning meal
5:30	manual labor: sweeping, cleaning, etc.
6:00	*zazen*
7:30	begging rounds, or *teishō* (Zen lecture) once a week
10:00	afternoon meal
10:30	free time
1:00 P.M.	daily work
4:30	evening service

5:00	evening meal
6:00	*zazen*
9:00	go to bed (Monks may also choose to continue their meditation deep into the night.)

In addition to the daily *zazen* sessions, monasteries also hold extended week-long meditation sessions several times a year. During these intensive sessions (*sesshin*, "concentrating the mind"), daily duties such as manual labor are reduced and time is concentrated on *zazen*; sleeping hours are also minimized.

Until the Meiji period, Zen Buddhist clergy were forbidden to marry, both by state law and the Buddhist precepts. A temple priest would "adopt" several young local boys and train them as monks, eventually choosing one as his successor. In the Meiji period the law against marriage was removed, but some temples were slow to make the change. However, after the Second World War, with the influx of Western values and new economic opportunities, there was a decline in the number of young men willing to devote their lives to the church. As a result, more temple priests began to marry, thus providing natural heirs and successors for the temples.

Despite the opportunity for male Buddhist clergy to marry, Buddhist nuns have voted not to do so. Although these nuns have made many gains since the Second World War, earning the right to ordain disciples and transmit the *dharma* in 1951, and being allowed to serve as the head of small branch temples, they do not marry. Furthermore, most of the advances made by Buddhist nuns have been made in the Sōtō sect (see chap. 5); the role of nuns in the Ōbaku and Rinzai sects is still small. However, while the opportunity to marry has helped to ensure the continuation of hereditary resident priests in local temples, it is the training monasteries that foster the Zen Master system to propagate their teachings.

ZEN ART

Zen has been called "a teaching without words" because Masters train their students to break the bonds of dualistic and logical thinking in order to reach the state of enlightenment. But if words and logic are denied, how is this religion taught, and how can enlightenment be expressed? Instead of "teaching without words," the phrase might often be "using words to go beyond words," since Zen Masters have written many books and commentaries as well as giving Zen sermons to their followers. Fukushima Keidō (b. 1933) of Tōfuku-ji monastery explains:

> It is not simply a negation of words and letters. Rather, what is being negated is the attachment to the word. This is because words and letters both consist of something having to do with intellectual knowledge, so to transcend words implies the transcendence of knowledge. So to not rely on words means to not be attached to the words; it does not mean to not use them or negate them. On the contrary, it means that you can truly, freely use them.[37]

Words play an important role not only in teaching, but also in the preservation of Zen history and culture. However, the words are not taken as

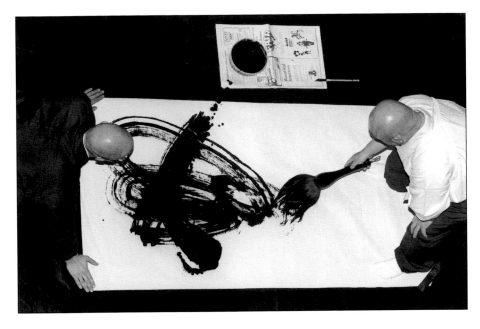

Figure 5. Fukushima Keidō
doing calligraphy of Mu
Spencer Museum, University of Kansas, 1989

direct truth, but rather as one of many ways to convey meaning through experience. Many Zen Masters have also turned to visual art to express their teachings. In this regard, Zen Buddhism is unusual among religions in that its works of art are created by the Zen Masters themselves, rather than by professional, commissioned artists.

Calligraphy is one of the best ways to convey many important aspects of Zen teachings because in Zen, words are not merely spoken or represented as scripture, but also become a means of artistic expression through line, form, energy, and movement. In turn, Zen calligraphy is also a means of spiritual expression by revealing the mind of the monk-artist. Therefore, both the words conveyed through art and the gestural action from which they emanate reflect expressions of "Zen mind" (FIG. 5).

The paintings produced by Zen Masters are also functional; there is a direct connection between the images and Zen teaching. This comes in part from the subject matter of the paintings (such as significant Zen figures and scenes of enlightenment from the past) and the calligraphic inscriptions (primarily short Zen texts and poems) that accompany them. Further, it has long been believed in East Asia that brush and ink reveal the true character of the artist so that viewing a painting or calligraphy is a form of communication with the inner spirit of the person who created it.[38]

Although monastics in training do not practice painting and are limited to sutra-copying for calligraphic practice, when their training is complete and they assume positions at a temple, not only will they have the freedom to pursue artistic expression, but they may also be asked by lay followers for examples of brushwork. Aside from practical adeptness with the brush, a young monastic's only other aesthetic "teaching" may be from viewing works of art within the temple, observing and possibly assisting when his or her own Master is doing brushwork, and taking advantage of opportunities to examine works by past Zen Masters. Generally speaking, the style of Zen Masters' brushwork is influenced by these visual encounters.

There are now many books providing various means of understanding Zen, including translations of *kōan* collections, collections of Zen poetry, anecdotes about Zen Masters, philosophical interpretations of Zen, intercultural Zen encounters, and personal insights into the monastic experi-

ence. However, someone else's personal revelation about the "Zen experience" is still a secondhand account. The only way to experience Zen directly is by encountering the Zen Master's mind; short of entering a training monastery, one of the most effective means of doing this is to experience his or her brushwork.

The ink traces of Zen Masters are somehow distinct from other forms of brushwork; there is a richness, a depth, and often a quirky awkwardness that reveals a freedom and unassuming quality unique to Zen. But beneath any superficial qualities, there remains an underlying breadth and concentration of experience that can only be conveyed by a Zen Master. The opportunity to encounter this expression and the Zen teachings that lie behind it is the special quality that Zen art provides to viewers.

Beyond the broad expansion and understanding of Zen during the twentieth century, and beyond the assimilation of Eastern philosophy into Western thought, there remains the heart of Japanese Zen: monastic training. This brings daily assurance that the vital transmission will continue from Master to student into the twenty-first century. This book respectfully acknowledges and celebrates the continuation of this tradition through the art, teaching, and experience of the Zen Masters who persevered through one of the most turbulent periods of Japanese history, reaffirming Zen's role in Japanese culture and taking it beyond Japan to the world.

"IF I CANNOT BECOME A PRIEST of extraordinary accomplishment, I will not walk upon the earth," vowed eighteen-year-old Nantenbō (Tōjū Zenchū, FIG. 6) to his Zen Master.[1] The impassioned spirit of this precocious young man was to burn brightly throughout his eighty-seven years.[2] Not only did he rise through ecclesiastical ranks to an exalted position at one of the most prestigious Rinzai Zen monasteries in Japan, he was "a Zen priest of the people."[3] In his determination to restore Zen to its former purity and brilliance, he emulated the severe methods of legendary Zen masters from the distant past. The thick staff of nandina he used to "encourage" disciples and frighten "false priests" resulted in a great deal of notoriety, giving him the nickname Nantenbō (nandina staff). He also published ten volumes of Zen commentaries, headed numerous Zen study groups and, by his own estimate, brushed over one hundred thousand calligraphies and paintings, which he freely gave away to anyone brave enough to ask. Certainly his efforts helped maintain Zen during Japan's tumultuous modernization. By wielding the brush with unmitigated vigor, he also may have unwittingly exerted tremendous influence on twentieth-century "action" artists and avant-garde calligraphers.[4]

NANTENBŌ'S LIFE

Born to a samurai who served the Ogasawara *daimyō* in the port city of Karatsu, Nantenbō forfeited the privileges of his birthright in order to join the clergy. The death of his mother when he was only seven deeply troubled the youth, and, as he expressed later in life, he was determined "to understand the origins of life and death, to work for the salvation of sentient beings, and to pray for the repose of my mother's soul."[5] At the age of eleven he joyfully submitted to the head-shaving ceremony for acolytes at the local temple of Yūkō-ji. The Buddhist name he received, Zenchū (Complete Devotion), was to be a prophetic indication of his enduring commitment to Zen.

By eighteen, Nantenbō was ready for more rigorous Zen training. Acting on the suggestion of his teacher, he journeyed to Empuku-ji in Yawata, south of Kyoto. Acceptance into Empuku-ji, one of the three leading Rinzai *sōdō* in Japan, was a formalized procedure designed to test the resolve of aspiring monks. After two days and nights of prostrate begging to be admitted, Nantenbō underwent seven days of meditation in isolation facing a wall. Having completed these trials in an acceptable manner, he was formally admitted into the temple and assigned a place in the *sōdō*. Well known for its strictness, Empuku-ji seemed a cold and friendless place, even for the determined young monk. "When I entered the *sōdō*," Nantenbō later recalled, "I stole a glance to the side and saw white eyes and hateful-looking faces—even now it makes me shudder."[6]

Despite the physical and mental rigors of life at Empuku-ji, Nantenbō flourished. On the very first night that he was accepted into the *sōdō*, he received the *Mu kōan* from the priest Sekiō Somin. This comes from a Chinese Zen story that a monk asked Jōshū (Chinese: Chao-chou), "Does a dog have the Buddha-nature?" Despite the Buddhist belief that all beings have this nature, the Master answered, "*Mu*" (no, not). What might this mean? Night after night, Nantenbō courageously visited the Master in order

USHERING ZEN INTO THE TWENTIETH CENTURY

Nakahara Nantenbō (Tōjū Zenchū, 1839–1925)

— MATTHEW WELCH

Figure 6. Nantenbō

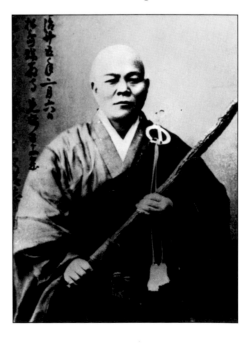

to proffer his "answer," only to be rebuffed. Undaunted, he redoubled his efforts. The evening meditation was not complete unless he had felt the force of the wooden *keisaku* stick across his back, encouraging him to greater depths of concentration. (For an example of a *keisaku*, see PLATE 25, page 52.)

Just before Sekiō's death in 1857, Nantenbō penetrated *Mu*. Over the next eight years, he devoted himself to *kōan* practice, doggedly seeking out noted Masters upon whom he tested his understanding. He met with Satsumon Sōon at Myōshin-ji and Sozan Genkyō at Empuku-ji. Traveling to Eifuku-ji in Fukuoka, he faced the notoriously inhospitable Rannō Bunjō, appropriately nicknamed "Demon Bunjō." From the surly priest, Nantenbō received the training stick "thirty, sixty, one hundred twenty times."[7]

During the ceremonies commemorating the five hundredth anniversary of Myōshin-ji, Nantenbō met Razan Genma, head priest of Bairin-ji, a temple located in Kurume. Impressed with the youthful abbot, Nantenbō returned to his native Kyūshū to study with him. After six years of strenuous effort, including meditating atop a board placed across the mouth of a well (if he fell asleep, he would plunge to his death), sleeping upright in the lotus position, and self-flagellation, Nantenbō managed to penetrate all but one of his *kōan*.

Illumination of the final *kōan* occurred when Nantenbō was twenty-six. According to his later account, as he traveled alone through the rugged terrain of Mount Aso, his path seemed to disappear into brambles and he was suddenly engulfed in an inexplicable darkness. At a loss, Nantenbō sat beneath a pine tree and began to meditate on the *kōan* "Turtle-nosed Snake of South Mountain."

> *Suddenly the surrounding grass was noisy with "zawa, zawa," and as I opened my eyes there appeared in the thicket before me a great snake some fifteen feet long. It moved forward, and the grass and trees divided, making a path. It encircled the tree where I was sitting. A wind arose. No sooner had I seen the dreadful thing than it disappeared. The blackness into which I had been plunged was replaced with brilliant light, which shone through the mountains and valleys.*[8]

Returning to Bairin-ji, Nantenbō immediately met with Razan, who was satisfied that his pupil had reached enlightenment. A few months later Razan recognized Nantenbō as his *dharma* heir with an *inka* (official certificate of spiritual attainment) and the priestly name Hakugaikutsu (White Cliff Cave).

Nantenbō's accomplishment earned him a position as the head of Daijō-ji in Tokuyama Prefecture in 1869. He took his new duties to heart, earnestly training younger monks, ministering to a small lay following, and repairing temple buildings. Although he would eventually become a renowned Zen evangelist, at age thirty-one he recognized his own shortcomings, ruefully noting, "My lectures are like the drum used in sumo matches; they only summon spectators. They are not worth the dregs of the wine pot."[9] He persevered, however, delivering lectures at Daijō-ji and throughout Yamaguchi Prefecture. On these occasions Nantenbō admonished his audience toward strict Zen practice, refusing to offer salvation of the kind "bought and sold" by other sects.

It was during his travels in Kyūshū in 1873 that Nantenbō discovered

a large nandina bush growing beside a cow shed. From the owner, he learned that it was an ancient growth. While his companions waited by the roadside, Nantenbō pleaded with the farmer:

> *I have searched here and there, and this is a perfect dragon-quelling training stick. If this tree goes on this way, how long will it live? Someday it will wither and die…. In my hands, however, it will become an instrument of the* dharma. *This nandina will resound for countless generations. What do you say? Will you let me have it?*[10]

The farmer gave in to the earnest monk's request. Nantenbō cut a thick trunk, addressing the remaining stump: "I cannot live unless I make the most of your great death, you who have lived for two hundred years."[11] When Nantenbō finally joined his waiting companions with stick in hand, they chided the zealous priest, playfully dubbing him "Nantenbō" (nandina staff). The appellation stuck, and the priest henceforth was known by this sobriquet. Inspired by his prized stick, Nantenbō embarked on a grand pilgrimage, visiting temples throughout Japan. According to Nantenbō's later accounts, he challenged resident priests to *dharma* battles, beating them with his stick and chasing them from their temples if they lacked true understanding.

Nantenbō's unshakable sense of right and wrong and fearless devotion to Zen often led to passionate disputes. On at least three occasions he even challenged the governing priests of Myōshin-ji, the head temple for his branch of the Rinzai sect. In 1879, amid great excitement over the building of a large new center for the study of Zen, Nantenbō was a vocal opponent. Echoing the ancient Chinese master Lin-chi's rejection of scriptural pedantry, Nantenbō argued that monks should concern themselves with spiritual training, not scholarship. He recommended that the sect's resources would be better spent by constructing a training hall. When his suggestion was rejected, Nantenbō's disappointment spilled forth in acrid criticism: "an impregnable fortress is sometimes broken from within…priests such as these are worms in the body of a lion."[12]

On another occasion, the governing body at Myōshin-ji considered ranking temples according to their income. Priests from well-supported temples would receive high positions, while priests from humble temples, no matter how accomplished, would not be able to wear the exalted purple robes. There was widespread condemnation of the idea, and Nantenbō was chosen to represent thirty-one temples throughout Japan in delivering a petition of protest. Rebuffed at first, he sat resolutely in the garden of Myōshin-ji, vowing not to leave until the petition was accepted. In the face of the formidable priest's determination, the Myōshin-ji authorities capitulated, and Nantenbō happily returned home.

Nantenbō's most dramatic attempt at reforming Zen in Japan occurred in 1893. Convinced that many priests were undertrained or altogether fraudulent, he proposed that all high-ranking Zen clerics submit to a standardized series of *kōan* in order to receive certification. In formulating the examination, Nantenbō consulted with six of the leading Zen Masters of the day, thus forcing the priests of Myōshin-ji to agree with the spirit of the proposal. Difficulty in carrying it out, and the discord that would arise as deficient priests were divested of their temples and rank, however, prompted Myōshin-ji to reject Nantenbō's proposal. Although he felt be-

trayed and defeated, Nantenbō had succeeded in pointing out the widespread need for reform.

The unflinching determination of Nantenbō in the face of conflict attracted the attention of military leaders of the day. Shortly after becoming the head of the *sōdō* at Sokei-ji in Tokyo in 1885, Nantenbō met the famous swordsman and calligrapher Yamaoka Tesshū. The two men seem to have enjoyed a relationship of mutual respect and admiration until Tesshū's death three years later. Tesshū invited Nantenbō to serve as Zen Master at a small temple in Utsunomiya that he was restoring. It was there, under Nantenbō's instruction, that the famous generals Kodama Gentarō and Nogi Maresuke came for Zen training.

Nantenbō's most prestigious appointment, in 1891 to the sprawling Zen complex of Zuigan-ji in Matsushima, ended a few years later amid a storm of controversy. While Nantenbō was away, an ancient statue of the famous warrior and patron of Zuigan-ji, Date Masamune, was accidentally damaged by a young acolyte. Although innocent, Nantenbō was blamed for the incident and ultimately resigned his position in an attempt to placate the outraged descendants of Masamune. Shocked and disheartened, Nantenbō secluded himself in the nearby dilapidated temple of Daibai-ji for two years. Far from being a period of bitter stagnation, however, it seems to have afforded Nantenbō a chance for quiet introspection and maturation. In a verse couched in imagery drawn from the name of the temple (Great Prunus) itself, Nantenbō suggested as much:

> *Great plum trees take twenty years to bear fruit.*
> *In this place Nantenbō, too, ripens.*[13]

Two years later, Nantenbō's first act after his reemergence from seclusion provides telling evidence of his new, more moderate approach to the propagation of Zen; he abandoned his cherished training stick. Reasoning that the formidable club might have frightened acolytes away from Zen practice, he locked it in the treasure house at Empuku-ji. Henceforth, although his Zen spirit remained fierce, he ceased the zealous rampages of his younger years.

In 1902, at the age of sixty-four, Nantenbō was asked by Myōshin-ji to take control of Kaisei-ji in Nishinomiya. A medium-size temple with a venerable tradition, Kaisei-ji was to be Nantenbō's home for the next twenty-three years until his death in 1925. Perhaps because of his former notoriety, Nantenbō immediately attracted a sizable following. His reputation was bolstered even further when, in 1908, he was designated as the 586th Exalted Master of the main temple of Myōshin-ji. Largely ceremonial, the honor nevertheless confirmed Nantenbō's high standing among his contemporaries.

NANTENBŌ'S ART

Nantenbō first began to produce painting and calligraphy in his early fifties during his brief period at Zuigan-ji. This late date is not unusual, given the traditional Zen rejection of artistic cultivation among its clerics. In the past, harsh judgments were levied against monks who strayed from their prescribed routines. The Zen Master Musō Soseki (1275–1351), for example, once disparaged monks who occupied their time composing poetry:

Then there are those, who besotted with poetry, conceive of their vocation as a literary one—these are shaven-headed laymen, not worthy of inclusion in even the lowest grade. Nay, they are stuffed with food and stupid with sleep, vagrant time-passers I called frocked bums! The ancients had another name for them: "robed ricebags." They are not monks, and certainly no disciples of mine.[14]

Similar criticisms have been aimed at those who neglect their spiritual practice while perfecting brush techniques. Nevertheless, there is also a seemingly contradictory tradition in Japan of collecting and admiring the calligraphy of high-ranking Rinzai Zen priests. Termed *bokuseki*, or "traces of ink," such works were thought to resonate not only with the spirituality of the priest who wrote them, but with that of his teacher and his teacher's teacher, all the way back to Daruma himself.[15]

In this light, it is reasonable that Nantenbō, as the newly appointed head of Zuigan-ji, complied with requests for samples of his calligraphy in spite of the fact that he had little previous experience with brush and ink beyond the rudiments of writing. Indeed, the earliest datable works of painting and calligraphy by Nantenbō are signed "one hundred twenty-fourth generation [of Zen abbots] at Matsushima, Nantenbō," thus indicating his historic position at that temple.

While Nantenbō was compelled to take up the brush by virtue of his new position, he seems to have taken readily to it. His own comments are refreshingly devoid of aesthetic or religious posturing, expressing instead a certain workaday quality in his approach:

My writing is quite fast, as I am not concerned with the rules of calligraphy or whether it is good or bad. I write a page a minute, so it is nothing for me to write sixty sheets in an hour.[16]

Despite this astonishing rate of production, there were times when Nantenbō was beleaguered with requests for works by his hand:

I don't know of any magical quality about my bokuseki, *but recently everywhere I go I am asked again and again to write. It is as if I have become a professional calligrapher.[17]*

Ultimately Nantenbō's use of the brush was a form of Zen practice. Like any activity performed by Zen adherents, it was an opportunity for concerted concentration. This concept was not a new one. At the heart of communal, monastic existence was the necessity of carrying on daily activities in addition to periods of seated meditation. Implicit in the ideographic compound *gyōjūzaga* (walking, standing, sitting, lying) is the idea that all activities should be performed with a Zen spirit.[18] Nantenbō reveals this attitude in a passage from his autobiography:

The reason for not speaking while writing a large character is that the character will "die" unless it is written in one breath. One should magnify one's spirit and write without letting this magnified spirit escape. The character will die unless it is written using the hara *[literally, gut, here suggesting the center of one's spirit].[19]*

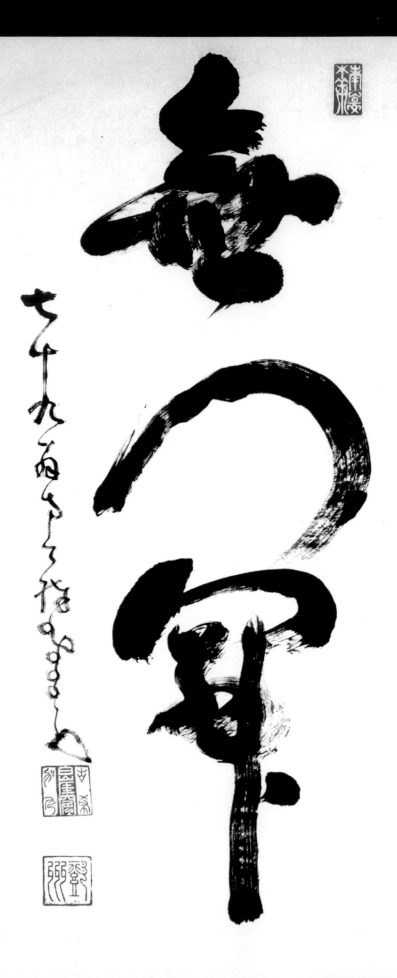

Plate 1. Tōjū Zenchū (Nantenbō, 1839–1925)
MUMONKAN (1917)
Ink on paper, 67.2 x 32.7 cm.
Chikusei Collection

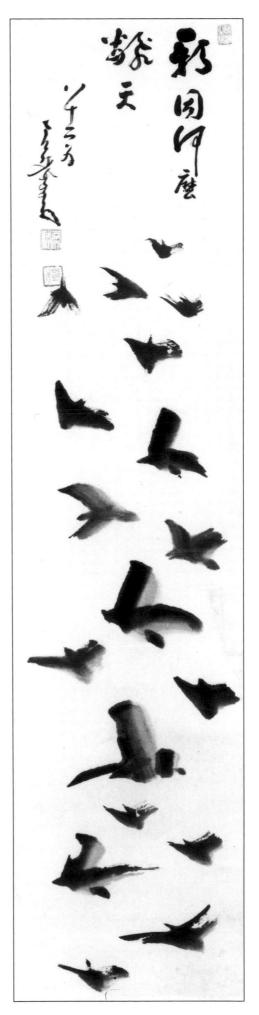

Plate 2. Nantenbō
CROWS (1920)
Ink on paper, 125.4 x 29.5 cm.
Private Collection

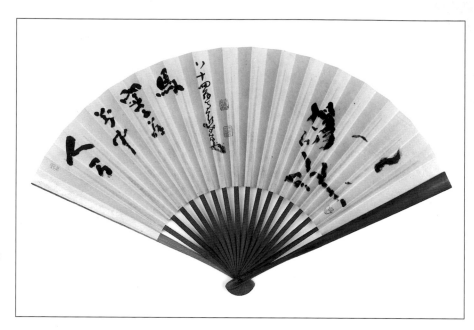

Plate 3. Nantenbō
HORSE (1922)
Ink on fan paper, 40.5 x 24 cm.
Genshin Collection

For his calligraphy, Nantenbō drew heavily upon existing Zen literature. In 1917, his seventy-ninth year by Japanese count, he wrote three boldly dramatic characters for *Mumonkan* in hanging scroll format (PLATE 1). Literally "no gate barrier" or "gateless gate," this calligraphy simultaneously refers to the classic *kōan* anthology compiled in 1228 by the monk Wu-men (Mumon) and to the nature of Zen itself, that is, an ineffable state that is at once "gateless," and yet not easily entered because of humankind's deluded manner of thinking.

Typical of Nantenbō's calligraphic style are the blunt beginnings and endings of each stroke, almost as if he were using a worn, old brush. The strokes are thick and meaty, and given further strength by dense ink tonalities. Eschewing supple smoothness and precisely shaped strokes associated with professional calligraphers, Nantenbō cultivated a certain coarseness and imperfection. The sweeping, abbreviated form of the character for *mon* (門 gate), for example, arches irregularly with bumps and ragged edges. By allowing the brush to go dry, each twist and turn is given accentuated texture. For all its masculine bravura, however, Nantenbō's *Mumonkan* is admirably composed. The open, airy character of *mon* contrasts nicely with the compact, complicated forms of *Mu* (無 no, not) and *kan* (關 barrier), above and below it.

When Nantenbō painted themes that lack such an obvious Zen connection, his accompanying inscriptions often suggest underlying Zen interpretations. The subject of crows is represented among the vast number of paintings by Nantenbō by a single known example painted in 1920 at the age of eighty-two (PLATE 2). Within the confines of a narrow hanging scroll, Nantenbō painted eighteen crows flying chaotically about. Each crow is the result of as little as two or three strokes of the brush. Nantenbō painted the splay of wing feathers by holding the brush diagonally to the paper. Also, by loading his brush with both dense and diluted ink, he was able to impart a certain depth and variation to the shape of each bird. Nevertheless, the overall technique is more expressive than descriptive. Indeed, certain shapes would not be readable as birds at all, if not part of a greater conceptual whole. The extreme brevity in which the crows were rendered, however, ultimately contributes to a sense of movement, as if the startled flock occupies

Plate 4. Nantenbō
IROHA (*pair of folding screens*)
Ink on paper, each panel 124.9 x 33.6 cm.
Man'yō-an Collection

いろはに
ほへとち
りぬるを
わかよた
れそつね
ならむう

ゐのおく
やまけふ
こえてあ
さきゆめ
みしゑひ
もせす

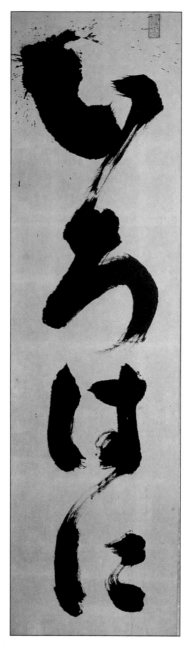

Plate 5. Nantenbō
IROHA *(first panel)*

the atmospheric space just before the viewer. Nantenbō's six-character inscription takes the form of a rhetorical question, akin to a Zen *kōan*:

Why are these crows flying about in the sky?

In Zen, the dualist distinction inherent in the question "Why?" is rejected; instead, there is an unquestioning acceptance of the nature of existence. In this case, the cause of the crows' commotion is irrelevant; there is just "flying." In this light, Nantenbō's choice of crows is particularly appropriate: their black feathers suggest somber-robed monks. The raucous, erratic behavior of the agitated birds serves as a metaphor, perhaps, of the unsettled, grasping minds of Zen acolytes searching for enlightenment beyond themselves.

On some occasions, Nantenbō's choice of a painting subject was influenced by a secular story or parable. His images of spirited horses, for example, were inspired by an ancient Chinese anecdote, as suggested by a fan painting dated age eighty-four with Nantenbō's inscription (PLATE 3):

The myriad concerns of man
are like old man Saiō's horse

The original account, attributed to the legendary Chinese philosopher Huai Nan-tzu, relates how old man Saiō was undisturbed when his horse ran away, saying that somehow, some good would come of his loss.[20] After several months the horse returned, leading a prize stallion. Much to everyone's surprise, however, Saiō did not rejoice. Within a short time, his son fell off the horse and broke his leg. Once again, however, Saiō accepted his misfortune with equanimity. Because he was lame, the old man's son avoided conscription in the army. The full extent of the old man's wisdom was made clear when his neighbors' sons failed to return from battle.

Nantenbō's method of painting horses is spontaneous and intuitive. With a few thin strokes he indicates the beast's muzzle, nostrils, and jawbone, and several dry, horizontal dashes serve to convey the flying mane. The forelegs are drawn with a stroke that abruptly shifts direction, effectively suggesting the sharp bend of the racing animal's knees. The hind legs are not shown; they exist just beyond the pictorial surface. The tail is a single dry stroke that swings upward. The absence of a ground plane, sketchily indicated in other paintings, further suggests the high-speed flight of the horse. Here, on the format of a fan, he has painted a horse that would move as the recipient of the painting waved the fan in front of his face.

In painting this theme, Nantenbō may not have been trying to convey any special Zen meaning. The historically auspicious nature of horses, coupled with the hopeful story of Saiō's horse, may have simply served to encourage lay followers who had fallen on hard times. If so, such paintings demonstrate Nantenbō's position as a compassionate community elder.

A sympathetic attitude toward his lay following may have been the impetus for Nantenbō to write the *iroha* syllabary across twelve panels of a pair of folding screens (PLATES 4 and 5). The *iroha* is a set arrangement of forty-seven simplified Chinese characters used for their phonetic value in order to record spoken Japanese. Until recently, Japanese children memorized this syllabary by using as a mnemonic a poem, legendarily attributed to the great ninth-century Shingon priest Kūkai, in which the syllables form the words:

Iro wa niedo	Though the colors [of autumn flowers]
Chirinuru o	Are bright,
Waga yo tare zo	They fade away.
Tsune naran	Who in this world of ours
Kyō koete	May continue forever?
Asaki yume mi-ji	Crossing today the boundaries of the physical world,
Ei mo sezu	No more shallow dreams or intoxication.[21]

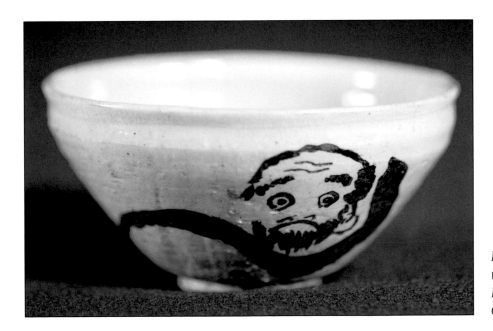

Plate 6. Nantenbō,
FUSUMA FROM KAISEI-JI
Ink on paper, 168 x 103 cm.
Kaisei-ji

While not specific to Zen doctrine, the verse—written across twelve panels—clearly represents the Buddhist view of life on earth as sorrowful and transitory. It also serves as a reminder to attend to one's salvation, the *raison d'être* of all Buddhist priests. Nantenbō's bold brush lends power to the simplified *kana* (Japanese phonetic) shapes of the *iroha*. The sheer size of the object transforms the familiar children's poem into a startling mandate. The characters are bold and substantial, defined by thick strokes of relatively even width. The interplay of velvety black ink and "flying white" creates a sense of movement and depth. Like the earnest letters of young children, Nantenbō's *kana* are devoid of refinement or elegance. Instead, the ragged edges and frayed endings of strokes convey a raw grittiness that is at once naive and powerful.

Nantenbō's most famous work on a monumental scale remains in the collection of the Kaisei-ji. Each character of an eight-character couplet was written on a full-size *fusuma* sliding door, one per door (PLATE 6). When installed within the bays of opposing sides of the main altar, they create an unsettling environment of great power and violent movement. The couplet, evoking the ominous sounds of powerful beasts, well agrees with the wild, untamed spirit of Nantenbō's calligraphy:

> *The dragon cries at dusk,*
> *The tiger roars at dawn*

In many cases the characters seem ill-formed, probably owing to the difficulties of working on so great a scale. What seems to have been of paramount concern to Nantenbō was not the proper rendering of the characters, but that they transcend their two-dimensional nature and con-

Plate 7. Nantenbō
DARUMA TEABOWL (1913)
Iron glaze on ceramic, 7.4 cm. tall
Gubutsu-an

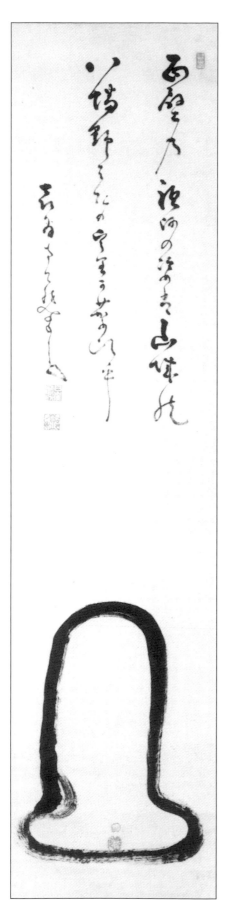

Plate 8. Nantenbō
ONE-STROKE DARUMA (1916)
Ink on paper, 146.3 x 34.5 cm.
Murray Smith Collection,
Promised Gift to the Los Angeles
County Museum of Art

vey the strength and movement of the brush. Nantenbō accomplished this by heavily loading his oversized brush, slightly pinching the tip to momentarily stop the flow of ink out of its bristles, and then with great gusto forcefully hitting the paper.[22] The result was a great splash of ink beginning the initial stroke of each character—a clear record of the drama and potency of the moment.

The ambitious scale and trademark splash of this work ultimately influenced later calligraphers. The works of Kanshū Sōjun (Deiryū; see chap. 2) and Kasumi Bunshō, both direct pupils of Nantenbō, clearly reflect his dynamic style. The celebrated contemporary calligrapher Morita Shiryū credits Nantenbō's work as having exerted a formative influence on his style.[23] And Yoshihara Jirō, founder of the Gutai group of avant-garde artists in the 1950s and '60s, frequently took fellow artists to Kaisei-ji to see Nantenbō's powerful sliding doors. Gutai members rejected traditional painting methods, which they believed dampened intuitive creativity by being overly intellectual. Instead, they advocated more direct, experiential methods of using material to reflect the physical, emotional, and spiritual moment of creation. This approach harkens back to Nantenbō's insistence on Zen concentration and the use of *hara*.

The fact that the majority of Nantenbō's images were painted during the final decade of his life is a testament to his continuing vitality. Ultimately he seems to have developed a basic repertoire of about sixteen subjects, which he painted again and again with great gusto. In doing so, Nantenbō followed in the footsteps of other Zen Masters, particularly of the Edo period (1600–1868), for whom Zen painting was a significant mode of expression. Their simple pictures were a convenient and vivid means of making abstruse Zen principles more accessible to lay people.[24] The spontaneity, technical naiveté, and humble materials were at least partially the result of Zen priests' avowedly amateur status. As with calligraphy, it was inappropriate for anyone but high-ranking, enlightened Masters to produce Zen paintings.

Imaginary portraits of the First Zen Patriarch, Bodhidharma, called Daruma in Japanese, are the most frequently encountered of all Zen-related subjects. All Zen Buddhists trace the existence of their doctrine to this Indian sage who, according to legend, left his homeland in the late fifth or early sixth century in order to propagate his brand of Buddhism in China. Daruma stressed meditation above all other methods of achieving enlightenment. In fact, it is said that he accomplished the astonishing feat of sitting in meditation ceaselessly for nine years while facing a wall at Shaolin temple on Mount Sung.

Nantenbō began to produce bust-portraits of Daruma in his early seventies. Many of these are boldly rendered, large-scale images. An unusual example, however, was painted in glaze when he was seventy-five on a small teabowl (PLATE 7). Rendered in iron-oxide on cream-colored clay, the composition was completed in just a few strokes. The furrowed brow of the First Patriarch is suggested by two parallel lines. The eyebrows, beard, and hair are indicated by a series of rapidly applied dabs. The mouth is a single downward arch, and the eyes are nearly round circles with black dots for pupils. A single stroke indicates Daruma's robe as it falls from his left shoulder across his chest, covering his hands. The overall effect is charmingly simple and humorous. With an extreme economy of means and deliberate naiveté, Nantenbō effectively conveyed the two character-

istics most associated with the First Patriarch: his devotion to meditation, suggested by his wide-eyed stare, and his fierce determination, conveyed by his firmly set mouth. Daruma's portrait on a teabowl also recalls some of the more fantastic legends associated with the revered sage's life. Unable to keep his eyes open during his protracted meditation at Shaolin temple, he is said to have ripped off his eyelids in frustration; tea plants sprang spontaneously from the ground where the eyelids fell, thus beginning the custom in monasteries of drinking tea to prevent drowsiness. Such stories make Nantenbō's use of a teabowl for a portrait of Daruma altogether fitting.

Nantenbō inscribed the teabowl with a short, four-character quote attributed to Daruma himself. According to tradition, this was Daruma's pointed response when Emperor Wu (502–550) of the Liang dynasty asked him to recite the sacred truth's first principle:

Vast emptiness; nothing sacred

In addition to frontal portraits, Nantenbō also painted a number of images showing Daruma seated in meditation as seen from behind the sage. Long favored as a painting theme by Zen priests, these images are identified as "*menpeki* Daruma" or "wall-facing Daruma," referring to the ancient sage's nine years of meditation while facing a wall. As early as the fourteenth century in Japan, Zen artists playfully depicted the sage's silhouette by means of a single, meandering outline in a technique known as *ippitsuga* (one-stroke painting). Later priests, including Hakuin Ekaku (1685–1769) and the Shingon monk Jiun Sonja (1781–1804), produced their own variations on this theme. Hakuin's *menpeki* paintings are characterized by two or three thick, even strokes that fluidly outline the shape of the First Patriarch.[25] Jiun, on the other hand, used a dry brush and angular strokes to create an architectonic Daruma.[26] Both men, however, clearly indicated the sage's head and the shoulders and the splay of his robe.

Nantenbō's conception of the *menpeki* theme is even more abbreviated than those of his predecessors (PLATE 8). By eliminating the distinction between the head and shoulders, Nantenbō further distilled the silhouette of the First Patriarch. A simple, inverted U-shape is used to connote Daruma's body, and a horizontal ellipse is meant to imply his knees beneath monkish robes. Nantenbō's method of rendering these elements, however, is so geometric as to be unreadable as a cloaked figure. In a final denial of pictorial volume, Nantenbō impressed his seals within the outline, thus assertively calling attention to the surface of the paper. The abstract nature of the figure, however, only accentuates the quality of the ink, applied in a single sweeping stroke of great energy.

Was Nantenbō simply inept at pictorial representation, or was he a visionary who pushed Zen painting further into a realm of dynamic epigraphs and emblems? The inscription on his *menpeki* painting offers a playful acknowledgment of the image's ambiguous nature:

The shape of Daruma facing the wall—
is it like a melon or an eggplant
from the fields of Hachiman in Yamashiro?

Plate 9. Nantenbō
BULL (1924)
Ink on paper, 135 x 33.6 cm.
Oliver T. and Yuki Behr Collection

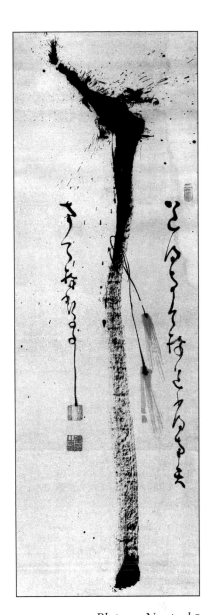

Plate 10. Nantenbō
STAFF
Ink on paper, 148.2 x 47.3 cm.
Private Collection

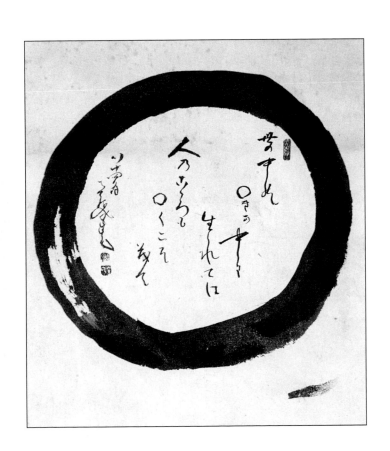

Plate 11. Nantenbō
ENSŌ (1922)
Ink on paper, 20.9 x 17.8 cm.
Hōsei-an Collection

It is likely, in fact, that Nantenbō intentionally challenges people's rigid preconceptions about the nature of Daruma. In his autobiography he notes that while he receives many requests for paintings of Daruma, his images are often criticized for looking like owls or octopi. "Very interesting," the old priest observes. "People talk as if they have seen Daruma, but who has seen the original Daruma?"[27]

Another traditional theme frequently painted by Chinese and Japanese Zen priests and literati artists is the ox or water buffalo. The gentle nature of these huge, lumbering beasts embodied their bucolic existence, far removed from the din and turmoil associated with life in the cities. In Zen literature, the progressively harmonious relationship between a herdsboy and his ox served as a metaphor for the quest for enlightenment. Composing *Ten Oxherding Songs*, sets of poems about each successive stage of spiritual awareness, became popular among Chinese monks during the Southern Sung dynasty.[28] Illustrated versions imported from China that are listed in the inventories of the shogunal collections helped to establish this theme in Japan.[29] Early Japanese versions closely follow Chinese prototypes; the ox is rendered in soft washes, fine texturing strokes, and occasional descriptive outlines, and the oxherder and his beast are usually pictured within an abbreviated landscape setting, as seen in PLATE 68 (page 149).

In contrast, Nantenbō created a drastically distilled composition (PLATE 9). The great bulk of the ox is defined by a single outline. Two dabs of ink indicate horns, and a thin, trailing stroke is used to connote a tail. A few horizontal strokes punctuated with vertical dashes indicate the grassy ground. The simple, triangular composition is balanced, imparting a sense of tranquillity to the already staid form of the recumbent ox. In the inscription Nantenbō likens himself to the old ox, thus transforming the painting into a form of self-portrait:

> *Nantenbō—*
> *when the bull is tamed*
> *it becomes peaceful*

Nantenbō clearly delighted in the expressive potential of abbreviated imagery that becomes self-portraiture.[30] He rendered his favorite subject, his Zen training stick of nandina, by striking the paper with a heavily loaded brush and then dragging it downward to indicate the length of the stick (PLATE 10). The initial explosion of ink, with spatters in all directions, is vivid evidence of the physicality of his approach. To this single stroke Nantenbō roughly rendered the cord and tassels attached to the stick in contrastingly pale ink tonalities. The overall result is an image that vibrates with energy, conveying the vigor of Nantenbō's technique rather than pictographic description. The potent ferocity of Nantenbō's images of training sticks is echoed by his inscription:

> *If you speak, Nantenbō*
> *If you don't speak, Nanten[bō]*

In other words, you will receive a blow from the nandina stick (and also Nantenbō himself) whether or not you are able to respond to Nantenbō's *kōan*. This inscription echoes a terse statement attributed to the Chinese priest

Te-shan: "If you speak, thirty blows; if you don't speak, thirty blows." This seemingly illogical and harsh message from master to disciple exemplifies a pivotal concept in Zen training: after experiencing an initial awakening, a Zen practitioner must not become complacent. This is why it is said that someone who has reached enlightenment never clings to it but moves on.[31] In the same manner, a responsible Master continues to prod his disciples onward, using every means available, including a few sharp blows with a stick.

Symbolic shapes and gestures have long been a part of Buddhist practice and worship. In Zen Buddhism, *ensō* (Zen circles) were first used by Chinese Masters during the Tang dynasty to symbolize perfection.[32] The Master Nan-yueh Huai-jang (677–744) used circular figures to "symbolize the nature of the enlightened consciousness or the 'original countenance before birth.'"[33] And several accounts in the *Hekiganroku*, (Blue Cliff Record), an eleventh-century compilation of *kōan*, record the use of circles—drawn in the air, scratched in the earth, or written on paper—during encounters between pupils and Zen masters. It is not surprising that Nantenbō, with his demonstrated penchant for elliptical imagery, also painted *ensō*. What is unexpected is his subdued approach. Rather than an explosive splash of ink followed by a rapidly brushed circle, Nantenbō's *ensō* inevitably exhibit the bumps and imperfections of a brush dragged slowly across paper, responding to the priest's every pulse and tremor. Nantenbō also altered his composition to best accord with the meaning of the inscription. In works where he likens the *ensō* to the full moon, the circle floats high above the inscription.[34] In a charmingly small example datable to his eighty-fourth year (PLATE 11), Nantenbō purposefully placed his inscription within the circle:

> Born within the ensō of the world
> the human heart must also
> become an ensō

Nantenbō playfully enlivened his inscription by using small circles to indicate the words *circle* and *round*, thus drawing two *ensō* within the larger *ensō*.

In spite of his crusty personality, it is clear that Nantenbō never lacked compassion or humor. On a number of occasions he even acquiesced to requests for non-Zen phrases, including the mantra of the Jōdo (Pure Land) sect of Buddhism: *Namu Amida Butsu* (Praise to Amida Buddha). Earnest recitation of this verse, according to Pure Land beliefs, would ensure rebirth in Amida's Western Paradise. Such deference to the saving grace of Amida (*tariki*, other-power) is antithetical to the Zen concept of enlightenment through one's own effort (*jiriki*, self-power). Nevertheless, many Zen priests demonstrated tolerance toward lay followers who found comfort in reciting the name of Amida. Recognizing the efficacy of such religious belief, Nantenbō wrote the character shin (信 faith) at the top of a hanging scroll (PLATE 12). In an attempt to remind us of the pervasiveness of the Buddha-nature, however, he playfully added the following inscription, substituting his own name for that of Amida:

> Faith
> If you have faith, then Nantenbō is also Buddha
> Namu Nantenbō, namu Nantenbō, namu Nantenbō. . .

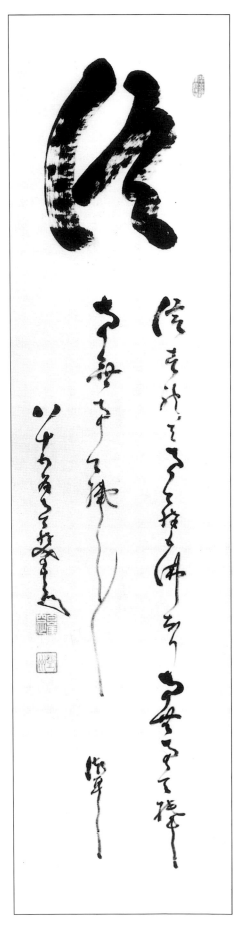

Plate 12. Nantenbō
FAITH (1923)
Ink on paper, 133.7 x 33 cm.
Private Collection

With a limited repertoire and humble materials befitting his position as a Zen priest, Nantenbō exercised remarkable creativity and freedom. He cultivated a rough, brusque quality in his calligraphy, and an equally unpolished style for his imagery. His vigorous approach and complete rejection of pictorial artifice pushed the boundaries of abstraction, surpassing even the abbreviated images of his immediate predecessors. In doing so, Nantenbō transcended his Edo-period roots and firmly established Zen expression within a twentieth-century context. And yet it is unlikely that Nantenbō purposefully set out to further the boundaries of artistic expression. As a dedicated priest, he strove to propagate Zen and to maintain the high standards of past Masters. His marvelous works of painting and calligraphy are only the residual remains of his fierce Zen spirit.

"DEIRYŪ . . . DEIRYŪ . . . DEIRYŪ . . ." the thunderous voice of Zen Master Yamamoto Gempō called out as tears flowed down his face.[2] Gempō conducted the funeral service for Kanshū Sōjun, better known as Deiryū, on the morning of March 7, 1954, at Empuku-ji, outside Kyoto. Gempō himself was already eighty-nine years old, and Deiryū had been only sixty when he died, but the deep sorrow and affection expressed by Gempō was indicative of many people's feelings toward Deiryū, who was well loved by monks and lay people alike.

Deiryū (FIG. 7) is best known as a follower of Nantenbō and is often so closely associated with Nantenbō that his own personality and approach to Zen have been overlooked. Despite being present in Nantenbō's *sōdō* during his formative years as a monk, and despite the powerful impression that the flamboyant Nantenbō must have made personally and artistically, Deiryū eventually followed his own path as a Zen Master and teacher.

In contrast to Nantenbō's outgoing, self-assured, often self-righteous manner, Deiryū led a much quieter life, reflecting not only his own personality but also the period in which he lived. Unlike Nantenbō, who ushered Zen safely into the twentieth century by working tirelessly to ensure the continuation and purity of Zen training and teaching, Deiryū represented an age in which Zen had rediscovered its role in Japanese society and was no longer struggling for survival.

Deiryū was born in 1895 to the Izawa family of Kobe, but his actual birth took place in Tomogashima in Wakayama Prefecture while his father worked as an engineer on the construction of a fort there.[3] Since his father was a noted naval engineer, Deiryū received the strict upbringing and education of a military family. In fact, his brother eventually became a rear admiral and, following his father's skills, consulted on the construction of a lighthouse. Throughout his life Deiryū held great respect for military men; however, his father's expectations were overwhelming, and, particularly in school, Deiryū became agitated and nervous. The answer was physical education, in which Deiryū is said to have excelled. He had a particular affinity for the sea and excelled the other students in swimming, often representing his school in competitions.

Despite Deiryū's athletic nature, he was soon diagnosed with pulmonary tuberculosis by doctors who predicted that he would not live past the age of twenty-five. As a result, Deiryū decided to begin serving as an acolyte at a Zen temple. Times were difficult, however, and many temples were under severe financial hardship. The local temple, Zenshō-ji, already had five acolytes, and because of its destitute state it could not afford another mouth to feed. As a result, the Zen Master Nantenbō from the temple Kaisei-ji in Nishinomiya stepped in, saying, "Kaisei-ji right now also has many troubles, but by all means I will allow this child to become an acolyte."[4] Thus, Deiryū began serving as an attendant to Nantenbō, against the wishes of his family, who still hoped that he would enter into military life.

Nantenbō was seventy-two years old when Deiryū entered his temple in 1911 at the age of sixteen. The discipline in the monastery was harsh; Nantenbō had taken great pride in his own ability to haul large loads of firewood as an acolyte at Bairin-ji, and now he participated alongside the acolytes and monks in the daily physical labor (*samu*) required to maintain the temple grounds. At Kaisei-ji, Nantenbō's disciples carried sacks weighing more than twenty kilograms (forty-four pounds) on their shoulders every day, and al-

2

THE TRANSMISSION OF ZEN ART AND TRAINING

Deiryū Kutsu (Kanshū Sōjun, 1895–1954)

If I hold a sake cup
my friend is there —
I think of Deiryū.

—ISAMU YOSHII[1]

Figure 7. Deiryū

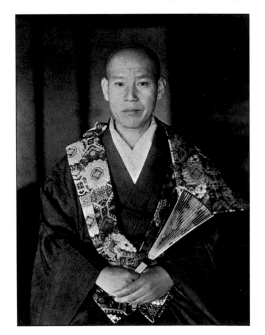

though the strap of the sack cut into Deiryū's frail shoulders, he persevered. He was also still attending junior high school at this time.

In the spring of 1912, Deiryū's father and mother passed away within a month of each other, a great shock that sent their son into a period of deep grief. He tried to escape his sorrow through physical activity. Deiryū was very accomplished in the art of *kendō* (Japanese fencing with bamboo swords), and at the time, a friend of Deiryū's older brother Tōru, named Teramoto Takeji, was serving as a *kendō* master in Kobe. Teramoto was acquainted with Nantenbō and often asked the Master to talk about Zen to his *kendō* group. Largely through Teramoto's influence, Deiryū finally quit school in 1913 and entered Kaisei-ji formally to train as a monk, rather than merely an acolyte, under Nantenbō.

With Deiryū serving as attendant to Nantenbō, the two of them traveled the countryside on lecture tours for the general public, which might include as many as thirty stops. Seated in the third-class cars of trains, they usually traveled at night in order to arrive at the next location in the morning. On these journeys, Nantenbō sat in *zazen* while Deiryū diligently memorized Zen texts and practiced calligraphy by tracing the shapes of characters with his finger in the palm of his hand.

Nantenbō's and Deiryū's pupil Kasumi Bunshō recalled:

When Deiryū was young and still called Jun-san, he used to practice calligraphy all day when his Master, Nantenbō, was away. He also practiced calligraphy whenever he was on a train or ship with Nantenbō. With an example by Wang Hsi-chih on his lap, he licked the index finger of his right hand and practiced copying the characters on his left palm with it. Once he started, nothing distracted him. [5]

Bunshō also explained that Kaisei-ji has examples of Nantenbō's lecture books copied by Deiryū at the age of thirty. These copies of the *Rinzairoku*, *Mumonkan*, and *Hekiganroku* are written in *kaisho* (square, printed style) with no mistakes or corrections and displaying an assuredness "as if written by a computer. As if he himself were the brush when he was writing." [6]

Despite his dedication to the practice of calligraphy and the memorization of Zen texts, Deiryū seems also to have had a slightly rambunctious side during his novice years. One of his fellow novices, Kakuji Sentari, recalled:

Deiryū and I both became disciples of Nantenbō Rōshi. . . . Deiryū had an extremely active nature. We would often sit together roaring, "Mu, Mu." He often got wild when he was drunk, so I sometimes flung him in the hondō. . . . Ever since his novice days, he tended to be popular with women, who called him Jun-san. He was a warm, open-minded person. He and I used to give a hard time to Nantenbō Rōshi, and were scolded by him in turn. [7]

Sōshin Ōmori, whose father had been a lay follower of Nantenbō, recalled, "My first encounter with Deiryū was when he was Nantenbō's attendant. I was still a child, but I would often visit Kaisei-ji with my grandmother and bounce on Nantenbō's knee. At that time, Deiryū was still only about twenty years old and called Jun-san. I got this confused with the term for 'police officer' (*junsa*) and asked, 'Don't the Nishinomiya police wear a saber? Where is it?'" [8]

Although Deiryū showed an early interest and skill in calligraphy, having won the honor of writing out the title of his junior high school's bulletin, his calligraphic and painterly style seems to have been strongly influenced by Nantenbō. Deiryū even used this skill to pay homage to his Master, creating a portrait of Nantenbō at the age of eighty (1918, PLATE 13), on which Nantenbō himself wrote the following inscription:

> Striking and pounding with the Nantenbō
> I annihilate all false Zen;
> This ugly old shavepate arouses hate for a thousand ages,
> Extinguishing the transmission like a blind donkey.[9]

Nantenbō is depicted in stern concentration, brows knit together fiercely and mouth turned down in a scowl—both the physical and textual descriptions revealing a Master of strong conviction, determined to protect and preserve the true nature of Zen.

Nantenbō himself painted self-portraits very closely resembling Deiryū's work. The earliest known self-portrait by Nantenbō is dated age seventy-nine (1917, PLATE 14)[10] and reveals a fairly simple, subdued approach to delineating the shape of the head and facial features. Eventually, in the latest known self-portrait, dated age eighty-three (1921, PLATE 15), Nantenbō reveals the calligraphic drama of which he was capable. The lines of the face are still refined and minimal, but the delineation of the robe is now treated with a great flourish of black ink, punctuated by a splattering of ink at the back of the head where the ink-loaded brush hit the paper.

Whether or not Deiryū's portrait influenced Nantenbō's subsequent depictions of himself, or whether Deiryū was merely copying his Master's work, is unknown. But it is clear that Deiryū was painting these images at the same time as Nantenbō. Comparing the portraits allows us the opportunity to compare how a Zen Master saw himself, as opposed to how he was viewed by a disciple. Deiryū portrays his teacher with awe and slight apprehension. The thick eyebrows and greater frown of the mouth enhance the fierceness of a Zen Master from the vantage point of a disciple. In contrast, Nantenbō's depiction of himself, three years later at the age of eighty-three, reveals a more wizened old man, eyebrows less pronounced, but with dry lines of ink suggesting the weathering of old age. But the strong force of the Master's brushwork is still felt in the dramatic splash of the ink surrounding him, reminiscent of Nantenbō's image of a training stick (see PLATE 10, page 31).

The existence of these portraits by both monks reveals even more; although Deiryū did several portraits of Nantenbō, there are no known self-portraits by him. In contrast, Nantenbō did self-portraits, and in his inscriptions on both his self-portraits and Deiryū's portrait, he proclaims his authority as the protector of Zen. Moreover, in works such as the calligraphy (PLATE 12) in which he asserts himself, saying, "Namu Nantenbō," and the image in which the training stick and himself become interchangeable, he demonstrates that his presence should be felt as much through his art as through his words and actions. Deiryū, in contrast, reveals a much more modest attitude in both his life and art.

The resemblance of the two monks' brushwork did not go unnoticed in their own time. Nantenbō once remarked to a friend, "Recently, fakes of

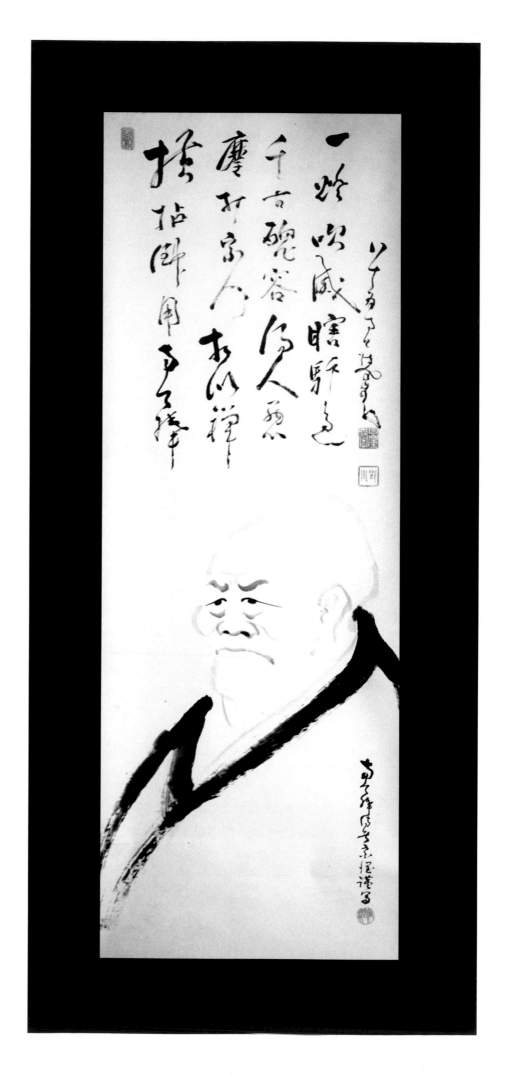

Plate 13. Kanshū Sōjun (Deiryū, 1895–1954)
PORTRAIT OF NANTENBŌ
Inscription by Nantenbō (1918)
Ink on paper, 132 x 46.2 cm.
Private Collection

my calligraphy are being sold. I think Jun [Deiryū] is doing them." When this comment was relayed to Deiryū, he jokingly replied, "What can I say? Through Nantenbō Rōshi's example, my calligraphy has become better. Do you think someone who can write better would dare to imitate inferior works?" Nantenbō later responded, "That's true, Jun's calligraphy may be better than mine, but people appreciate works by Nantenbō. Can we say the same about Jun?" He laughed loudly. [11]

Although many of Deiryū's artistic works reveal a charming, gentle quality, not unlike descriptions of his own character, he also occasionally displayed the drama of Nantenbō. For instance, in the same vein as the bold gestural quality of the robe in Nantenbō's self-portrait, Deiryū displays a dynamic flourish of brush and ink in his character for "dragon" (PLATE 16).

Often depicted winding their way through billowing clouds, dragons represent one of four supernatural animals in Chinese lore and are identified with the male principle (*yang*). From this Taoist association, dragon images were adopted by painters in the Zen tradition. While Deiryū has written the word "dragon" by virtue of the pictographic origin of this Chinese character and the gestural quality of calligraphy, might he also be suggesting a representational dragon floating dramatically through the composition? The word *ryū*, "dragon," (龍), is the second character in Deiryū's own name, so it becomes a personal form of expression. We can see how he has altered the shape of the "dragon" character by comparing the large character with the second character in his signature below. [12]

In Zen, the dragon appears in the *Hekiganroku*, an anthology of *kōan*, in which Zen Master Unmon (Chinese Yun-men, d. 949) says, "My staff has transformed itself into a dragon and swallowed the universe! Where are the mountains, the rivers, and the great world?"[13] The dragon in this case serves as a symbol for the enlightened monk who has come to the full realization of nonduality.

In another work in smaller size, Deiryū has once again written the word for *dragon*, but here instead of the wild, gesturally cursive style in the previous example, he has written the character in highly stylized seal script (*tensho*), an archaic style of writing most often used in the carving of stone seals (PLATE 17). In contrast to the highly individualistic, expressive nature of cursive script with its brush flourishes and fluid contiguous lines, seal script is noted for its unmodulated brushstrokes and carefully balanced proportions and structure. On this *shikishi* (square poem-card), Deiryū follows the main character with the inscription:

> *Every day the dragon offers*
> *waters of the four seas*

The inscription, referring to a folk legend of the dragon bringing rain to parched farmlands, is written in a combination of running and cursive scripts, providing a strong visual contrast to the compositional clarity and austerity of the seal script "dragon" character.

In 1924[14] Deiryū left Kaisei-ji and went to Empuku-ji in Kyoto to continue his training under Kōzuki Tessō (1883–1941), from whom would eventually receive *inka* (certification of enlightenment).[15] Deiryū marked the occasion with a poem:

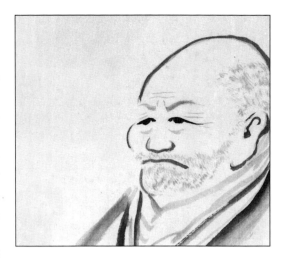

Plate 14. Nantenbō
SELF-PORTRAIT (*detail, 1917*)
Ink on paper, entire work 101.5 x 22.8 cm.
Genshin Collection

Plate 15. Nantenbō
SELF-PORTRAIT (*detail, 1921*)
Ink on silk, entire work 124.4 x 52 cm.
Private Collection

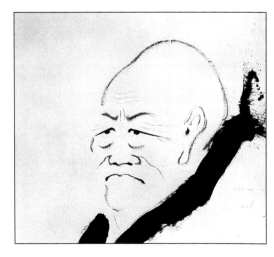

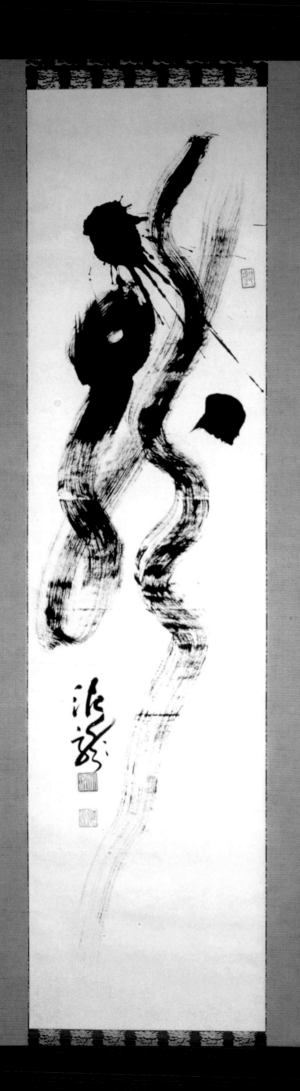

Plate 16. Deiryū
DRAGON
Ink on paper, 134 x 52.2 cm
Chikusei Collection

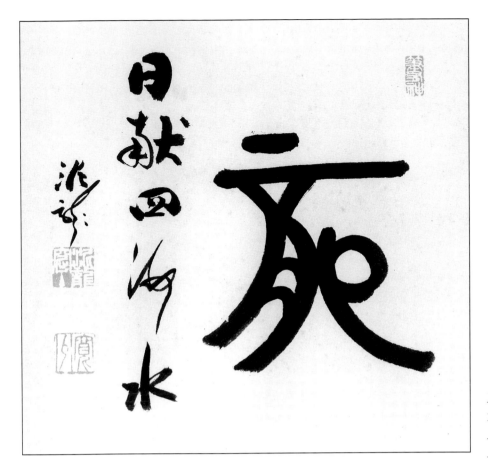

Plate 17. Deiryū
DRAGON SHIKISHI
Ink on paper, 27 x 24 cm.
Hōsei-an Collection

ENTERING EMPUKU-JI

At this Hero Peak Border,
The blue pines and green bamboo are beautiful.
Looking intently East, West, North, and South—
No doors, and also no gate.[16]

Deiryū implies that as he enters the Empuku-ji *sōdō* among the pine trees
and bamboo groves, there are no barriers or obstacles to his training.[17] Un-
fortunately, the following year Nantenbō became ill, and Deiryū returned to
Kaisei-ji to be with him during his last days. In 1927 Deiryū was sent to Tai-
wan, where he became head of the temple Rinzai-ji, a branch temple of
Myōshin-ji, and promoted the spread of Zen in Southeast Asia. In 1929
Deiryū became head of Kenshō-ji in Kumamoto Prefecture, Kyūshū, and
then in 1932, at the age of thirty-seven, he returned to his first temple, Kaisei-
ji, as abbot. During this time he established a private school for students
from Southeast Asia at the temple. The establishment of this school required
great effort on Deiryū's part; he received help and support from many
friends and acquaintances whom he had met in Taiwan, and also from his
elder brother, who was now a naval officer.

In the spring of 1937 Deiryū began touring the country, giving Zen
lectures for the general public. The lecture tours were a continuation of the
trips he had taken when he served as Nantenbō's attendant. However, al-
though he maintained the legacy of Nantenbō by giving Zen lectures
(*teishō*), he apparently would not give any other types of public speeches, in-
cluding sermons (*hōwa*). When informed by a disciple, Hitomi Sochū, that
a women's group in Hirakata city wished him to speak on "religion and life,"
Deiryū refused and told the disciple, "Don't you know I can't do such a

thing?"[18] Although Deiryū did give Zen lectures in the tradition of Nantenbō, unlike his prolific Master he did not write many books. Where Nantenbō mocked intellectualism but at the same time published over twenty volumes of his writings, Deiryū was a man of few words, with the exception of his occasional poetry.

On November 24, 1939, Deiryū erected a pillar at Kaisei-ji and wrote the following commemorative poem:

> *Twenty-eight gods protect this temple,*
> *Sea Turtle Mountain doesn't move, but this moss spreads.*
> *I again enjoy raising a ridge pole;*
> *Over the entire peaceful world, the white moon is pure.*[19]

Ironically, although not yet involved in the Second World War, Japan was in the midst of its military campaign in Asia, so the world was not as peaceful as Deiryū would have wished.

In 1937, in the middle of one of his lecture tours, Kōzuki Rōshi died in a car accident, and Deiryū was asked to take over his position as Zen Master at Empuku-ji, one of the major training centers for Rinzai Zen. Before he would begin his duties at the Empuku-ji *sōdō*, however, Deiryū decided to visit twenty-five *sōdō* around the country, meeting the Masters at each. The journey, which lasted into the fall of 1938, included stops at Bairin-ji in Kyūshū where Nantenbō had meditated over a well; Zuisen-ji in Inuyama where, after receiving no reply after numerous efforts, Deiryū and his two monks simply walked in unannounced; and Tokugen-ji in Nagoya. In Mishima, the monks visited Ryūtaku-ji and then Shōin-ji, paying their respects to the grave of Hakuin. Next, they went to Engaku-ji in Kamakura and Kaizen-ji, in Tokyo. From there they traveled to Matsushima and visited Zuigan-ji, where Nantenbō had been chief priest. This stop included a guided boat tour of the famous pine-dotted islands. They then returned to Empuku-ji, where Deiryū began his seventeen-year tenure as Zen Master.

Between 1874 and 1876 Nantenbō had made a similar pilgrimage to training halls around the country, seeking out Masters. However, Nantenbō intended to challenge and test the true Zen understanding of the various Zen teachers he met. Deiryū's pilgrimage seems to have been much the opposite in nature, focused on paying his respects and hoping to learn as much as possible from the different *sōdō* masters before taking on his position at Empuku-ji. Here again the difference between Nantenbō and Deiryū becomes apparent, in spite of superficial similarities.

As a teacher, Deiryū revealed great concern for his disciples. Tairei (Sōjun) Mizuno became an *inji* (attendant) of Deiryū's at Empuku-ji several years after the war, also being called Jun-san as his teacher once had been. He was put to work in the kitchen, but because he had no cooking experience, he was nervous about the situation. He also thought himself to be rather slow, so he made great efforts to use good materials and cook well for his Master. Despite his efforts, Deiryū never made any comments about the food.

When Tairei asked a friend what to do about this, his friend replied, "Udon, udon." Tairei prepared the noodle dish for Deiryū's next meal. "It worked! Rōshi's big eyes, which usually looked sour, bore a smile."[20] Later, on New Year's Day, guests arrived to pay their respects to Deiryū, many bringing with them a bottle of sake as a gift. According to Tairei:

Great laughter continuously flowed from Rōshi's room, but behind the scenes in the kitchen, things were chaotic. Food, sake, sake, food, sake, food . . . "Bring some sake, inji-san! Can't you bring it faster? Don't you have anything to serve to our guests?" Deiryū called out rapidly. Owing to my slow nature, I just looked around helplessly in the kitchen. "Sake! Bring sake! Aren't you there, inji-san?" Deiryū continued to call. "Yes, sir!" I replied and went to his room, where I saw that his large eyes appeared bigger than usual, looking cloudy as if a thunderstorm were about to strike with a great roar. When I returned to the kitchen, I found food burning on the stove and black smoke billowing above. Now everything would taste like smoke. I quickly opened the windows and moved things around. Then I shouted, "What are guests anyway? Understand inji's mind too!" At that moment, I saw Deiryū standing beside me. In a loud voice he said, "Jun-san! What are you doing!" I squatted down on the floor. "What kind of man are you? Fire prevention is a first priority in temples." Then he left and went back to his waiting guests.

When the guests left, I cleaned up the room and began to prepare the next meal. Rōshi said, "Jun-san, watch the fire; then come to my room." Of course, I knew I would be admonished for the day's mistakes. In Rōshi's room I heard him say, "Look up." When I did, I saw that his big sullen eyes bore a smile, and he said, "Jun-san, this is your first experience and I know how hard it is. But this is also your shūgyō [training]. I also served Nantenbō as his inji, but Jun-san, it was even harder, with longer days than yours. Don't be discouraged, make constant efforts, and someday you will shine, that is certain." His face was so gentle as he spoke to me, like a father.[21]

Deiryū's sympathy and understanding of the trials and tribulations of the life of a monk in training were evident in other ways as well. His close friend Isamu Yoshii, a noted poet, recalled, "My house faced the road that led from Empuku-ji to town. Over the hedge I used to see a group of monks on begging rounds walking down the road chanting, 'Oh, oh,' in the morning mist. At the head of the group was Deiryū himself, wearing a brown robe that distinguished him from the other monks in black robes."[22] For the Zen Master of such a large monastery to participate in begging rounds with his training monks was highly unusual.

The sight of black-robed monks on their morning begging rounds can still be witnessed today in Japan, their chanting voices resounding down narrow neighborhood streets. The visual as well as aural impression is striking and has lent itself to one of the most charming and beloved subjects in Zen painting. Although the theme is known to have been painted by Zen monk-artists of the Edo period (1600–1868) such as Kogan Gengei (1747–1821),[23] it was Nantenbō who simplified the compositions into two gently swaying groups of monks clad in black robes and straw sedge hats.[24] Influenced by his teacher, Deiryū continued the tradition and painted his own pairs of monks going out and returning from their rounds (PLATE 18). The visual effect of the simplified ink figures is quite stunning as the black streaks comprising their robes fade into gentle gray wash as the monks recede. Beyond the charmingly simplified feet, the faces which peer out one after another, mouths open in chant, also reveal the delightfully uninhibited nature of Zen (PLATE 19). Particularly charming is the final figure in the procession of monks walking toward us, his eyes peering demurely over the other monks. The inscription on the scroll of monks walking away reads:

One bowl, the offerings of a thousand houses

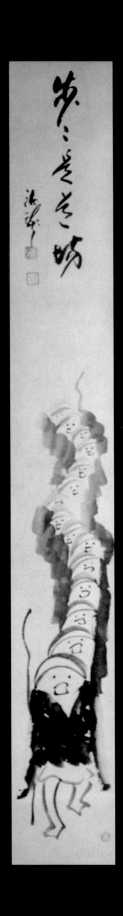

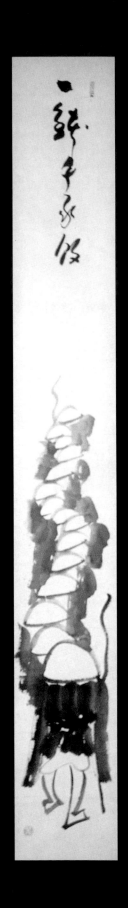

Plate 18. Deiryū
BEGGING MONKS (*pair of scrolls*)
Ink on paper, each 121.6 x 16 cm.
Hōsei-an Collection

The scroll with them facing out reads:

Walking, walking this Buddhist path

Isamu Yoshii held great fondness for these images of begging monks, possibly because of his personal memories of seeing Deiryū out with his disciples. He noted that Deiryū often painted while drinking sake and wrote this poem:

Perhaps painted while drunk,
the sedge hats of my friend's monks
are halfway off the paper.[25]

While the visual effect of the long line of monks on hanging scrolls is quite striking and enhances the idea of the procession, a carved wooden board depicting only three figures by Deiryū is equally delightful (PLATE 20). In this case, the reduced number of figures allows for a bit more detail. The monks' sedge hats are colored red to add some visual excitement, and the legs and feet of the lead monk are more carefully delineated and covered in traditional cotton footwear and straw sandals. The inscriptions on each side of the figures are the same as on the pair of scrolls. On this work, instead of following his signature by seals in red ink, Deiryū has used a *kaō*, an abstracted cipher-signature.

The tradition of these begging-monk images remains alive today as carried on by Kasumi Bunshō, the current abbot of Kaisei-ji. He not only paints monks on hanging scrolls but has also done large versions on the *fusuma* at Kaisei-ji, and even larger figures on the exterior walls of the temple's buildings (FIG. 8). The begging monks are a perfect example of new subjects being introduced and utilized over several generations to keep Zen art and teaching alive and evolving.

Deiryū himself sometimes expressed the joy we sense in his paintings of monks. For example, one follower recalled that Deiryū used to go to Osaka after the *dai-sesshin* (long meditation sessions) held in May and December. "During one trip he saw a pair of rain shoes in the Hankyu Department Store. He really looked like he wanted them, but he did not buy them. Later, after hearing the story, someone gave the shoes to him as a gift. A few days later, I happened to see Rōshi putting them on and walking around his room when he was alone. He looked so happy, like a child with a new toy. The Rōshi's face was so different from what I was used to seeing, it gave me a smile."[26]

Although Deiryū was often described as having harsh or stern-looking eyes, at the same time his nature is always referred to as gentle, kind, generous, and quiet. It is this quality that is revealed most often in his art. In particular, Deiryū's depictions of animals reveal a delightfully intimate charm, in quiet contrast to the bold, dramatic expressions often associated with Zen brushwork. In one scroll Deiryū used a brush loaded with heavily watered ink to created the beautifully mottled portrait of a lone snail (PLATE 21). It makes its way through the center of the empty composition, inching along without a care. The inscription above expresses exactly why the small mollusk has few worries:

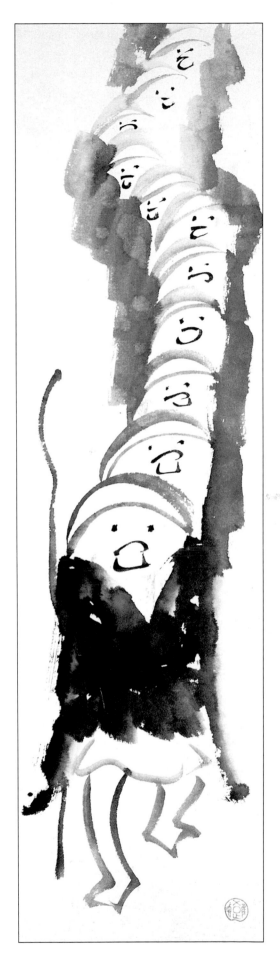

Plate 19. Deiryū
BEGGING MONKS (*detail*)

45

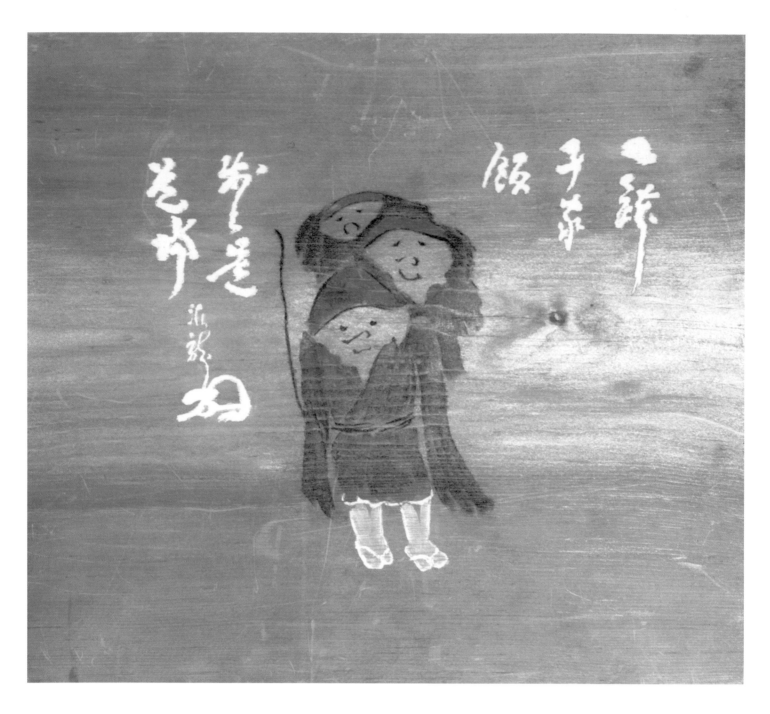

Plate 20. Deiryū
BEGGING MONKS (*wooden board*)
Ink and color on wood, 29 x 33.4 cm.
Hōsei-an Collection

Wherever he goes,
he carries his home —
the snail

While obviously accurate in describing the natural state of the snail, the message also has a deeper meaning. Zen emphasizes a reliance on oneself; enlightenment is achieved only through one's own determination and dedication to meditation and Zen training. All sentient beings have a Buddha-nature, even snails, and we always carry with us what we need.

This inscription is in the form of a haiku, structured in three lines of 5-7-5 syllables respectively. Although Japanese Zen Masters more often used Chinese-style poems on their artwork, continuing the tradition imported from China, they were also skilled in traditional Japanese forms of poetry. In this case Deiryū uses a simple verse, possibly of his own creation, to suit the modest subject of his scroll.

Visually, the contrast between the dark, rich ink of the inscription and the wet, blurry snail is strong. The loose, slightly wobbly characters seem to ooze down the composition, perhaps imitating the damp trail of a snail. In contrast, the pale, wet delineation of the snail suggests the mottled pattern of snail shells while at the same time maintaining the idea of dampness. The delicate lines forming the snail's antennae are particularly gentle and serve to lead the viewer's eye up to the inscription.

In another work, this one quite small, Deiryū writes a single line of calligraphy followed by the simple image of a horse viewed from the rear (PLATE 22). The calligraphy says:

> The myriad concerns of man
> are like old man Saiō's [horse].

This is the same reference to an ancient Chinese tale that Nantenbō also often utilized (see PLATE 3, page 24), suggesting that worldly gains and losses are empty. Deiryū is not merely enhancing or illustrating the inscription by adding the image of the horse. Instead, the painting substitutes for the word *horse* in the inscription, establishing a unique relationship between text and image.

In East Asian art this is particularly appropriate, since many Japanese and Chinese characters were originally derived from pictographs. In contrast to Nantenbō's version of this subject on a folding fan, in which the image of the horse is spatially distinct from the calligraphy and the character for *horse* is actually present in the inscription, Deiryū places the horse immediately following the calligraphy, thus creating a continuous flow and making no distinction between word and image. Deiryū's interpretation of the horse is also markedly different from that of Nantenbō. Where the earlier Master depicted a more animated and stylized image, Deiryū's horse sits quietly with its back toward us. In this way, the differences in personality between Nantenbō and Deiryū are clearly revealed in their depiction of horses: the ebullient, energetic Nantenbō striding into the composition, versus the quiet, introspective Deiryū already seated within.

Figure 8. BEGGING MONKS *by Kasumi Bunshō, on wall at Kaisei-ji*

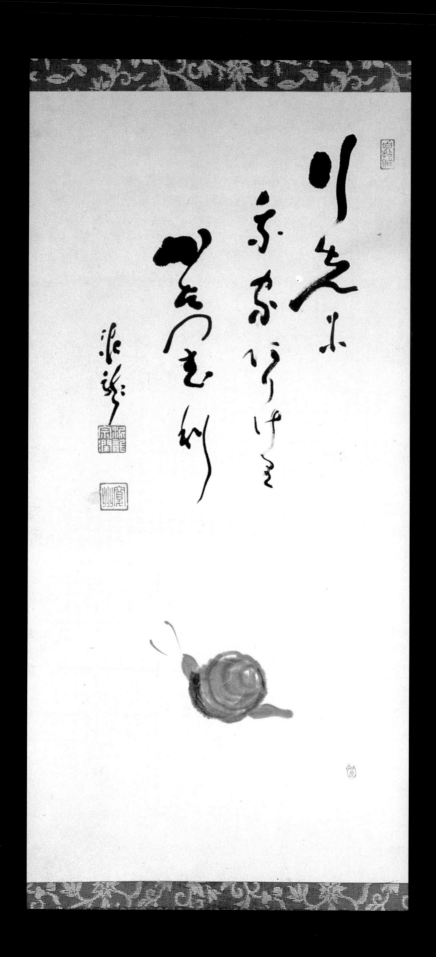

Plate 21. Deiryū
SNAIL
Ink on paper, 64 x 31.6 cm.
Oliver T. and Yuki Behr Collection

One of Deiryū's disciples, Shōdō Tanaka of Kanshō-ji in Hyōgo, recalled a time when he and another monk entered Deiryū's room to scatter beans to mark the *setsubun* (beginning of spring). "Rōshi was not doing well, and we opened a window to chase the *oni* [devils] out. Rōshi asked, 'What are you going to accomplish by opening the windows?' But it was too late to close them by then, so we just scattered the beans and left. But I had the impression that I had been told to chase the *oni* from my own mind."[27] In his reminiscence, Tanaka continued, "Rōshi was very harsh, but also had a sense of humor. One day I was sitting next to him on the Keihan train. He pointed to some shoes worn by a young woman sitting in front of us and said, 'Those are what they call high heels!' I got embarrassed and could not even look at them." [28]

Deiryū was also kind and compassionate in regard to his lay followers. One woman recalled:

> *My late husband often visited Empuku-ji with acquaintances and requested audiences with Deiryū. He would seek Deiryū's advice, and each time he received refreshments. After hearing various stories, my husband would return home with great joy, telling me about this spiritual man who possessed a stern exterior but a warm and gentle heart, and who was a preeminent ink painter.*
>
> *One day I invited Deiryū to my old house for refreshments. I was shocked and embarrassed when he arrived with a group of monks. Although it has been many decades since that time, I still see it in my mind. In the main room Deiryū sat at the head seat and had one attendant. In the next room I managed to squeeze in four monks who filled the room to capacity. Monks' training is severe, emphasizing proper manners, and they remembered to stiffen their bodies. I had already ordered the food, and Deiryū was aware that the amount was humbly insufficient. But he was tolerant and everyone seemed to be having a pleasant chat, drinking together and having a good time. My husband also liked sake and drank leisurely. To the ordinary person, heaven and earth are different; a situation that had deteriorated slightly had not become a disaster, but for me, as the hostess, the thought naturally caused me to bow my head.*
>
> *Although a car was prepared for Deiryū's departure, he earnestly declined, graciously deciding that he would prefer to return along with the monks [on foot]. After this reply, he had a little more sake and then knelt on the floor and bestowed a blessing on the ancestral family shrine and the image of Kannon.*[29]

Another lay follower, Sōshin Ōmori, whose father was the seventh-generation head of the Tamagawa Enshū-ryū (related to the Enshū tea school) and a follower of Nantenbō, recalled, "I had not understood clearly the difference between Lao-tzu and Zen, so I asked Deiryū about it. He simply said, 'Lao-tzu has no *hō* [inner law or structure].' He meant that there is inner law in Zen but not in Taoism. After that I began to pay attention to the inner law. . . . Lao-tzu conveys a teaching that people can read about and think about. On the other hand, Zen is a realization, an experience. . . . In this sense, there is also *hō* in tea. Tea is not a thought. It places the utmost importance on experiences and practice. I came to understand that this is why tea and Zen are considered to be one thing."[30]

The relationship between tea and Zen is long and deep, and Deiryū

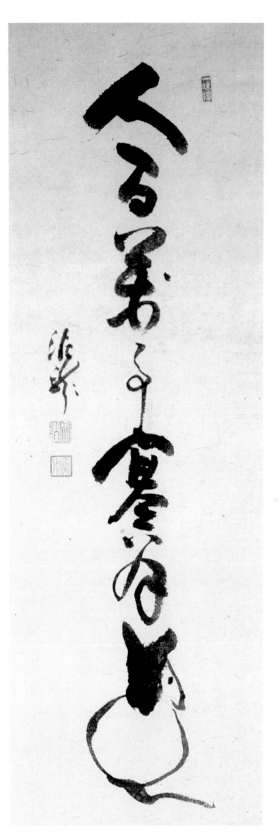

Plate 22. Deiryū
HORSE
Ink on paper, 47.2 x 14 cm.
Hōsei-an Collection

49

himself often wrote calligraphy on teabowls and cups. On one example, the words "Bamboo has upper and lower nodes" are written in rich iron glaze (PLATE 23). As one of the "four gentlemen" (along with plum, orchid, and pine), bamboo is highly appreciated in East Asia. With its unpretentious appearance, it represents many of the virtues highly regarded in Zen. Its vertical growth symbolizes the upright character of a noble person; its hard yet flexible stalk represents the ability to be steadfast as well as lenient; its hollow core suggests Zen emptiness; and its evergreen quality reflects loyalty, consistency, and harmony.

The bowl, crafted by the Kyoto potter Tōan from Higashiyama, is a low, wide "summer" shape, made from a textured off-white clay with underglaze iron calligraphy and a clear glaze. It has a rather wide foot with a spiraling center cut. The character for "bamboo" (竹), which appears to the right of the inscription, is larger and more prominent than the subsequent characters, and represents a slightly abstracted ideograph of bamboo stalks and leaves. On the opposite side of the bowl, Deiryū has signed the work with his cipher and signature.

The duties of a Zen Master include writing commemorative poems marking the death or birth anniversaries of past masters as well as lay followers, or other auspicious occasions. In May 1938 Deiryū marked the thirteenth anniversary of Nantenbō's death with a poem:

> For thirteen springs the sparks have caught fire
> at the Immortal's Turtle Peak.
> My former teacher's virtue has no storehouse;
> As far as the eye can see, the mountains become more green.[31]

Four years later he wrote another commemorative poem:

> "Old Pine" has been at the cloud-gate for seventeen years,
> so we perform a small service amid sighing winds and flowing streams.
> Thinking of my teacher, I don't sleep, and dawn has already come;
> In the misty rain, lonely and bleak, the mountains darken.[32]

In early 1944, Deiryū also wrote a poem in honor of the establishment

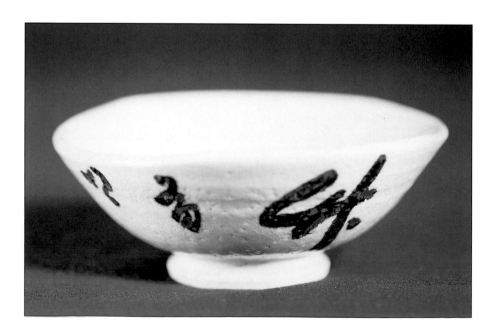

Plate 23. Deiryū
INSCRIBED TEABOWL
Glaze on ceramic, 5.4 cm. tall
Gubutsu an

of a memorial hall (*hōdō*) for Zen Master Rozan Ekō of Tokugen-ji in Nagoya (see chap. 6), who had died that year.

THE NEW MEMORIAL HALL
FOR THE ZEN MASTER ROZAN

At the side of the boundlessly enlightened Hekishō [Rozan]
Brightness and darkness all contained in his Zen.
I don't know where his spirit and his bones now dwell;
Cold clouds gather and disperse in front of the hōdō.[33]

Deiryū even wrote a poem in commemoration of the fortieth anniversary of a paint company:

The blowing of the breeze perturbs the flag on the tower,
Green bamboo and blue pines sweeten the gate.
Yellow birds chatter under Yūtoku Mountain;
The entire universe sits by the warm brightness of the scene.[34]

Deiryū had a life-long affinity for sake (a trait he shared with Nantenbō), and despite a general atmosphere in which monks politely refused sake, he indulged freely, often landing in unusual predicaments. Masahiro Yoshida, a *kendō* master who taught this martial art for the police department, recalled an evening when Deiryū came to his house in Osaka for a visit. The two friends drank sake until they became drunk. When Deiryū left the house for the evening, the streetcar he needed—the last one for the night—was pulling away. Deiryū shouted, "Train, wait!" But it was too late. Deiryū was arrested for obstructing traffic and taken to the Yoshihara police station, where he was detained overnight. The next morning, the police officer asked Deiryū where he had been drinking the previous night. Deiryū replied that he had been at the house of Yoshida, the police station's *kendō* teacher. "Last night when you were asked, you said you didn't know where you had been drinking. Why didn't you say you had been at Yoshida's house?" Deiryū answered that he could not use a friend's name to help him resolve his own misconduct, since that would be a cowardly act. He then left the police station. When Yoshida arrived at work later that morning, the story of a drunk monk at the teacher's house was circulating. When he inquired more fully, he was told the whole story and came to understand Deiryū's personality. [35]

Because of his athletic disposition, Deiryū had been very fond of *kendō* since he was a boy. In 1949 his friend Yoshida was eager to revive general interest in the sport. With Deiryū's support, fifty *kendō* teachers gathered in the Empuku-ji *sōdō* to practice and receive vegetarian meals. As a result of this gathering and the enthusiastic encouragement of Deiryū, interest in the sport was revived. Deiryū himself often wrote out the word *ken* (sword) on scrolls, demonstrating both his personal interest in the sport and also the long relationship between *kendō* and Zen. This had been established in the Muromachi period, and later notable Zen Masters such as Takuan Sōhō (1573–1645) also taught the ideals of swordsmanship by relating them to the discipline and spirituality of Zen. Takuan wrote:

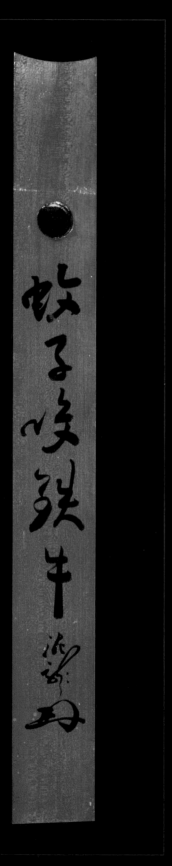

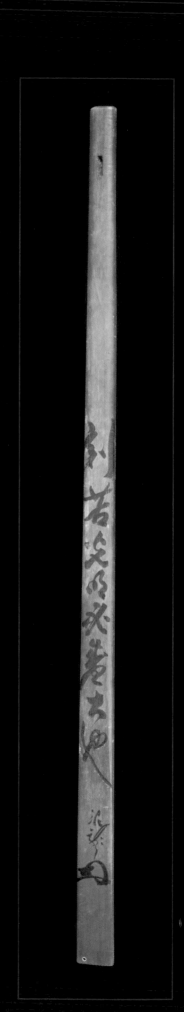

Plate 25. Deiryū
KEISAKU
Ink on wood, 105 x 5 cm.
Chikusei Collection

Plate 24. Deiryū
CHIN REST
Ink on wood, 54 x 6 cm.
Hōsei-an Collection

Although you see the sword that moved to strike you, if your mind is not de-
tained by it and you meet the rhythm of the advancing sword; if you do not
think of striking your opponent and no thoughts or judgements remain; if the
instant you see the swinging sword your mind is not the least bit detained and
you move straight in and wrench the sword away from him; the sword that was
going to cut you down will become your own, and, contrarily, will be the sword
that cuts down your opponent.

In Zen this is called "Grabbing the spear, and, contrariwise, piercing the
man who had come to pierce you." [36]

Nantenbō himself had strong friendships with military-minded men, including the Buddhist lay follower Yamaoka Tesshū, who wanted to revive samurai discipline and dedication through Zen practice, and who encouraged his *kendō* students and military acquaintances to practice Zen under Nantenbō. General Nogi Maresuke also studied Zen under Nantenbō, for twenty-five years beginning in 1887. But while Nantenbō was practicing during a period of heightened nationalistic fervor, and thus associated with military figures, Deiryū lived in an age in which Japan saw defeat and the abolishment of its nationalistic and imperialistic policies. For Deiryū, *kendō* was an art reflecting Zen discipline; it no longer held any militaristic or feudal connotations.

In terms of Zen training, Deiryū was very direct with both his monks and lay followers. He once said that the following words of Daitō Kokushi (1282–1338) were the most important for monks in training: "Pass your days eating vegetable roots boiled in a pot. Place your primary importance in investigating your own nature, and you will become an old priest and a person who repays kindness every day."[37] He added that if you can do this, everything else is unnecessary. Once, during the intensive week-long *sesshin* in May, ten young officials from a major bank were sent to Empuku-ji to participate (Japanese corporations often send their employees on retreats to Zen monasteries to help develop discipline and self-confidence). One of the employees asked Deiryū, "I am a very timid person and easily blush or break into a cold sweat in front of people. Would it be possible for me to become braver by doing *zazen*?" To which Deiryū replied simply, "A person who is too timid will become braver, and one who is too brave will become more timid."[38]

Despite the rigorous and harsh nature of Zen training, with its long hours of seated meditation, the implements associated with this training are occasionally transformed into works of art themselves. In one instance, Deiryū wrote the inscription

The mosquito bites the iron bull

on a wooden chin rest (PLATE 24), used during the long meditation sessions to prop one's head up. This inscription invites us to consider if we are the mosquito on a seemingly hopeless task, or the bull able to ignore the insect, or both.[39] In another example, Deiryū wrote on a wooden *keisaku* (PLATE 25), a long stick used by a presiding monk (*jiki jutsu*) who walks silently around the meditation hall whacking dozing monks (often at their own invitation) during meditation sessions. In this case, Deiryū has inscribed the appropriate words:

When you train hard, your satori will be much greater.

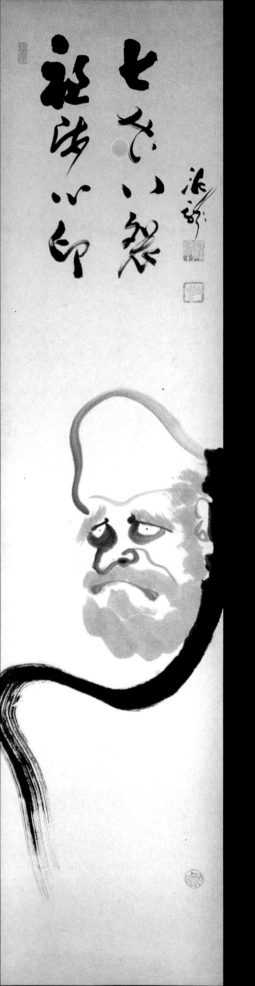

Plate 26. Det...
DARUMA
Ink on paper
Private Coll...

The inclusion of the calligraphic inscriptions on functional objects such as the chin rest and *keisaku* reinforces the continuity in Zen among art, teaching, training, and life. Just as a painted scroll conveys the Zen Master's mind and Zen experience, the inscribed objects reveal not only his enlightened experience but also the tools with which his experience will be transmitted. The personal experience and spiritual tradition merge.

Deiryū was not as vocal or demonstrative as Nantenbō in expressing his opinions about the training of monks, but one monk recalled an occasion when he did receive a reprimand after the Bon Festival for the Dead. "I stopped at the house of a lay person and we had some sake. I became weary on my way back to the Empuku-ji *sōdō*, so I got off my bicycle and rested by the side of the road. A dog licking my face sobered me up. At three o'clock in the morning I got up with unsteady legs and returned to the *sōdō*. I was called by the head monk, who admonished me. Then Deiryū scolded, 'When I was young I also did stupid things now and then, but do it twice and that's it!' However, in truth, the training of monks at Empuku-ji was not that severe."[40]

As noted earlier, the most traditional subject in Zen painting is the original teacher and Patriarch, Daruma, who traveled from India to China. Historically depicted as a robust figure with voluminous robes, earring, beard, and foreign facial features, Daruma has been artistically interpreted by many Zen Masters over the years. Over time, the Patriarch has reflected intense discipline and sternness, gentle humility, and quiet reflection. Nantenbō humorously depicted Daruma with wide, popping eyes and startled expression (see PLATE 7). In contrast, Deiryū's portrait of Daruma appears almost brooding, with heavy eyes and a solemn facial expression (PLATE 26). Deiryū borrowed Nantenbō's sweeping stroke to define Daruma's robe, but the resemblance stops there. The humor of Nantenbō is replaced by somber intensity, punctuated by the thick lines under the eyes, the deep crease of the brow, and the downcast mouth, nose, and eyebrows. Deiryū's image also displays a rich variety of ink tones, from the gray of the beard to the progressively darker shades of the mouth, nose, and eyes, finally framed by the black lines of the robe. The inscription above reads:

> The Patriarch's mind
> smashes to pieces.

In other words, even his *satori* is gone.

Like many Zen Masters, Deiryū worked tirelessly following the war, helping to rebuild the physical and spiritual ruins of the country. At the same time, his health began to decline, exacerbated by the work, his drinking, and his already frail condition. His brothers, Tōru and Tadashi, had lost everything during the war, and Deiryū attempted to assist them as well. He became unable to travel, but his poet friend Isamu Yoshii recalled that despite his illness, "he would walk up thirty stone steps to sit in a cottage with a southern exposure. Through the *shoji* paper screens it was always warm on a fall day. He would keep the *hibachi* burning so steam could rise up. Even when he was resting, his face revealed the power to both scold and laugh."[41] On April 24, 1949, Deiryū wrote a poem in which he described the joys of this hermitage, the Suigetsu-an, including the steps.

On the Anniversary of Repairing
the Stone Wall at Suigetsu-an

Blue pines and green bamboo shade my window,
Flowers smile, warblers sing by my hermitage.
As I climb the stone steps, I see the strengths of cedars;
At the pure cool mountaintop, Buddha is bright and vivid. [42]

In 1953 Deiryū began planning a meeting to commemorate the anniversary of Kōzuki Rōshi's death, but his plans had to be abandoned as his health declined. He wrote a final poem:

A FOOL'S DREAM

To explain the dream within a dream is a fool's dream
My experiences have come and gone for fifty-nine years.
While poisoned blood flows and flows like a rain of ripe plum-juice,
Trees return to vivid blues and greens. [43]

Deiryū's illness deeply affected many, in particular Isamu Yoshii, who was moved to compose a poem:

Warm nabe *dish before me,*
but a cold December wind blows—
news of Deiryū's illness has come.[44]

Eventually, Deiryū was moved to a hospital in Toneyama. One of the last monks to enter Empuku-ji under Deiryū recalled, "When I learned from the head monk that [Deiryū] had entered the Toneyama hospital, I inquired and visited him. He smiled a big smile and said, 'Come often. It is unfortunate that I cannot give you tonsure; if you and I had only met a year earlier.' To me this is extremely regrettable."[45]

The Master died on February 2, 1954; one of Deiryū's attending doctors, Kazue Yamanaka, recalled, "After the Rōshi had died, Dr. Watanabe [Deiryū's friend] wanted to have his body autopsied but was not sure if religious reasons would prevent this. However, we found that the Rōshi had left a small note that said, 'Submit my body to an autopsy and cremate it.' It moved us, and we were very grateful to him."[46]

Recalling Deiryū's funeral service on the twenty-fifth anniversary of his death, his former disciple Sano Taigi of Hōrin-ji in Kyoto wrote, "As a bird returns to the nest during a late cold spell in the third month, as the river that surrounds Empuku flows and flows, entering the sea, Deiryū Rōshi also quietly returns to the original source. . . . In the twenty-five-year period since Deiryū Rōshi's funeral, one by one all have disappeared. Everything uncertain returns to its origin."[47]

Deiryū lived only to the age of sixty, and despite his seventeen-year tenure in the Empuku-ji *sōdō*, he probably never reached his ultimate potential as a Zen Master. Aware of Deiryū's frail health, Nantenbō once said, "You should live to fifty, or sixty, but seventy or eighty is full bloom."[48] Nonetheless, Deiryū protected and fostered the tradition of monastic Zen training and practice in Japan, making sure that the efforts made by Nantenbō during the turn of the century were not in vain.

The relationship between Nantenbō and Deiryū as master and disci-

ple is unique, largely due to their vastly different personalities. Although some of their art resembles each other's so closely that it is at first difficult to distinguish the two artistic hands, in broader terms their approaches to life, art, and their personal roles in Zen teaching reveal different choices and priorities. Why would Deiryū copy Nantenbō's images of begging monks faithfully, and yet treat other subjects like the horse and Daruma so differently? Did he feel that the former subject was truly Nantenbō's invention, which he ought not to change, whereas the other subjects were more general or traditional themes allowing for more personal interpretation? Perhaps the image of begging monks, by sheer virtue of what it represents, led Deiryū to faithfully continue his Master's vision. The monks in training symbolize the continuation of Zen in Japan and thus are appropriately associated with one's teacher. Deiryū was bound to protect the legacy that was passed down to him, and spent his life continuing the training that would lead new monks into the future. As a result, while other subjects in Zen painting may be open to the expressions of each Master's experiences, the tradition of monks in training remains a constant that must be preserved. In this way, the images of begging monks by Nantenbō, Deiryū, and Kasumi Bunshō are a visual reminder of Zen in Japan, past, present, and future.

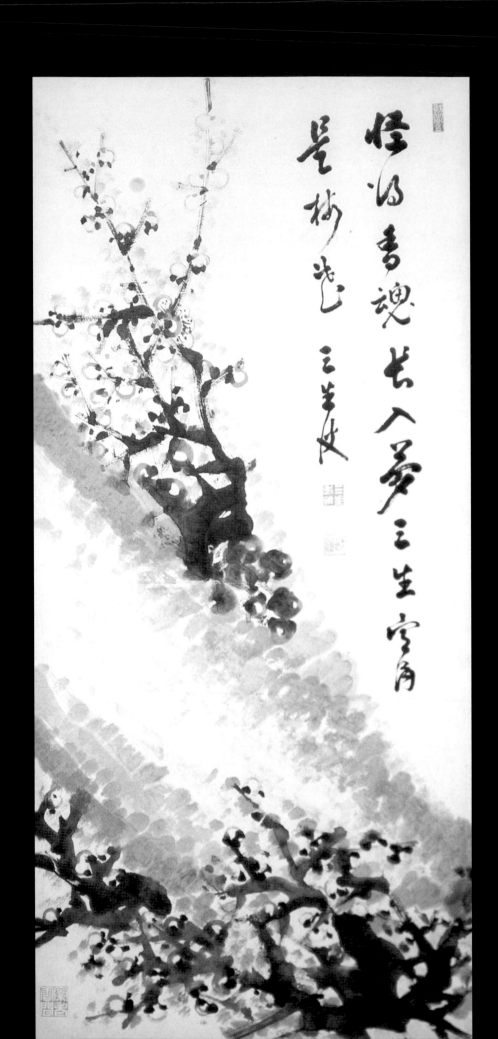

Plate 27. Yūzen Gentatsu (1842–1918)
PLUM BLOSSOMS

THE POLITICAL OPPRESSION of Buddhism during the early Meiji period had detrimental effects on temples throughout Japan. Priests were forced to leave the clergy, either out of financial necessity or from loss of recognition as representatives of the Buddhist church. This decline left many temples vacant or in a state of impoverished disrepair. Despite these conditions, many monks, priests, and Zen Masters persevered in their training and teaching. Yūzen Gentatsu served at a small rural temple and dedicated his life to rebuilding not only the physical structures of the temple, but also the spiritual foundations of its parishioners. In contrast, his disciple Takeda Mokurai helped to fuel a resurgent interest in Zen. Since he was located in the cultural center of Kyoto, Mokurai's tenure as Zen Master at Kennin-ji reflected greater social and cultural appreciation for Zen, and enabled Mokurai to expand his interests and teachings beyond his regular parishioners to the artistic elite of Kyoto.

YŪZEN GENTATSU

During the last years of his life, the poet and novelist Natsume Sōseki (1867–1916) maintained a friendship with two young Zen monks with whom he regularly corresponded. Although Sōseki generally discarded most of the letters he received, after his death his wife discovered the correspondence carefully collected in Sōseki's desk. In a letter to the monk Kimura Genjō, dated August 4, 1916, Sōseki wrote, "Do you know Yūzen of Bairin-ji, Kurume? I have heard that the ink paintings he does of plum blossoms are very sweet. I would like to obtain a work, but I have no introduction; may I impose upon you?" Unfortunately, despite the monk's efforts, Sōseki never received one of these works. He died four months later.[1]

Although Sōseki had a strong interest in Zen, it is somewhat surprising that he was aware of Yūzen and his art, since Yūzen spent much of his life in a small temple in Kyūshū, far from the bustling life of Sōseki's Tokyo. Yūzen was in fact most noted for his ink images of plum blossoms, which are distinguished by their rich ink tones and soft, wet quality of brushwork (PLATE 27), a complete contrast to the traditionally crisp, delicate depictions borrowed from Chinese models. That Yūzen's reputation as a Zen artist was known to such a cosmopolitan figure as Sōseki says a great deal about a Zen Master who maintained a humble existence during a tumultuous period for Japanese Buddhism.

Yūzen (FIG. 9) was born on the eighteenth day of the fourth month of 1842 in Nōnomura, Hōken-gun, Gifu, to the Ōtani family. The date is auspicious, as it is the same day as the Buddha's birth. Yūzen's father reportedly said, "If the child is born a boy, he will certainly enter the priesthood."[2] Accordingly, at the age of twelve Yūzen entered Eri-ji in Atobe to begin training under the priest Reigen. At the age of twenty, Yūzen packed up his books and few belongings and traveled to Tokyo, where he spent a year at the Rinshō-in. During these years the temples where the young Yūzen trained were very poor, and so he could not expect extra money for school expenses, sandals, or other necessities. On his journey to Tokyo he had very little money, and Yūzen later recalled, "At that time it was a long journey on foot, and I could not afford straw sandals; my feet ached, but I had no money. There were some discarded straw horseshoes by the side of the road, so I

3

RESTORING ZEN AND TAKING IT FORWARD

Yūzen Gentatsu

(Sanshōken, 1842–1918)

and Takeda Mokurai

(1854–1930)

Figure 9. Yūzen

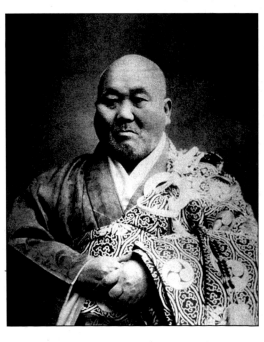

picked them up, put them on, and continued walking. It was considerably painful."[3]

Yūzen continued his training at Tenki-ji in Mino under the guidance of Izan Soan (1788–1864).[4] Yūzen was given Joshū's *Mu*, traditionally the first *kōan* given to beginners, which he had difficulty penetrating. He grappled day and night with this *kōan* for several years, almost forgetting about food and sleep. Izan appreciated the young monk's dedication and determination, so Yūzen began serving as his special attendant, accompanying him when Izan was invited to renovate the temple Mampuku-ji in Uchino-mura, Shizuoka, in 1862. He was also with his Master in 1864 at Tōkō-ji when, during a lecture on the *Hekiganroku*, Izan became ill and died soon thereafter.

On one of their journeys together, a surprising incident occurred that shook Yūzen's confidence:

> *I encountered a nun one day and we traveled together. I was young then, speaking nonsense and boasting greatly. To my surprise, the nun showed the knowledge and experience of an equivalent amount of training. Her calm opposition quickly silenced me. I couldn't say anything in reply to show any Zen understanding. This nun harshly demonstrated my ignorance. At her sarcastic words all I could do was make the sound, guuu—. The chagrin of that time was severe; if there had been a hole, I would have crawled into it. It lasted a long time and inspired me to work harder.[5]*

It has also been suggested that as a result of this encounter, Yūzen developed a personal dislike of nuns.[6]

After this incident Yūzen requested a leave of absence from Izan in order to concentrate on *kōan* study. Izan had already granted him recognition of a small *satori* on the *Mu kōan*, but Yūzen felt the need to concentrate more deeply because of the nun's challenge. Yūzen later often said, "If a person acquires faith suddenly, it easily results in laziness; this is an error of the ego. When people's egos lead to mistakes, they must go beyond their errors to understanding. This must be thoroughly taught."[7]

After Izan's death in 1864, Yūzen spent ten years training under Suigan Bunshū (1818–1874) at Mampuku-ji, at Tōun-ji in Hamamatsu, and at Eigen-ji in Shiga.[8] Yūzen recounted his personal worry and apprehension during his training under Suigan, no longer from lack of self-confidence but due to outside forces.

> *When I was training under Suigan at Eigen-ji, the abolishment of Buddhism during the Meiji Restoration occurred. There was a lot of clamor, and I worried that the wisdom of Buddhism would not be allowed to be spread. I thought somehow that if in Suigan's lifetime there were an end to this understanding [of Buddhism], I would not be able to become a Zen priest despite my earnestness, so I worked extra hard, and eventually this worry subsided in my mind. Truly, if a person lives by the* dharma, *he will not face this worry, but during training such concerns arise. Nevertheless, I soon crossed over in my understanding.[9]*

In fact, Yūzen was devoted to Suigan; as a fellow monk at the temple recalled, "Gentatsu [Yūzen] was at Eigen-ji at the time and really admired the priest. Because Suigan was very prone to illness, Yūzen sometimes went to the local shrine barefoot. The shrine was five *ri* [2.44 miles] from Eigen-ji.

Figure 10. Bairin-ji Gate

Because everyone had fallen asleep, in bare feet he passed through; I won't forget this because Gentatsu's feet swelled up due to a malicious spirit."[10]

Upon Suigan's death in 1874, Yūzen studied for two years with Gōten Dōkai (1814–1891)[11] at Tokugen-ji in Gifu, and then with Suigan's successor, Kanshū Gensei, at Chōshō-ji in Aichi. Yūzen eventually received *inka* from Gensei in 1878 at the age of thirty-eight. Both Tokugen-ji and Chōshō-ji were poor temples, and Gensei in particular had a difficult time. Public opinion of Buddhism was low at this time, and the temple was deteriorated and the kitchen's storehouse impoverished. This was not unusual; many monks at this time were forced to leave their temples, leaving only a few behind to manage temple affairs.

In 1879 Yūzen went to Bairin-ji (FIG. 10) in Kurume, Kyūshū, in order to succeed Mugaku Bun'eki (1818–1897).[12] Bairin-ji was the family temple of the Arima clan and had been receiving a generous stipend of rice, but the poverty and uncertain status of Buddhism facing Gensei at Chōshō-ji did not escape Yūzen at Bairin-ji. After the Meiji Restoration, the temple support by the descendants of the Arima samurai ended as a result of their financial ruin. The monthly rice offering of seven *masu* (1.8 liters) was insufficient, and there was no money for temple repairs. Yūzen described the dismal state of affairs when he entered the temple:

> *I first lived in the* hondō *and there was no tile roofing. The wind blew through the roof, and at times like that you had to carry an umbrella around in the middle of the* hondō. *It was called Bairin-ji's 'mud-splattered floor'; from one side of the building to the other, debris was scattered. Often there were injuries when people fell through the floor.*[13]

Yūzen's diligence and determination to rebuild the temple was extreme and did not go unnoticed by local farmers, who donated wheat, vegetables, grain, and other provisions to replenish the storehouse. Despite this generosity, Yūzen himself could be found in the fields in the early morning cultivating the land. His frugality was well known; according to one story, when his towel ripped, he patched it; if it ripped again, he patched it again.

He eventually patched it so many times that finally it was retired and used as a scrubbing rag. He lived completely in this manner, respecting every cup of water or sheet of paper. When he washed his face in the morning, he never ladled out more than five scoops; in summer evenings, even his bath water was minimal. Once, when a new attendant let the water overflow the washbasin and hot water spilled everywhere, he received a terrible scolding from Yūzen for his waste.[14]

Yūzen described the austere conditions:

> *At that time Bairin-ji was very poor. In the evening the futons we used for sleeping were good but in the middle of the night we would wake up from the cold; the cotton in the middle of the futons had clumped up here and there creating pockets of cold, so we had to shift our bodies. Cotton clumping here and there inside futons, is that a part of religious austerity?*[15]

Gradually, more and more monks came to train at Bairin-ji, and as a Zen Master, Yūzen seems to have been fair yet stern in his training of followers. With his gentleness and sharp sense of humor, he seemed fully aware of how everyday events best conveyed Zen teachings. One autumn day an attendant was cleaning the garden, but because leaves continued to fall from the trees after the attendant swept, he stopped sweeping and looked up resentfully at the trees. Yūzen began to laugh at this and said, "Worldly dust on this righteous path—as much as you sweep, as much as you sweep, there is always more, always more. . . ."[16]

There was an earthenware pot that Yūzen used for cooking soup. One day he said to a young attendant, "Today's soup is especially good, so please give me one more bowl." The attendant replied, "If you eat the rest, then there will be none for me." The boy had surprised him with his open abandon even when serving his Master. The next morning Yūzen said to the young boy, "Thank you. Childlike *mushin* [no-mind] prevails," and he laughed loudly.[17]

In general, Yūzen's humble nature did not allow him to accept any special treatment from the monks in his charge. For instance, his three meals a day consisted of vegetables, usually those grown in the adjoining fields, but one day one of his attendants decided to give him a little treat and served some tofu to his Master.

> *"Where did this come from?" Yūzen asked.*
> *"I accepted it from a patron," replied the monk.*
> *Yūzen then said, "People will give faithful alms, but you all came here as begging monks. I, alone, cannot eat this. Hereafter, I will not accept any secret charity to me."*[18]

Yūzen was in fact quite generous to his monks and others at the temple, and as Bairin-ji's revitalization became complete, more lay followers would visit bringing special gifts for Yūzen. One such visitor brought a sponge cake, and after having a taste for himself and offering some to the other monks in attendance, Yūzen said, "I have eaten some, and you all have had some also, so please take some to the old man who works in the fields." The attending monk agreed, but instead of taking the cake to the old man himself, he gave it to two young novices to carry. The boys then ate it up.

Two or three days later, when Yūzen went out, he encountered the old man and bowed deeply. "Old man, have you recently eaten some sponge cake?" The old man said no. Upon his return to the temple, Yūzen severely reprimanded the young novices.[19]

Despite the poverty with which Yūzen had been so well acquainted during his training, food seemed to play an important role in his life, and in particular he seems to have had a great fondness for udon (thick wheat noodles). An acquaintance told this story:

> It was common knowledge that Rōshi liked udon. From his days as an unsui [training monk] he enjoyed these noodles. Once, while he was at an initiates' meeting with old friends, a servant named Saifu Chikumae brought in some udon but was embarrassed and confused because everyone was flooding in and the udon was running out fast. Three times he brought in trays. The attendant said, "Rōshi likes udon a lot, but please, there is a shortage." Yūzen said, "What? Everyone has brought their appetite, but this person won't let us eat!" Rōshi continued, "I don't have a single tooth and often eat udon. In Japan, people with all their teeth missing eat udon. Like all of them, I can get along without using tooth powder." Looking at the servant's face, he laughed.[20]

Yūzen also attributed his generally calm demeanor to his diet, "All the people of the world eat things that walk on four legs, or fly with wings, so there is no calm, they are always restless and fidgety. I always eat what grows in the field, so I move calmly."[21]

Yūzen was know for his sense of humor; in particular he was adept at making puns in poetry and conversation. Once someone asked, "Rōshi, which do you prefer, udon or soba [buckwheat noodles]?" Yūzen answered, "In this neighborhood, I like to eat udon." Yūzen had made a pun on the words *soba de* ("in this neighborhood").[22] He also utilized puns in the inscriptions on his paintings. On one occasion he painted a picture of gardenias on which he wrote, "Because it has no mouth, it will not speak of good or evil." Yūzen had made a pun on the word *kuchinashi*, meaning "gardenia," but also meaning "having no mouth." Not to be outdone, the old man to whom he gave the painting replied, "Through hard work over many years, the effect has emerged." The old man made a pun on the word *kō*, meaning both "fragrance," and "effect."[23]

Yūzen's interest in painting began at a young age, and he continued to pursue it until it began to disrupt his training. "From my youth I often liked to paint. I continued this while training with Suigan, but he said it would hinder my training and got very angry. So I gave in and abandoned my brush and inkstone. Later, by chance I began to paint again."[24] His approach to painting is generally loose, with an emphasis on wet applications of ink. This is readily seen in his depiction of the Zen Patriarch Daruma, in which the wet ink blurs beyond the strokes of the brush, creating a soft, gentle composition (PLATE 28). Above, Yūzen has written, "See your own nature, become Buddha," a phrase commonly inscribed on images of Daruma to encourage viewers to seek the Buddha-nature within themselves instead of relying on outside forces. Although often depicted with a stern or determined expression by other Zen painters, Daruma in Yūzen's painting instead reveals a rather sad or forlorn feeling, enhanced by the soft, wet brushstrokes and full, rounded facial features.

Yūzen's brushwork did not go unappreciated during his lifetime, and,

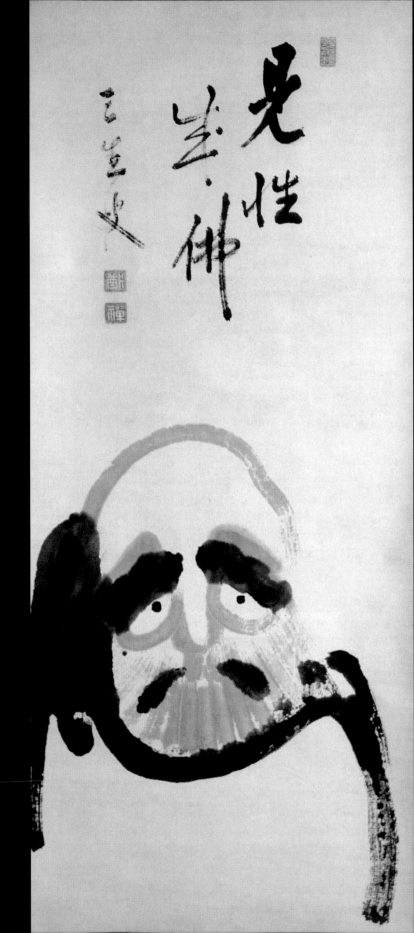

Plate 28. Yūzen
DARUMA
Ink on paper, 80.2 x 32.5 cm.
Hōsei-an Collection

as with Sōseki, many patrons requested examples of his painting and calligraphy, which often amused him. Once, an actor named Takada arrived in Kyūshū on a provincial tour, offering to pay one hundred yen in gold for a painting of arhats (*rakan*, reclusive beings who have achieved a state of enlightenment) by Yūzen. The Master was delighted and told everyone with great pride and amusement about the actor's offer.[25]

Yūzen practiced his art diligently, retreating every morning to his private room to create calligraphy and painting; on summer evenings he even practiced under mosquito netting. For practice he copied the characters of the Chinese calligraphy master Wen Cheng-ming (1470–1559) and also worked from copybooks, but his actual works reveal a much more individualistic, spontaneous, and expressive approach. Similarly, in painting he often chose traditional subjects but added his own free brushwork.

In an album leaf of wild orchids, the languid leaves of the plant are suggested by Yūzen's casual strokes of the brush sweeping out in all directions (PLATE 29). The flowers themselves are mere dashes of pale ink punctuated by darkly colored stamens. The orchid, along with bamboo, plum blossoms, and chrysanthemums, is one of the "four gentlemen" in the tradition of the Chinese literati. Its natural elegance and inconspicuous manner have made it a symbol of total purity and modesty, captured in traditional Chinese painting and poetry throughout the ages. Despite the orchid's association with the literati arts, some of the finest orchid paintings have been produced by Zen Masters, both in China and Japan. One of the greatest Chinese Zen monk painters of orchids was Hsueh-ch'uang P'u-ming (d. 1349), and his approach to painting orchids was recorded by one of his followers:

> One should grasp the brush firmly with his index finger, support it with his middle and fourth fingers, and use his little finger to guide the movement of the brush by touching the surface of the paper and supporting the brush from underneath. The initial stroke should be heavy, the middle one light, the last one heavy, and the closing one somewhat light. This will show the leaves in their back, side, oblique, and frontal views just as in nature.[26]

Yūzen, in keeping with his more individualistic and expressive style, demonstrates his personal approach to orchid painting. Although the slender, elegant shape of the orchids can clearly be distinguished, the leaves do not reflect the more clearly modulated and controlled brushwork of past masters. To the side, Yūzen has written:

> *Fragrant wind*
> *sweeps away evil.*

The simple inscription suggests that an appreciation for nature can help to cleanse the human heart.

Occasionally the requests for paintings and calligraphies by parishioners and admirers became a bit overwhelming, but Yūzen took it in stride and did his best to subdue the situation with a little Zen teaching. When a particularly anxious patron continued to ask Yūzen about the work he had requested, Yūzen merely replied, "Hmmmm. That painting? Well, to make a painting requires a lot of *zazen*."[27]

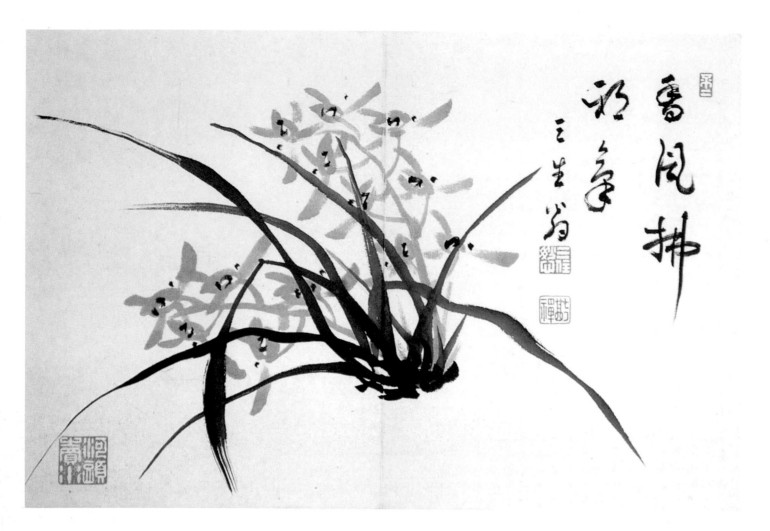

Plate 29. Yūzen
ORCHID
Ink on album paper, 24.2 x 36.3 cm.
Private Collection

Gradually, lay followers came to appreciate the Zen message within Yūzen's art and, more important, came to recognize and appreciate the activity of painting as an extension of the Master's Zen mind. One of Yūzen's physicians in Kurume, Dr. Ozeki, especially valued Yūzen's art and often requested examples. One day when Yūzen had a cold and high fever, the doctor examined him and prescribed complete rest, saying:

> *"Because the Rōshi's body is important, won't you please take care of it?"*
> *To which Yūzen replied, "For you there is the importance of the paintings, but for the general public the Buddhist Law is important. . . ."*
> *The doctor then said, "Painting is also within the* dharma.*"²⁸*

Occasionally, however, Yūzen's own interest in painting and calligraphy got the better of him. During a lecture Yūzen said, "When I was at a big Buddhist meeting and ceremony that was attended by Zen Masters and abbots from all the Zen sects, there was a collection of autographs and writings by these monks. Among them the *Kanchō* of Daitoku-ji, Kazan Rōshi, had written the words 'Bright Dignitaries' [*meirekireki*]. But the *reki* character was written incorrectly as the word *ma*, so the phrase could not be read properly. I let this slip out of my mouth, and Kazan Rōshi said, 'Yūzen, there is no need to worry, since it has my name below it. It is not a problem for you.' His point was that a person who follows his own spirit has no excess nose to stick into another person's work."²⁹

Yūzen's loose, expressive brushwork and wet-ink style contributed to his odd, humorous depiction of a pair of cranes (PLATE 30). In the diptych

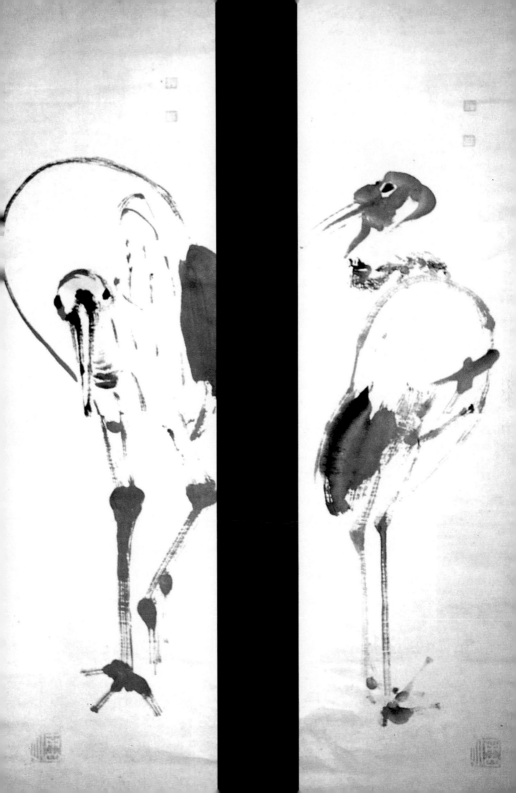

Plate 31. Yūzen
CRANES (detail)

the traditionally regal and refined birds appear rather awkward, one looking directly out at the viewer and the other gazing over its shoulder at its companion. Cranes are traditionally found in Chinese and Japanese painting, in lush landscape settings or by the sea, but they are generally treated as tall, elegant birds reflecting the grace and dignity of the Taoist Immortals with whom they are associated.[30] However, Yūzen treats them in a much different manner; each fills its space almost completely, and their ungainliness is emphasized by Yūzen's wet blotches of ink and rough brushwork (PLATE 31). In a sense, he has brought these lofty creatures down from their immortal realm to the simple, everyday, ordinary world of Zen, an attitude reflected in a traditional Zen phrase:

> An itchy dog doesn't
> want rebirth in heaven.
> Instead, it sneers at
> white cranes in the clouds.[31]

Yūzen was also capable of utilizing his rich, wet brushwork to create more compositionally intricate and elaborate works. In images such as the landscape of autumn mountains painted in 1915 (PLATE 32), Yūzen used his characteristic wet dots of ink to add texture to colorful washes of orange, blue and green. The result is more reminiscent of the pointillist style of literati painters than traditional Zen painting, but reveals the appreciation and awareness of different styles of painting that many Zen Masters possessed. Despite the more complicated composition and rich overlayering of brushwork, the image maintains the gestural spontaneity and personal expression associated with Zen brushwork. The inscription refers to the mountains:

> Jutting up on all four sides as if in competition[32]

After becoming abbot, Yūzen not only painted but also continued his own Zen study diligently, reading one volume of the *Rinshūbun* sutra every morning without fail. He maintained this practice even while riding on trains or staying in *ryokan* (inns). Once, while he was staying on the second floor of a *ryokan*, he began his morning reading routine and came to the word *Daihannya* (Great Wisdom) in the *Rinshūbun*. Suddenly a loud voice rose out of nowhere calling him. Then from the staircase the maid emerged; Yūzen tumbled over in surprise.[33]

In the spring of 1905 Yūzen was elected *Kanchō* (Chief Abbot) of Myōshin-ji, a vital appointment since it placed him in charge of one of the most important and influential Rinzai monasteries of the period.[34] As a result, Yūzen no longer merely administered his own small temple, Bairin-ji, but also managed the large operations of Myōshin-ji and its numerous subtemples throughout Japan. An Osaka morning newspaper reported:

> Today Yūzen Oshō of Kurume Bairin-ji will become Kanchō of Myōshin-ji. He does not have excessive scholarship but is an oshō [revered monk] of high virtue; therefore, Myōshin-ji's affairs will be quickly settled.

Yūzen heard about this report and said, "My scholarship is sufficient, but as far as virtue is concerned, there is never enough."[35] Again his sense of humor prevailed, but Yūzen himself commented on his lack of education:

Because I didn't have much education, I didn't have fortune, didn't have wisdom, didn't have cleverness to deal with people, didn't have other merits. I think I was gifted only for training in the Zen Law earnestly for a lifetime. Still, because one is a dunce, one must increase his exertion; only through exertion can a person plan to defeat foolishness.[36]

Despite its position as a prominent Zen temple, Myōshin-ji too during this period found itself in dire financial straits. Every day bank personnel or private loan officers would descend upon the temple. Yūzen told them, "Even I, a begging priest in the middle of Japan, am troubled; I have to do my best for everyone, therefore you must just wait awhile."[37]

Gradually, internal reforms were established to help get the temple back on its feet. But the loan officers remained impatient and eventually demanded to see what art treasures were in the temple storehouses. Because of the unusual circumstances, Yūzen gathered his assistant priests together and told them, "Just as if the treasures and halls were threatened by fire or other disaster, please conceal them. Under these circumstances, follow the worldly ways of lay people." The loan officer overheard this and admired Yūzen's character.[38]

Yūzen eventually cleared up the temple's financial affairs and left behind a modern system of management and administration. Yet, despite his prominent position as chief abbot of Myōshin-ji, Yūzen still maintained a humble air. Kanshū Gensei recalled:

Plate 32. Yūzen
AUTUMN LANDSCAPE
Ink and color on paper, 23 x 34 cm.
Bairin-ji

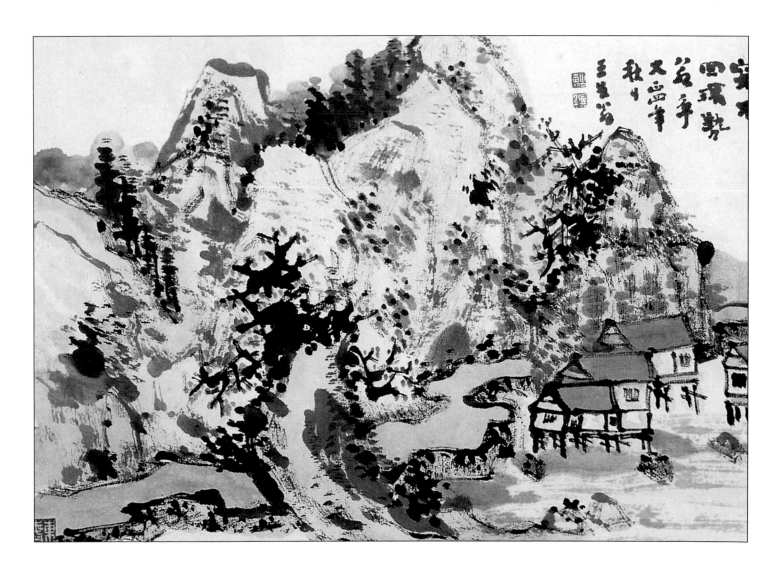

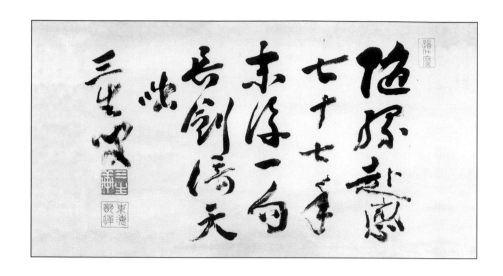

Plate 33. Yūzen
DEATH POEM
Ink on paper, 30 x 52 cm
Bairin-ji

For a short time Yūzen did angya *[a pilgrimage], during which time he met a wealthy family of devout Buddhists. They welcomed him into their home, but Yūzen was indifferent. While heating the bathwater, he became their cleaning man. He turned black from the work. At this time there were many requests from large temples from all over for him to lecture, but he turned them all down. After a year, Yūzen became* Kanchō *of Myōshin-ji. Later he was invited to speak at a large initiation ceremony and meeting. The wealthy man with the bathtub was also in attendance and spoke to another monk who said, "Ya. That Tatsu-san [Yūzen] became* Kanchō.*" To which the man replied with a loud fuss, "That bathtub-heating priest?"[39]*

Yūzen eventually retired to the Boun-ro (Evening Cloud Hermitage), which contained a room called the Sanshōken, from which he took his artistic name. Despite his retirement from official duties, he remained active in spreading the Buddhist teachings and overseeing the needs of lay parishioners. He founded the Taisaikai, a lay Buddhist society with a total of seven hundred members who met throughout the country at twenty-five Buddhist seminaries. Yūzen lectured to them on the *Rinzairoku* and assisted them in meditation. He also founded the Mokushōkai (Silent Voice), a meditation group whose purpose was to provide a broad general introduction to Buddhism for the curious.

Yūzen's career spanned one of the most turbulent periods for Zen in Japan; despite poverty, dilapidated temples, and anti-Buddhist sentiments, he represented the determination to keep the pure spirit of Zen alive. By the end of his life, the fruits of his labors emerged. Temples had been revitalized, physically, administratively, and spiritually, and he was now able to devote his time to the needs of lay followers. He remained dedicated to serving the lay public patiently; when one old gentleman persisted in asking question after question about Buddhism, Yūzen always obliged him.

I serve as a chief priest, so time is short, and monks have nothing to store up. The difficulties of development are beyond imagining, so I must say that a single word or explanation is not sufficient.[40]

In commemoration of his seventy-seventh birthday, photographs of Yūzen from the front, sides, and back were taken on New Year's Day. From these photographs a seated portrait was carved from wood by the sculptor

Kanō Tessai. Yūzen and Tessai had known each other from years earlier when they were both young novices at the same temple, but Tessai was not content with temple life and returned to the secular world. They had had no correspondence since that time, but when Yūzen went to Tokyo, he had a chance meeting with the now-famous sculptor at the house of the Arima family. They rejoiced at the meeting.

"So, the runny-nosed little monk has become a *Kanchō*, how times change!" remarked Tessai. "This is your impudent manner, but not even in a dream could you have thought this would happen," replied Yūzen. The two reminisced, and Yūzen requested that Tessai make the carved portrait.[41]

On May 1, 1918, just before he died, Yūzen wrote his final poem (*yuige*, PLATE 33),

> *My experience, guided by fate,*
> *has lasted seventy-seven years.*
> *One phrase in the hour of death,*
> *leaning on the sword of heaven:*
> Totsu![42]

TAKEDA MOKURAI

Yūzen had occasionally collaborated artistically with one of his main disciples, Takeda Mokurai. In a charming image of a bull, Yūzen again utilized his personal loose, wet brushwork to enhance the bulky, muscular, and rather awkward nature of the resting animal (PLATE 34). In this example Yūzen has further enhanced the figure of the bull by highlighting it with a pink wash. Above, Mokurai has simply written the character *shitsu*, "to scold or reprimand," followed by three repeat marks. The simple image and inscription leave much room for interpretation. We have already seen Nantenbō's rendering of a bull (PLATE 9), which he clearly identified in the inscription as representing himself. In this image, has Yūzen also painted the bull to represent himself? If so, then are Mokurai's words of reproval emanating from the Master to pupils and practitioners alike, or is Mokurai, now a Zen Master himself, playfully admonishing his aged teacher for his laziness and inactivity? This would indeed be a touch of Zen humor.

Mokurai (FIG. 11) was not only the most noted disciple of Yūzen, he also became celebrated in Kyoto as a major Zen Master and artist. His path to this goal was not easy, however, and he had many teachers before training under Yūzen. Born on the third day of the seventh month of 1854 on the island of Iki off the northeast coast of Kyūshū, Mokurai was the fourth child in a family of five sons and two daughters.[43] He began his Buddhist studies at the age of seven under the monk Ryōdō at Taiyō-an and the following year formally entered Buddhist orders at Ankoku-ji, a temple in the Daitoku-ji line. He later returned to Ryōdō for further training. At the age of ten, Mokurai followed Ryōdō to Shōdan-an, where he began studying Buddhist precepts from the monk Kōdō and continued his Zen training from Ryōdō. He also began Confucian studies. In his later writings, Mokurai recalled:

Figure 11. Mokurai

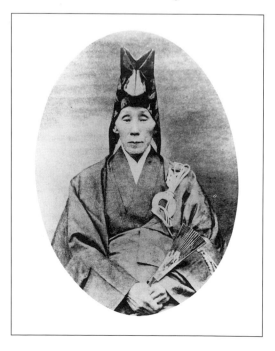

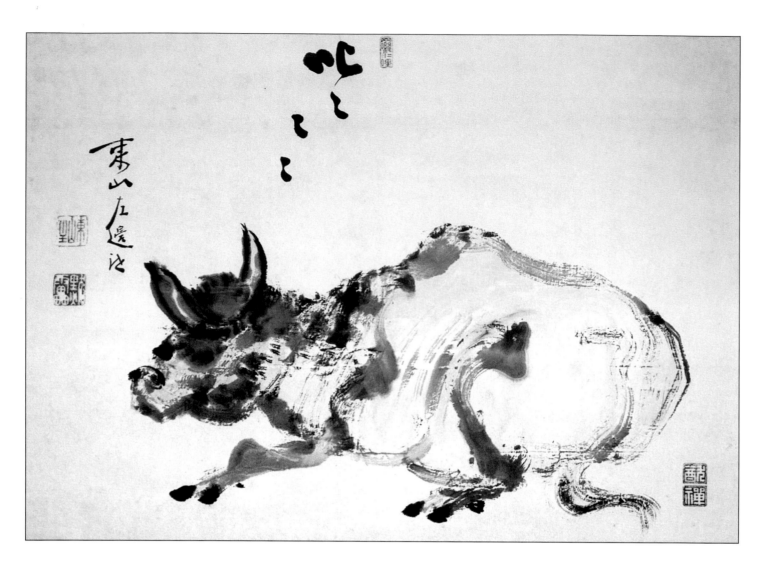

Plate 34. Yūzen
BULL
Inscription by Mokurai
Ink and color on paper, 33 x 48 cm.
Private Collection

When I was a boy priest reciting sutras, my master said, "What kind of sutra-chanting is this? Your reading is very strange. The way you chant word is strange, person is strange, even tree is strange. You are reciting with the words jumping and flying; they should have more depth. Each word should come from your hara [gut] when you chant. This is also true for zazen, flower arranging, and tea; if they don't come from your hara, they're no good." These words from my teacher I have never forgotten.[44]

Ryōdō died when Mokurai was fourteen, so the young monk first served the priest Shugaku at Kannon-ji and then the following year went to the major temple Sōfuku-ji in the city of Hakata as a pupil of Ranryō Gishū.[45] This move was important because it enlarged Mokurai's cultural vision; in Hakata he furthered his study of Confucianism as well as Chinese and Japanese poetry with the well-known scholar Kamei Nanmei. Mokurai also studied calligraphy with Kosone Kendō, a master of Chinese clerical script. This would prove to be an important artistic step because Mokurai would later become noted for his unusual and skillful use of clerical script in his painting inscriptions and other calligraphies.

Mokurai began traveling at this time as part of his training, studying both with Shūgaku in Shōzen-ji and with the scholar Kondō Mokken in Osaka. Sōfuku-ji was his home base, however, and as the Meiji period began in 1868 in the midst of national turbulence and change, Mokurai was struggling with fundamental religious questions. As he wrote later about this pe-

riod, "If at this time of life a monk is deluded by worldly matters, his practice is cut off . . . this is truly a dangerous moment."[46]

In 1873, at the age of twenty, Mokurai traveled to Mino to study with Tairyū Bun'i (1827–1880)[47] at the Sōgen-ji sōdō, but he became ill and went to recuperate at the Shūkō-in subtemple of Kyoto's Daitoku-ji, where he studied with Gisan Zenrai (1802–1878).[48] Mokurai later remembered this teacher with an anecdote that must have been significant to a young man who had chosen a celibate life:

> At the time I was still a training monk, I was able to meet the Master Gisan; his eyebrows were white as clouds, his complexion as bright and clear as jujube, and he was really a marvelous old monk. One time a Buddhist layman decided to test the Master, so he brought him a painting of a bedroom scene by Maruyama Ōkyo. Gisan looked, smiled, and said: "Sah, take it back; a gentleman takes one look and does not look again." These were truly marvelous words, and became a story that spread to Zen temples in all directions. What does "takes one look and does not look again" mean? For military men as well as for monks, if one happens to see a beautiful woman's skin, one does not look twice. This story has a lofty Zen flavor.[49]

Worldly temptations must have been considerable for the young monk, but he seems to have taken Gisan's words to heart and done his best to avoid difficult situations. In fact an elderly woman once visited Mokurai's Master, Yūzen, after he had retired from Myōshin-ji and told him this story:

> I was in Kyoto and went to see a play with the virtuous Mokurai Oshō. A beautiful and charming young maiko [geisha in training] came and sat down next to us. Mokurai made a face and said, "You can't sit here; go over there." After driving her away, he explained that if there are beautiful women nearby, it causes evil feelings. The virtuous monk exerted great spirit.[50]

Even at the subtemple, however, the training program was too severe for Mokurai's delicate health, and he must have had mixed feelings watching Gisan practice sumo wrestling as a hobby while he could only serve as referee. Mokurai eventually moved to the monk's dormitory at Kennin-ji, also in Kyoto, where he studied with Shungai Tōsen. Mokurai also continued his study of Chinese and Japanese poetry, and his interest in painting and calligraphy was stimulated by the artistic milieu of Kyoto, still the cultural capital of Japan although the government was in Tokyo.

At the age of twenty-four, his health no better, Mokurai temporarily returned to his home in Kyūshū, and in the next two years he went first to Hirado's Yūkō-ji (where Nantenbō began his training) and then Nagasaki's Shintoku-ji, studying with Kōdō and Chōsō Genkai (1830–1903).[51] At this point in his training he formally changed from the Daitoku-ji to the Kennin-ji affiliation within Rinzai Zen, moving from the Inzan to the Takujū tradition of kōan training.[52] He also received the name Mokurai at this time.

In 1881, Mokurai went to Bairin-ji in Kurume, where he became a pupil of Yūzen Gentatsu. He describes this period in no uncertain terms:

> At first I just did whatever I wanted and caused many problems, exhausting my health. Finally I came to study at Kōnan [Bairin-ji], still full of poison, my

bone marrow completely pulverized. Polishing myself was very painful; despite twenty years of diligence, I'd done nothing meritorious.[53]

After so many teachers, this was to be Mokurai's final period of training; he stayed with the Master until 1888, when he received Yūzen's certificate of enlightenment. Despite Yūzen's acknowledgment of Mokurai's achievement, it did not mark the completion of his Zen training. Beyond enlightenment there is also continued training that many monks go through; Zen Masters often consider this post-*satori* practice a crucial part of Zen experience. Mokurai explained:

> *Rinzai training is just binding oneself with a rough rope to untie. . . . Zen is ninety-nine percent work to be accomplished, but there is also one percent that is a barrier. If one cannot penetrate that one percent, one cannot succeed in Zen. It's like melting many hairpins and bangles into a single lump of gold . . . to understand the "rough rope" of Zen practice, in the moment of great enlightenment the origin of illusion is exterminated. However, the fragrant power of illusion remains as a habit, gradually becoming smaller and smaller. Post-satori practice is to remove this thin wire of habit. If one can at first experience the great death, entering the gate of satori is easy, but post-satori practice can be very difficult.*[54]

During Mokurai's years in Kyūshū, the situation in Kyoto had changed. Recovering from the anti-Buddhist fervor of the first decades of the Meiji period, several Zen temples were being renovated and new training centers established. In 1887 Mokurai was invited to move back to Kennin-ji by the abbot Sekisō Shōkyū to help reconstruct the *zendō*, and so the following year Mokurai left Bairin-ji with, perhaps, some reluctance. He wrote the following haiku at this time:[55]

> *The wind and moon*
> *of Kōnan are finally*
> *difficult to forget.*[56]

Figure 12. Kennin-ji

Kennin-ji (FIG. 12) was in the process of extensive renovation. In 1887 it had received a guest reception room from Myōshin-ji, and Mokurai was to supervise not only the *zendō*, but also the reconstruction of the Founder's Hall in 1894 and the completion of the *sōdō* in 1898. Meanwhile, 1889 marked the 650th anniversary of the founder of Kennin-ji, and a large celebration was being planned. Sekisō, however, died in 1888, and Ryūkan Kokan became the new abbot and led the proceedings with Mokurai's assistance. However, Ryūkan himself died on May 5, 1892, and so Mokurai became abbot of Kennin-ji at the age of thirty-nine. He was to spend more than three decades there in charge of the temple, training monks and also working extensively with Buddhist lay people.

Kennin-ji is located in Higashiyama, the "Eastern Hills" of Kyoto, not far from the Gion shrine and also near a traditional ceramics center. Among Mokurai's lay pupils were women, military leaders, court nobles, scholars, industrialists, Shinto priests, doctors, tea masters, painters, and potters. Among those to whom he granted certificates of enlightenment were the artist Tsuji Kakō (1870–1931), a pupil of the Shijo-school painter Kono Bairei who served as director of the Kyoto Municipal School of Fine Arts and Crafts, and his sister Tsuji Mitsuko, a tea master. Another artist who studied

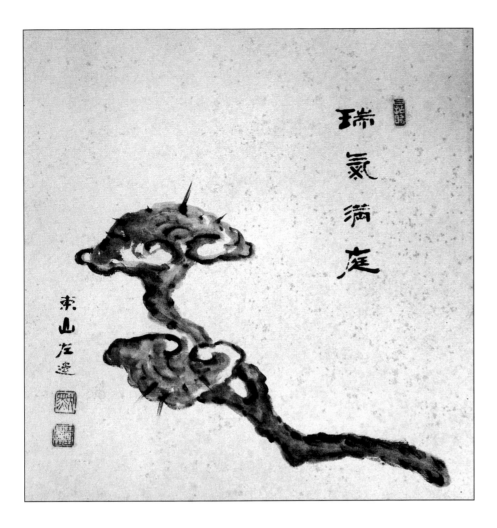

Plate 35. Takeda Mokurai (1854–1930)
MUSHROOM SHIKISHI
Ink on paper, 27.3 x 24.2 cm.
Hōsei-an Collection

with Mokurai was Tamura Gesshō, who painted many themes in ink that clearly demonstrate his Zen interest. Mokurai, who did not have a painting teacher, may well have been influenced in his own paintings by the styles of Kakō and Gesshō.

Although Mokurai was a Zen monk painter, most often producing compositionally simple works in ink on paper, the possible influence of Shijo-school artists can be seen in more delicate works such as the small *shikishi* of a fungus with the inscription "Auspicious Spirits Fill the Garden" (PLATE 35). This fungus is the Mushroom of Immortality, the shape of which is often replicated in wooden "wish-fulfilling" scepters (*nyoi*) carried by Zen Masters, and is also associated with Chinese Taoist figures. Mokurai has nicely captured the irregular, almost cloudlike surface quality of the mushroom with his careful outlines and swirling gray wash. Here we can also see the clerical script calligraphy for which Mokurai was famous. This script is noted for its clearly delineated lines and squat, boxy character shapes, which Mokurai has used to offset the swirling curvilinear shape of the fungus. Although spatially distinct from the image, the calligraphy of both the inscription to the right and the signature to the lower left serve as visual counterpoints, balancing the compositional placement of the image and preventing it from tipping over to the left. The black ink and brisk strokes of the calligraphy also enhance the dark swirling highlights and short spikes protruding from the top of the mushroom. Typical of clerical script, the brushwork is only slightly modulated, but it is punctuated by triangular flourishes at the tips of some angles or horizontal brushstrokes, here seen in the lower horizontal stroke in the last character.

Mokurai's understanding and personal appreciation of art brought him into contact with other leading figures of the day, including the literati artist Tomioka Tessai (1836–1924) with whom on one occasion he discussed the work of the Zen Master Sengai (1750–1837).

> *Tomioka Tessai is an authority in the present day, and it seems he is able to en- ter full concentration. One day he came to a ceremony at Kennin-ji, and af- terward he paid his respects and was invited to have a cup of tea. At this time he said, "Mokurai-san, I've just come back from a painting pilgrimage to Kyūshū. At Shōfuku-ji in Hakata, I saw paintings by Sengai and they were re- ally marvelously interesting."*
>
> *At this point Tessai took out his traveling brush-and-ink set from his hip, and before I could even drink a sip of tea, he rudely took a tea-tile and used it to wash his brush. He then naively took up the brush and began painting to show us the interesting things he had seen. Tessai straightforwardly used his brush to empty out his conscious self and reach true concentration, manifest- ing the authority of a lion-lord. Indeed, attaining the singleness of art is not something an ordinary person can do, and is quite admirable.*
>
> *In Kyoto there are as many painters as polliwogs, but it is said, "The plum in the painting should have both color and scent." True artists who can paint this color and aroma, how many are there?[57]*

Like his Master, Yūzen, Mokurai also painted images of the Zen Pa- triarch Daruma, but with a much different vision (PLATE 36). In contrast to Yūzen's rather sad portrait with its broad, wet brushstrokes, Mokurai's depic- tion of the Patriarch reveals a slightly reclusive figure in profile, head barely protruding from his robes, delineated here by a single broken sweep of black ink. Above, Mokurai has written, "Outside the heart, no law." Again, this is a reference to the fact that what one seeks in Zen is actually found within one's own self, within one's own Buddha-nature.

It is interesting to see how each Zen Master's own Buddha-nature re- veals itself in images of Daruma. The depictions of the Patriarch by Nan- tenbō, Deiryū, Yūzen, Mokurai, and Rozan (see chap. 6) are quite varied; how do they reveal each Master's personality and individual approach to Zen teaching and training? Fukushima Keidō (see chap. 7) has speculated that monks paint Daruma's experience of meditation through their own experi- ence of *zazen* and that sometimes parts of their physical nature are also con- veyed.[58] For example, an abbot of Tōfuku-ji, Ichidō Ienaka (Shikatsu-an), depicted Daruma with a long face; he himself also had a long face. Is it a co- incidence that Yūzen's Daruma is round, full, and robust like himself, while Mokurai's appears more mild and diminutive?

The idea that one must rely on oneself in Zen is extremely important. Although the relationship between Master and disciple is crucial in training, the Master can only serve as a guide; disciples must come to their own un- derstanding. Mokurai explained:

> *Zen teachers can't even offer their pupils a drop of rain. If it is misunderstood, even a mother's kindness can lead to a deformity. Master Hakuin would say that a pupil's enlightenment was exactly like a cicada slipping out of its cocoon. If any help is given from the outside, it is impossible to escape the cocoon, and if one pulls the cicada out, it will die without ever flying or singing. Therefore one must wait for the right moment for enlightenment to*

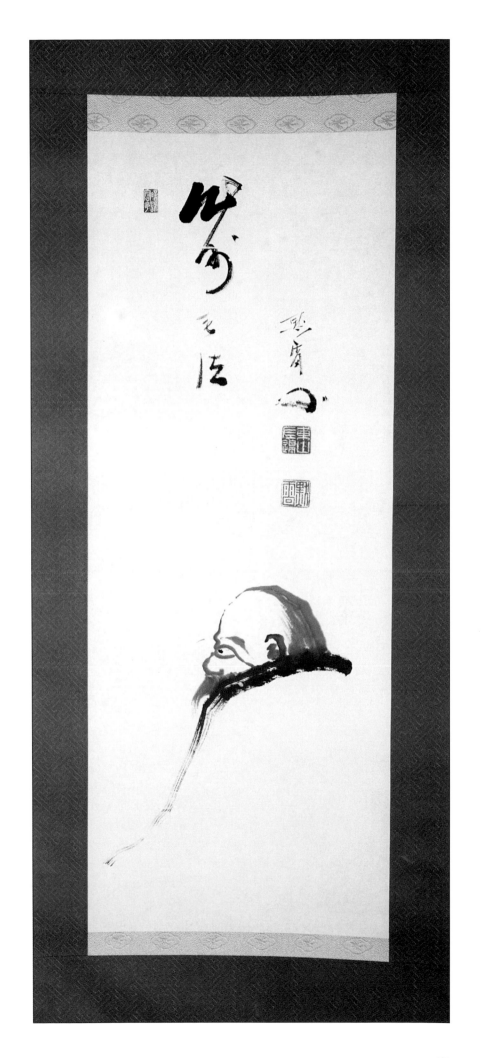

Plate 36. Mokurai
DARUMA
Ink on paper, 63.8 x 23 cm.
Private Collection

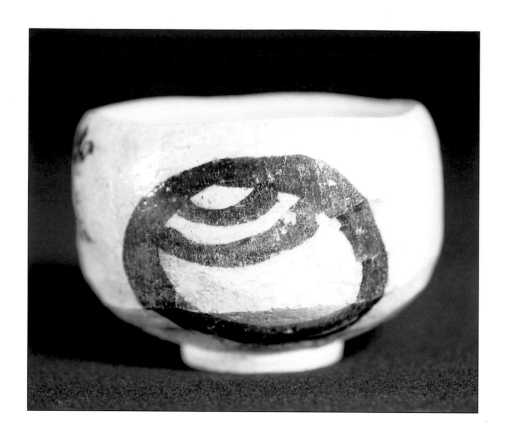

come; hurrying recklessly only makes it impossible. One sees the shaven head, but when the time comes naturally it will burst open and the fruit will emerge.[59]

This commentary deals specifically with monk pupils with shaven heads, but the principle is equally true for lay followers. In Japan, lay people have studied Zen as a discipline to help them in their everyday lives, but some have been eager to achieve *satori* quickly, and these must be taught patience as well as self-discipline. Historically, people who have devoted their lives to the arts have often been especially receptive to Zen training, and Mokurai was particularly effective with leading ceramicists of his time.

Among Mokurai's potter pupils were Kiyomizu Rokubei, Itō Tōzan, Suwa Sozen, and Uno Gozan, all of whom lived near Kennin-ji. Uno Gozan created *Sixteen Rakan* and also a ceramic sculpture of Kannon for the temple, the latter of which was enshrined in the "Cherry Blossom Gate" of the Founder's Hall. Mokurai himself not only inscribed ceramics and the all-important wooden boxes in which prized ceramics were stored, but also created some of his own pottery, such as a teabowl painted with the image of a Zen jewel (PLATE 37).

The teabowl itself seems to have been wheel-thrown and then scraped and shaped slightly with a sharp tool in an attempt to make the bowl lighter and its walls thinner. Rather than a delicate or refined example of pottery, it reflects the Zen appreciation for the mundane, the everyday, and even the slightly awkward. This taste has permeated the art of tea in Japan, making a virtue of what might be seen as a defect, and making individual character rather than technical perfection the standard of quality.

The Zen jewel represents good fortune, as well as representing one's inner light and being, as suggested in the passage by the Chinese Zen Master Ta-an (d. 883):

A Priceless Jewel

Each of you has a priceless jewel in your own body. It radiates light through your eyes, shining through the mountains, rivers, and earth. It radiates light through your ears, taking in all sounds, good and bad. It radiates light through your six senses day and night. This is also called absorption in light. You yourself do not recognize it, but it is in your physical body, supporting it inside and out, not letting it tip over. Even if you are carrying a double load of rocks over a single-log bridge, it still doesn't let you fall over. What is it? If you seek in the slightest, it cannot be seen.[60]

However, in the case of this tea bowl, the symbol of the jewel also serves as part of a ribald pun. On the underside of the lid to the wooden box in which the bowl is stored, Mokurai has inscribed a poem by the Zen Master Sengai:

> *If my jewels were made of gold*
> *what a rare treasure*
> *I'd have!*

The more off-color reading of the poem might be,

> *If these testicles of mine*
> *were made of gold*
> *What precious equipment I'd have!*[61]

The poem utilizes a pun on the word *chimpo*, meaning "jewels" or, colloquially, "testicles."

Despite the informality of Mokurai's approach, Zen and tea had a long history. Zen Masters of the fifteenth and sixteenth centuries had been courted by *daimyō* and *shōgun* alike to share in their growing appreciation of the tea ceremony (*cha no yu*). Behind the enthusiasm for Zen was tea aesthetics, which were based largely on an appreciation of naturalness, rusticity, solitary serenity, and the beauty of simplicity (*sabi* and *wabi*) associated with Zen. By patronizing Zen Masters, the *daimyō* and *shōgun* in turn gained an affirmation of their aesthetic sensibilities and refinement, an important and valuable tool in a country that has long measured political substance alongside cultural and artistic understanding. One result was that Zen Masters became entrenched in political matters, leading to numerous complications for temples and rulers alike.

During the Edo period (1600–1868), however, Zen Buddhism had lost political favor, replaced by neo-Confucianism, which served the needs of the Tokugawa *shōgun* more effectively. Zen Masters became free to return their energies to monastic training, the needs of lay parishioners, and Zen activities such as art. Less burdened by official patronage, Masters could enjoy tea as a leisure activity without overt political implications, and at the same time could encourage the appreciation of tea as a means of better understanding certain aspects of Zen. It was this type of appreciation that Mokurai continued to encourage in the twentieth century, believing that it offered lay people a flavor of Zen when done correctly, but he also noted that "for Zen monks, doing tea should never become a dissipation."[62] The Kyoto elite had such respect for tea that Zen monks, if they were not careful, could be drawn excessively into this rarefied world, which Mokurai both resisted and warned against (which perhaps explains his off-color poem).

As much as Mokurai seems to have appreciated the numerous arts

of painting, ceramics, tea ceremony, poetry, and calligraphy, both for himself and in the work of others, he was quite clear that the arts should never get in the way of Zen practice for a monk. He emphasized this point in an anecdote:

> Before I served there, a monk named Tetsuō[63] was abbot of Shuntoku-ji in Nagasaki during the period just before and after the Meiji Restoration in 1868. At that time many patriots came to Nagasaki. Tetsuō was good at literati painting [nanga][64] and his orchids were especially marvelous; no one before him could be compared for skill. One day a samurai turned up at Shuntoku-ji's gate, knocked, and asked to study orchid painting with Tetsuō. When Tetsuō's pupils conveyed the Master's refusal, the samurai then said, "In that case, I'd like to have one painting of orchids by Tetsuō." However, the Rōshi again declined, saying through his pupils that "during my recent illness I neglected the brush." The samurai replied, "If so, I'd like to pay a visit to wish good health," but the Rōshi continued to refuse.
>
> The samurai was helpless; nevertheless, the next day he returned to the temple and said that he had brought a Chinese-style poem for the Master, and he wanted Tetsuō to respond with a poem in Japanese. The Rōshi's reply was conveyed that he was unlearned and couldn't offer a single poem, waka, or haiku. As might be expected, the samurai flew into a rage, puffed out his chest, and pulled out his sword, saying, "I've come from afar to Nagasaki to meet the Rōshi and I've visited this temple several times. His conduct is certainly very strange, and declining to meet me is insulting."
>
> Tetsuō's pupils were greatly distressed, and they ran in to tell the Rōshi that he might be in danger. Tetsuō coolly faced his pupils and said, "I am not a painter; I do understand brushwork a little, but I have declined his requests. There are many things under heaven; a samurai studies military matters and drills with weapons every day without fail. It is enough for him to study literature and the arts to some extent, but it is not appropriate for him to take up the brush at the expense of his swordsmanship. This samurai seems to want to study painting, but this I don't like, and if he decides to run me through with his sword, then running me through is fine. But tell him that I won't paint an orchid or write a poem for him, and send him away." His voice was so severe that it could be heard out on the porch where the samurai was waiting; the samurai gave up and returned to his home. Tetsuō's views were absolutely correct for a Zen Master.[65]

The fact that painting and calligraphy have been considered to be a secondary aspect of a Zen Master's life and practice meant that generally, until the twentieth century, Masters rarely if ever commented on their art. Even Hakuin, the most important Zen Master of the past five hundred years and a highly prolific monk-artist, never commented about his painting. But Masters of the twentieth century have been more inclined to acknowledge the role that painting and calligraphy could play in Zen teaching, and not only remarked on their own works, but also appreciated and commented on the work of past masters. Mokurai even seems to have collected at least one painting by Hakuin, of whom he said:

> Hakuin's paintings are not limited to rough-style brushwork, there are also much more delicately painted works of beauty. As evidence, in my possession there is his Skeleton Doing Zazen painting, which is very controlled in style. As I have said before, there is a waka.

Plate 38. Mokurai
PUPPY
Ink and light color on paper, 106 x 30.4 cm.
Oliver T. and Yuki Behr Collection

Plate 39. Mokurai
STAFF
Ink on paper, 136.6 x 32.1 cm.
Shōka Collection

遇
事
了
平
生

却
云
堂

東
山
左
邊
淨
心

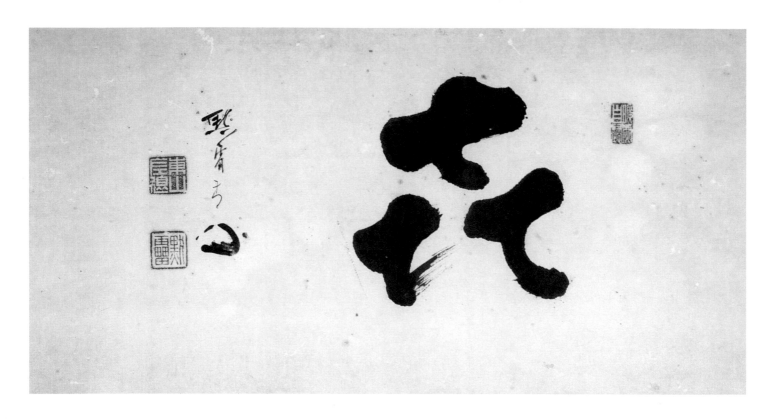

Plate 40. Mokurai
CELEBRATION
Ink on paper, 26.9 x 51.8 cm.
Hōsei-an Collection

In Japan
true wonders
 are two—
Suruga's Fuji
and Hara's Hakuin

I myself was once asked to write an inscription on a painting of Mount Fuji, so
I did this imitation:

In Japan
true wonders
 are two—
Suruga's Fuji
and Kyoto's Mokurai

What do you think of this?[66]

Whether or not they commented directly about their painting and calligraphy, however, Zen Masters past and present have understood the potential in conveying their teachings through art. In Mokurai's charming, seemingly insignificant image of a puppy viewed from behind, no Zen meaning or teaching may appear immediately obvious (PLATE 38). However, Mokurai has written above the puppy three simple characters meaning, "Shū says *Mu*." This is a reference to the famous *kōan* in the *Mumonkan* in which a monk asks the Zen Master Jōshū, "Does a dog have the Buddha nature?" Jōshū replied, "*Mu*." Thus, in this simple little image of a puppy, a much more profound, fundamental Zen teaching is revealed. This is the unique power and ability of *zenga*.

In another painting, Mokurai with one swift stroke of the brush demonstrated, in action and image, the authority of a Zen Master through an image of a staff (PLATE 39). Here his own focus and years of determined training are demonstrated in the strength, power, and beauty of the single brushstroke pounding down the scroll. At the same time, the staff symbolizes

the Zen Master and his authority as a Zen teacher. This painting is striking in the way the ink starts out rich and black at the top and then, as the brush moves downward, begins to break into streaks of "flying white" where the hairs of the brush separated. Echoing the vertical movement of the staff, the inscription running along the right side reads, "If you can figure out your whole life's *mugaku no koto*, then you are finished." *Mugaku no koto* literally means, "thing of no learning," referring to the Zen ideal of eventually moving beyond all things, including intellectualism, to a state of *mushin* (no-mind) in which all distinctions and dualities are removed. And, as Mokurai states on this image, if you can achieve this state, you have achieved the goal.

The path to this type of understanding is, of course, not easy, and Mokurai likened the experience to traveling like a Chinese Immortal through a gourd.

> *Living by Zen is exactly like entering a gourd. The mouth is very small, so it is not easy to enter, but once one has overcome the difficulty, a complete world appears. One advances through a wide section, and if one can penetrate the thin part in the middle, then for the first time it is like sailing though a great lake on a light skiff and enjoying the cherry blossoms along the banks. However, if one merely gazes with rapture at the scene forever, in the end one's buttocks will decay; truly even this gourd must finally be destroyed.*[67]

This passage from Mokurai's writings stresses not only the difficulty of enlightenment, but also the necessity of returning to the everyday world to work with compassion for all living beings. The freedom and joy of *satori* cannot be fixed upon as a form of clinging, and Mokurai's entire life as a teacher was proof of his constant effort to deepen his own attainment as well as to teach others. Ultimately, the only goal is an ever-deeper working of the Zen spirit, and that is why Zen Masters who have reached *satori* in their middle years become even more impressive in their old age.

Mokurai became seriously ill in 1925 but recovered and continued his duties. He was feeling his years, however, so in 1928 he resigned his position as Master of the Kennin-ji *sōdō*, and two years later retired completely. He died in November 1930 at the age of seventy-seven, the same age at which Yūzen had passed away. Both Masters had played important roles in reaffirming the strength of Zen in the twentieth century, Yūzen by persevering through a time of anti-Buddhist sentiments and dire poverty, and Mokurai by rebuilding an important Kyoto temple and training many monk and lay pupils. At some point Mokurai wrote a single-character calligraphy in which he simplified the character *ki* (喜 *yorokobu*, celebration). In simplified form, the character looks like the numbers seven, ten, seven, or, in Japanese, seventy-seven (PLATE 40). Because of this calligraphic association with the character *ki*, the number seventy-seven is considered auspicious. For Yūzen and Mokurai, seventy-seven marks not so much their age at death but rather the number of years each lived the Zen life of striving and then compassionate teaching. This strict, paradoxical, and ultimately joyous teaching continues today through traces they have left in their art.

Mokurai's death poem sums up his Zen spirit:

> *I've been roping the wind, shoveling snow in the well,*
> *a life of seventy-seven years.*
> *Now as I undergo the great change, I look back—*
> *My transgressions reach to the sky.*[68]

LARGE MONASTIC CENTER VERSUS SMALL RURAL TEMPLE

Sōhan Gempō (Shōun, 1848–1922) and Yamamoto Gempō (1866–1961)

Figure 13. Shōun

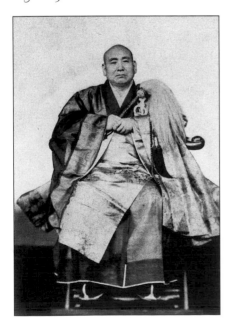

ONE OF THE MAJOR DISTINCTIONS within the Zen system in Japan occurs between large monastic training centers and smaller parish temples. Today, large monasteries oversee the training of as many as twenty to twenty-five monks in meditation, the study of texts, chanting, working, begging rounds, and *kōan* study under the guidance of a Zen Master. Upon completion of a minimum of three years of training, monks may then go on to serve as priests at smaller temples. Their duties largely encompass conducting traditional ceremonies and religious services, and tending to the spiritual needs of local parishioners. Monks who continue their training for at least ten years and successfully complete their *kōan* training and receive the certification of their Master become Zen Masters and may go on to train future generations of monks at large training monasteries. In some cases, however, even smaller temples are overseen by full-fledged Masters who also supervise the training of a few monks. The contrast between Zen Masters at a large monastic training center and a smaller rural temple is demonstrated by Sōhan Gempō and his disciple Yamamoto Gempō.

SŌHAN GEMPŌ

PEACEFUL DARUMA

*Just as watching
the moon brighten
 brings happiness,
so too in the mind
clouds may disappear*[1]

Sōhan Gempō (FIG. 13), often known as Shōun, was born the eldest son of a Shinto priest in Ishikawa Komatsu.[2] At the age of twelve he became a monk at Kōgen-ji in Kanazawa. After a long period of study and travel, Shōun entered Empuku-ji outside Kyoto in 1880 to study under the priest Kasan Zenryō (1824–1893).[3]

Shōun approached his Zen training and meditation with complete determination, and also demonstrated a love of learning. His dedication to Zen practice was reflected in his approach to *kōan* study. When he received from Kasan the *kōan*, "The Single Hand at Mount Fuji's Summit" (a subquestion of Hakuin's "Sound of One Hand Clapping"), Shōun climbed Fuji and meditated there in an attempt to penetrate the *kōan*. When Kasan was not satisfied with his answers, Shōun climbed Fuji again. In all, Shōun climbed Fuji seven times seeking to deepen his understanding of the *kōan*.

Many late-nineteenth-century monks approached Zen training as Shōun did. Not highly educated, and not having attended college, they took a pragmatic rather than intellectual approach to their Zen studies. If the *kōan* was about Fuji, it made sense to go directly to Fuji and experience it. These monks were considered very serious in an earnest way, regardless of outside study. In this regard, Nantenbō (see chap. 1) attended a meeting at Kennin-ji in Kyoto in 1879 to discuss the planned establishment of a large Zen studies center. Nantenbō believed that monks should concentrate on their monastic training practice rather than scholarship. He wrote:

The most important thing is to understand the Buddha's spirit. Even laymen can study. They have money [for books], so they can study. We should not compete with such laymen in scholarship. Other sects, as a business, sell the Buddha's spirit through scholarship. . . . What we should have is a big Zen training hall to discipline true priests who can then serve our country.[4]

Shōun eventually left Empuku-ji and went to Dōrin-ji in Tokyo to train under Nantenbō, from whom he eventually received *inka*. He then returned to study further under Kasan at Empuku-ji. Upon completion of his training in 1893, Shōun went to Kenshō-ji in Kumamoto and took the name Kenshō.

In 1898 the monk Hōrin of Empuku-ji died, and Shōun was invited to return to his former temple to run the monks' training program in the *sōdō*. At this time he took the name Shōun Shitsu and initiated the repair and renovation of the temple's structures as well as tending to its lay followers.

Shōun was warm-hearted, candid, and unpretentious in manner. Large in stature, he was affectionately referred to as Hotei after the jolly god of good fortune (Chinese, Pu-t'ai). When visiting the houses of his parishioners, Shōun often amused the children by carrying them around on his back. His unassuming nature did not change while he was at the temple. Even a visit by the chief priest of Kenshō-ji in 1898 did not affect Shōun's personality; he treated all people the same. For this reason he was known as a modern-day Ikkyū.[5] His easygoing nature is revealed in one of his poems:

> *For fifty years*
> *I have been satisfied*
> * roasting chestnuts—*
> *my chopsticks are also*
> *a dream of the floating world.*[6]

In 1901 Shōun traveled to China to observe local religious practices, just as his teacher Kasan had done eight years earlier. In Shōun's absence, Nantenbō was asked to take over the monk's training hall, but he stayed less than a year. Convinced that the monks lacked any determination or substance, Nantenbō left Empuku-ji in disgust, turning the training program back to Shōun. Since he was already well versed in many religious teachings, Shōun's one-and-a-half-year stay in China had only enhanced his knowledge and deepened his spiritual awareness. Upon his return to Japan, his composure and dignity had increased and he revealed a more active, energetic approach to life and Zen practice—as if the whole world were now his temple.

In 1908 Shōun was appointed *Kanchō* of the major Kyoto temple Daitoku-ji; he served three consecutive terms, until 1922. Daitoku-ji has one of the longest and richest histories of all Zen monasteries in Japan. Built in 1319 as a temple to house the increasing number of followers who came to study with Daitō Kokushi (1282–1337), Daitoku-ji rose to prominence originally as one of the Gozan (Five Mountains)[7] but eventually received special status as the monastery in which prayers for the Emperor's health were given, thus forging strong Imperial ties. During the fifteenth and sixteenth centuries Daitoku-ji became the center of Zen cultural activities, particularly the tea ceremony under tea masters such as Sen no Rikyū (1522–1591)

and Kobori Enshū (1579–1647). Its role as a cultural center fostered increasing Imperial and political patronage of the temple during this period. As a result, Daitoku-ji Zen Masters wielded considerable influence in medieval Japan, culturally, spiritually, and politically.

Nevertheless, on the day of his *shinzan* (investiture) ceremony, Shōun approached the event as he would any other. Not one for pretense, even on this momentous occasion he left Empuku-ji unawed by the coming events, strolling to Daitoku-ji in plain robes. Having no concern for ceremonial matters, he had no perception of the need for special attire for this ceremony. On his journey to Daitoku-ji, Shōun gazed at the scenery as he strolled along casually. If his legs got tired, he simply stopped and stretched out in a grassy field until he was rested, then continued on his way. Even the pageantry of this auspicious ceremony left him unfazed.[8]

As *Kanchō* of such a large and culturally prominent temple as Daitoku-ji, Shōun was responsible for numerous administrative duties encompassing hundreds of Daitoku-ji sect temples and subtemples throughout Japan. He was also obliged to represent the temple in an official capacity at large Buddhist assemblies and Imperial functions. For example, when the Taishō Emperor was crowned in 1912, Shōun was invited to come to the ceremony. Not interested in pomp and circumstance, he attended out of obligation. He left the temple in his usual everyday robes, and when he arrived at the ceremony looking like a beggar, he was quickly escorted by a guard to the local police station. After questioning by the police chief, it was revealed that this "beggar" was in fact Abbot of Daitoku-ji. Shōun was allowed to leave.[9]

Despite his casual manner and lack of formal education, Shōun was well versed in Buddhist texts and history, as well as being skilled in calligraphy, painting, and seal carving. He also had a great affinity for poetry, both Chinese and Japanese, and often composed *waka* (five-line poems in Japanese), many of which were collected in an anthology titled *Dokuge-shū*. One of these *waka* shows his respect for the earlier Zen Master Sengai Gibon (1750–1837):

UPON READING SENGAI'S WAKA
COLLECTION, DRIFTING BOAT

> *In this world*
> *a drifting boat*
> *in any bay or inlet*
> *when entrusted to the breeze*
> *can cross over to the other side.*[10]

Other poems by Shōun reflect his daily life. Tōzan Sōkaku Rōshi of Empuku-ji recounted that, as an attendant to Shōun, he once escorted his Master to Kyoto Station when Shōun was embarking on a lecture tour. First-class tickets had been purchased by Tōzan, but Shōun was nowhere to be found; a station attendant had mistakenly escorted him to the third-class car. Tōzan eventually found Shōun seated in a small corner seat. "Rōshi, the first-class car is this way," explained Tōzan. "Oh, is that so?" replied Shōun, not bothered by any problems or inconveniences. As they made their way to the first-class car, Tōzan described the Rōshi's retreating figure as "floating without a care."[11] On journeys such as this, Shōun found time to write poetry:

COMPOSED IN A TRAIN

The autumn moon
exchanged from the past
to right now—
seen from a train
it looks rather charming.[12]

One day in the Spring of 1919 Shōun was traveling with two of his pupils, one of whom was Yamamoto Gempō (see below, page 93). The two young monks got into a discussion of what the following day's weather would be like as they continued on their journey with Shōun. The first monk said it would be good weather, but Gempō said, "No, tomorrow it will rain." Back and forth they argued, good weather, bad weather. Finally Shōun, who was amused by the discussion, suggested that the loser of the discussion should chant the *Wisdom Sutra* (*Hannya-kyō*) one thousand times for the winner's benefit. The monks agreed. The next morning as they departed the inn, the day was clear, but when they boarded the boat, a few drops of rain fell. Gempō claimed that he was victorious, but the other monk claimed he was the winner since it had been clear when they left the inn. Neither would give in. Finally they mutually agreed to chant the *Wisdom Sutra* one thousand times for the benefit of each other. Shōun congratulated them on their solution.[13]

Despite his warm-hearted, easygoing nature, Shōun was strict in the training hall. For example, one day when a monk offered an answer to a *kōan*, Shōun turned to his desk and started doing calligraphy instead of listening. The monk, having no method for dealing with this situation, went and sat down next to Shōun, who was still doing calligraphy, and offered his solution to the *kōan* again. Again there was no expression of acknowledgment. When the monk was finished, Shōun did not say yes or no. The monk finally concluded by himself that the *kōan* had not been penetrated; realizing this, he had no choice but to leave the room.[14]

Shōun was very firm with his followers and didn't give them any hints in their *kōan* training. In his chambers, when a monk gave a correct answer, Shōun merely nodded his head, but if an incorrect answer was given, he revealed only indifference. Receiving even one word in reply was encouraging to the monks, but when only silence was received, Shōun's fierceness was understood. Similarly, Shōun showed no care for comfort or ease. One of his *waka* exemplifies the rigors of temple life:

LINGERING COLD WIND

Again this morning
the wind blows cold—
at the mountain temple
water offered to the Buddha
remains solid ice[15]

Although temple life was strict, Shōun received lay visitors graciously, and every day people could request a visit at any time. As a believer in country manners, he made no social or economic distinctions. If someone was

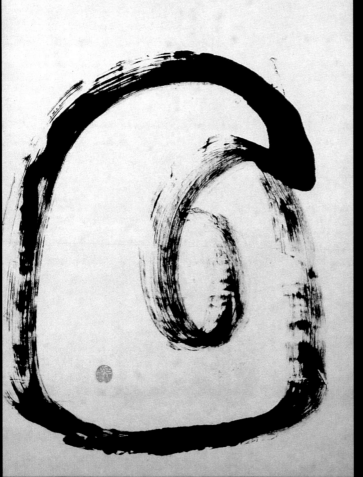

seeking the Way, Shōun would devote his attentions to providing a serious explanation to this one person. He generally spoke with a storyteller's art, projecting a warm magnanimity.

Collecting antiques was Shōun's only hobby. In particular, he had great affinity for Buddhist sculpture and while traveling he took pleasure in walking to secondhand shops to see if he could find any unique pieces. If there happened to be a sculpture with some spirit, he would disregard the expense and buy it. Handing over the Master's purse, his attendant, who was unaccustomed to this type of extravagance, thought it quite serious. At worst, if Shōun purchased a particularly costly piece, the attendant would repeatedly chastise him. Sometimes Shōun didn't have enough money, so his attendant would be sent back to pay for it later.

Shōun lined up the sculptures in his room and was very particular about their order and placement. In the morning the attendant would come in to clean the room and had to do it quickly while the other monks were doing their morning chanting. Occasionally, a sculpture got put back in the wrong place, upsetting Shōun.[16] Fukushima Keidō Rōshi of Tōfuku-ji explains that this type of appreciation for something is a form of *samari*, meaning "at play," committed fully but with playfulness.[17]

Shōun's own artworks reflect his natural demeanor — sometimes playful but always maintaining a powerful Zen presence. In his image of a *menpeki* Daruma (wall-facing Daruma), Shōun has brushed an imposing shape that represents the seated figure of the Zen Patriarch as he meditated before a wall for nine years at a Shaolin temple in China (PLATE 41). Such *menpeki* figures, usually created with a single, continuous stroke of the brush, have been popular images in Zen since the Edo period when Zen Masters such as Daishin, Hakuin, and Tōrei created simplified representations of the Patriarch.[18] Shōun's teacher, Nantembō, also created single-stroke figures and in his accompanying inscription often likened their shape to the melons and eggplants of the Yamashiro district of Kyoto (see PLATE 8, page 28).

Unlike most *menpeki* images, which depict the figure from the back with a single outline, Shōun's figure is less clearly defined and the brushstroke circles around into the figure's interior. We know that the abstracted shape is Daruma because of the inscription above:

> The old wall-gazer's form
> seen from behind—
> springtime of flowers.

If we examine a smaller work of the same subject by Shōun, we see that he has utilized the same basic shape curling in upon itself (PLATE 42), but in this example he has added two eyes at the top, thereby more clearly defining the figure by enhancing the impression of a face with a frowning mouth. The inscription on the smaller image is the same haiku as on the previous scroll.

In the larger work, Shōun not only has omitted the eyes, but has approached the subject differently; the brushstroke is a bold sweep of black, punctuated by sections of "flying white" where the white paper shows through the ink. This is particularly prominent on the right side of the figure where Shōun's brush comes up and then circles inward. This "flying white," beyond adding visual interest and variety, enhances the sense of gestural en-

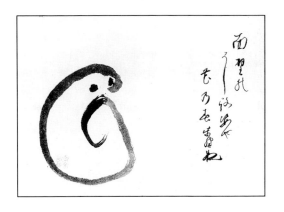

Plate 42. Shōun
SMALL DARUMA
Ink on paper, 39.1 x 52.2 cm.
Private Collection

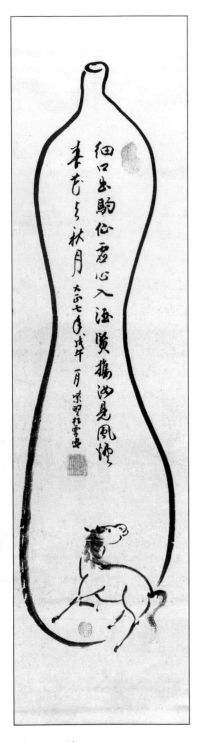

Plate 43. Shōun
HORSE AND GOURD
Ink on paper, 118.7 x 30.8 cm.
Genshin Collection

ergy. The shape of the larger figure is also more balanced and stable; it does not reveal the slightly precarious balance of the smaller image, but appears solid and stable in meditation. Without any eyes, it seems to have closed in upon itself in concentration. Thus, even in what may seem like a simple, abstracted image, the spiritual essence and power of a Zen Master is revealed, not merely in the representational subject but in a dramatic artistic gesture.

In a more light-hearted image of a large gourd containing a horse, dated 1918, Shōun reveals a more refined approach (PLATE 43). The inscription, playfully framed along with the horse by the gourd, reads:

> *Like the immortal horse coming out of the gourd,*
> *or the person who drinks freely,*
> *ultimately, in spring there are flowers*
> *and in autumn there is the moon.*

Once again, the natural opening of flowers in spring is part of the inscription. Compared with the previous work, however, the brushwork here is more detailed, enhancing the elegant shape of the gourd and the charming nature of the horse. Particularly interesting is the way Shōun has allowed the tail end of the horse to protrude from the gourd, despite the fact that the inscription refers to the horse emerging from the mouth of the vessel. The symbol of a gourd is related to the Taoist image of a magical horse, but a gourd is also used in everyday life for serving sake. The flowers and moon are also, in their own way, both common and magical.

Shōun occasionally collaborated with other artists and clergy, including the Zen nun Kōgai Gyokusen (1858–?), who seems to have been acquainted with numerous Zen figures of the day, including Nantenbō, Takeda Mokurai, Yamamoto Gempō, and Shōun. On an evocative painting of a mountain hermitage and plum trees by Gyokusen (PLATE 44), Shōun has added this inscription, dated New Year's Day, 1920:

EARLY PLUM BLOSSOMS AMONG THE FARMERS

> *Already have I welcomed in*
> *seventy-three spring seasons;*
> *I so love being a man of leisure*
> *among the rivers and lakes!*
> *The stream-side plums behind my house*
> *have just put forth young flowers:*
> *fresh fragrance of their rich perfume*
> *enters my poem, all new!*[19]

Compositionally, the gentle slope of the hillside dotted with pine trees is nicely balanced by the gnarled limbs of the plum tree as it rises upward, leading the viewer's eye to the inscription. The image is highlighted by the dots of orange pigment punctuating the plum branches.

Although little is known about Gyokusen, there are several accounts of her journeying to Ryūtaku-ji in Mishima. Accompanied by another nun named Takahashi who was in her fifties, Gyokusen, then in her sixties, visited the Zen Master Gempō, who was fifty-seven or fifty-eight years old at the time, about 1922 or 1923. Gyokusen would often talk about how she and

さ迎ハ七十三老且春江湖きる人

全陽汚楊柳吐葉活客橡神入物新

大正九季一月百柴聖松雲思作

Plate 44. *Kōgai Gyokusen* (1858–?)
PLUM LANDSCAPE
Inscription by Shōun
Ink and color on paper, 132.4 x 24.7 cm.
Chikusei Collection

Plate 45. *Shōun*
MOUNT FUJI
Ink on paper album leaf, 24.2 x 36.3 cm.
Private Collection

Takahashi had served as spies during the Sino-Japanese War (1894–1895), and Gempō once replied, "The two of you, when you went crawling around at night, walking without a sound, were like an *obi* [sash] winding round and round."[20] During this visit Gyokusen painted an image of white baby birds on a *fusuma* in the temple study. In place of a brush, she used a scrub rag dipped in ink.

On another occasion a small party was held and beer was served; Gyokusen is described as being an accomplished drinker. Gempō pointed to a young monk and said, "This is a person of great achievement now." Gyokusen then turned in the monk's direction and said, "It's not unusual for Rōshi to say such a thing. Don't let it go to your head."[21]

Gyokusen was an accomplished painter, and besides landscapes, her subjects included portraits of Daruma, light-hearted folk dancers, and, in particular, scrolls depicting monks coming and going on their begging rounds, following the tradition of Nantenbō and Deiryū. There are examples of Gyokusen's begging monks inscribed by Nantenbō and by Takeda Mokurai.

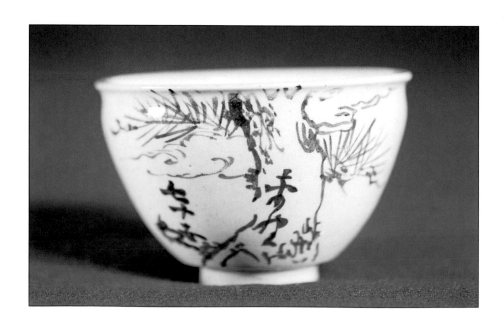

Plate 46. *Shōun*
PAINTED TEABOWL
Glaze on ceramic, 7.5 cm. tall
Gubutsu-an

One of Shōun's own landscapes, painted on an album leaf, is minimalistic but still powerfully direct in its austerity (PLATE 45). With five strokes of his brush (the descending stroke broken into three sections), he deftly reveals the shape of Mount Fuji. Since it is one of the most revered symbols in Japanese culture, there is no need for additional detail or scenic enhancement; the shape is instantly recognizable. To the left, Shōun has written an inscription reflecting more Shinto than Buddhist sentiments:

> *Above the clouds*
> *towers Mount Fuji's*
> *lofty peak—*
> *the eternal mother's form*
> *from the age of the gods.*[22]

Like other Zen Masters before him, Shōun also painted on objects including ceramics for the tea ceremony. In one example, he boldly painted an image of pine trees in blue on the surface of a teabowl, the knotted trunk rising up with needled branches outstretched, as clouds float in the background (PLATE 46). Because the inscription is signed at age seventy-five, the year he died, the painting can be interpreted as a type of final self-portrait since the image of a pine tree (*shō*) and clouds (*un*) reflects his name, Shōun.

Shōun's disciple Yamamoto Gempō later commented, "When a sick man begins to gasp out his last breath, '*Paku paku*,' I know he has little time left. . . . Monks in training have many chances to see people in their final moments. Sōhan would say to me when someone was dying, 'Please come and be in attendance; it is good for you to witness this.'"[23]

Shōun himself died peacefully on December, 23, 1922, at the age of seventy-five. The following poem was chanted at his funeral:

> *My followers appear hazy—*
> *like the moon of Suma and Maigo*
> *on a summer evening.*[24]

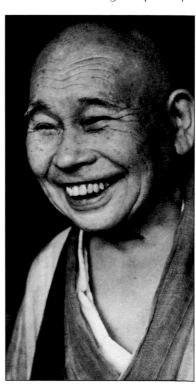

Figure 14. Gempō

YAMAMOTO GEMPŌ

During the mid-nineteenth century in rural areas of Japan, infanticide was sometimes practiced in order to relieve poor families from the burden of extra mouths to feed. According one account, the Zen Master Yamamoto Gempō (FIG. 14) was born in 1866 to a poverty-stricken family in Shingū, Wakayama, near the Yu-no-mine Hot Spring. His father had remarried, and there were already children by the first wife when the second wife gave birth to Gempō. Unwanted babies were placed in tubs and left near the hot spring overnight; the heat would become so intense that they would die. Fortunately, someone took pity on the newborn Gempō and rescued him. Then a member of the Okamoto family saw the baby and offered to adopt him since they had no children of their own.[25]

In his youth Gempō mixed with the workers and helped with the fam-

ily lumber business. His adopted father Zensō was very strict and often beat the young boy. Gempō later recalled, "How many times was I beaten by my father? I didn't understand then why he struck me with his fists, but now I am grateful to him."[26] In contrast, his adopted mother, Tomie, was very warm and compassionate, and Gempō loved her dearly. When he was eleven years old Tomie became ill, and Gempō walked the lonely mountain roads near his home carrying medicine to her. Years later he kept a calligraphic scroll hanging in his private room at Ryūtaku-ji with the single character for "mother" written on it. Even then, thoughts of his adoptive mother brought tears to his eyes.

In 1877, when Gempō was twelve years old, his adoptive mother died at the age of thirty-five after giving birth to two sons. Without the affection of his mother and now seemingly displaced in the family by two natural Okamoto sons, Gempō started down a path of dereliction. There were few amusements in Gempō's poor village, and as a result he began spending more and more time as a teenager with the men who worked for his father. Through them he was introduced to drinking, gambling, and the local red light district. His father often contributed to this behavior, sending Gempō to buy sake in town, about two and a half miles away. One day he had purchased the sake as usual and was returning home with it in a basket when he tripped on a small rock. The sake went tumbling to the ground, and Gempō crawled around trying to lick up what was left.[27] Gempō's affinity for sake continued his whole life.

In an attempt to curb Gempō's delinquent behavior, his father arranged an early marriage to a young woman named Ichi-jo when Gempō was nineteen. However, a year into the marriage, Gempō was diagnosed with an eye disease. As the disease advanced, he entered the Kyoto Furitsu Hospital in 1886, when doctors confirmed that he would eventually go blind. The following year, at the age of twenty-two, Gempō traveled to Nikkō to say a prayer to the kami at Kegon Waterfall. Deeply distressed by his condition, he then set out on a pilgrimage visiting eighty-eight holy sites in Shikoku;[28] in total, he would make the pilgrimage seven times. He described his pilgrimages, which lasted as much as sixty days: "Somehow it became cold within cold. I visited Shikoku in the cold seven or eight times. In freezing cold, in snow, I walked. I walked in warmth too. I didn't even think it was very painful. However, walking over the pebbles that paved the road in the heat affects the whole body."[29]

On his seventh pilgrimage in 1889, Gempō visited the temple Sekkei-ji in Tosa, where he encountered the priest Yamamoto Taigen, who encouraged Gempō to become a Buddhist priest. Gempō replied, "My eyes are close to blind, I can't read; how can I become a priest?" Taigen answered, "The eyes you received from your parents are part of the uncertainty of life, and someday you may not be able to see. However, the eyes of the mind cannot be blinded. Your inner eyes are not yet open, but if someday they are opened, you will see. If you cannot read, maybe you will not become a sutra-reading priest . . . but if you can give up your life, you can become a true monk."[30]

In 1890 Gempō divorced his wife and entered Sekkei-ji as a monk, taking the name Yamamoto Gempō. After staying for about one year, he spent the next few years traveling to study at different temples throughout Japan, staying at each for a year or two. He first stopped at Eigan-ji in Shiga

Prefecture, then went on to Shōfuku-ji in Hyōgo in 1893 at the age of twenty-eight. Two years later he moved on to Hōfuku-ji in Okayama, where he encountered Kyūhō Issei (1833–1916),[31] a small but fierce Zen Master. Of his attempt to gain entrance to Kyūhō's temple, Gempō recalled, "I meditated for three days and he struck me. Still, I kept trying to enter the temple, bowing politely. He said I was a stubborn fellow. I persevered, and he struck me. At that time I determined that I would work as hard as I could. Even now the pain rises up when I think of the beating. But when I think about it, I am grateful."[32]

In 1897 Gempō went to Eihō-ji at Kokeizan in Gifu. A fellow monk there described Gempō as "having a round face and frail bearing, and speaking in a calm whisper."[33] Despite his determination and dedication to training, Gempō faced unusual difficulties because of his lack of education, which was compounded by his increasingly poor eyesight. As a result, Gempō tried his best to compensate by spending his free moments under the dais of the Buddha image reading practice books and Buddhist texts with a small oil lamp and a magnifying glass. He studied the texts by looking up the characters one by one in a dictionary, slowly making progress.

> *Because I didn't have any education, I think I read the* Hekiganroku *ten times and the* Rinzairoku *one hundred times. Even in the temple, when I had free time, I would go up to the second floor of the storehouse and read. My eyes were bad and my reading wasn't very good, but I read the* Rinzairoku *many times using a dictionary to look up characters. If your eyes are good and your body healthy, you should study as much as you can.*[34]

In 1902 Taigen became ill, and Gempō left Kokeizan and returned to Sekkei-ji to tend to his Master. In June 1903 Taigen died, and Gempō succeeded him as chief priest of Sekkei-ji. Gempō immediately set out to revitalize the temple, restoring many structures, including the *hondō* (main hall) and the Great Buddha Hall. He also oversaw the construction of a Treasure Hall for the temple's artworks, many of which were designated Important Cultural Properties during his tenure at Sekkei-ji.

At this time Gempō was also invited to pay his respects to Shōun Rōshi at Empuku-ji during a meeting on national defense. He formed an immediate affinity for the Master and decided to resign from his position at Sekkei-ji and deepen his Zen training under Shōun. In order to do so, Gempō recruited a fellow monk from Kokeizan, Taigaku Oshō, who adopted the Yamamoto name and took over the duties of chief priest at Sekkei-ji.

Gempō trained at Empuku-ji under Shōun (FIG. 15) from 1908 until 1915, when he received Shōun's certificate of enlightenment at the age of forty-nine. Gempō served his Master faithfully, assisting him in all aspects of temple life.

> *When Shōun had a large meeting, I served as an attendant. There were about seven hundred people there, and we received them for twenty-one days. At that time I did everything, receiving a variety of jobs. But I was never a clerk or an accountant; because I could not write characters properly, I never was given those jobs. In general, I cooked. I knew how to cook everything. That kind of cooking was not easy, it's not like cooking a usual household meal. My body*

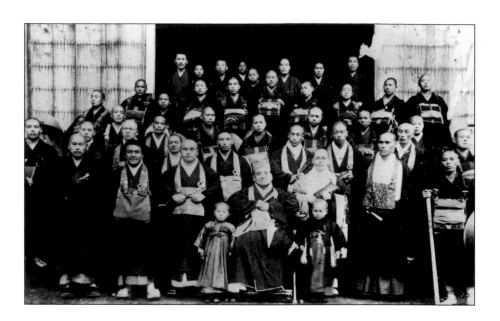

Figure 15. Empuku-ji Sōdō, with Shōun (seated center) and Gempō (second from left)

was weak, I had no education, but we all must do our share of work. Everyone does his respective job; a person who can cook, cooks; a person who can write, writes. Everyone has a strong point and does that work. Everywhere I went, I cooked. My eyes were bad, but I cooked.[35]

Some of Gempō's duties at Empuku-ji were strenuous. He was in charge of collecting the daily rice offerings for the Buddha, which meant walking more than ten miles to collect rice from seventy or eighty houses associated with the temple. He was also in charge of ordering the monks into Shōun's chamber to present their answers during *kōan* training. Often the monks were repeatedly called to present their answers with only five- or ten-minute intervals in between, not enough time to prepare new answers. As a result, many of the monks would refuse to return, wrapping their arms around a pillar in the *zendō* and forcing Gempō to whack their arms and hands with a *keisaku* (see PLATE 25, page 52) until they let go.[36] Furthermore, the winters at Empuku-ji were very cold, and at night Gempō would burrow in his bed like a mole hugging his arms. He would also wear as many socks as possible.

In the spring of 1915, Ryūtaku-ji (FIG. 16) in Mishima was in need of a resident priest, and the Zen Master Mamiya Eishū of Hōkō-ji, who began his training at Ryūtaku-ji (see chap. 6), was consulted about the appointment. Gempō was recommended for the position, and Eishū went to Empuku-ji to discuss the matter with Shōun, who voiced disapproval. Ryūtaku-ji is a small rural temple in the seaside town of Mishima, but despite its unpretentious size and location, it is historically important as a temple founded by Hakuin Ekaku (1685–1769). Despite its auspicious origins, the temple had fallen into great disrepair, which concerned Shōun, who said, "The temple is rough and the monuments are overturned. Hakuin is not there." Gempō then replied, "The temple is rough and the monuments are overturned. Because Hakuin is not there, I will go." Shōun acquiesced.[37]

Gempō formally entered Ryūtaku-ji as its resident priest in March 1915, determined to revive the temple. He began repairs on the storehouse and the study but was particularly determined to finish construction of the *zendō*. Of those early years at Ryūtaku-ji, Gempō said, "When I arrived here I had no futon. There was no bowl or tea cups to dedicate to the Buddha.

Likewise, there was no kettle. There was no tile roofing and no ridge pole. When rain fell, it leaked here and there."[38]

Gempō's gentle and virtuous nature quickly attracted many monks and lay followers, and the temple began to prosper. When the *sōdō* was opened, Gempō said, "The honest people I will entrust to others; I will aid the hussies and gamblers of the world."[39] This was a far cry from the Gempō who visited the red light district of Wakayama for pleasure in his youth.

It was at about this time that Gempō began doing calligraphy, taking lessons from a calligrapher in Shizuoka, to whom he said, "I wish to learn calligraphy and have waited a long time to start. From my youth, I have wanted to be a person who uses skill in calligraphy to help people."[40] He found great joy in calligraphy, identifying not only with how Zen writings could be used to affect people, but also with the pure activity of brushwork. He would say, "When I write *wind*, I have the feeling of becoming the wind. When I write *water*, I become water."[41]

Gempō's character for "wind" (風 *kaze*) can be seen in the inscription accompanying the image of a seated solitary figure, painted in the spring of 1953 at the age of eighty-eight on an old wooden box lid (PLATE 47). Although the seated figure might at first seem to be Daruma meditating, the inscription above reveals it to actually be Hotei, one of the seven gods of good fortune. The poem reads:

> *Longevity Mountain and Happiness Ocean,*
> *together in one bag.*
> *Demons are expelled—*
> *he laughs in the spring wind.*

The inscription reads from right to left, and the "wind" character is the final character of the fourth column. The last column contains Gempō's cipher-signature (*kaō*), which he used in place of seals. In this case, the shape of the cipher somewhat mimics the domed shape of the seated figure. Although no bag is seen in the image, Hotei is named for his ubiquitous cloth sack which can at once contain the universe and represent the void.

Figure 16. Ryūtaku-ji

Plate 47. Yamamoto Gempō, (1866–1961)
HOTEI (1953)
Ink on wood, 30.5 x 20.9 cm.
Gitter-Yelen Collection

In 1917 Gempō held a meeting at Ryūtaku-ji commemorating the one hundred and fiftieth anniversary of Hakuin's death. Shōun and Nantenbō, now at Kaisei-ji (see chap. 3), both paid their respects during the three-week meeting. Repairs on the storehouse continued, and the Zen Master Dokuzan Gengi (1869–1938) of Sōkoku-ji donated some paintings to help raise money for the project. Gempō was determined to restore the temple to a level that would honor Hakuin's achievements, and his admiration for the Master often led to humorous moments. Once, when it began to rain, Gempō called out from the *kaizandō* (Founder's Hall), "Quickly, come here!" to some monks, and asked them to put an umbrella over the statue of Hakuin.[42] Perhaps because of this respect, in 1919 Gempō was also appointed chief priest of Hakuin's main temple, Shōin-ji in nearby Numazu, while continuing his duties at Ryūtaku-ji.

In 1921, Shōun became ill, and Gempō went to Empuku-ji to care for him. Upon Shōun's death, Gempō dedicated some important works to the storehouse in a private funeral. Although Gempō was devoted to his Master and respected him greatly, some basic character differences between the two are revealed by one of Gempō's attendants who used to give him massages. "Gempō would say, 'When I was young I gave massages to Shōun every day and during those times the things he said were extremely useful [for my Zen study].' But when I gave massages to Gempō, aside from his saying it was skillful, the most wonderful sayings I received from him came just through the sense of touch from his skin."[43]

In February 1923 Gempō, now fifty-eight years old, set out on his first trip abroad. He traveled alone without an interpreter and as a result experienced a few mishaps. In Honolulu he was arrested as a beggar and taken to the police station, and when he crossed the United States by train, because he could not communicate to order food, he simply fasted for three days. A flier summarizing the ideals of the Ku Klux Klan, which someone handed him, also made little impact. Gempō carried a letter of introduction with him, but because he had to meet so many people, he kept the letter attached to his sleeve with a string, and as soon as someone was finished reading it, he reeled it back in and returned it to his purse. He did not learn any English for the trip, only learning to sign his name, "G. Yamamoto," in order to endorse checks given to him as payment for talks during his travels. In a telegram that he sent back to Ryūtaku-ji, he said:

> *Sunday after riding the train, I rode a bicycle around town to work and to the store where you look at everything through glass cases. No one lives in the store, that is the American style. These days, bugs eat everything, so the goods are covered and you must ask to see them.[44]*

Next he traveled to England where he attended a conference in Birmingham at which he lectured on "World Peace and Buddhist Studies." He then returned to Japan by ship. During the journey a commemorative banquet was held on board; everyone was asked to inscribe the guest book, but Gempō refused despite everyone's encouragement. When asked why, he said, "Don't you know? Since old times Buddhist priests and geisha do not give their addresses. If their addresses were known, geisha would certainly have too many visitors, and priests would have to carry an appointment book." Everyone laughed.[45]

Later that same year the Kantō earthquake devastated Ryūtaku-ji, causing large-scale damage to many structures; the *hondō* in particular suffered greatly. Up to that time the *hondō* had had a thatched roof, but grass would have be bundled by hand to replace it, and there was no time for that. Tile was considered to be too breakable, so Gempō decided to have a copper roof installed, and his resourcefulness was greatly admired. That year also marked the one hundred and fiftieth anniversary of Tōrei Enji's renovation of Ryūtaku-ji.[46] A large commemorative meeting was held at the temple, and Seki Seisetsu (see chap. 6) and Takeda Mokurai (see chap. 3), among others, donated paintings and calligraphies that were exhibited and thereupon sold at a Tokyo department store.

Two years later, in 1925, Gempō, now age sixty, set out on another pilgrimage, this time to Buddhist sites in India. A lay follower asked to accompany the Rōshi and offered to pay for all of their expenses. Despite the financial assistance and the fact that an attendant might prove useful for the near-blind Gempō, he did not believe it would be a good idea. His physical limitations notwithstanding, Gempō's independent spirit and affinity for personal journeys, which had developed at an early age, prevailed. He remarked, "If I'm alone, I have the freedom to go wherever I want; if I'm burdened by an attendant, it would be a mistake."[47] This affinity for solitude, at least during his pilgrimages, was deeply embedded in Gempō's nature. From his journeys around Shikoku in his twenties to his pilgrimages abroad later in life, he seemed to prefer traveling alone. He captured this feeling in an image of a lone figure walking with a long staff (PLATE 48). The inscription reads:

I walk to where the waters end.

This is a line from a verse by the Chinese poet Wang Wei (699?–761). The figure is believed to be Gempō's self-portrait, and it is possible to gain a sense of his gentle nature and deep spirit from the simply drawn but richly moving image. As a man who not only maintained a strong affinity for pilgrimages throughout his life, but also chose to experience them alone, this depiction of a slightly hunched figure leaning on a long staff reveals how Gempō may have viewed himself. The composition and brushwork feature gentle curves in the top of the staff, the sleeve of the robe, and the round head, contrasted with terse strokes used to delineate the feet, bottom of the staff, and the figure's waist.

Gempō's trip to India had a great effect on him, and upon his return to Ryūtaku-ji he built a Treasure Hall that featured Indian influences. Becoming more famous, over the next few years Gempō was appointed chief priest or abbot of several other temples while maintaining his position at Ryūtaku-ji. In 1932, Gempō lectured at a *sesshin* in Tokyo; in attendance was a young monk named Nakagawa Sōen (1907–1984), who later went to hear Gempō lecture on the *Mumonkan*. Seated directly in front of Gempō, he felt he was being addressed personally when Gempō said, "If you practice, it must be genuine practice; if you get insight, it must be true insight."[48] Two years later, on January 29, 1935, Sōen wrote in his journal:

It has been said, "It is not that there is no Zen in Japan, but that there is no Zen master." In the past I was repeatedly disappointed in my search for a true

行到水窮處

teacher, but recently I vowed to practice to the death in the hall of Gempō Ya-mamoto Rōshi."[49]

What were Gempō's primary teachings? In his lectures on the *Mu-monkan,* he wrote:

> *The mind runs here and there, thinks of hot and thinks of cold, dislikes this and likes that. By yourself, just cut off this road the mind is running along; just one time, experience the great death. When you cut off the road of the mind, the eighty-four thousand delusions will gush out fiercely. If you can do this just one time, everything becomes your ally. Delusions, evil passions, foolishness, self-denial all vanish. Everyone becomes your supporter, and every substance becomes protected. But if you cannot do this, because of delusions and passions you won't recognize your own ghosts, and your life will pass by like a blur.[50]*

Gempō also captured the essence of this idea, of breaking away from the numerous avenues the mind runs along between passions and delusions, by simply writing in a teabowl the words "One mind" (PLATE 49).

The bowl was made in Inuyama, where Gempō was priest of Zuisen-ji. On the interior surface of the simply potted bowl, Gempō has written the two characters in rich iron glaze, revealing a forcefulness and determination usually denoting his later works, although this bowl is not dated. The tips of the characters are open (the brush has not turned back over the line to form a neat, rounded tip), enhancing the gestural quality of the brush, but a balance of proportion is maintained in the way the two characters fit together within the well of the bowl, as if the "one" (一) character is sitting on or covering the "mind" (心) character.

In 1933 Gempō became abbot at Kakuōzan in Nagoya, and in 1934 abbot of Shōju-an in Nagano. Then in June 1935 Gempō traveled to China alone to attend the Japan-China Buddhist Study Association meeting to promote better relations between the two nations. However, before his labors could be rewarded, conflict between the two countries emerged. Amid this political strife, Gempō traveled to Manchuria in July of the following year, at the age of seventy-one, to open a branch temple for Myōshin-ji in Manchuria's New Capital.

Although the commissioned officers and Japanese civilians in Manchuria felt they were sincere in their motives, Gempō maintained his belief in trying to bring spiritual and cultural understanding to all; as a result, he promoted antiwar beliefs to the Japanese officers he encountered. He also did his best to promote a better understanding between Japanese monks and their Manchurian counterparts.

Once, while on begging rounds in the town, he paid a visit to the Manchurian Buddhist temple, Hannya-ji. It happened to be mealtime, and although language was a problem, through various gestures he was escorted into the dining hall, where he joined the Manchurian monks for a meal. After this, the head of Hannya-ji was invited to the Myōshin-ji branch temple several times for meals. Gempō spent the next few years dividing his time between Japan, Korea, and China until he finally resigned his abbotships at both the temple in Manchuria and at Shōju-an in Nagano.

As Japan's nationalistic sentiments grew, Gempō tried to balance his

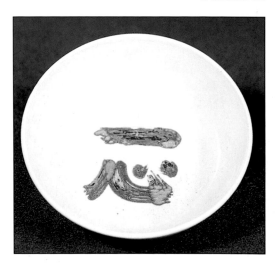

Plate 49. Gempō
INSCRIBED TEABOWL
Glaze on ceramic, 4.7 cm. tall
Gubutsu-an

support for his country with comforting the devastated victims around him. To this end, many of the calligraphies he wrote at this time were prayers to keep people safe. Gempō had always had a compassionate and charitable nature; once when he was young he took pity on someone who was collecting funds for an orphanage and gave him a considerable amount of money. When his father found out, he scolded him and, as punishment, demanded that Gempō make ten pairs of straw sandals. Years later, during the Great War, Gempō opened all the rooms of Ryūtaku-ji to people displaced by bombing raids; saying, "After a fire, footwear is a problem," he could be found seated in the Ryūtaku-ji garden making sandals and distributing them to the victims. It was like reliving his childhood experience.[51]

Government officials also often came to Gempō for insight. These visitors included Prime Minister Suzuki Kantarō (1867–1948), who paid his respects to Gempō after the war, and to whom Gempō said, "Speaking in sumo terms, Japan is an ōzeki [champion], but even an ōzeki should accept defeat like a champion."[52] He concluded, "We must endure even what is most difficult to endure."[53]

Gempō also seems to have played a role in the planning of Japan's New Constitution in 1946. During the writing process, when the cabinet ministers were deliberating over several drafts of the constitution, Narahashi Wataru, Chief Secretary of the Ministry, decided to visit Gempō.

> At that time I was discouraged, so I went to Yamamoto Gempō for suggestions. I called on Ryūtaku-ji, but Gempō had gone to the hot springs, so I rode a bicycle to the hot springs and found Gempō in a ryokan under a foot warmer with a bottle of sake. As soon as I entered the room he said, "There is a problem with the Emperor, isn't there?" Then he said, "I think the internal disputes will not end as long as the Emperor has an interest in government and political power. What can be done? We have received the Emperor's proclamation [stating that he was not divine], but there are still groups asserting his power. If he is removed from government, his great spirit will be like the sun rising and brightening the sky. If a compassionate person governs with care, and the Emperor is present [as a symbol], then can't we have a true democracy? The Emperor should therefore be like a shining symbol in the sky." I was extremely inspired and presented this plan to my superiors.[54]

In 1947, at the age of eighty-two, Gempō was appointed abbot of Myōshin-ji. He accepted the position by saying he would hold it for only one year, but he maintained it for two years. His inaugural address lasted for thirty seconds. "From my youth I have been mostly blind, so from blind and deaf, best wishes!"[55]

Despite his exalted position as the head of the Myōshin-ji sect, Gempō maintained the demeanor of a country priest. One day, the temple monks laid out a nice new pair of geta (wooden slippers) for Gempō. But when he emerged from his private quarters after a meeting with the temple's financial advisor, he was wearing old, worn-out geta. Then the financial advisor emerged, wearing the new ones. Gempō promptly said, "As the financial officer, indeed he has nice geta!"[56]

Gempō finally turned over the position of resident priest of Ryūtaku-ji in 1951 to his dharma heir, Nakagawa Sōen, and retired at the age of eighty-six. Two years later, on April 12, 1953, a large celebration was held to celebrate his eighty-eighth birthday, an auspicious occasion known as the

"rice year" in Japan because the characters for "eighty-eight" (八十八) can be combined in a manner to resemble the character for "rice" (米). Four hundred monks attended the celebration, and Gempō wrote a huge *kotobuki* (long life) character to mark the occasion.

In 1955, at the age of ninety, Gempō wrote the single-line calligraphy "White clouds embrace the hazy rock," a line from a poem by the Chinese T'ang dynasty (618–907) poet Hanshan (Japanese, Kanzan).[57] In contrast to many of Gempō's calligraphies, particularly those done in his eighties, this later work reveals a more solid, bolder approach to brushwork (PLATE 50). All the characters reveal at least one heavy, broad stroke, even if it is just the top dot above the otherwise wispy and floaty "cloud" (雲, second from the top) character, which Gempō writes in a loose, cursive style to resemble the drifting movement of a cloud. In contrast, the last character, "rock" (石), is bold, sturdy, and solidly square with its heavy brushstrokes.

In his later years, Gempō's calligraphy often showed this more pronounced, bolder style of brushwork, which strongly contrasted with his charming, light-hearted images. Suzuki Sochū, former abbot of Ryūtaku-ji, once commented that because of his near-blindness, Gempō "wrote on paper like he was carving into stone";[58] in other words, very deliberately. Sochū also described Gempō's calligraphy as resembling bent nails, a calligraphic term meaning having a wiry internal strength. Gempō himself wrote in his journal, "My characters may look like bent nails, but they perfectly adorn the *tokonoma* [alcove]. If a calligraphy hung in the *tokonoma* is inferior, it will die."[59]

Gempō's calligraphy is highly individualistic and easily identifiable. His works reveal a playfulness and freedom of movement that allow his characters to move across the paper joyfully. In East Asian culture, calligraphy is regarded as a reflection of one's true nature, so the joyfulness must reflect Gempō's personality. It is also possible that because of his eye disease, and because he began practicing calligraphy relatively late in life, that he was able to approach it not as a technical skill with formal rules, but as a process in which he sought to capture the essential shapes of the characters without worrying about formalities. As a result, in general the tips of his characters are left open, contributing to the visual sense of movement, openness, and playful abandon. His brushstrokes tend to be unmodulated but possess a round, sweeping quality that causes the characters to tilt and dance.

Because of his lack of education and poor vision, Gempō never took for granted his ability to do calligraphy. Not only did he use it to help and inspire others, he also never demanded fine materials. If there was no good paper around, he was just as happy to write on newspaper, or on any small scrap of paper available, taking just as much care with each character. When one of his assistants mentioned that he wanted to study calligraphy because his writing was awkward, Gempō said, "To become skillful at calligraphy, you can start at any age. You need not be young to become good at calligraphy."[60]

Gempō responded to requests for his calligraphy cheerfully. For the cleaning shop near the entrance to Ryūtaku-ji he answered a request and wrote "House for Washing the Heart," saying, "They are kind to always wash my robes. Not only my robe, but it is also like washing my heart."[61]

For Gempō, calligraphy and painting were a cheerful way to reply to and connect with others. Just as Hakuin utilized numerous subjects as a

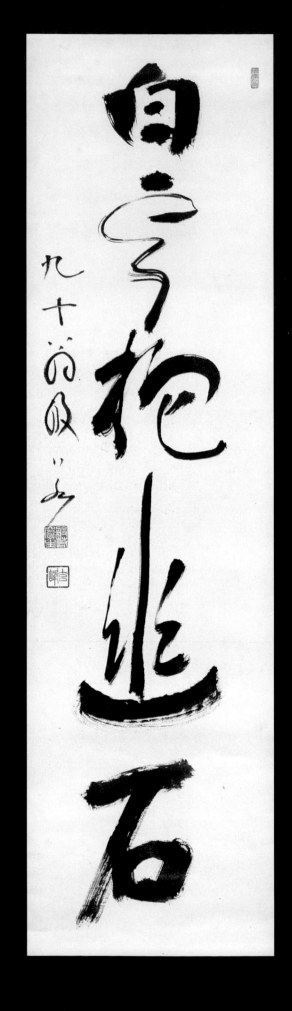

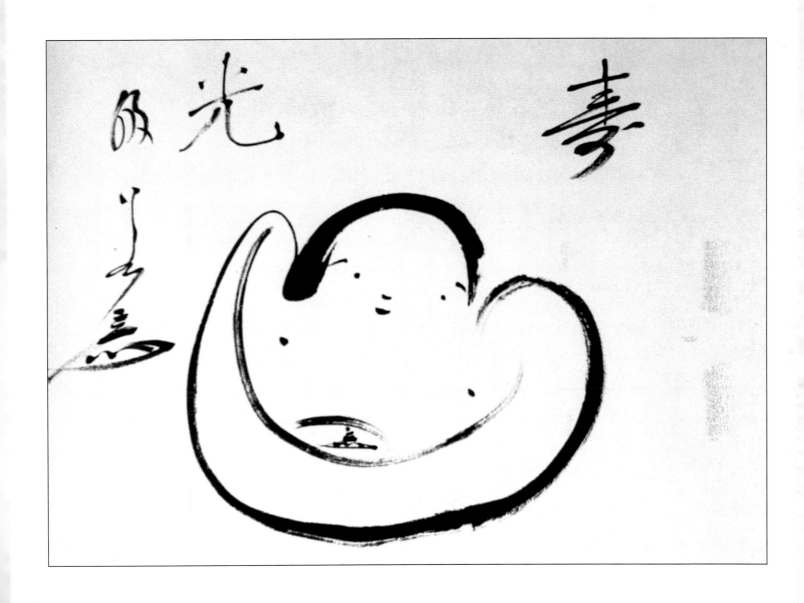

Plate 51. Gempō
BABY
Ink on paper, 33.5 x 45.3 cm.
Hōsei-an Collection

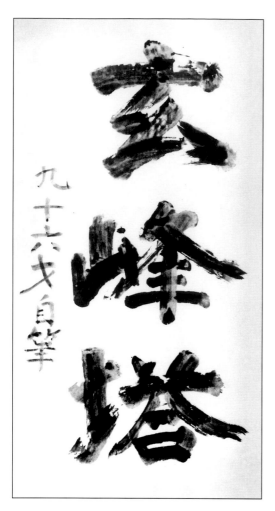

Plate 52. Gempō
GEMPŌ STUPA (1961)
Ink on paper
Ryūtaku-ji

means of approaching people from all walks of society, Gempō too used his art to reach everyday people. In times of war, he wrote out prayers, and when a parish family had a baby he would paint a happy figure of a baby and inscribe it with the characters "bright" (光) and "longevity" (壽) in celebration (PLATE 51).

Although slightly more complex than the images of the walking figure and Hotei, the baby maintains Gempō's affinity for broad curving lines. The great sweep of the bottom line and the inner semicircle, as well as the gesture shaping the baby's head, enhances the sense of movement of the baby rocking with great happiness. Although he uses only tiny dots to create the baby's face, the spacious quality also adds a sense of openness and delight.

Gempō has included his cipher-signature not only to the left of the image, but also inside on the baby's belly. In contrast to the rather solemn, solitary quality of the walking figure, or the serenity of Hotei, this baby reveals the wonder and joy for which Gempō was noted despite the hard times and misfortunes that beset his life.

In 1957 Gempō's portrait was painted by Yūki Somei, and Gempō added the inscription:

Inside the cave of Great Wisdom
As always barred by a gateless gate
The days and months are passing by
And I endlessly mix with sentient beings.[62]

In December 1960 Gempō suffered a heart attack and was confined to bed. He said, "My body has managed to use up ninety-five years. I have already exhausted my allotment of life."[63]

In a journal entry for spring 1961, Sōen wrote:

At the age of ninety-six, Gempō Rōshi is still vital. He has probably signed his name, "Hannya" [Sanskrit, prajna, wisdom] more than eighty-four thousand times. The poetic theme given by the emperor to this year happens to be "Youthfulness." I am celebrating the true body of that which is before birth and beyond old age by whisking tea in a bowl on whose surface Gempō Rōshi wrote "Youthfulness," and on whose exterior he wrote "old age."[64]

The following year on May 12, Gempō called to his attendant and said, "Not much longer," and asked for his writing materials. Ten sheets of paper were laid out, and he started to write. "Not very strong," was his reaction to his brushwork, and he put the brush down.[65] Two days later he wrote, "Gempō Stupa, age ninety-six, self-brushed" (PLATE 52). In his journal entry of August 1975, Sōen Rōshi recalled this event:

On the morning of May 16, 1961, nineteen days before his passing away, I visited Gempō Rōshi, who was convalescing at the hot springs of Takekura. He crawled out of bed and said, "Give me a brush." We students were flustered, and in consideration of his condition, we put one table on top of another and spread paper out for him. He said, "In that position, I don't have the strength to transmit my energy. Please take away the tables." He sat formally on the floor, as usual, and with the breath flowing through his entire body, he inscribed three large characters. He had been asked to write the character for "birthplace," to be used on a stone to mark his native village at Unomine in

Kumano. But instead, he wrote "Gempō's stupa" for his tombstone. Total birth, total death—Gempō Rōshi vanished into vast space at age ninety-six.[66]

Gempō had wanted to die during a beautiful time of the year when it was neither too hot nor too cold. Once he reached the age of ninety, every spring when the weather became mild he would say, "The curtain is descending on the floating world *kyōgen* [comedy]," and he would stop eating and drinking. This would distress the monks, who tried to coax him to eat. Finally, a monk raised a glass of water and said, "This time too the curtain is going down." Gempō smiled and drank the water. During his final spring, three days before he died, Gempō again began to fast.[67]

Gempō passed away on June 3, 1961, at 1:25 in the afternoon. The *Asahi Shinbun* newspaper reported that three thousand people attended his funeral, including many foreigners. In September 1962, the stone monument carved with his final calligraphy was erected at his birthplace, Yu-no-mine Hot Spring in Wakayama. Thirteen years later, on the anniversary of Gempō's death, Sōen composed these poems:

Born deep in Kumano Province
poling a raft and digging tree roots
 he was almost blind
but through a mysterious unfolding
his true eye was opened.

Just now, just a person
just a free ride
 just.[68]

Gempō often said, "Monks are like *shōji* paste." Asked why, he replied, "Whatever sect of monk, if the paste is missing, the frame and paper will separate, and such a monk cannot perform his duty. However, seen from outside, you can't tell if the paste is there or not. A monk, like the *shōji* paste, helps people in their difficult times. We must work for everything and everyone to achieve harmony."[69]

THREE SŌTŌ ZEN RESPONSES TO THE TWENTIETH CENTURY

Nishiari Bokuzan (Kin'ei, 1821–1910),
Taneda Santōka (1882–1940), and
Kojima Kendō (1898–1995)

— STEPHEN ADDISS

ZEN IN JAPAN is divided into three major traditions: Rinzai, Sōtō, and Ōbaku. The first two came from China in the late twelfth and early thirteenth centuries, while Ōbaku did not arrive until the immigration of Chinese monks in the middle of the seventeenth century. Ōbaku monks consider themselves part of the Rinzai tradition, which emphasizes intense *kōan* practice leading toward sudden enlightenment. Sōtō Zen, in contrast, puts more emphasis on *zazen* for its own sake.

Considering that so much Zen painting and calligraphy has been created by monks of the Rinzai sect, including all the works in this book outside this chapter, it may come as a surprise that Sōtō is the largest Zen sect in Japan. Why, then, have Sōtō monastics not created more works of art? There are several possible answers to this question, one being that Sōtō temples tend to be situated in rural areas where there has been relatively less interest in painting and calligraphy. In contrast, many Rinzai temples are located in larger cities that provide a more active and sophisticated artistic environment. For example, at the tea ceremony a scroll is often hung in the *tokonoma* alcove, with Zen works being considered especially appropriate. Since tea gatherings most often take place in or near cities, works were often requested from Rinzai monks by tea masters of various schools; this led to artistic traditions that have continued for hundreds of years.

The fact that there are fewer Sōtō temples in major cities also tends to obscure the fact that many Sōtō Masters did create *zenga*, most often calligraphy but sometimes also painting. In this chapter, the works of three Sōtō monastics will be examined, demonstrating both the depth and the great variety of Sōtō Zen practice and art. Bokuzan worked at the turn of the century to strengthen the Sōtō sect at a time of great change, Santōka was a solitary poet on constant pilgrimage during the next several decades, and Kojima led the way for equal treatment for female monastics later in the century. Before discussing them, however, some major features of the Sōtō Zen tradition should be briefly introduced.

While there are several early Japanese Rinzai Patriarchs of great importance, the Japanese Sōtō tradition has one towering figure, Dōgen (1200–1253), who not only founded the sect in Japan but also set the standards that have generally been maintained to the present day.[1] Dōgen's writings are voluminous and deal with everything from deep and complex questions of religious experience to rules of behavior for monastics when eating or going to the bathroom.[2] Primary among his teachings, however, was the importance of meditation:

> *The most important point in the study of the Way is* zazen. *Many people in China gained enlightenment solely through the strength of* zazen. . . . *Therefore, students must concentrate on* zazen *alone and not bother about other things. The Way of the Buddhas and Patriarchs is* zazen *alone. Follow nothing else.*[3]

> *Setting everything aside, think of neither good nor evil, right nor wrong. Thus, having stopped the various functions of your mind, give up even the idea of becoming a Buddha. This holds true not only for* zazen *but for all your daily ac-*

tions....Think of nonthinking. How is this done? By thinking beyond thinking and nonthinking. This is the very basis of zazen.[4]

One important point in Sōtō Zen is that *zazen* itself is considered a form of Buddhahood, or as Dōgen wrote, "training encompasses enlightenment."[5] Therefore one does not sit in *zazen* as a means of reaching enlightenment, but rather as a form of *satori* itself.

> Zazen *is not "step-by-step meditation." Rather, it is simply the easy and pleasant practice of a Buddha, the realization of the Buddha's wisdom.....To practice the Way single-heartedly is, in itself, enlightenment. There is no gap between practice and enlightenment or* zazen *and daily life.*[6]

This idea that practice *is* enlightenment was crucial to the development of the Sōtō sect in Japan. It led to the emphasis on "silent sitting" that was not bound to the purpose of attaining enlightenment but constituted a "Way" of its own, complete unto itself. What then of the world around us? Dōgen wrote a classical five-line *tanka* that expresses his view of its impermanence in a highly poetic vision:

> *To what*
> *can I compare this world?*
> *A waterbird's beak*
> *touching moon-shadows*
> *in a drop of dew.*[7]

If the world is this ephemeral, what is our own place within it? Dōgen ties together the self, moving beyond the self, and true realization of the world around us in two remarkable passages:

> *To study the Way is to study the self. To study the self is to forget the self. To forget the self is to be enlightened by all things. To be enlightened by all things is to remove the barriers between one's self and others. . . .*

> *At that time everything in the universe—whether earth, grass, tree, fence, tile, or pebble—functions as a manifestation of enlightenment; and those who receive the effects of this manifestation realize enlightenment without being aware of it. This is the merit of nondoing and nonstriving—awakening to the Bodhi-mind.*[8]

NISHIARI BOKUZAN

Dōgen's writings are extremely extensive and have served as the primary teachings of Sōtō Zen in Japan to the present day, although there have been times when his influence has slowly waned, only to be revived again by major Sōtō Masters of later centuries. The leading monk who studied Dōgen deeply in the later nineteenth and early twentieth centuries was Nishiari Bokuzan, also known as Kin'ei, whose editions of Dōgen writings are still current.

Born in Aomori Prefecture to a family named Sasamoto, Bokuzan was adopted by the Nishiari family as a child.[9] However, the family unexpectedly had a son of their own, so Bokuzan left, never to return. Learning

young about the inconstancy of life, he entered the temple Chōryō-ji at the age of nine (by Japanese count) and served as an attendant for seven years to the monk Konryū. When Bokuzan was nineteen, Konryū retired, so the young monk moved to Shōon-ji in Sendai, where he studied under Etsuon; two years later he continued his studies in Edo (Tokyo) at Kichijō-ji. Continuing to practice under leading masters, at twenty-two he studied with Ansō Taizen of Hon'nen-ji in Edo and received his *dharma* transmission. Although Bokuzan served as abbot of Hōrin-ji in Edo, he continued to seek out teachers, studying with Guzen at Kichijō-ji in Edo and gaining his *dharma* transmission in 1849. The following year, Bokuzan returned to his native village to visit his mother, who welcomed him with great warmth. He then continued on to Kaizō-ji in Sagami, where he heard a lecture on the meditation sutra *Ryōgon-kyō* from Gettan Zenryū and had a powerful enlightenment experience, which Gettan acknowledged.

Upon the completion of his training, Bokuzan served as abbot of several different Sōtō temples, becoming a Zen Master at the age of forty-four when he relieved Gettan, who had become ill. However, as has been mentioned earlier, Buddhism experienced a crisis during the Meiji period (1868–1912), since it was considered a "foreign religion" as compared with Shinto, and therefore lost its primary government support. Bokuzan was one of the monks during this turbulent period who worked to revive and strengthen Sōtō Zen. Since he had developed a reputation as an outstanding scholar-monk, he was one of three monks given responsibility for the Sōtō Education Bureau in Tokyo in 1872, and he advanced in ranks and responsibilities as the Sōtō sect adjusted to the new governmental regulations.

In 1873 Bokuzan, along with several senior monks of the Rinzai sect, protested a new directive that monks should wear everyday clothing. Arguing that the Buddhist tradition would suffer, they succeeded in overturning this decision. Furthermore, aware that the new national focus upon education would be a major factor in the changes that Japan was undergoing, Bokuzan devoted much of his time to Buddhist teachings. He gave a series of successful lectures in Tokyo, and became the Assistant Director of the Sōtō Educational Bureau in 1874, Associate Director the following year, and Director in 1883. During this time he also continued his temple activities, especially after 1875 when he was appointed abbot of Hōkō-ji in Mutsu.

It seems that Bokuzan was involved in almost all the major movements taking place in Japan at this time. For example, in the early Meiji period there was a concerted effort by the Japanese government to control and develop the northern island of Hokkaido, so Bokuzan traveled there to oversee the development of Buddhist education. He so impressed the government envoy Miyamatsu Honjūrō that he was given a large plot of land, upon which he organized the building of a temple that is now known as Chūei-ji.

As a leading Buddhist cleric, in 1876 Bokuzan had an audience with the Emperor at the temporary Imperial headquarters in Aomori, and two years later he was granted another audience. The year between these prestigious occasions, Bokuzan moved to Kasui-sai in Tōtōmi, where he built a Buddhist school in 1881 called Manshō Gakkō (School of Ten Thousand Pines). Continuing his rise in the Buddhist hierarchy, Bokuzan was granted the right to wear the Yellow Robe of honor in 1886. However, he never lost his understanding of the transience of all worldly matters, including success and honors, which is very clear when we examine his art.

Bokuzan did both Zen painting and calligraphy; what might we ex-

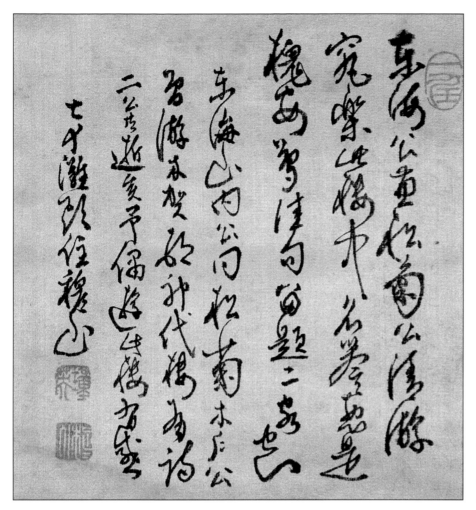

Plate 53. Nishiari Bokuzan (1821–1910)
SMALL POEM
Ink on silk, 18.2 x 16.7 cm
Private Collection

pect to see in the works of such a scholar-monk? One example of his calligraphy seems both modest and scholarly, since it consists of a poem and prose inscription written in small size on silk (PLATE 53). Yet this scroll exemplifies Bokuzan's inner feelings as he faced a changing Japan, seeing underneath the changes some age-old truths. The inspiration for this work came in 1890 when Bokuzan, age seventy, visited a pavilion in Ryōga where two verses were inscribed. The poets were Yamanouchi Yōdō (Toyoshige, 1827–1872) and Kido Takayoshi (1833–1877), both of whom had been major figures in the Restoration of the Meiji Emperor.

Moved both by the beauty of their poems and by the evanescence of human life, Bokuzan wrote his own quatrain that alludes to a famous Chinese story. This tale, by the T'ang-dynasty author Li Kung-tso (c. 770–c. 848) recounts that an official fell asleep under a locust tree and dreamed of a life in which he found fame, fortune, and marriage while he governed a southern province. When he woke up, he noticed that under the "southern bough" of the locust tree there was a busy anthill. This colony of ants had been his dream world.

The idea of another reality within a dream was not new in China. Li Kung-tso's story was based upon an earlier tale by Shen Chi-chi called "The World Inside a Pillow," which itself harkened back to the Taoist sage Chuang-tzu dreaming that he was a butterfly. When he woke, he wondered if he was really Chuang-tzu, or just the butterfly now dreaming it was a person?

All these tales emphasize the transitory and illusory nature of what we regard as reality and provide the focus of Bokuzan's poem and commentary:

His Excellency of the Eastern Sea and His Excellency
of Chrysanthemum and Pine
Once serenely visited this pavilion,
experiencing complete joy!
But true it is that reputation
is a "Dream of Locust Peace"
Their lovely lines remain inscribed,
but they have disappeared.

> —His Excellency of the Eastern Sea, Yamanouchi, together with His Excellency of Chrysanthemum and Pine, Kido, once visited the Pavilion of the God's Substitution at Ryōga Village and wrote poems. The two gentlemen are both deceased. I have now happened to visit this pavilion, and I have been moved. Bokuzan, 70 and residing beside the sea.[10]

The underlying theme of the poem, that earthly glory is fleeting, has long been a Buddhist truth, but it would have had a special meaning to those living during an era of such great disruptions in Japan. For their roles in the Meiji Restoration of the Emperor, Yamanouchi Yōdō and Kido Takeyoshi were considered great heroes. Yet by the year 1890 when this scroll was created, they had both been dead for more than a decade, and all that remained of their glory for Bokuzan to experience was the poems inscribed in the pavilion. Similarly, when we now view the poem and calligraphy by the Zen Master, we may well ask, where is the reality in this locust dream?

The scroll itself is written in running-cursive script on high-quality silk, with the poem occupying the first three columns, the commentary the next three (slightly indented from the top), and the signature the final line. Bokuzan's calligraphy is bold and confident, creating a sense of motion with the characters sometimes tilting to the right or left. The medium of silk allows the ink to fuzz, most visibly on the first character, softening the otherwise intense rhythm of curved and angular strokes. At the end of the third column, the final character of the poem (空 empty, disappeared) is larger and set off to the left, giving it extra emphasis. This character also shows Bokuzan's typically forceful hooking stroke that appears dynamically in many of his works of painting and calligraphy. Although this poem is small and seemingly quiet, upon close viewing the ink seems to be emblazoned into the silk, and each stroke of the brush demonstrates the sense of disciplined energy and inner conviction that marks Bokuzan as a Master of both Zen and visual art.

Bokuzan did not let his understanding of transience deter him from his responsibilities in the changing aspects of religion in Japan. In 1892 he became the Tokyo representative of Sōtō Zen, receiving the appointment to manage the offices of the sect from the Interior Minister of the Meiji government. That year he officially retired from temple duties, giving him more time for scholarly writing in order to strengthen Buddhist teachings during an age strongly committed to education. For this purpose he turned to the words of the Japanese founder of the Sōtō sect, Dōgen. Although Bokuzan wrote many books during his long life, the study of Dōgen's magnum opus, *Shōbōgenzō*, was his major task. In 1896 he published the *Shōbōgenzō shiki* (Private Record of the *Shōbōgenzō*) and the *Shōbōgenzō kōgi* (Lectures on

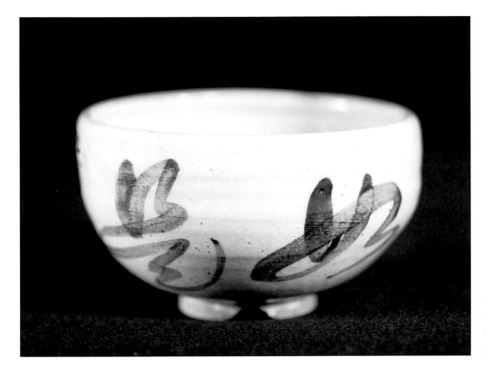

the *Shōbōgenzō*). These books, along with his *Shōbōgenzō keiteki* (An Explanation of the *Shōbōgenzō*), remain important sources for both Dōgen's thought and the study of Sōtō Zen.

Although Bokuzan had retired, in 1900 some of his followers resolved to build a temple in Yokohama in his honor. They named it Saiyū-ji, using a Chinese-style reading of his family name Nishiari as Saiyū. He was persuaded to become the official founder of the temple, but the following spring, at the age of eighty-one, Bokuzan could not refuse the request to become the third abbot of the headquarter Sōtō temple Sōji-ji in Ishikawa. In honor of his achievements, on June 19 of that year he was given the honorary Zen title of Jikishin Jōkoku Zenji (Honest Heart Pure Nation Zen Teacher). In 1902 Bokuzan was elected to a two-year term as *Kanchō* of the entire Sōtō sect, a position to which he was reelected in 1904. That June he was given the first chair at an all-Japan Buddhist Education conference, but in December, feeling the press of his years, he resigned as Sōtō *Kanchō,* and the following February he also withdrew from Sōji-ji, retiring to Saiyū-ji where he spent his final five years.

During his final retirement, Bokuzan continued his painting and calligraphy. For a scholar-monk, the poem he had written in 1890 with its references to the Chinese past might be expected, but an inscription on a teabowl by a monk in his late eighties must seem more unusual (PLATE 54). Yet this inscription is perhaps even more meaningful, because it proclaims a fundamental Zen two-word phrase: "like this!" (如是). This inscription, which can also be translated "just this," along with the dynamic quality of this calligraphy, makes clear that Bokuzan was not merely a scholar but also a Zen Master. He has written the two characters in underglaze blue with bold curving brushwork in fully cursive script—the first word is written with two strokes and the second with a single stroke of the brush. Not shown in the illustration, to the left of the inscription is his signature in underglaze iron-brown, "Written by Bokuzan, formerly of Sōji-ji." The bowl itself was made in Oribe style, with a rich green glaze covering one section of the pitted and crackled white glaze over light brown clay.

What does "like this!" or "just this!" mean? There are several Zen stories from China that relate to this phrase. In one, Dongshan asked Yunyan, "After your death, if someone asks me if I can describe your reality, how shall I reply?" After a while Yunyan said, "just this is it." In another story, the Master Yantou said "If you want to know the last word, just this is it."[11]

Taking this one step further, when asked a cosmic question about the Buddha, one eminent Chinese Master replied, "Have a cup of tea." In this way Zen is different from many religions that emphasize life in the hereafter; "just this' is all you get, say the Masters. Dōgen, whom Bokuzan studied so extensively, wrote that "'like this' is the body-mind of right now."[12] This sense of the ordinary as potentially extraordinary has animated much of later Japanese culture, including haiku poetry, flower arranging, garden design, ink painting, and tea. All of these arts combine a sense of nature, an intensity of focus, practice rather than intellection, and an appreciation of empty space in which that which cannot be said and cannot be shown—can exist.

There are other reasons why Zen Master Bokuzan inscribed a teabowl. We may now consider *cha no yu* (usually translated as "tea ceremony") as a formal and complex discipline, but at its heart it is nothing more than heating water and drinking tea. In Zen, as in tea, discipline is essential in learning how to quiet the mind, not to construct an identity, but rather to strip away illusions. We are told that when sitting, just sit; reading a book, just read; the world is constantly changing, so there is no immutable self, past or future. What is left? Just this!

A third work by Bokuzan, *Three Buddhist Jewels* (PLATE 55), has the inscription: "*Fukuju nyoi!*" These four characters have three possible translations:

Happiness and longevity as you wish!

Happiness and longevity scepter!

Jewels of happiness and longevity!

The key two-character word *nyoi* literally means "as one wishes" but can also mean a scepter, about fifteen inches in length with a slight S-curve. It is usually carved from jade, bamboo, or wood, and is said to resemble the mushroom of immortality. This scepter was originally carried by Taoist adepts and then became a symbol of Zen Masters; they sometimes brandish it during their public teachings and occasionally may also find it useful to whack a disciple who is just . . . not . . . getting . . . it. In Buddhism, the *nyoi* also has wish-fulfilling connotations, especially because with one more character added it becomes the *nyoi-ju*, or wish-giving jewel, called *cintamani* in the original Sanskrit. (See PLATE 37, page 78, for an example by Mokurai.)

In some forms of Buddhism, as in other religions, people pray for their wishes to be fulfilled, and this jewel is revered as a symbol of good fortune. But what about Zen? For those not expecting anything beyond "just this," what can the Buddhist jewel mean? Perhaps this is exactly the question that Zen Masters want us to ask. There is a *kōan*, the ninety-third from the collection translated as *The Book of Serenity*, that deals directly with this issue:

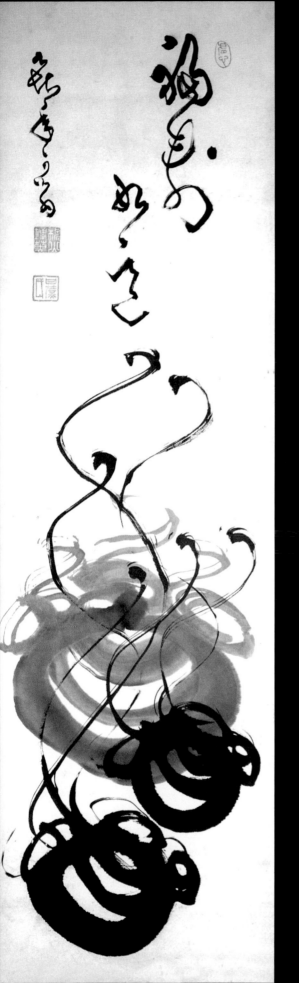

Plate 55. Bokuzan
THREE BUDDHIST JEW
Ink on paper, 109.6 x 29.8 cm
Private Collection

A precious gem hits a magpie, a rat bites a gold piece—they don't know they are treasures, and can't put them to use. Is there anyone who suddenly notices this jewel hidden in his clothes?

CASE

Luzu asked Nanquan, "'The wish-fulfilling jewel, people don't know—it is personally obtained from the mine of realization of thusness.' What is this mine?"
 Nanquan said, "That in me which comes and goes with you is it."
 Luzu Said, "What about that which doesn't come and go?"
 Nanquan said, "It's also the mine."
 Luzu said, "What is the jewel?"
 Nanquan called him by name: Luzu responded, "Yes?"
 Nanquan said, "Go—you don't understand my words."[13]

Difficult *kōan* such as this are given to Zen students well along in their training, and the answers are not expected to be easy. However, there are two interesting passages in the commentaries to this *kōan* that offer it added richness. The first is the opening quatrain of the accompanying verse:

> *Distinguishing right and wrong, clarifying gain and loss.*
> *Responding to it in the mind, pointing to it in the palm.*
> *Coming and going, not coming and going—*
> *It's just this—both are the mine.*

The second comment is by the Zen Master Dongshan (Tong-shan): "It's not that there is no joy; it is like finding a lustrous jewel in a heap of trash."[14]
 Dōgen included this *kōan* in his own collection, the *Three Hundred Kōan Shōbōgenzō*, number 185, with a new prologue and capping verse:

PROLOGUE

It includes heaven and encompasses the earth. It is beyond the sacred and the secular. Revealed on the tips of a hundred thousand weeds—the wondrous mind of Nirvana, the exquisite teachings of formless form. From deep within the forest of brambles, the light of the mani *pearl is released. This is the adamantine eye of the adept.*

CAPPING VERSE

It illuminates itself,
The solitary light of one bright pearl.
No . . . It illuminates the ten thousand things.
See—there are no shadows.
When looking, who does not see?
Seeing, not seeing—Bah!
Riding backward on the ox
Distant mountains endlessly unfold.[15]

Dōgen also wrote even more directly: "Everyone holds a precious jewel, all embrace a precious gem; if you do not turn your attention around and look within, you will wander from home with a hidden treasure."[16]

Bokuzan, in his painting and inscription, suggests meanings through his art that go beyond the image and words themselves. The three jewels are not depicted as still and serene, but rather moving, falling, bouncing through space in a very lively and dynamic way. Two smaller, darker jewels, tilted into active positions, overlap a larger gray one, and all three send forth antennae up toward the calligraphy. The words echo these shapes, especially the curves at the bottom of the second and fourth characters, which are upside-down echoes of the antennae. What is the effect? It is clear that the image and words, like the jewels, are not separate but interacting, part of a process that is always moving and changing—like the distant mountains in the verse, endlessly unfolding.

As is the case with many Zen Masters, Bokuzan seems to have done the majority of his works of art in his final years, as a kind of distillation of his wisdom and experience through a medium that uses words but does not depend entirely upon them. Death finally came to Bokuzan on December 4, 1910, at the age of ninety. Like many earlier Zen Masters, he composed a death poem as his final act:

> An old monk of ninety years,
> My words end, my speech ends;
> But there is no end to the poem:
> The moon is cool, the wind is cold.

TANEDA SANTŌKA

> All day long
> meeting demons
> meeting Buddhas[17]

The story of Santōka is very different from that of Bokuzan, or indeed of any other Zen artist featured in this volume. Never becoming a Zen Master, Santōka was a wandering poet-monk who drank too much, yet he has become beloved in Japan for the difficulty of his spiritual journey, the depth of his trial and effort, and the simple but profound haiku that he left to the world.[18]

Santōka was born in a small village in Yamaguchi Prefecture, in the southern part of the largest Japanese island of Honshu, where his father was a landowner, womanizer, and heavy drinker.[19] The second child in the family, Santōka was eleven years old on the eleventh of March 1892 when his mother committed suicide by jumping down a well on the family property. When the young boy saw his mother's corpse being brought up from the well, he suffered a severe shock that had lifetime repercussions. Two years later his elder brother died, leaving Santōka the oldest son in the family. This was a position of responsibility that, despite his best efforts, he was never completely able to fulfill. He took some refuge in his studies, developing an interest in literature during his childhood that blossomed when he entered middle school in 1896 and began to write haiku.[20]

Santōka graduated from middle school in 1901, and the following September he entered Waseda University, one of the finest educational institutions in Tokyo. Intending to major in literature, he was invigorated by the chance to live on his own but also felt a great deal of personal pressure since he knew that his family was in ever-worsening financial condition.

Amid the bohemian atmosphere of his literary friends, he took to drinking heavily, and in February of 1904 he suffered a nervous breakdown and left Waseda. He briefly tried living on his own, but four months later he returned home. In 1906 his father sold off a large piece of the family land in order to set up a sake brewery that he planned to operate with Santōka's help. Unfortunately, this was rather like hiring a fox to guard a henhouse; neither father nor son was a good businessman, and both were much too fond of the product they were trying to make and sell. Nevertheless, Santōka persisted in trying to become a responsible member of his family, even following his father's insistence and going through an arranged marriage with a young woman named Sakino Satō in August 1909. Their only child, a son named Sen, was born almost exactly one year later.

During this time, Santōka had not lost his interest in haiku, and in 1911 he began to follow the lead of the poet Ogiwara Seisensui (1884–1976), who was one of the originators of a modern movement in haiku that ignored both the traditional 5/7/5 syllable count and the need for a seasonal reference in favor of more freedom and emotional expression; poems now might have two lines, or four, to create their image. Seisensui began a haiku magazine in 1911 called *Sōun* (Layers of Clouds), in which seven of Santōka's haiku were published two years later. At this time, he used two pen names, Santōka (Fire at the Mountain Peak) and Denrakō (Prince of the River Snails), but he soon settled upon the first of these as his poetic identity.

In 1914 Santōka finally met his mentor Seisensui at a two-day haiku meeting in Tabuse, and in 1916 Santōka was made an editor of *Sōun*. However, in the meantime disaster had struck. At the end of 1915, the entire stock of sake spoiled in the brewery, and the following April the family went bankrupt. The father disappeared with one of his mistresses, and Santōka took his wife and son to Kumamoto in northern Kyūshū. There he opened a bookstore named Garakuta (Many Elegant Joys), specializing in old and secondhand editions. Unfortunately, this business did no better than the sake brewery, and his wife converted it into a store that sold picture frames.

Unable to stop his heavy drinking, Santōka did not settle well into life as a shopkeeper and family man. One of his haiku of 1918 shows his ambivalent attitude toward alcohol:

> Sometimes
> the sound of swallowing sake
> seems very lonely

The shocks to Santōka's system were not over. In June of 1918 his younger brother committed suicide, and the following year his grandmother Tsuru, who had raised him after the age of eleven, died. In October of that year Santōka gave up on his dreams of either literary success or an ordinary life, and left his wife and child. Settling in Tokyo, he took up a variety of jobs, including working for a cement company and then working in a library. In November 1920, Sakino obtained a divorce from Santōka, and in May of 1921 his father died. Drinking heavily, Santōka suffered a nervous breakdown in December 1922 and quit his job at the library. As if nature were responding to his downward cycle, there was a great earthquake in Tokyo on the first day of September 1923, and the ensuing fire reduced the boardinghouse where he was living to rubble. Santōka returned to Ku-

mamoto, where he helped his wife at the picture frame shop from time to time, deeply uncertain about what to do with himself.

In December of 1924 Santōka got seriously drunk and stood on a railroad track, facing an oncoming train. The train was able to stop in time, but his life, as it had been lived up to this moment, was nonetheless over.

Santōka was taken to Hōon-ji, a nearby Sōtō temple, where he sobered up and was accepted as a guest by the abbot Mochizuki Gian. After three months of temple life, including sitting in meditation and chanting, Santōka was tonsured as a monk in February 1925 and was given the name Kōho. The next month, Gian sent him to serve at the Kannondō (Kannon Hall) on the outskirts of Kumamoto, where Santōka wrote two haiku that suggest aspects of his new life:

> *In the pine breeze*
> *the morning and evening bells*
> *tolling*

> *Pines all weeping—*
> *praise to Kannon!*

It would be nice to report that from this time on, Santōka's life as a monk was peaceful and serene, but instead he lived fifteen more difficult years, never completely controlling his problems with alcohol, but finding that his life as a monk offered him some surcease from the inner demons that tortured him.

What worked best for Santōka was to walk and beg. He set off on his first pilgrimage in April 1926, moving through southern Honshu and northern Kyūshū (see map of Santōka's journeys, FIG. 17). That summer he composed one of his most celebrated, and simplest, haiku:

> *Walking deeper,*
> *walking deeper—*
> *into green mountains*

Along the way he visited Dr. Kimura, a poet friend in Yanagawa, and this pattern was to continue of begging trips occasionally interrupted by visits to haiku poets. The next year Santōka traveled through Hiroshima in January and Tottori in September, with rests back in Kumamoto between the pilgrimages. Walking along country roads, begging for just enough food and a bed for the night, Santōka could quiet his mind. In this state, he was able to compose haiku that expressed his life as a wandering monk in direct and unadorned language:

> *Walking on—*
> *bush-clover,*
> *pampas grasses*

In 1928 Santōka walked the circuit of eighty-eight holy places in Shikoku, the fourth of Japan's larger islands. This had long been a famous pilgrimage, and it offered Santōka the chance to pray at both Shinto shrines and Buddhist temples, many of which were far from urban centers. Two of his haiku of this year show differing aspects of his life. The first emphasizes the age-old interaction of Buddhism and nature:

Figure 17. Santōka's Journeys

Figure 18. Santōka

> *This rain*
> *is very familiar*
> *to the gravestones*

The second suggests the freedom of his life as a begging monk, and this haiku must have meant a great deal to Santōka because he wrote it frequently when asked for calligraphy later in his life:

> *Freely floating,*
> *tasting pure waters*

This kind of freedom meant that he did not have to worry about each day, each meal, each place that he would visit.

> *Lost on the road—*
> *so just here*
> *stopping for the night*

This poem has echoes of "just this," and despite the very different lives of Bokuzan and Santōka, one can see that they reached the same understanding.

A photo of Santōka shows the poet-monk in his traveling clothes, which consisted primarily of his black robe and *kasa*, a half-round straw hat (FIG. 18). This hat occasionally appears in his poems, such as a haiku from a rainy day on his travels in 1929:

> *Does my* kasa
> *also leak?*

Rain was of course a frequent companion on his travels and offered him the opportunity to identify himself with many moods of nature, as in a haiku of 1930:

> *The sound*
> *of the rain—*
> *also grown older*

In the southern parts of Japan where Santōka usually walked and begged, when it wasn't raining it was often extremely hot. In the same year of 1930, Santōka wrote:

> *Accepting*
> *the scorching sun,*
> *I walk and beg*

In these years, home base for Santōka was Kumamoto, where he would help his former wife with her shop when he wasn't off on pilgrimage. In 1930 he got a room at a Kumamoto boardinghouse called Sambaku ("three-eight-nine"). When he tried to stay for any length of time, however, he found himself reverting to his alcoholic ways, and he would set off on the road again. It was also vitally important for him to compose haiku, and this did not go as well when he was settled in one place.

Santōka's journals are invaluable records of his thoughts as he traveled.[21] On September 14, 1930, he wrote:

I'm on the road again; beyond a monk begging for food, I am nothing at all. A foolish traveler, I have only a life of wandering, and like grasses floating from one bank to the other, I can find a sense of peace, compassion, and joy. . . . Traveling from morning to evening, I touch here and touch there, the shadows of my heart changing as life provides for me. This record of travel and begging is the record of my life.

On September 20, he noted in his journals the three most important activities in his life: "A day without walking is lonely, a day without drinking is lonely, a day without composing haiku is lonely. Being by myself is also lonely, but walking alone, drinking alone, and writing poetry alone are not lonely." Once in a while he paused; on November 13, he wrote, "The words of Christ, 'sufficient unto the day is the evil thereof' are welcome; today I just stayed in one place, ate and slept—but if that is all I do, it isn't enough. This life of walking and begging is for me the only peace." For these reasons Santōka spent a great deal of his life on the road, noting on November 30, 1930:

The life of travel and begging must be like floating clouds, flowing water. If it stagnates even a little, it becomes confused and disordered; it must be born anew as each moment provides, like scattered leaves, like the wind blowing.

Although Santōka tried at various times to stay in one place, it tended to atrophy his creative spirit. For example, in Kumamoto on January 17, 1931, he wrote in his journal, "I couldn't come up with a single haiku and felt absolutely poverty-stricken. If I don't go on the road, my haiku just don't appear."

In 1931, with the help of friends, Santōka started a haiku magazine called *Sambaku* and managed to put out three issues in February and March but then had to go on pilgrimage again to clear his mind, discipline his body, and compose more poems. He returned in May but then set off again, this time on a journey he named "Ridiculing Myself." Along with this ability to make fun of his own life, Santōka had the courage to write extraordinarily simple haiku, the kind of poems that he himself would have disdained when he was a young intellectual at Waseda University. For example, one poem of 1931 describes the snow of southern Japan:

Peaceful, peaceful—
chilly, chilly—
snow, snow

Perhaps it was the same year when he wrote a poem that shows that, although he could not live as her husband, he kept Sakino in his mind:

Returning from the snow
and writing a letter
to my wife

January 1932 saw Santōka traveling to Fukuoka, where he made a pilgrimage to thirty-three temples dedicated to the merciful Bodhisattva Kannon. That month, experiencing another mood of nature, he wrote about his *tetsubachi*, the iron begging bowl that he carried with him wherever he walked:

Even in my
begging bowl—
hailstones

He continued his travels that year to Saga and Nagasaki. In April, nature offered another surprise:

On my kasa—
plop!
a camellia

That year, friends of Santōka set him up in a cottage in Yamaguchi, which he called the Gochū-an (Hut Amid This). Here he would live for the next six years when not traveling, and he occasionally welcomed poet-visitors for haiku meetings. On June 1, 1932, his first book of poems, entitled *Hachi no ko* (Child of the Begging Bowl), was published by friends, and perhaps this led him to ruminate about the form itself. Unlike many of his contemporaries who worked by creating variations on traditional themes, Santōka stressed the personal aspect of writing, along with the need for intense and focused experiences of nature. On July 1 he wrote in his journals:

As for haiku, if it is true haiku, it must be a poem of the spirit, because when not expressing the heart and mind, the essence of haiku is gone. The moon shines, flowers bloom, insects chirp, water flows—these circumstances are the mother's womb of haiku, there is nothing other than seeing the flowers. When you've gone beyond the past, forgotten any sense of purpose and intentionality, and separated yourself from historical limitations, that is the fundamental existence of art, as well as religion and science. This is my belief right now.

He later noted: "When art becomes earnest, loneliness appears, serenity appears, strangeness appears; if it doesn't go that far, it's a lie."

One crucial element of all poetry is the use of words not only for their meaning but also for their music. As Santōka noted in his journals:

What expresses the subject is the words, but what gives life to the words is rhythm. That which transmits the heart of an individual poet from a special time and particular place, the aroma, tonal shading, and reverberation, is this sense of rhythm. It is just this rhythm, and only its rhythm, that makes it good. I dislike haiku that are crafted carefully with a knife, by a sharp razor; what I hope to create are bold and decisive poems.

We can see his particular sense of rhythm in two poems that use the word for silence; in these cases we will include the Japanese readings:

| Yama no shizukasa e | *To the mountain silence—* |
| shizukanaru ame | *silent rain* |

Yuki e	*Snow*
yuki furu	*falling on snow—*
shizukesa ni oru	*creating silence*

Both poems break the rules of traditional haiku through their unusual syllable counts, and yet each maintains a strong rhythm of its own. The repeti-

tion of the words for "silence" in the first poem and "snow" in the second also helps to establish the strong, simple, and yet unique music of the haiku. They could have been written by no other poet.

Encouraged by the growing interest in his poetry, in December Santōka put out the fourth issue of *Sambaku*. He seemed to be settling down; in January 1933 he put out the fifth issue but then felt the need to walk and beg again. He visited his Buddhist teacher Gian in May and then invited his poetry mentor Seisensui to a haiku party at Gochū-an in November. In December his second volume of poems, *Sōmokutō* (Stupa of Grasses and Trees), was published.

In many ways Santōka's life seems to have been going well at this period, but it was never easy. After he became seriously ill in 1934, he became despondent as he continued to wrestle with the questions that had occupied his life. On May 22 he wrote in his journals, "Becoming free from the passions and desires is the purpose of Zen training. Indeed, continuing to practice can finally free oneself from passion, but lingering in tragic affections is human nature. In other words, if you end in extinguishing human passions, it feels like you have also extinguished human life and human nature, so I have a weak spirit that would like to free myself, but would also like not to completely free myself."

Still discouraged by his health and personal problems, the following year Santōka considered suicide again, but eventually he recovered his confidence, realizing that although his faults might never be completely corrected, he could continue to live, walk, and compose haiku. In his journals he once stated that "good poems are written by good people—but I don't necessarily mean good people are 'moral beings.' Humans as such can improve themselves; they must be refined and polished." The way that Santōka tried to refine himself was through Zen practice, primarily by walking and begging. In 1935 for the first time he traveled to the northern island of Kyushu, and that same year his third volume of haiku, *Sangyō suigyō* (Traveling through Mountains, through Waters), was published.

The year 1936 brought the publication of another volume of verse, *Zassō fūkei* (Weedscapes), and more travels for Santōka. In January he was in Okayama; in March he visited Kobe, Kyoto, and Nagoya, and he made a special pilgrimage to the Ise Shrine, the most famous Shinto site in Japan. The next month he went to Tokyo, where the publisher Chūō-Koronsha gave a party for contributors and editors of *Sōun*. Despite the ever-increasing size of the metropolis, Santōka still found that nature had not been entirely abolished there:

> *Relieved*
> *to see the moon—*
> *arriving in Tokyo*

Soon Santōka was on the road again. In June he went to Sendai and Niigata, during which time he followed the steps of Bashō's famous journey through northern Honshū, immortalized by the famous poet in his *Narrow Road to the Interior*. In the newly industrializing Japan, this journey was not as grand and remote as it had been two and a half centuries earlier, but it gave Santōka a taste of what Bashō had experienced. Admiring his poetic ancestor who had immortalized a frog jumping in the waters of the old pond, Santōka composed this poem:

Becoming a frog—
and jumping!

In July of 1936, Santōka visited the major Sōtō training temple Eihei-ji in Echizen for five days. He then returned to the Gochū-an, continuing his pattern of long journeys punctuated by pauses at his cottage. Even here his life was extremely simple. Several anecdotes about Santōka are told by his friend Sumita Ōyama; the first is that when he visited Santōka at the Gochū-an, they shared a lunch of boiled rice and one red hot pepper, but Santōka had to wait for his guest to eat, since he only owned one bowl. When night fell, Santōka gave Ōyama his only quilt, but even this was not enough to keep Ōyama warm, so eventually Santōka put his robe, his old magazines, and finally even his desk over his guest, and stayed up all night sitting in meditation.

Friends such as Ōyama often asked Santōka for his poems written in his own hand, and he therefore became a calligrapher perforce. He did not think much of his brushwork, commenting as early as 1932 that "from dawn to dusk I have flung around a large brush, but I wonder at the clumsy characters I produce! Perhaps clumsy is not so bad, but I am startled at such vulgar characters! Even a happy mind would be cast down to see them, like fine weather clouded over."

Regarding the question of clumsy and skillful, on December 9, 1934, Santōka visited an exhibition of children's art. He commented in his journals that "the calligraphy from first-graders was truly delightful. By the time the students reached the third or fourth grade, however, the work lost its beauty, it only got more skillful. For me, more than anything, I love unskillfulness. I hate skill, but even more I hate primped-up unskillfulness."

For Santōka, unskillfulness was not the same as what he called his "poor handwriting" and "evil brushwork." There were times when he looked at what he had written and wanted simply to rip it up, even the special gold paper that he had once been given for calligraphy.[22] In fact, his calligraphy has been criticized, especially his larger characters, which, according to one expert, "flow strangely with no sense of brakes."[23] According to this authority, this was because Santōka had no chance to see fine calligraphy from the past or to practice from high-quality models. However, even the most conservative scholars have praised Santōka for the special flavor of his writing, in which his own personality shines forth. Perhaps he was at his best when working quickly, without self-consciousness, as on September 9, 1936, when he wrote in his journals that "I finally finished writing thirty *tanzaku* without any mistakes, and I'll send them off shortly."

Examining a *tanzaku* (tall, thin poem-card) by Santōka, we can see the bold and relaxed flow of the poem down the decorated paper (PLATE 56). The haiku exhibits Santōka's special talent for making a simple observation and giving it a subtle depth of feeling:

Hitori hissori	*Alone, silently,*
take no ko	*the bamboo shoot*
take ni naru	*becomes a bamboo*

The first column of the calligraphy, "*hitori hissori,*" matches the first line of the translation; it was written without pause, the brush getting drier toward

the end of the line. In the second column, Santōka completed the poem, "*take no ko take ni naru.*" He redipped the brush for the top character *take* (竹) bamboo), and when the word repeats midway down the column, it extends in dry brushwork until the descending line almost disappears. The final words "*ni naru*" (becomes) are reinforced to their right by the signature "Santōka." The total mood is forceful, slightly rough, and certainly does not "primp up" any unskillfulness. But is it actually unskillful? According to most professional standards of calligraphy, yes, but perhaps Santōka's special art has been to go beyond any such questions and simply write his poem so that it too becomes a bamboo.

In August of 1937, a fifth collection of Santōka's verse, *Kaki no ha* (Persimmon Leaves), was published. Two of his poems from March of that year suggest how his own life echoed that of both ordinary grasses and Japan's most celebrated flowers:

> *The tufts of the reeds*
> *move wherever the wind*
> *wants to travel*

> *Meeting and parting—*
> *buds*
> *of cherry blossoms*

However, Japan entered into a war with China in July that year, and in contrast to the patriotic enthusiasm that was sweeping the country, Santōka wrote a series of haiku that expressed his antiwar sentiments. Three of these suggest the initial training and eventual return of the soldiers:

> *Tromping the ground*
> *they will not walk upon*
> *again*

> *Bones without voices*
> *crossing the sea*

> *Both courageous*
> *and sad—*
> *white urns*

The sixth day of March 1938 was the forty-seventh anniversary of the suicide of Santōka's mother. Having nothing more elegant, he offered some thick white *udon* (noodles) to the Buddha in her memory:

> *Dedicating udon*
> *for my mother,*
> *I too receive it*

Another poem from 1938 may describe the rather dilapidated Gochū-an:

> *From the crumbling wall—*
> *creeping vines*

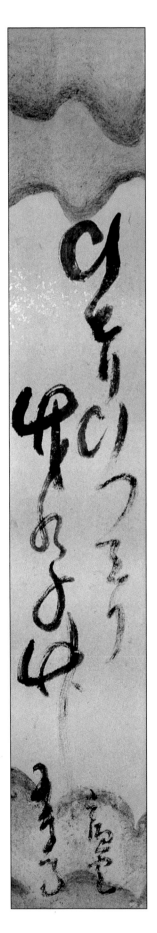

Plate 56. Taneda Santōka (1882–1940)
ALONE, SILENTLY
Ink on decorated paper, 36 x 6 cm.
Shōka Collection

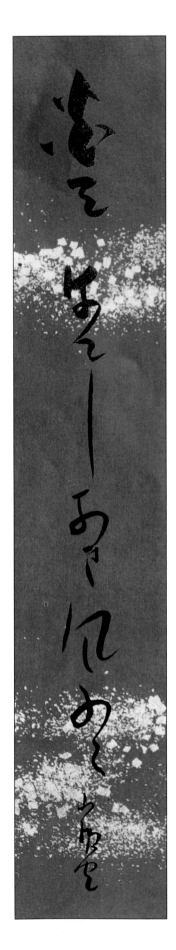

In November of that same year, Santōka's cottage finally collapsed, and he had to seek new lodgings. He first stayed nearby at Yuda Hot Springs in a small dwelling that he called Fūraikyo (Wanderer's Hut), but after a few months he was offered a cottage in Matsuyama, northern Kyushu, by his friends. This he named the Issō-an (One Blade of Grass Hut), and it was to be his final home. He celebrated the Bon Festival for the Dead in July with another offering:

Offering a tomato
before the Buddha—
before my father and mother

In January 1939 Santōka's sixth collection of haiku, *Kokan* (Orphan Cold), was published. Despite worsening health, he did not cease his travels; in March he journeyed north and east, and in September he again visited the island of Shikoku. In October he went to Hiroshima, returning by boat to Matsuyama, and in November he once more traveled before returning home for the New Year.

Nineteen forty was to be Santōka's final year. On January 1 he planned a poetry party at the Issō-an for October to be called *Kaki-no-kai* (Persimmon Meeting). His *Sōmukutō* was republished that year in an expanded version with may new poems, and Santōka received more requests for his calligraphy than ever. Those who love his work especially enjoy his final calligraphy, such as the *tanzaku* on red decorated paper (PLATE 57) with the poem:

Enten hateshinaki *Endless scorching sun—*
 kaze fuku *the wind blows*

Here the calligraphy seems more restrained and graceful than the previous *tanzaku*, but the freedom of the brushwork is at least as strong as before, if more subtle. The single column of words is maintained within the center of the format as though the red paper were itself the blazing sunlight, withering the calligraphy as though it were Santōka's body in the heat. For example, the *kana* syllable *shi* (し) is created with a single thin vertical line in the center of the *tanzaku*, but when the character *kaze* (風 wind) is written three graphs later, it opens the space as it might cool the pores of a sweaty body. For some viewers, it may seem odd to see a Santōka poem, with its simplicity of diction and plainness of speech, on a surface so highly decorated with fluid patterns of cut squares of gold leaf. However, the contrast may add to the effect of the calligraphy, just as it gives extra impact to the words of the haiku.

One of Santōka's rare larger-scale works from his final years is a horizontal scroll (PLATE 58) with one of his most characteristic poems:

Kane ga nai *No money*
 mono ga nai *no things*
 ha ga nai *no teeth*
 hitori *just me*

The first word, *kane* (金 money), is the largest and conveys a bold, wet sense of asymmetrical balance. The rest of the column and the following two lines

Plate 57. Santōka
ENDLESS SCORCHING SUN
Ink on decorated paper, 36 x 6 cm.
Private Collection

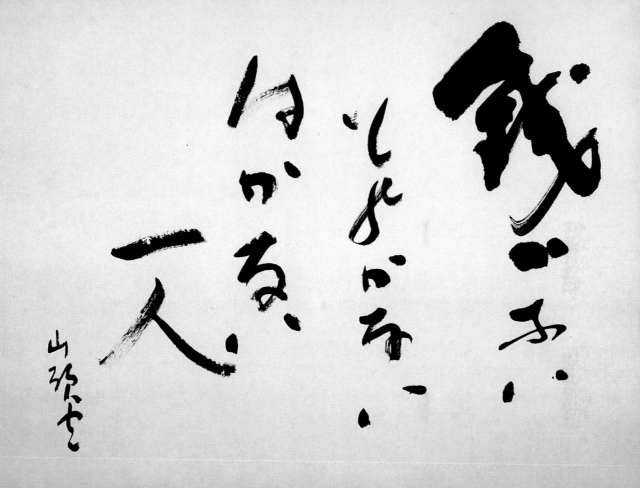

我に一人

しかも一人

わかる

一人

山頭火

are written solely with the simple *kana* syllabary, with the *ga nai* (have not) repeating in ever-varied rhythms. The final two dots in each column (which form the syllable *i*) have an important effect of visual punctuation, and they seem to dance more and more freely on the paper. The final two characters, *hitori* (一人, literally, one person), are two of the most basic forms that a child learns to write, consisting of one and two strokes of the brush. Here they are set low, close to the words to their right, and seem to have been written with no thought, no skill, and yet a full sense of bold confidence. The signature in small characters completes the work, or perhaps it is the empty space that Santōka has left that completes the work, because without that space the mood would be quite different.

Viewing this calligraphy as a whole, it certainly conveys the Zen ideal of going beyond good and bad. From an academic point of view, it could be criticized since the large character on the right may seem unbalanced with only empty space on the left, while the individual words are written with a childlike lack of care. Yet the brushwork flows with a natural pace, its combination of bold simplicity and irregular repetition creating the same flavor and rhythm as Santōka's haiku.

That June of 1940 Santōka completed his final travels, returning to Issō-an well in time for his poetry meeting. On October 7 his seventh collection of poems, *Karasu* (Crows), was published. The *Kaki-no-kai* took place three days later, on October 10, but since Santōka was both drunk and unwell, his fellow poets left him to sleep and went to a neighboring house. The next morning they found Santōka had died during the night.

Santōka's attitude toward death, both as a person who found life very difficult and as a Zen monk, was certainly not one of fear. A number of his haiku touch on this subject directly or indirectly:

> *Today*
> *I'm still living,*
> *and stretching my legs*

> *Winter rain—*
> *I'm not dead yet*

> *Serenely*
> *grasses sprout,*
> *soon to die*

> *When I finally die—*
> *wild grasses,*
> *rain*

KOJIMA KENDŌ

Women have been important in Buddhism since the days of the historical Buddha himself. Several of his major disciples were women, and when Buddhism reached Japan, the first to take monastic orders were three women. In

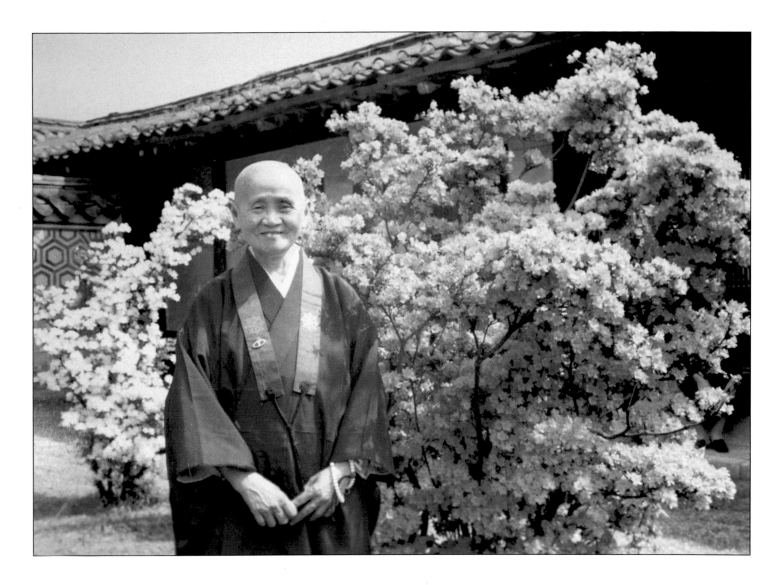

Figure 19. Kojima

the world of Zen, women have also made their mark, as can be seen from historical records; among many notable female monastics was Ryōnen Gensō (1646–1711), whose remarkable story of courage and determination is told in *The Art of Zen*.[24]

One of the most distinguished of Zen nuns of this century has been Kojima Kendō (FIG. 19), whose long life was remarkable for its sustained intensity of spirit. Her life and work have been studied in a ground-breaking book, *Women Living Zen: Japanese Sōtō Buddhist Nuns*, by the Asian-American scholar Paula Arai; she discusses how Kojima was perhaps the most important of the leaders working toward equality of women in the Sōtō sect. [25] Kojima tells of her original calling to become a nun in her autobiographical writings:

> *I first raised my solitary voice on October 25, 1898, as the third daughter of Kojima Sōgorō in Nan'yō Village, Kaitō-gun, Aichi Prefecture. I had two elder brothers and two elder sisters, and as the youngest child I was raised by a mother who spared no efforts in her loving care. However, as fate would have it, in my fourth and fifth years of grade school I gained the aspiration for Buddhahood and desired to become a nun. My mother was very perplexed by this unexpected wish. Every night when she scrubbed my back in the bath and then as she put me to bed, she tried to dissuade me, but her words did not make any impression upon my young ears. It seems that my eldest brother had wanted to become a monk, but as the oldest son in the family he decided this was a wish*

that he had to relinquish. He may have considered me as a fortunate substitute, and so he did his best to persuade my mother to allow my request. Mother cried and cried over my brother's words, but after many days of persuasion she finally became willing to listen to my heart's desire. Gossip spreads like lightning, it is said, and the very next day a teacher came from the next village and the pledge was made that I should enter a nun's temple. This was during the summer vacation when I was in fifth grade. Before I could enter a Buddhist school, my hair had to be cut, so during that summer vacation I shaved my head. Leaving my beloved family, my esteemed teachers, and my dear friends, I entered the new school on September 1, 1910, boarding with a man named Teranishi Tō, who also lodged young monks at the neighboring temple. [26]

After completing six more years of grade school and two years of high school, during which time she participated in Buddhist rites, Kojima entered a training academy for nuns in Nagoya called the Nisōdō. This had been established in 1903 by four Sōtō nuns who believed that women's Buddhist education had been allowed to decline. They were determined to create a training center that would teach not only meditation practice but also such subjects as Buddhist tenets, history, and ceremonies, classical Chinese, science, math, and arts such as calligraphy, flower arranging, and the tea ceremony. As the first issue of the center's journal, *Jōrin*, reported in 1923, the Nisōdō was founded "for the purpose of waking up those nuns who have accepted many years of the indolence in the status quo. . . . This was an alarm bell awakening those who had lost sight of the religious mission of teaching the Dharma."[27]

The young Kojima became a member of the notable group of nuns who were determined to work even harder than monks in training, in order to establish their worth within the Sōtō sect. She later commented that the regimen was so difficult that at times she thought she could not survive, but since it had been her own choice, she had to persevere.[28] If the strict training was not enough, in 1912 a typhoon destroyed one of the classrooms of the Nisōdō and killed three of the nuns. Undaunted, they rebuilt, beginning a new worship hall in 1913 and a large lecture hall in 1914. Graduating in 1918, Kojima became the assistant to the director, but she was determined to continue her education. Although no women had been allowed into the Sōtō sect's Komazawa University, she knew that such discrimination was not authorized by Buddhist teachings, especially the egalitarian beliefs of Dōgen. Along with four other nuns, Kojima prevailed and entered Komazawa University in 1925 for three years of study. She then returned to teach at the Nisōdō for ten years, during which time she worked with her colleagues for more equality in their positions within the sect. In 1930 she joined other leading Sōtō nuns at a national meeting where they wrote a statement of their concerns:

We monastic women have largely been neglected by members of the sect, to say nothing of general society. The result has been that the institution of the sect has not granted us our natural rights. Due to this negligence, a great number of monastic women have endured under miserable conditions, and the situation has not changed much over time. However, we will not permit the flow of history to stop and leave us in our current situation. Indeed, we have arrived at a time when the actual day is not far for women in society clamoring with a loud voice and claiming the right to participate in government. At the next spe-

*cial meeing of the legislature, the government and the people from both polit-
ical parties will introduce a bill for the civil rights of women. Is there a more lu-
cid tale to have seen than this? Even if it is only one day sooner, we monastic
women, too, must awaken from our deep slumber; we must free ourselves from
the bonds of iron chains. . . . We must succeed in attaining our original des-
tiny, and in so doing let us claim the natural rights that we deserve but have
not yet gained.* [29]

Among the specific resolutions that came from this meeting were for nuns to
be allowed to designate *dharma* heirs, to participate in governing the sect, to
be considered for appointments in each category of religious teacher, and to
be allowed positions as heads of temples rather than only subtemples. Fur-
ther resolutions that followed at another meeting in 1937 were to have access
to full education opportunities, and to be allowed to wear robes other than
black, signifying experience and rank. These requests were not immediately
granted by the sect administration, but it was clear that the winds of time
were changing, in part because of larger historical circumstances. It is sig-
nificant that the first nuns' meeting stressed how changes were taking place
in governmental regulations for women in Japan, in large part because of the
influence from the West. The fact that early Sōtō traditions promulgated by
Dōgen had featured equality for women was another important idea stressed
by the nuns in the struggle for their rights.

Kojima took an increasingly large role in the world of Sōtō nuns, but
despite the value of her work, she felt that it was important to gain a wider ex-
perience of the world. Beginning in 1938, she took a leave from the Nisōdō
and spent four years at temples in Hawaii as part of the Sōtō sect's Interna-
tional Division. Life in Hawaii was different from, but no less busy than, life
in Nagoya. Kojima worked primarily with second-generation Japanese-
Americans, whose parents had come from Japan but who had not them-
selves experienced Japanese life directly. In addition to Buddhist teachings,
Kojima and her fellow nuns found themselves offering the community a
Sunday school, a women's club, a girls' club, a female youth club, and a
children's club, as well as giving lessons in tea, sewing, music, children's sto-
ries, dance, and calligraphy.[30] In short, they gave a sense of the cultural as
well as religious values of Japan to women who felt themselves cut off from
their roots.

The beginning of the Second World War marked the end of the
Hawaiian experience for Kojima, and she returned to teach at the Nisōdō.
Despite the ravages of war, she did not neglect her work for women monas-
tics, and when the Sōtō Sect Nuns' Organization was founded in 1944, Ko-
jima was elected president. The motto that the nuns chose was "The true
Law of the supreme Buddhist way does not discriminate by gender." When
the war ended, the organization was given an office in the sect's headquar-
ters building in Tokyo, and soon it had divisions for training, education, arts,
and social service. Kojima remained in charge of this coalition of nuns for al-
most twenty years until 1963, despite the distance from Nagoya that she had
to travel in order to attend both her own meetings and larger sect organiza-
tional conferences. Frequently the only nun at these latter occasions, she
spoke out freely and forcefully, leading the battle for women's rights in the
Sōtō sect with very positive results.

Again, the cultural context aided Kojima in her struggle. When the

Occupation Army decreed five steps for Japan on October 9, 1945, one of them was political and legal equality for women. Moving quickly, Kojima led a meeting at Eihei-ji in December that studied the works of Dōgen relating to nuns, and the following year they made an appeal to the sect administration for a number of changes in procedure. These included that nuns should be given charge of nunneries, that nuns should be allowed free access to study at Komazawa University, that monks and nuns at the same level of practice should be granted the same ranks, that nuns have the same rights as monks to head temples, that nuns have equal rights in voting for and holding sect offices, and that nunneries be allowed to grant advanced teaching degrees. The sect responded by granting many of these requests, adding each year to the rights of nuns until 1953, when almost all the requests had been granted. A further series of reforms in 1965 saw most of the final issues settled, and Kojima could reflect upon the monumental change in the rights of nuns within the Sōtō sect, an accomplishment that had required thirty-five years of constant effort.

However, Kojima not only worked for nun's rights, she also maintained her primary responsibility of presiding over the Nisōdan in its efforts to promote the training and spiritual opportunities for nuns. Although monks were allowed to marry, Zen nuns voted to adhere to the earlier Buddhist tradition of celibacy, and Sōtō nuns also followed a more severe schedule of practice in their training than did monks. Kojima was known as a very strict teacher, but perhaps she was most strict with herself.

As though her multiple duties were not enough, Kojima also kept busy initiating and overseeing various social service projects. One of these was helping to found the Lumbini Orphanage in the outskirts of the city of Toyama in northeast Japan. This project had begun in January 1947, when Kojima decided that something had to be done for the many orphans that she saw trying to survive in the parks and unused subway stations of Tokyo at the end of the war. As there were no buildings in the war-ravaged city that could house them, she arranged for the children to travel to Toyama where the orphanage was named after the garden in which the historical Buddha had been born. Led by another extraordinary nun, Taniguchi Setsudō (1901–1965), the Lumbini-en was staffed by Sōtō nuns under the direction of the Nisōdan. In regard to social responsibilities, Kojima also served from 1958 to 1965 as supervisor and guardian of the Vietnamese nuns who came to Japan to study.

Kojima's work was acknowledged not only by nuns but eventually by the entire Zen community. She received a special award of excellence on September 29, 1952, upon the occasion of the seven hundredth anniversary of Dōgen's death, but she felt she had just begun her work. She served as administrator of the All-Japan Buddhist Nun Association from 1951 to 1961, and from 1961 to 1965 she was its director, with the motto:

> *Brilliant like the sun,*
> *Pure like a lotus blossom,*
> *True well-being comes*
> *From compassion,*
> *From wisdom,*
> *From liberation.*[31]

This organization, under the lead of Kojima, began publishing the journal *Hanahachisu* (Lotus Blossom) in 1961, with poems, pictures, and articles on many subjects of interest to Buddhist nuns, ranging from the plight of nuns in Vietnam to health and medicine. Kojima also was the executive director of the Japanese Federation of Buddhist Women from 1952 to 1965.

In an effort to increase her knowledge of Buddhists around the world, Kojima participated in the Third International Buddhist Conference in Burma in 1954, and two years later she attended the fourth such conference in Nepal. The Japanese delegation to this meeting also traveled to major Buddhist sites in India, and Kojima noted that at Bodh Gaya, the site of the Buddha's enlightenment, there were temples from many countries but none from Japan. One of her disciples, the nun Kitō Shuntō (b. 1925), thereupon traveled to India and took on the daunting task of supervising the building of a temple that would represent all Japanese Buddhist sects. After many tribulations, Nihon-ji was opened in Bodh Gaya on December 3, 1973, with Kojima presiding.

Another great honor that Kojima gained was to become the celebrant at the ceremony honoring the seven hundredth anniversary of Koun Ejō at the major Sōtō temple Eihei-ji in 1980. At this service she wore the Yellow Robe of honor that would have been denied her earlier. She commented in her autobiographical writings that "I never thought that nuns would be able to hold a ceremony at Eihei-ji, but we have accomplished our goals very quickly. This is a testament to the heart and spirit with which we have endowed our actions. It is like being in a dream . . . but anything can be done when we join our forces and work together."[32]

Despite her great efforts, and eventually her great success in the world of Buddhism, Kojima's inner resolve and profound meditation were the core of her being, and provided the foundation that allowed her to lead a life of activism. She commented that whether in the nun's organization, a training monastery, a temple, or alone, a nun's strength derived from her independence, but no matter how powerful this strength on the outside, it must come fundamentally from within.[33] For this reason, she stressed the discipline of meditation, and always taught the freedom from ego that comes from profound realization.

Becoming ill in 1982, Kojima retired to a temple in Toyoda, but she then moved to the Lumbini-en for her final years. The current director of the orphanage, the nun Tsuneda Sen'ei, recalls how the fierce teacher Kojima was so gentle and kind to the children that they regarded her as a favorite grandmother in the age-old Japanese tradition.[34] Tsuneda also marveled at the sense of quiet serenity that Kojima exuded, although she loved jokes and was able to make fun of herself. For example, in her final years she became extremely thin; she jested that she was only skin and bones, and must look like the starving Shakyamuni before he was enlightened.[35]

Kojima's popularity with children is shown by a drawing done by a little girl named Mayumi (PLATE 59). Above is Kojima, and below is a self-portrait of the girl, who has added their names to the left of their portraits. To the right, Mayumi has written:

Kojima Sensei, please come again quickly!

Kojima herself took up brushwork in her final years. Confined to bed

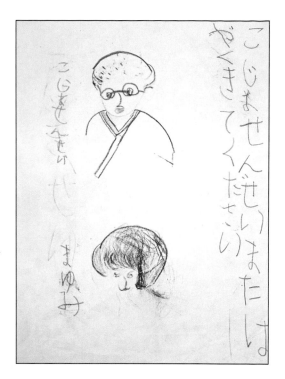

Plate 59. Mayumi (dates unknown)
DRAWING OF KOJIMA KENDŌ
Crayon on paper, 25.2 x 17.2 cm.
Private Collection

by a broken hip and other disorders at the age of ninety-three, she began to do calligraphy on square poem-cards called *shikishi*. Propped up in her bed, she would take up the brush and write as the spirit moved her. One *shikishi* for each of the last five years of her life can demonstrate her combination of freedom, energy, strength, and delight.

The first of these works was done when Kojima was ninety-three. In terms of her calligraphy, we can therefore call it a "young work." She has written the character *wa* (和), which means peace, harmony, and reconciliation (PLATE 60). As a verb, it can also mean to soften, to pacify, and to comfort. All these words represent the impression that Kojima made on Tsuneda Sen'ei, and yet one can also see the dynamism of Kojima's character in the calligraphy. The left half of the word was written with bold, blunt strokes, including some "flying white" where the paper of the *shikishi* shows through the ink. The right half of the word, however, is much more lightly written; Kojima has taken the basic form of a square (originally representing a mouth) and transformed in into an asymmetrical form that expresses energy and movement. On the bottom left she added her name, Kendō, and her age, ninety-three.

The second *shikishi* is written in Japanese *kana* phonetics, and says *yaiya dekiruta* (PLATE 61). This is an extremely colloquial expression, far from the kind of calligraphic inscriptions written by those trying to be eloquent or stylish, and means:

Hey, you can do it!

This phrase certainly could have been the motto of Kojima's notable life. The shapes of the syllables are simply and roughly composed, seeming childlike in touch, but full of even more energy than the previous work. To the left is her signature and the number ninety-four.

The third work again has one character, this time *ku* (空), which in most contexts signifies sky, but in Zen it means emptiness (also on PLATE 61). The form stands alone and solitary on the *shikishi*, and while it is without pretention as calligraphy, it conveys a sense of Kojima's personal conviction at the age of ninety-five. This Zen emptiness, as expressed in her calligraphy, is full of life and being.

The fourth *shikishi* has three characters, *mu ichi butsu* (無 一 物), literally meaning "not one thing" (PLATE 62). This is a famous Zen phrase, taking us back to the emptiness of the previous work, but now with calligraphy dominated by strong horizontal strokes that rise at a slight angle to the right. At age ninety-six, Kojima is in her prime as a Zen artist, and the sense of inner force is even more apparent than before. Although Tsuneda Sen'ei reports that Kojima had a very modest attitude toward her work, occasionally she would remark, "Oh, that came out well!" with the pleasure of a child. This might well have been such a time.

The final *shikishi* was done in Kojima's final year and is dated to the age of ninety-seven; we have finally reached her "old-age style." It represents an *ensō*, the Zen circle that can signify everything, nothing, unity, the moon, or even a rice cake (also on PLATE 62). The circle here is broad and bold, not quite touching its end to its beginning; within it floats the word *Mu* (無), meaning no, not, nothingness. This *Mu*, which is usually the first and ultimate *kōan* to meditate upon, is not quite centered in the *ensō*, giving it a

Plate 60. Kojima Kendō (1898–1995)
WA SHIKISHI *(1990)*
Ink on paper, 26.8 x 24 cm.
Private Collection

Plate 61. Kojima
YAIYA *(center) and*
KU SHIKISHI *(bottom)*
(1991 and 1992)
Ink on paper, each 26.8 x 24 cm.
Private Collection

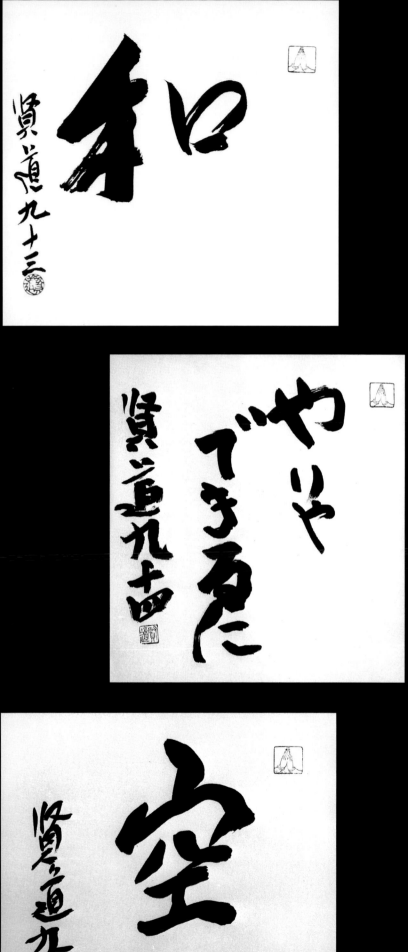

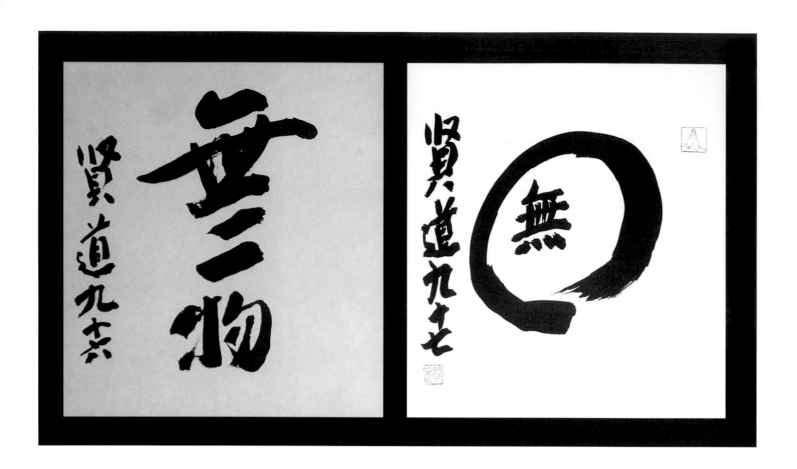

Plate 62. *Kojima*
MU ICHI BUTSU *(left) and* ENSŌ
SHIKISHI *(1993 and 1994)*
Ink on paper, each 26.8 x 24 cm.
Private Collection

sense of movement even though it is rendered with great architectural strength.

With the two ultimate symbols of Zen painting and calligraphy, the *ensō* and *Mu*, we have come to the end of Kojima's work, and of her life. She died at 10:15 on the morning of August 22, 1985. Tsuneda Sen'ei reports that Kojima maintained an amazing aura of strength and peace to the end, inhaling and exhaling slowly, but with great power, until she took her final breath.

THE FIRST HALF of the twentieth century was a period of dramatic change, upheaval and hardship for Japan. As noted earlier, Buddhism had fallen from political favor, and monks of all sects had to restructure and re-organize in order to maintain their position, physically and spiritually, in Japanese culture. As a result, Zen monks strove to rebuild and reorganize; temples and training centers were renovated and improved, preventing them and Zen from becoming merely dilapidated cultural ruins. Zen Masters spoke out about and reacted to the spiritual and physical needs of the public, particularly in times of national and international unrest. Beyond verbal and physical responses to the new circumstances and challenges, however, they also continued to do brushwork, preserving centuries of spiritual and artistic tradition during one of Japan's most chaotic periods.

ROZAN EKŌ

Rozan Ekō was born in Nagoya and entered Keiun-ji at the age of eleven under the guidance of the monk Ninbō, who sensed great potential in Rozan and guided him with a benevolent eye.[1] Eventually, Rozan moved to Dōsen-ji and Ninbō asked the Zen Master there, Mokusō, to look after him.

Soon after, Rozan began studying literature and Buddhist doctrine with the abbot of Hōo-ji in Okuyama. Rozan's training was strict, and it was at this time that he cultivated the foundations of his disciplined study and practice of Zen. At the age of eighteen, Rozan went to train under Gōten Dōkai (1814–1891) at Tokugen-ji in Nagoya, and after Gōten's death he continued his training under Gōten's successor, Jissō Jōshin (1851–1904). After twenty years, Rozan received *inka* from Jissō. He is considered to be Jissō's main *dharma* heir.

When Jissō was appointed *Kanchō* of Myōshin-ji in 1904, he passed his position at Tokugen-ji (FIG. 20) over to Rozan, who now took charge of training monks in the *sōdō*. Despite his new position and elevated status of carrying on the teaching lineage of Gōten and Jissō, Rozan's disposition did not change. Rozan's teaching method was described in this way:

> *He was a* Rōshi *who had the general opinion that monks should not be scolded. People, like things, become damaged if quickly abused, so there is no need to scold a monk. He was a* Rōshi *who believed that when you treat people, like everything else, with kindness, opposition is avoided.*[2]

Because of his character, Rozan placed a great deal of trust and faith in personal nature, even in the *sōdō*. In the morning, even if he had woken up already, he would stay in bed and wait for the senior monk to wake him. This gave the senior monk more responsibility by allowing him to make decisions. This type of action reveals Rozan's approach to training; to monks and to lay followers he said only, "um, um," never indicating a word of resistance. As a teacher, he preferred to let lay followers be lay followers, and monks be monks, each as they are. Only in regard to meditation was he stern, using harsh words to discipline monks and occasionally striking them with a stick. He also did not judge answers to *kōan* easily, displaying a severity that was diametrically opposed to his general character. Otherwise, there was no variance in his gentle attitude.

APPROACHES TO TRAINING AND ART DURING SOCIAL UPHEAVALS

*Rozan Ekō (1865–1944),
Mamiya Eishū (1871–1945),
and Seki Seisetsu (1877–1945)*

Figure 20. Tokugen-ji

The success of the Tokugen-ji *sōdō* was largely the result of Rozan's efforts. Admired by both monks and lay followers, he was instrumental in enabling the temple to purchase 800 *tsubo* of land (1 *tsubo* = 36 sq. ft.). A new Great Buddha Hall, the Chinese-style Gate, the Main Gate, the North Gate, and the Visitors' Reception Room were all constructed thanks to Rozan's efforts; his influence in the temple was profound.

In October of 1916, Rozan invited over six hundred young monks from all over Japan to a great meditation and precepts session. The opening ceremony of the Great Buddha Hall at Tokugen-ji was attended by over four thousand lay people. Even today this grand occasion continues to be talked about.

In 1919 Rozan, following in his Master's footsteps, was appointed head abbot of Myōshin-ji, the chief temple of the largest sect of Rinzai Zen. This was a position that entailed great responsibility for temples all over Japan, and he served there for five years before retiring and returning to Tokugen-ji. In 1928 he turned over the training of monks in the Tokugen-ji *sōdō* to his *dharma* heir, Hōshū Genzui (1877–1946) and retired to the Kakoku-an (Misty Valley Hermitage), where he passed the time writing and visiting with priests and lay people.

Artistically, Rozan's brushwork is said to reflect the influence of Zen Master Takujū Kosen (1760–1833) in many works. The founder of Tokugen-ji was from the Takujū lineage; thus Takujū's artistic style influenced the work of Tokugen-ji Zen Masters through the generations.[3] The aesthetic influence of Takujū is most apparent in Rozan's image of Daruma, whose glowering facial expression resemble Takujū's earlier works.

In one such portrait (PLATE 63), Rozan depicts the story of the Patriarch crossing the Yang-tze River in China on a reed. Originally, Daruma traveled from India to China at the invitation of Emperor Wu (464–549, reigned 502–549) of the Southern Liang dynasty in Nanking. Despite the Emperor's devotion to and patronage of Buddhism in China, he did not understand Daruma's Zen teachings. As a result, Daruma left the Liang court and traveled across the Yang-tze River to the north, where he settled in a Shaolin monastery. According to Zen semilegendary history, Daruma made this journey across the river on a reed.

The earliest extant image of a *Royō Daruma* (Daruma on a Reed) dates to the thirteenth century in China. By this time, accounts of the event can also be found in numerous Chinese texts. Rozan's treatment of the figure here is more detailed than in many portraits of Daruma; in particular, the treatment of the robe is much more elaborate. The sweeping calligraphic lines and subtle wash enhance the idea of the Patriarch's voluminous robes billowing in the breeze as he drifts along the river's current. Rozan's depiction of the facial features is typical of his style, although here Daruma's brow wrinkles with great seriousness, appearing quite fierce. Perhaps this reveals Daruma's determination to find a place in China where his teachings would be fully understood. Rozan also uses gentle washes of gray ink over the eyes to enhance this sternness. The treatment of the ear is also clearly detailed here in a fully developed seashell shape, including an earring. The inscription reveals a light, fluid hand, echoing the graceful lines of the robe.

> You know he came from the West over the ocean to the East;
> But if you also know that he sat peacefully at Shaolin in the evenings,

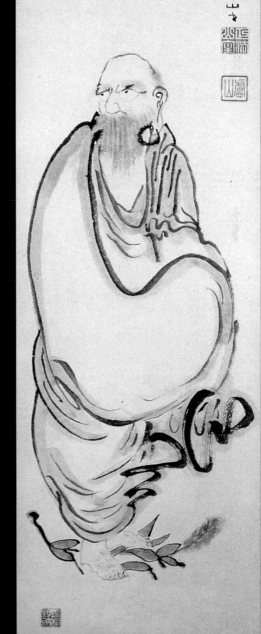

365–1944)

ED

.2 cm.

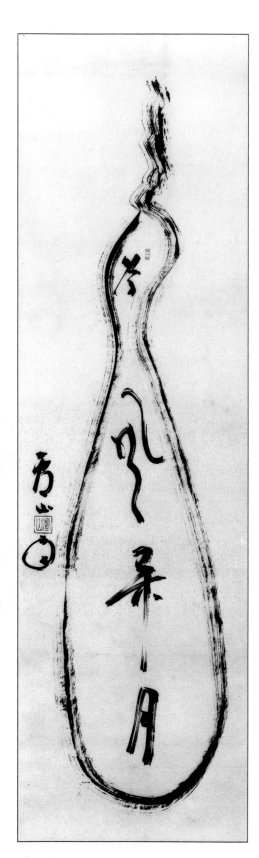

Plate 64. Rozan
GOURD
Ink on paper, 139.9 x 39.4 cm.
Private Collection

Then for you the wind in the pines,
The moon in the ivy are also pure emptiness.

In another example of Rozan's work, we see his more purely calligraphic approach; within the shape of a gourd he has written, "fragrant wind, shining moon" (PLATE 64). In contrast to the painterly brushwork of the Daruma image, here Rozan reveals a more gestural quality. From the upper tip of the gourd, down, around, and back up, and then into the calligraphy, we can feel the movement of Rozan's brush as it sweeps around and dances through the composition. This sense of rhythm and movement is enhanced by the broken streaks of black ink where the "flying white" of the paper shows through.

Despite the relatively simple theme, Rozan has created an interesting composition. Placing the first character, "fragrant" (香) in the rather narrow upper portion of the gourd, he then completed the inscription in the lower portion, allowing the characters to become larger, freer, and more dynamic as the space opens up. This is particularly evident in the second character, "wind" (風) which dances loosely and elegantly between the neck of the gourd and the wider area. Rozan has even tilted the character slightly so as to allow it to fit and expand through the space as it gently opens up.

Rozan's treatment of the gourd shape and placement of inscription is very different from Shōun's image of the gourd with a horse (see PLATE 43, page 90), in which the two lines of the calligraphy are much more conventionally and formally spaced and written. The long narrowness of Rozan's gourd is also enhanced by the final two characters, "shining" (華) and "moon" (月), which are elongated.

The work is signed "Rozan," and his familiar round cipher-signature is also present, mirroring the round bottom of the gourd. Although the final seal is present with the signature outside the image, Rozan has playfully placed the opening upper seal within the gourd, noting the beginning of the calligraphy more than the image. Is the fragrant wind about to escape as it pushes upward to the mouth of the gourd? Although it is a rather common object, here the gourd contains the fragrant wind and the shining moon—both precious in Zen for their purity.

This pragmatic, unromanticized view of life is also revealed in an image of a skull and grasses (PLATE 65) on which Rozan has written:

Once a beauty
Now a skeleton

Rozan has contrasted the deep black ink of the highly abstracted shape of the skull with the wet gray strokes of the tall grasses, which also serve to spatially distinguish the area of the inscription from the image.

The Zen idea of life and death as a natural cycle is boldly shown here, as well as the fact that no matter what our wordly achievements or attributes may have been, in the end we are just bones. The fifteenth-century Zen Master Ikkyū Sōjun (1394–1481) wrote in his "Skeletons":

Humans are indeed frightful beings.

> *A single moon*
> *Bright and clear*

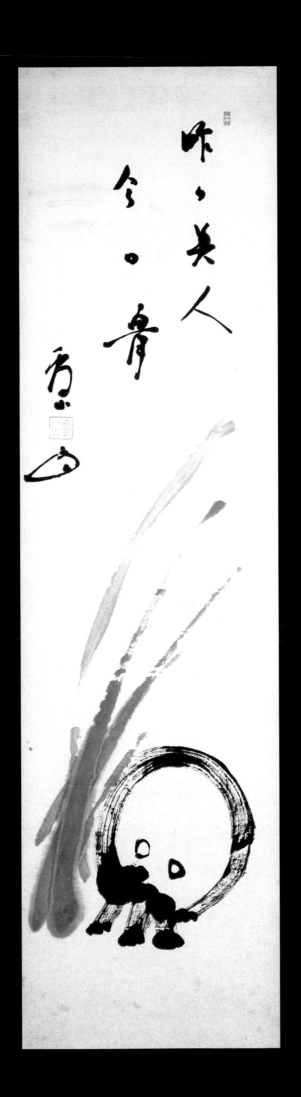

In an unclouded sky:
Yet still we stumble
In the world's darkness.

Have a good look—stop the breath, peel off the skin, and everybody ends up
looking the same. No matter how long you live, the result is not altered. Cast
off the notion that "I exist." Entrust yourself to the windblown clouds, and do
not wish to live forever.

This world
Is but
A fleeting dream
So why be alarmed
At its evanescence?

Your span of life is set and entreaties to the gods to lengthen it are to no avail.
Keep your mind fixed on the one great matter of life and death. Life ends in
death, that's the way things are.[4]

Rozan's image also refers to the ninth-century poet, Ono no Komachi, who was most probably a lady in waiting in the Heian court during the mid-ninth century. Her poems appear in the *Kokinwakashū*, an anthology of over 1,100 verses compiled in the early tenth century. Komachi's story is an unsubstantiated mixture of fact and fiction. Although there is little specific information about her biography, her poems have given life to Komachi legends that have been enhanced over the centuries by Noh plays (of which there are several concerning aspects of her life). According to these legends, she was a woman of great wealth, passion, and extravagance who was well versed in Buddhism, had many lovers, but lived in destitution in her final years. In one story Komachi insisted that a suitor, Captain Fukakusa, visit her house for one hundred consecutive nights and wait outside before she would see him. He visited in all types of inclement weather, until on the ninety-ninth night he froze to death in a snowstorm. In her old age, Komachi was said have been haunted by the spirit of Fukakusa. Old and destitute, Komachi wandered the countryside seeking Buddhist salvation.

When the poet Ariwara Narihira (825–880) was traveling in the countryside one night, he heard a voice emanating from the fields reciting the first three lines of a poem:

Every time
the autumn wind blows
ah my eyes hurt, ah my eyes hurt.[5]

In the morning, when Narihira went to search for the voice, he found only a skull with grass growing from its eye sockets. When he inquired, he was told that Komachi had died alone in that field and that was her skull. Narihira was deeply moved by the story and composed two lines to complete the poem:

Don't say "Ono. . . ."
It is the pampas grass growing.[6]

Thus, even the beautiful and talented poetess was reduced to bones in the end.

Rozan died in 1944 at the age of eighty. On his sickbed he was attended to by the owner of an inn and his wife, whose company provided great joy and ease for Rozan. He even joked with the old woman, saying, "Today I received a good shot (injection) and feel fine again. Shall I go back to the pleasure quarters now?"[7]

MAMIYA EISHŪ

Born on October 1, 1871, in Aichi Prefecture, Mamiya Eishū (also pronounced Eijū or Eisō) entered the temple Ryūtaku-ji in Mishima at the age of nine under the guidance of the priest Tengan.[8] At the age of twenty, Eishū moved to Tenryū-ji in Kyoto to train under Gasan Shōtei (1853–1900), a disciple of the noted Zen Master Tekisui Giboku (1822–1899).

Tekisui had worked to restore Tenryū-ji after it had been heavily damaged in 1864 during warfare prior to the Meiji Restoration. In 1871 Tekisui was appointed abbot of Tenryū-ji and the following year he was made supervisor of the three branches of Zen (Rinzai, Sōtō, and Ōbaku). He turned his position at Tenryū-ji over to Gasan in 1891, but in 1896, at Gasan's request, Tekisui served a second term as abbot of Tenryū-ji, until his death in 1899. During this time Gasan served as assistant abbot, and upon Tekisui's death he was appointed abbot, serving for only a year until his own death in 1900. Upon Gasan's death, Eishū became head priest of Seiryū-ji.

In his numerous writings, Eishū refers often to his teacher Gasan. In one instance he reveals the importance of focusing attention toward a single goal and not trying to be anything one is not:

> Gasan Rōshi once went to visit Matsukata-sensei, a merchant of garden stones. Matsukata-sensei became elated and pointed to a garden rock. "This rock is sold, but what do you think?" he asked Gasan. Gasan was a good judge of rocks, but he said, "As a Zen priest I don't know good and bad rocks. You must be a rock merchant or a garden teacher to know rocks."

Eishū then comments:

> Although we know a little about this and that, we are . . . not like a hundred small-type pocket dictionaries. Likewise, for a Zen priest to do only zazen is good. When a nembutsu person praises the nembutsu, that also is fine.[9] There is no disgrace in being the master of a single house; one must not be wasteful. . . . Perhaps those people who wear false clothes, those who have no strength, are merely putting their ideals in a picture frame.[10]

Eventually, Eishū went to train at Empuku-ji in Kamakura under Kōgaku Sōen, better known as Shaku Sōen (1858–1919). After four years, Eishū received Sōen's certificate of enlightenment. Shaku Sōen had been the first Zen monk to visit America, lecturing on *karma* at the World Parliament of Religions in Chicago in 1893. He later returned to America for an extended visit in 1905. Similarly, Eishū's own career as a Zen monk followed an unusual path.

During the Russo-Japanese War (1904–1905), Eishū served as chaplain for General Nogi's troops. Following the end of the war, Eishū contin-

ued his own missionary activities and began writing a series of Buddhist books. In total, he wrote over twenty such books, many of which were compilations of stories and anecdotes as well as Zen lectures. Some of the entries were originally used as public radio broadcasts in the 1920s and 1930s, again revealing the changing times and the ability of Zen to adapt itself.

In his books Eishū addressed the general public, explaining in clear, easy-to-understand terms the basic tenets of Zen practice and belief. Although he included discussions of Zen philosophy, most of his teachings were enlivened through anecdotes from everyday life, encounters he had had, and other stories that he felt conveyed Zen ideals. Although he, like other Zen Masters of the twentieth century, utilized technology such as radio transmission and modern transportation, he was nevertheless concerned with the effect of modernity on society. He reveals this concern in one story about a tea master who pays a visit to a friend:

> Long ago, a teacher who was a master of the tea ceremony enjoyed visiting friends who also appreciated tea. One of these friends was a cabinetmaker. When he saw the tea master coming, he said, "I am delighted with your visit; please come in. Right now I'm busy packing cabinets since I lack an assistant. I will be finished soon, just a moment please"; and the man continued with his packing. The tea master went out to the cabinetmaker's teahouse. The garden was untidy, littered with leaves. He waited there until the cabinetmaker came. "Please excuse the wait, I apologize. Since I've finished my work, we can leisurely chat"; he served tea to the tea master. Then the cabinetmaker said, "Today I do not have any tea sweets. Here is a yakinigiri [grilled rice ball]." Because there were two people, they split it in half and ate it. They had a very pleasant tea, and later the tea master returned to his big house with its grand tea hut.
>
> "Ah, today's tea was very sufficient, but the visit to the cabinetmaker was not completely pleasant. . . . I must invite the cabinetmaker when he has finished work. Then we can meet, pleasantly talk, and experience the heart of the tea," thought the tea master. Soon the cabinetmaker arrived at the tea master's house. Through the teahouse window a beautiful moon could be seen. While they were looking at the moon, the tea master's wife entered and said, "Ah, we don't have any rice for tomorrow, what shall we do?" "Rice? Never mind rice, isn't there a

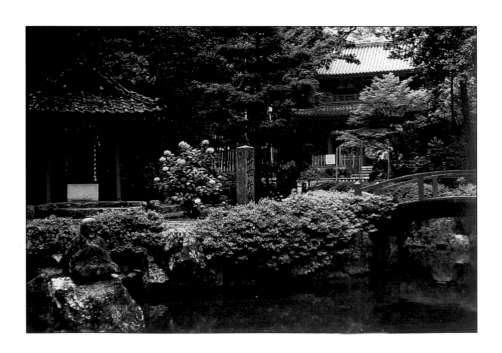

Figure 21. Hōkō-ji

144

beautiful moon out?" replied the tea master, gazing at the sky. "I said we have no rice for tomorrow," repeated his wife. "Tomorrow is tomorrow. If there's no rice, we'll drink water. More importantly, the moon is beautiful. Looking at the moon, shouldn't we just talk tonight?" After he said this, the rice was forgotten. That night the wife and the two men gazed at the moon and talked.

Eishū concludes the story by comparing the pure pleasure that the three people received from looking at the moon to modern society's preoccupation with worldly possessions. He writes:

Today we are concerned with material things, which completely vex people's minds. In this way, we do not share the feelings of the people who could just look at the moon and forget they had no rice. This materialism is especially prevalent in the Nihonbashi and Ginza areas [in Tokyo]. It's becoming crazy. We must confront this attitude and enter into a pure spirit.[11]

In 1914 Eishū moved to Rinsen-ji in Kyoto, and in 1916 he was appointed chief priest of Hōkō-ji (FIG. 21) in Shizuoka Prefecture. He also continued his active career of lecturing and writing. In his writings he often utilized the words of other Buddhist and Zen figures, including those of the poet-artist-nun Otagaki Rengetsu (1791–1875), to help convey his point. In 1937 he wrote:

Often when a wealthy believer is involved, a splendid Buddha sculpture is carved and donated for the family altar. Rengetsu rejected this and said something interesting: "To me, a main image is not about celebrating a splendid sculpture. Whether the image is splendid or unskilled makes no difference. Amida Buddha simply resides in my heart, therefore if I recite the nembutsu, I can feel a response from the divine being. As for the sculpture, I neither rejoice nor detest it. It is totally separate."[12]

Eishū's own artistic expressions seem to reflect this attitude, usually displaying a gentle, serene quality. This subdued, often charming artistry is apparent in his image of Hotei, a historical figure who lived in China, dying in either 904 or 916 (PLATE 66). Hotei was an itinerant monk who wandered the countryside carrying a huge cloth bag. His name, in fact, means "cloth sack." In this bag he carries everything he collects along his journeys. Because he wants for nothing, he is a symbol of prosperity as one of the Seven Gods of Good Fortune in Japanese folklore; but he also has a Zen interpretation, as is suggested in this scroll.

Shown with his ubiquitous cloth sack and fan, Hotei is here shown in tranquil repose—a reflection of his Zen no-mind. Compositionally, the repeated rounded forms of the bag, fan and Hotei's body are framed by the sweeping curves of his robe. Even his facial features and ears are based on gently curving lines, giving a feeling of jolliness, warmth, and compassion. Eishū has deftly blended the thin, fluid lines delineating Hotei's body and bag with a series of broader, rougher brushstrokes suggesting that Hotei's robes have now slipped haphazardly off his shoulders. The simple inclusion of these bolder brushstrokes provides a certain stability and weight to the composition, which otherwise might seem overly wispy. Even Eishū's inscription is written in rather small, delicate characters that dance playfully above Hotei's head, moving from the upper left to the lower right.

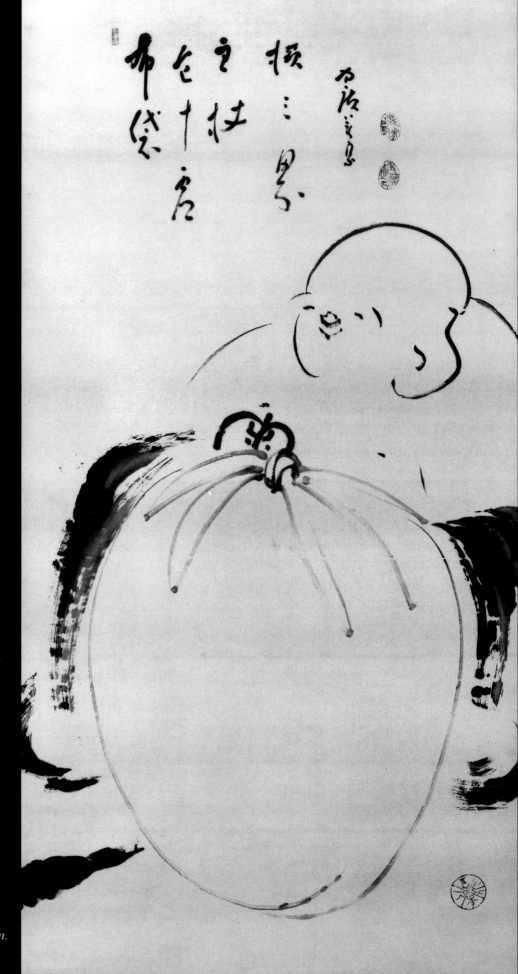

Hotei carries the weight of the whole universe in his sack.
His long staff supports the three worlds.

Despite the great burden and responsibility that the inscription suggests, Hotei remains in a state of gentle repose because he has attained the pure state of *mushin*. Although he is often shown distributing toys to children from his large sack, it has also been suggested that the sack serves as a container of emptiness; the "Three Worlds" that Hotei supports refer to the entire cosmic universe.

In addition to his evocative paintings, Eishū was capable of powerful calligraphy as apparent in the single-line scroll (PLATE 67) that reads:

Longevity Mountain,
100,000 feet high.

Here we can feel the brush's terse, abrupt, and punctuated actions. Particularly interesting is his treatment of the second character, "mountain," which originated from the pictographic image of a mountain and is traditionally written 山. Eishū quickens the gesture, hooking the strokes around, but the basic shape remains apparent.

Although many of his painted images can be described as charming, this single-line calligraphy demonstrates another aesthetic side to Eishū's work, a side that he must have felt was important. He wrote, "I appreciate Taiga's paintings, Ikkyū's calligraphy, and Sengai's paintings; the experience of them still has use beyond practicality. This strength must be retained."[13]

Ike Taiga (1723–1776) was a literati painter who studied Zen with Hakuin, Ikkyū Sōjun (1394–1481) was a Zen Master noted for his untrammeled calligraphic style, and Sengai Gibon (1750–1837) was a popular Zen Master whose images were noted for their humor and popular themes. Indeed, the terse gestures and forceful quality of Eishū's calligraphy here suggest some influence from Ikkyū, while Eishū's paintings often have the light touch of Taiga and Sengai.

In one such painting, Eishū depicts a scene from a classic Zen theme, the Ten Oxherding Pictures (*Jugyūzū*), which had its origin in eleventh-century China (PLATE 68). The complete series of images compares the gradual path to enlightenment to a herding boy's search for his ox. The ten stages are:

1. *Jingyū*: looking for the ox. Having lost the ox, the practitioner is separated from the Buddha-nature within himself.

2. *Kenseki*: seeing the tracks of the ox. Through the study of Zen teachings and monastic practice, the practitioner begins to see the path that leads to understanding.

3. *Kengyū*: seeing the ox. The practitioner gains insight into his true nature.

4. *Tokugyū*: catching the ox. The practitioner has discovered the essence and true nature of things, but like the undisciplined ox, it is hard to tame. The powers of the physical world must be conquered through great effort.

5. *Bokugyū*: herding the ox. The practitioner has discovered truth, but

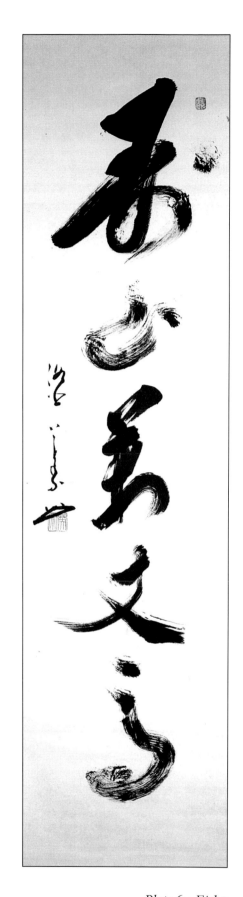

Plate 67. Eishū
LONGEVITY MOUNTAIN
Ink on paper, 132.3 x 32.5 cm.
Marsh Art Gallery, University of Richmond

he must still continue to hold on to it firmly. The deluded mind is susceptible to illusions, but these illusions are only manifestations of an unenlightened mind.

6. *Kigyū kika*: returning home with the ox. Having achieved enlightenment, the practitioner is no longer concerned with losses or gains; he has conquered dualities. Instead, as the boy returns home with his ox, the self has become one with the Buddha-mind.

7. *Bogyū sonjin*: the ox forgotten, the self remains. Now enlightened, the practitioner realizes that the Buddha-nature is within himself, and the ox for which he had been searching disappears.

8. *Ningyū gubo*: both the self and the ox are forgotten. All desire and dualities have disappeared; pure emptiness remains (usually shown by an empty circle).

9. *Henpon gengen*: returning to the fundamental, back to the source. The pure essence of nature (usually represented by an image of plum blossoms and bamboo).

10. *Nitten suishū*: entering the city to help others. Following the example of Hotei, leading a happy life free of worldly desires, the enlightened person goes about his business, helping those he encounters to achieve enlightenment (usually represented by an image of Hotei).

In this image, Eishū has depicted the fifth stage, the boy herding his ox. The inscription says:

Having time to arrive on the higher plain,
Entering the cloudlike smoke and dwelling in its depth.

The delicate lines of Eishū's painting and the use of subtle colors enhance the intimate scene and the relationship between the boy and ox. Eishū's light-hearted style lends a warmly personal quality to a subject rich in meaning and steeped in Zen tradition. Particularly delightful is the way the boy looks directly at the viewer as the ox looks at the boy; everyone becomes involved in the experience.

Oxherding images are traditionally painted within circular spaces because the circle represents a shape without beginning or end, continuous without opposition; hence complete unity. In Zen, the circle is often referred to as representing the "true void," *shinku* (see *ensō* images in PLATES 11, page 31; 87, page 189; and 90, page 193). Here not only does the circle serve as an intimate framing device, but its prominent gesture reinforces the idea that the void is the ultimate goal.

In a Zen subject seemingly unique to Eishū, he has simply made a cross with two strokes of the brush (PLATE 69). The inscription says, "Penetrate this and all will be well." The work is dated spring 1929, and it was likely given to a Japanese Christian, but despite the symbolism, Eishū still approaches it in a Zen manner, encouraging the follower to "penetrate" it as if it were a Zen *kōan*.

The uncomplicated nature of this image enhances its visual impact. While the cross almost fills the space, the two simple strokes of the brush reveal vibrant tones of gray *sumi*. The horizontal stroke in particular seems to vibrate with wet shades of ink. The vertical stroke, in contrast, begins at the

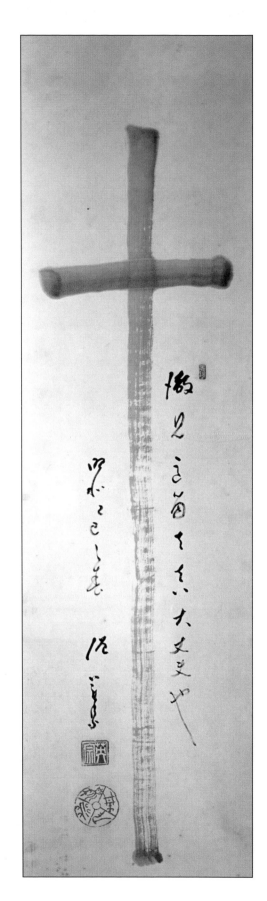

Plate 69. Eishū
CROSS
Ink on paper, 68.5 x 32.4 cm.
Private Collection

top in a similar rich manner, but as it descends it breaks into a dry sweep of the brush.

For Zen Masters such as Eishū, the teaching of Zen to followers was of the utmost importance. However, they did not deny the existence of other faiths and encouraged practice of them if it would lead the believer to spiritual well-being. Eishū's experiences traveling abroad, particularly under the uncertain conditions of war, probably gave him new insights into people's needs for some sort of spiritual guidance, be it Christian or Buddhist. And in his personal attempt to encourage spiritual awakening, he added this subject to his Zen repertoire.

Eishū reveal in his writings a particular concern that people should lead a true and sincere life, whatever their religious path. Commenting on the words of the Shingon monk Jiun Sonja (1718–1804), who said, "As for unexpected happiness, be aware of coming misfortune," Eishū noted:

> For many people, happiness means good circumstances and great prosperity; as wealth increases, the old worries of the past are forgotten. Believing that beautiful clothes and good food will always be in abundance, people's hearts become arrogant and they become warped, wanting to ride in cars rather than walking. There is no true inner spirit. Conduct becomes unrighteous, truth is discarded, and people don't look back to examine their own selves.
>
> If conduct is always righteous and the heart is always peaceful, people can have a prosperous life, but if the heart is always guilty and pained, there can be no good fortune. It is a form of premature death. If truth is not demonstrated in conduct, success will not result. . . . Good fortune yields to misfortune. In the foundation of misfortune there is good fortune. That is what I teach.[14]

Eishū was also clear in stating that beyond sincere and just actions, people should realize that the dualities one encounters in this world are products of their own minds. To live successfully according to Zen ideals, these mental boundaries and limitations must be destroyed. Eishū explained in a radio broadcast:

> For a long time I served Tenryū-ji's Gasan, and he always said, "As for speaking, if it is truthful, then even the words of an inexperienced two-year-old must be respected and admired. Admiration is an important practice in our use of words."
>
> But that's easy to say and difficult to practice. As far as I'm concerned, the idea of taking away boundaries or limitations is an interesting point. For example, when an intense heat hangs before you, you flap a round fan. It is hot. But hot or not hot is in the way your mind perceives it. The person who thinks it is hot is moved that way and wipes away beads of sweat, even if it is not hot.
>
> Also with food, tasty or not tasty is a matter of breaking people's boundaries. The same food can be delicious or tasteless. This is the wondrous part of our daily lives. At the end of this broadcast, go do calisthenics. One, two, go do it! When your stomach is hungry, go sit at a dining table. The same bits of pickle and the same miso soup that you thought were tasteless yesterday, in a moment will be different. The pickles are not tasteless, the soup is not tasteless; to us, tasteless things are in the mind. This is part of the laws of cooking; a mind that thinks food is tasteless must be cast aside. Soup is not tasteless, the mind only thinks it is. If these limited people can press their hands together in thanks for a single bowl of soup, they can discover the Great Light of Hope (daikomyō).[15]

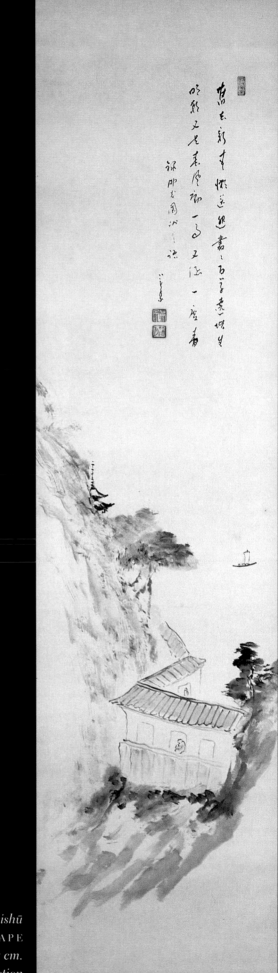

Plate 70. Eishū
LANDSCAPE
ight colors on paper, 129.7 x 32.5 cm.
Private Collection

The idea of a sincere life applied to art as well. A painter named Murakami once asked Eishū, "Please preach about the Buddha, like the ideal Buddha figure emerging from my brush. Speak about how an earnest person may or may not receive praise. How many years must pass before I am able to paint a Buddha figure without being embarrassed?" To which Eishū replied:

> As for a sincere life, first in the role of an artist, exquisite beauty is the one thing that exists. How else does one receive dignity and worth? . . . It is not only in painting and calligraphy. . . . If a person enters an evil path and becomes proud, I think his life will change. How many gold brocade robes can a monk try to wear before he becomes a worldly monk?[16]

Eishū may have been expressing his concern over the changes that Japan was encountering in the twentieth century, which he saw as potential obstacles to people living a sincere life. This sense of new replacing the old is also suggested in the inscription to one of his paintings (PLATE 70). The scroll itself is a gentle landscape done in shades of blue-gray ink. Two small figures look out from opposite sides of a winding covered bridge that passes through a gorge along a steep embankment. Beyond the bridge a single boat drifts along, providing important compositional balance, and a temple pagoda peers out from behind the cliff.

For Eishū this landscape is a rather elaborate painting. The bold strokes of gray ink that delineate the gorge provide a dramatic contrast of wet and dry brushwork as they forcefully descend down the slopes. Despite this sense of downward motion, the landscape maintains a rather quiet, peaceful feeling, enhanced by the two figures, who, despite being in the same place, are left to their solitary thoughts. The inscription above reads:

> Old times pass by, the new arrives,
> lazily sent off and welcomed;
> Thick bushes and myriad grasses
> surround the foot of the steps.
> As dawn brightens,
> spring winds are aroused—
> One moment of rain
> accompanies one moment of blue sky.

Perhaps Eishū is lamenting the changing world and attitudes around him. Yet, at the same time, he has not lost hope; there is still a sense of optimism about life as the new dawn emerges.

Eishū's own experience encompassed the difficulties of war. In January 1945, at the request of the commander of the Shanghai military force, Eishū went to China to preach. During the turbulent times surrounding the Pacific War, Eishū held great compassion and concern for the public. He consistently entreated people to strive to attain the pure heart of the Buddha. He had written in 1937, "Now a lifestyle of one hundred yen becomes a lifestyle of eighty yen; twenty yen goes to defense expenditures. Yet even in times of emergency, we must help those in distress. Still, there are those who, because they prolong ending the journey on the evil road, find that their heart is trapped like a straight line between two points; the space grows greater and greater, we must not forget this."[17]

During his visit to Shanghai Eishū became ill, and he died there at the age of seventy-five. His legacy was not only that he trained disciples in a strict Zen fashion, but that he had also been able to reach large numbers of people through his books, radio broadcasts, public talks, paintings, and calligraphy. In all these ways, he expressed both the forceful energy and the delight of his Zen spirit.

SEKI SEISETSU

Seisetsu (FIG. 22) was born into a long line of sake merchants. It would have been logical for him to continue in the family business, but his fate was otherwise determined on his birthday. It was the local custom that all children born on the first day of the first month in the Year of the Ox in Tajima, Hamasaka (Hyogo Prefecture), would be given to families in neighboring villages. As a result, despite his family's protests, the baby was given to Seki Soshun, a priest at Tenrin-ji, the Zen temple in the neighboring village. From that day, Seisetsu was trained to follow the path of a monk.

He was raised lovingly by the priest Soshun and formally entered the priesthood at the age of six, at which time he received the name Genjō. By the age of seven, Seisetsu was receiving lessons on the *Doctrine of the Mid-*

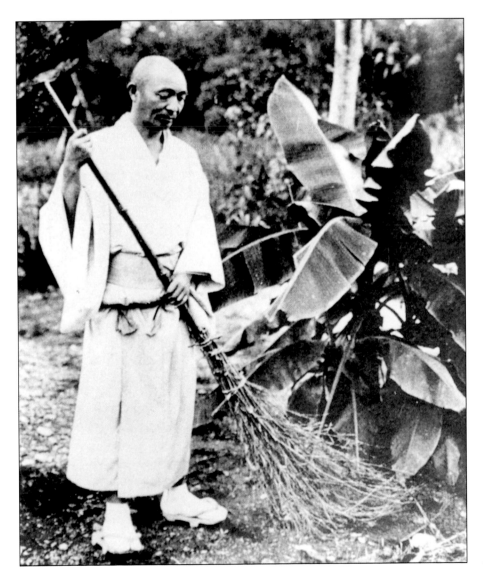

Figure 22. Seisetsu

dle *Path* and the Confucian *Analects*. His task at the temple was working as a scribe, copying Buddhist texts. It is said that copying the characters day after day affected and encouraged the young boy.

By the age of nine he was taught versification by reading the *Rinzairoku* and the *Hekiganroku* without to concern for meaning. The young Seisetsu also studied temple services, beginning his daily lessons with the *Kongo-kyo* (Diamond Sutra) and continuing to learn other important sutras and texts by ear during memorial services. Even at this young age he demonstrated an affinity for poetry and religious texts. At about this time, Seisetsu's original Master, Seki Soshun, retired and he was raised thereafter by the monk Jinshū, who once remarked that "Genjō has the manner to become a *Kanchō*.[18]

Seisetsu was first taught *zazen* on the veranda of the *hondō* on December 8. This day, refered to as *rōhatsu*, is celebrated in Zen monasteries as the day on which the historical Buddha, Shakyamuni, attained enlightenment. It is the conclusion of a seven-day meditation session called the *rōhatsu sesshin* ("concentrating one's thoughts on the eighth day of the last month"). During this meditation period, which begins on the first day of the last month and ends early on the eighth day, all usual work and administrative duties stop, and monks meditate from 3:30 in the morning until 2:30 the following morning.

In his later years Seisetsu remarked, "Every year on the eighth day of the twelfth month, I would listen to the old priest [Jinshū] read from the words of Shakyamuni. I thought, 'Someday, no matter what, I will go to that splendid India.' That vow eventually came true, and I traveled to India. I thought I wanted to go to China and I was also rewarded with that. Because the Master [Jinshū] had said that this child would become *Kanchō*, somehow I became *Kanchō*. As a rule, in great circumstances, a pure prayer is answered. Therefore, people, no matter what, should maintain their prayers. This is important."[19]

In 1893, at the age of seventeen, Seisetsu entered the *sōdō* of the sect headquarters, Tenryū-ji in Kyoto, to study under Gasan Shōtei. Like Eishū, Seisetsu served as Gasan's attendant while at Tenryū-ji. However, his relationship with his Master seems to have been rather tenuous. He recalled the severe training he received under Gasan.

> I served well as his attendant, rushing to Gasan at the first clamor of the bell. Outwardly, he was a different person; his appearance was solemn and majestic, but in truth, he was fierce. As soon as you assessed his appearance and assumed a solemn nature, he would press your neck with his left hand, and with his right hand continue to strike you with a stick thirty times. There was even a monk whose head ruptured with blood [from the beatings]. At night inside the monks' quarters, his disposition was similar. During the nightly meditation sessions, the enemy would be made of green bamboo. If you fell asleep, you would be made to benefit from a strike from the green bamboo. All in all, he had a stiff, unsociable manner. Only in his eyes did you see his great authority. Many bones were broken.[20]

It is possible that Gasan had himself learned these severe training methods from his own Master, Tekisui Giboku, who had once kicked Gasan, breaking his ribs.

After a year in the Tenryū-ji *sōdō*, Seisetsu had the opportunity to visit his family. During his journey he stopped to pay a call on the monk Hokuon, who had recently taken over the temple Shōgen-ji. Hokuon was a slightly eccentric figure; upon his appointment to Shōgen-ji he had received a letter from his own Master asking him to return home because the temple where he began his training had burned down. Hokuon burned the letter and remained where he was to continue his work. Although he gained great popularity among his practitioners, eventually he did return to help his Master. However, when he was later approached to receive the position of abbot of Nanzen-ji, he did not reply.

During Seisetsu's visit with Hokuon, the two exchanged brief greetings; then Hokuon began to speak to the young monk.

> *"Your training in the Master's sōdō must be something."*
> *"Yes, I have the honor of training with Gasan."*
> *"Ahh, Gasan. I don't know that name. But whichever man makes no difference. Whose* dharma *heir is he?"*
> *"I don't know," replied Seisetsu frankly.*
> *Suddenly, Hokuon's face changed gravely. "What? You don't know the* dharma *lineage of your own training Master? Ah, what kind of training are you receiving?!" he asked in a loud voice.*[21]

This encounter shook Seisetsu's confidence, and he went into seclusion in Kyoto. He gradually collected himself and determined to return to his training with greater diligence.

During the Sino-Japanese War of 1894–95, times grew hard for much of the Japanese population, and many people turned to temples for assistance. Seisetsu was still under the training of Gasan, but Tenryū-ji was opened up to the public, and a large hall was prepared. Bedding was borrowed and collected until eventually a dormitory emerged. Up to this point, the temple storehouse had been maintained to support forty people, but soon there were eighty mouths to feed.

During the confusion of the war, times were difficult even for begging monks because people had nothing to offer. At the temple, everyone subsisted on thin rice gruel, and because *miso* (soybean paste) was rare, there was a mixture of rice bran and salt, occasionally seasoned with chopped *kombu* (seaweed) received from local restaurants. Because of the dire situation, it was impossible to maintain strict rules. Instead, an atmosphere of doing whatever one could, contrary to one's own desires or previous plans, was evident. It was unforgivable to turn away someone in need. Eventually there were one hundred needy arrivals at the temple, and soon many other Zen abbots were opening their temple halls and storehouses to the masses, including Dokuzan and Eishū.

Seisetsu studied under Gasan for seven years at Tenryū-ji until Gasan's death in 1900. At this point Ryūen Gensui (1842–1918), who was also a disciple of Tekisui Giboku, assumed leadership of the Tenryū-ji *sōdō* for a year. After turning the Tenryū-ji *sōdō* over to his disciple Taigoku Shūdai in 1901, Ryūen entered a brief retirement. However, he was asked to establish the Tokkō-in subtemple in Kobe, where he remained and served as abbot until 1913.

Seisetsu accompanied Ryūen to the Tokkō-in and continued his

training there. In contrast to Gasan's fierceness with monks, Ryūen seems to have had a more compassionate nature. During the *tenzaeki* (enthronement ceremony) for Ryūen at Tokkō-in, guests began arriving for the ceremonial meal. Among them were a few who often scolded the novice monks serving the meal, saying they were annoying. Seisetsu, trying to clear a plate, asked one of the guests if he was finished, and was quickly reprimanded by the guest. Ryūen, upset by his guest's behavior, did not eat his meal, and it sat there untouched. The following morning his meal continued to sit there untouched. He was still angry. His meal sat there through the afternoon until he finally ate. Thus, Ryūen held great sympathy and compassion for his monks and responded strongly to them.[22]

Seisetsu remained with Ryūen for ten years, eventually receiving *inka* from him. Upon completion of his training, Seisetsu served as chief priest of the Jizai-in and Tokkō-in, both subtemples of Tenryū-ji. He was now beginning to establish his own place as a Zen teacher within the Tenryū-ji subsect. In 1917 he traveled to China, and from his travels wrote a book that he called "Daruma's Footprints."

One of his disciples remarked, "I became a student on the fifth day of the third month, 1930. After half a year, I began to work for Seisetsu. What surprised me was that he revealed to me and the other monks the whole life and being of a monk. Why did I admire this transmission of the nature of life? Because he taught everything very concretely. Today, we rely on money, yet amusements should come from the self with no reliance on money." There was one aspect of training, however, in which Seisetsu refused to help his monks: defeating wine and women. He simply stated, "Those who fail because of wine are only capable of going as far as wine. Those who fail because of women are men who are capable of going only as far as women. Their training will never progress."[23]

Another disciple, Seki Bokuō, the current abbot of Tenryū-ji, recalled a further anecdote about Seisetsu's nature as a teacher and Zen Master:

Figure 23. Tenryu-ji

When I was very young, I refused to work in the temple. But because the fifth-generation head of the Kiyomizu pottery was retiring and was to be given an honorary name from Tenryū-ji [I agreed to work]. The potter was also to present a large ceramic plate to Seisetsu. As Kiyomizu was putting things in order, I picked up the plate to place it before him. As I picked up the plate, however, it suddenly slipped from my hands. The dish broke in two, my stomach jumped, and I instantly fainted and fell on top of the broken plate. The Master's voice called out, "Hey, you're not hurt, are you?" Thinking about his compassionate words, I realized that simply crying and asking, "Why me?" while I picked up the broken dish was no solution. With his words, my destiny changed, and I decided to devote my lifetime of service to Seisetsu. I followed this plan from when I was sixteen years old until his death.[24]

Seisetsu was appointed *Kanchō* of Tenryū-ji (FIG. 23) in 1922 at the age of forty-five, replacing Taigoku Shūdai who had passed away. Thus, Jinshū's prediction about the young Seisetsu had been fulfilled. One of his first orders of business was to reorganize, restructure, and rejuvenate Tenryū-ji. For the monks' *sōdō* he enlisted the help of the Jizai-in's Murakami Dokutan and Shōgan-ji's Hirata Tekizen to oversee the training facility and program. During his twenty-year term as *Kanchō*, Seisetsu built

new chief priest's quarters and made many repairs. The contents of the storehouse were improved and many treasure halls were rebuilt.

At this point Seisetsu was able to turn his attention to art. Although his elevated position as abbot enabled him to express his artistic side as an aspect of his Zen mind, his appreciation and interest in art had begun much earlier; some scholars have even suggested that it was inherited, since Seisetsu's father, Kabumoto Yasuhisa, had been a noted painter known by the art name Sozan. Despite his own background in art, however, Seisetsu's father did not encourage his son's artistic inclinations. During a visit home, the young Seisetsu was found copying some of his father's painting albums. He was promptly scolded by his father, "You were sent to the temple to become a good monk, not to learn how to paint."[25]

However, Seisetsu's inclinations could not be ignored. Although he was not free to pursue artistic expression during his training, he had been taught to use a brush skillfully through his job as a scribe. Of course, as a monk he had no specific training in painting, but he sometimes asked a senior monk, Hashimoto Dokuzan, a noted painter who had also trained under Gasan and eventually became abbot of Shokoken-ji, about the nature of art. Dokuzan explained: "See as many old paintings as possible, and look for the scenic peaks, poetic composition, and structural influence that the heart understands, and which cannot be found elsewhere."[26]

Seisetsu followed this advice. While residing at the Tokkō-in and Jizai-in subtemples of Tenryū-ji, he was able to study many of the old paintings owned by the temple, thereby enriching his aesthetic taste and developing his eye. He was very sincere and diligent about his study and practice of brushwork.

Seisetsu once encountered a calligraphy board reading, "Sōryū-en" (Garden of Twin Dragons), written by Jiun Sonja, which he admired quietly by himself. He later stated that he had great appreciation for Jiun's calligraphy, which he sometimes studied and strove to match in quality. Small aesthetic encounters such as this often had great influence on Zen Masters.

The influence of the bold, terse brush style for which Jiun was famous can be seen in a single-line calligraphy by Seisetsu, "Ten thousand laws return to one" (PLATE 71). All of the openings and closings of the brushstrokes here are open and rough rather than rounded off smoothly, another feature borrowed from Jiun's calligraphy. Here the first two characters, "ten thousand" (萬) and "laws" (法), are written in a strong, running style, but there is nothing especially unusual about them. In the third character, "return" (歸), however, Seisetsu draws the vertical down almost to the bottom of the scroll. The ink on the brush dries and breaks as it progresses down the paper, revealing patches of "flying white." Jiun was famous for his use of this type of rough, broken ink.

After the boldness of the first two characters and the dramatic vertical descent of the third character, Seisetsu finishes with a terse little horizontal stroke of the brush for "one" (一). The ten thousand laws of Buddhism come down to this "one," and Seisetsu has reduced it to as minimal a gesture as possible.

Seisetsu's calligraphic style has also been said to resemble that of Tekisui and, later in life, of Hokuon and Ryūen. His style was also have said to have changed when he was sixty-four years old when, by chance, he saw a calligraphy by Ikkyū reading, "Strike the Bamboo" (a reference to the monk

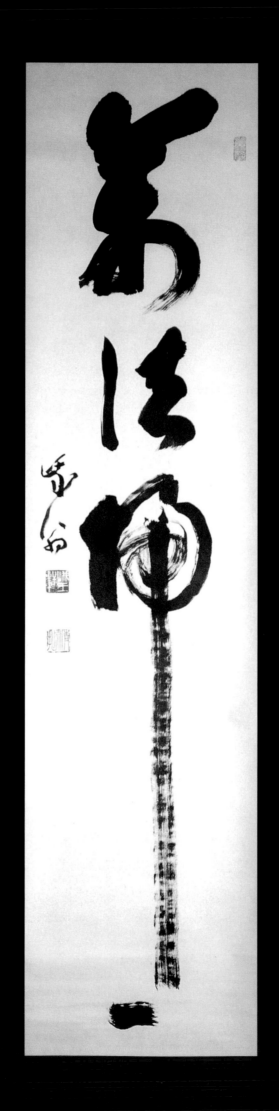

Plate 71. Seki Seisetsu (1877–1945)
RETURN TO ONE
Ink on paper, 131.9 x 31.7 cm.
Private Collection

who was enlightened when a small rock he was sweeping struck a bamboo). The elegance and individualistic strength of Ikkyū's style deeply moved him. This sense of elegance can be seen in Seisetsu's scroll of a branch of plum blossoms, above which he has written:

> *A single blossom and it is spring,*
> *Although there are ten thousand miles of snow south of the river.*

In place of the dramatic abrupt quality of the single-line calligraphy, here Seisetsu utilizes a lucid style in which he compositionally places the elegantly written phrase in diagonal opposition to the lovely plum branch (PLATE 72).

Plum blossoms, along with the pine tree and bamboo, are considered to be among the "Three Friends of Winter," appreciated for their ability to bloom while the weather is still cold, often while snow still covers the ground, as this inscription suggests. In the *Shōbōgenzō*, Dōgen's fundamental text of Sōtō Zen, the fifty-ninth volume bears the title *Baige* (Plum Blossoms). Within it, Dōgen gives the allegory about an old plum tree that was used by the Chinese Zen Master Ch'ang-weng Ju-ching (1163–1228) to instruct his pupils:

> *A plum tree blooming in the snow is the manifestation of the* udumbara-*flower [which Śākyamuni held up before Mahākāśyapa]. We have the opportunity to see the Eye and Treasury of the True law of the Tathagata in our everyday life. Yet most of the time we lose the chance to smile and show our understanding. However, my late master has transmitted the principle of a plum tree blooming in the snow and that clearly reveals the Enlightenment of Buddha. The wisdom of Enlightenment is the supreme wisdom, and if we study the plum blossoms more deeply we will undoubtedly realize this. A plum blossom is the observation that "Above the heavens and throughout the earth I am the only honored one"—each thing is the most honored thing in the world.*[27]

This subject has been captured by artists through the generations; the crisp, delicate beauty of the blossoms, which denote the arrival of spring, contrasted with the strong, gnarled branches. Seisetsu's use of space here is quite dramatic despite the rather gentle nature of the subject. Although separated in the upper and lower portions of the scroll, the text and image interact by means of the slender plum branch, which reaches upward as the calligraphy drifts down. Seisetsu once remarked about the art of calligraphy:

> *It is best to write simple characters; do not be indulgent, because in writing humble characters you are writing just those characters. Since it is to be hung in the* tokonoma *alcove, it must have dignity and refinement.*[28]

This sense of quiet dignity is also apparent in an image of a bull resting next to a planter full of grasses painted on a ceramic *mizusashi* (jar for holding water used in the tea ceremony) made by the potter Itō Tōzan (PLATE 73). The inscription says simply, "Water the color of grass." The meaning is rather cryptic, but one can consider that in Asia, water buffalo are used to plow rice paddies, thus their watery existence is the color of grass. The fact that Seisetsu chose to include this image and inscription on a ves-

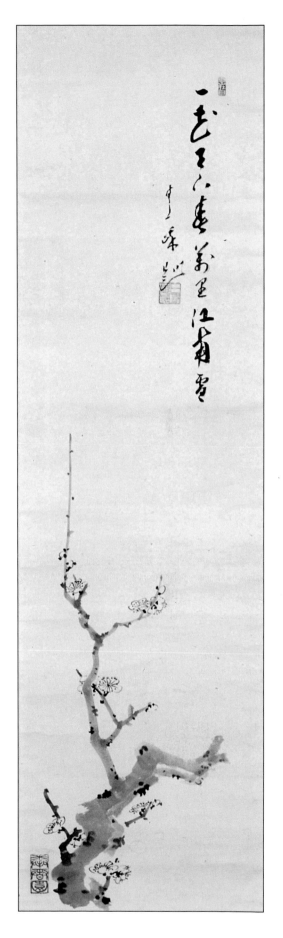

Plate 72. Seisetsu
PLUM BRANCH
Ink on paper, 101.4 x 26.9 cm.
Private Collection

159

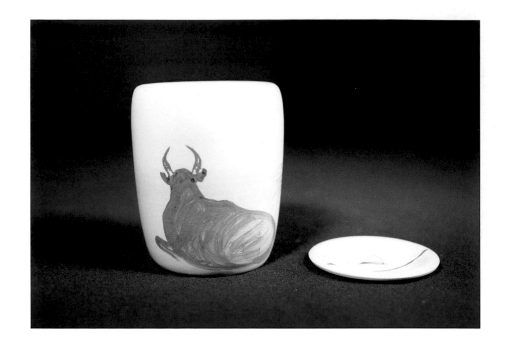

Plate 73. Seisetsu
MIZUSASHI
Glaze on ceramic, 18 cm. tall
Gubutsu-an

sel used to dispense water for the tea ceremony is also intriguing. Bulls are also an important symbol in Zen, as discussed above regarding the Eishū painting of oxherding.

Seisetsu's successor at Tenryū-ji, Seki Bokuō, said, "Seisetsu Rōshi's *zenga* all came to have a bright, cheerful characteristic. He painted various types of Daruma, and as a whole, his open-hearted personality is clearly evident."[29] We can compare two vastly different approaches to Daruma by Seisetsu. The first, a large portrait of the Patriarch, reveals the immense power of Seisetsu's brush (PLATE 75). He delineates the figure with a series of broad strokes in which streaks of "flying white" appear through the dramatic applications of black ink. The heaviness of the brushstrokes is highlighted by gray wash, deftly applied to create the Patriarch's thick beard and neck, while a touch of humor appears in Daruma's slightly sorrowful expression (PLATE 74).

Plate 74. Seisetsu
LARGE DARUMA *(detail)*

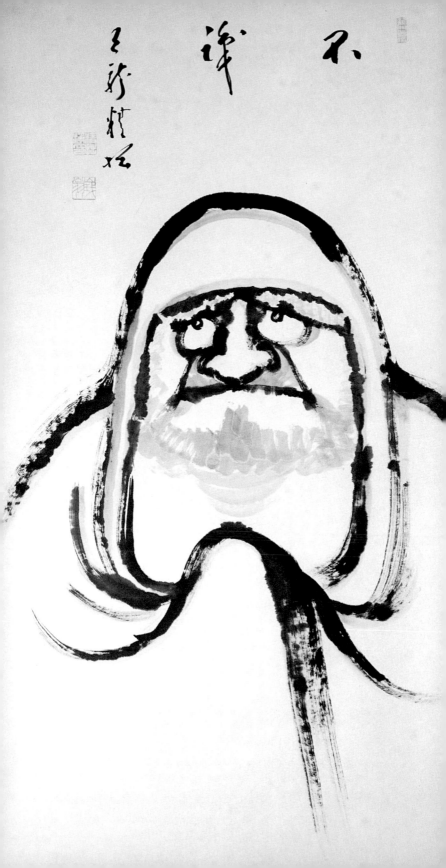

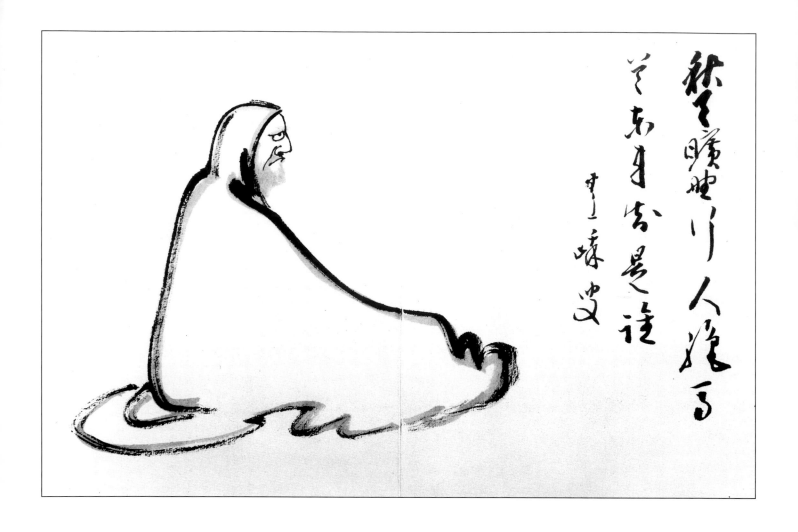

Plate 76. Seisetsu
SEATED DARUMA
Ink on album paper, 24.2 x 36.3 cm.
Private Collection

Above, Seisetsu has written only two words, *Fushiki* ("not know"), a reference to the story of Daruma's meeting with the Chinese Liang dynasty Emperor Wu in the year 520. During their encounter, the Emperor asked Daruma what merit was gained from endowing temples and monasteries, to which Daruma answered, "No merit." When the Emperor then inquired about the basic principle of doctrine, Daruma replied, "Vast emptiness, nothing sacred." "Who, then, now stands before me?" asked the Emperor. Daruma replied, "*Fushiki*" (usually translated as "I don't know" but literally meaning "not know" or "not knowing").

Seisetsu apparently had a strong personal affinity for Daruma. Not only did he paint this subject often and in various styles, but when he became tired he was said to have called upon Daruma to renew his energy. The figure of Daruma would then appear to him, and he would always say, "Good, I did it!"[30]

In contrast to the powerful image in PLATE 74, Seisetsu also painted a smaller image of Daruma on an album leaf (PLATE 76). Technically, he uses the same combination of heavy black ink highlighted by gray washes to delineate the Patriarch wrapped in his robes. Here, however, Daruma appears from the side in seated meditation with a much fiercer, more determined expression on his face. Despite the smaller size within the album leaf, the spiritual strength of the figure is conveyed clearly, reflecting Seisetsu's reverence for him. According to legend, after Daruma left the court of Emperor Wu, he traveled north and settled at a Shaolin temple where he meditated in front of a wall for nine years.

Seisetsu's inscription, referring to the whisk as a symbol of the Zen Master, reads:

> In the wilderness under the autumn sky
> no one travels.
> When the horsehair [whisk] from the east arrives,
> who is it?

Seisetsu's own personal appreciation and love of art not only deepened his understanding of aesthetics and encouraged his personal discipline in brushwork, but also made him more aware of others' appreciation for his own work. Seki Bokuō, serving as Seisetsu's attendant, recalled:

> Once, when we visited the house of a devotee in Osaka, there was a gold screen on which the owner wanted to have something painted. He was delighted to receive the Rōshi and have him paint something. Seisetsu lined up the screen on the tatami matting and began stepping on it. In this surrounding, everyone was amazed, but he calmly said, "Getting up on a screen to paint on it will not break it." Then he rolled up a piece of newspaper and, using it as a brush, began painting with it. In an instant, there was a splendid painting of a pine tree on the space.[31]

Despite Seisetsu's usual magnanimous nature regarding his calligraphy, Bokuō also recalled one instance when Seisetsu was less inclined to do brushwork:

> There was a memorial service that we proceeded to, and because the Rōshi had gone to such great pains to get there, the mayor of the town, who was the chief mourner, requested a calligraphy from the Rōshi. Although he was always ready to consent, that time he firmly said, "I will not do any ink work here," refusing in all seriousness. However, the mayor entreated him again, so the Rōshi replied, "I will write just one sheet," and he drew a picture of the mayor himself. Receiving a painting had become this man's one motive; this one focused motivation was enough, and through the splendid painting his spirit came alive, indeed the mayor's courage emerged as a personal characteristic. For the purpose of believing in oneself, do not compromise with the world, the Rōshi explained in his pure manner, and the energy in the room increased. I think the Rōshi was expressing his true heart.[32]

In this case, Seisetsu saw not merely an appreciation for his art, but also how it enabled the mayor to totally focus his energy and being, which came alive through the motivation for Seisetsu's brushwork.

The relationship between art and human nature was something Seisetsu seemed to understand deeply. Not only did he appreciate the ability for people's characters to strengthen through their desire for art, but he also saw the potential for revealing aspects of human nature and teaching spiritual lessons at the same time. This approach is seen in an image of a woman gazing at herself in a mirror (PLATE 77). She is not pleased by what is reflected back at her and says,

> If I look at my heart
> in the mirror,
> I'm ashamed because it
> looks like this.

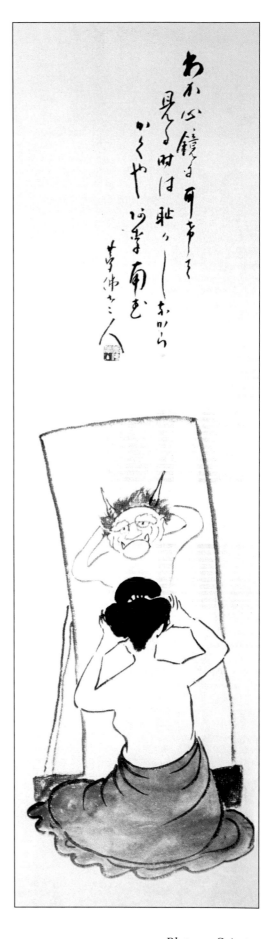

Plate 77. Seisetsu
WOMAN LOOKING IN A MIRROR
Ink and color on paper
Private Collection

163

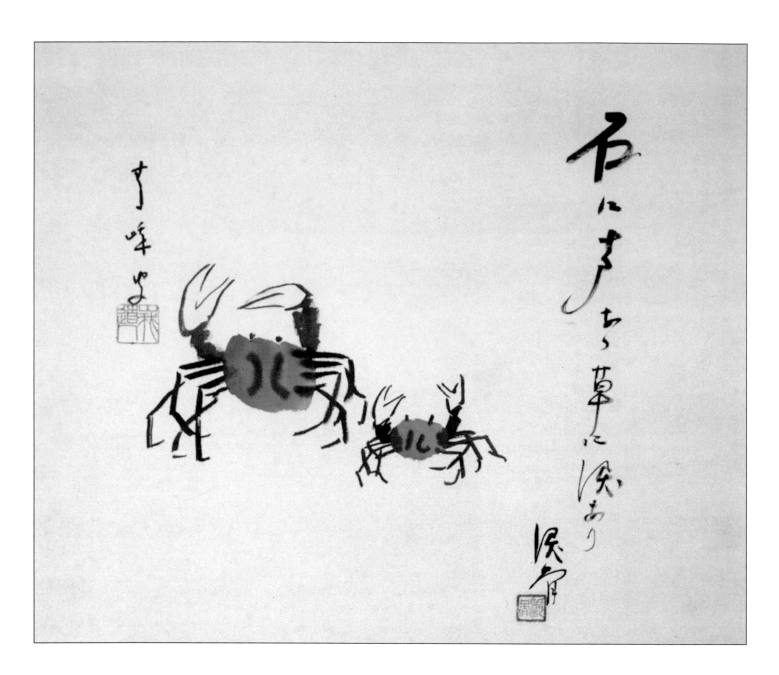

Plate 78. Seisetsu
TWO CRABS
Inscription by Sugimura Sojinkan
Ink on silk, 37 x 42.9 cm.
Oliver T. and Yuki Behr Collection

The image is rather charming and humorous, but at the same time it cuts deeply into the human psyche. Like many Zen Masters, Seisetsu understood the suggestive power of art and its ability to make people examine their own nature more deeply.

Requests for Seisetsu's *bokuseki* (ink traces) were numerous and came from all levels of Japanese society. Once, he received a postcard requesting a work from a homeless man who lived under Tenman Bridge in Osaka. Seisetsu promptly wrote something and sent it off addressed to the "Palace under Tenman Bridge." Despite his love of painting and brushwork, Seisetsu never forgot his position as a Zen monk; according to one anecdote, Seisetsu was at a restaurant in Arashiyama (west of Kyoto) drinking and doing calligraphy. However, when the appropriate time came, he stopped to do his meditation.

The bright, cheerful quality of which Seki Bokuō spoke earlier is particularly evident in Seisetsu's charming *Two Crabs* (PLATE 78), accompanied by the free-style haiku poem:

In the rocks, there are voices —
In the grasses, tears.

This poem was composed and inscribed on the painting by Sugimura Sojinkan (1872–1945), a journalist from Wakayama who wrote *New Buddhism* in 1900 and who worked for the Tokyo *Mainichi* newspaper. From 1904 to 1905 he traveled in England, eventually publishing his travel diaries as well as novels.

The artistic combination of painted image and haiku poetry is referred to as *haiga*. In contrast to the bold, powerful images associated with Zen, *haiga* tend to be more delicate, light-hearted, and charming, as exemplified here by the pair of crabs with their claws raised high. In *haiga*, the image does not necessarily illustrate the poem, nor does the poem always explain the image. Instead, the two serve to enhance one another by suggesting richer, more multidimensional interpretations and relationships.[33] It is these potentially more complex interpretations that the viewer may impart to the image which make the otherwise apparently simple poems and images of *haiga* so appealing, and so uniquely Japanese. The poem and painting here present an interesting and somewhat contrasting combination of image and text. Both are conveyed in a rather casual manner, with little regard for formal spatial organization or brushwork, but they offer different moods of nature simultaneously.

In a scroll that reflects a completely different style and attitude from the crabs, Seisetsu depicted a ghost rising into the sky (PLATE 79). There is no inscription, so it is difficult to determine what Seisetsu is trying to convey. However, ghosts have long played an important role in Japanese culture and artistic expression. This seems to be a *yūrei*, a female ghost who had been ill-treated in her life. In Japanese folklore, ghosts are beings who reside in an interim world, between their earthly existence and their eternal world where they will become an ancestor spirit. In this state, angry or unhappy spirits can wreak havoc upon the living, haunting their former residences and creating stress and fear for anyone who may have mistreated them.

Although ghosts and angry spirits have played a part of the Japanese imagination for centuries,[34] they did not become popular in art until the Edo period.[35] At this period, ghosts were depicted with long, disheveled hair and either a scowling or a sadly forlorn expression. Most important, their feet were never visible, allowing them to rise eerily from nowhere.

Although depicted by many artists in different styles, during the Edo and Meiji periods, ghosts were not part of traditional Zen subject matter. The Zen Master Hakuin Ekaku (1685–1769) often painted images of goblins and demons, but not ghosts. Thus, Seisetsu seems to be introducing a new subject to Zen. More significantly, he is borrowing a theme already established in popular culture; Seisetsu's ghost closely follows traditional compositions. However, his rough brushwork, particularly the crude horizontal strokes with which he fills the background and the broken patches of hair, enhances the already uneasy quality. Instead of signing this image with his usual signature and seals, Seisetsu has simply placed his cipher-signature within the lantern before the ghost.

Seisetsu had many opportunities to experience the darker side of life. During the Pacific War (1941–1945), he made sympathy visits to various army hospitals, and toured Manchurian and Korean army divisions. He held many Buddhist meetings to provide spiritual guidance for the troops, and at the ceremony for the opening of the Northern Capital (Manchuria), he ad-

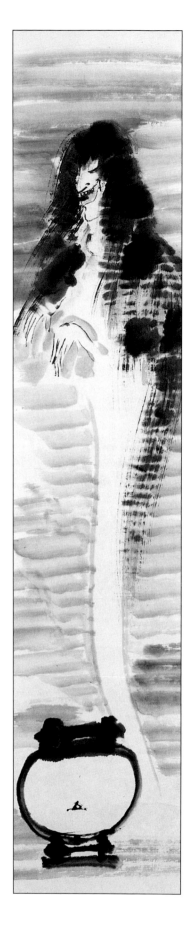

Plate 79. Seisetsu
GHOST
Ink and color on silk, 135 x 26.2 cm.
New Orleans Museum of Art:
Museum Purchase, Friends of Asian Art

vocated a means of peace through the cooperation of Japanese and Chinese Buddhism. Seisetsu also gave a series of talks that were published in 1942 under the title "The Promotion of Bushidō" (*Bushidō no kōyō*). In this work he discussed the long and complex relationship between Zen and *bushidō* (Way of the Warrior) and their combined integration into Japanese culture, which he believed should continue into the modern era. However, the goal of this relationship, according to Seisetsu, was peace. He wrote:

> *The true significance of military power is to transcend self-interest, to hope for peace. This is the ultimate goal of the military arts. Whatever the battle may be, that battle is necessarily fought in anticipation of peace. When one learns the art of cutting people down, it is always done with the goal of not having to cut people down. The true spirit of Bushidō is to make people obey without drawing one's sword and to win without fighting. In Zen circles this is called the sword which gives life. Those who possess the sword that kills must, on the other hand, necessarily wield the sword which gives life.*[36]

Japan, of course, faced immense devastation following the Second World War. Defeated and isolated, Japan was on the brink of starvation. In September 1945, although gravely ill, Seisetsu stated, "For the purpose of Japan's recovery, the whole nation needs to strive for a spirit of universal brotherhood. . . . This is not a time to idly do *zazen*; right or wrong, it is instead time to do something, because if within myself I recover, together we can all recover. Until that time, I entreat you to do this."[37]

A month later, just before his death, Seki Bokuō asked Seisetsu to leave his last words. Seisetsu replied, "Having lived until today, the training I have done all my life completely expresses my last words." Then, with an odd expression on his face, he laughed.[38]

In 1950, D. T. Suzuki (1869–1966) began a decade-long tenure in the United States, lecturing on Zen and Japanese culture at Columbia University in New York and Claremont College in California. As a result, he became known as a "Bridge of Buddhist Law and Eastern Culture." Eventually, in 1965, at the age of ninety-four, Suzuki decided it was time to retire and return to Japan. However, while he was concerned about who would continue his duties in America, Columbia had decided that it did not want another Zen scholar to take his place, but instead an actual Zen Master. Suzuki decided to ask Shibayama Zenkei, from Nanzen-ji in Kyoto, to consider the possibility.

Suzuki, who lived in Tokyo, made numerous requests through Shibayama's interpreter Sumiko Kudō, who regularly visited Nanzen-ji, but Shibayama continued to decline the offer. Eventually, Suzuki paid a personal visit to Nanzen-ji and made a direct plea to Shibayama.

"Shibayama-san, there are many hardships, but please consider it."

"I am already an old Zen Master; I do not want to go to another country. If I go, I might do something embarrassing."

"From my vantage point, you are still young."

Shibayama was seventy-one years old. The words "you are still young," coming from the ninety-four-year-old Suzuki, struck a chord, and Shibayama agreed to make the journey to America.[2] This journey began a series of visits that still continue today with Shibayama's *dharma* heir, Fukushima Keidō.

SHIBAYAMA ZENKEI

Shibayama Zenkei (FIG. 24) was born on November 30, 1894, to a large family in Aichi Prefecture. He was a scholar from his youth; one of his younger brothers remembered that he "often heard from my older sister that she would place a cup of tea on his desk, but all he would do was read."[3] While in elementary school, like many boys his age, Shibayama had ambitions of becoming a military general, but he was not physically strong enough to enter the junior military academy. Influenced by one of his uncles who was chief abbot of Myōshin-ji, Shibayama decided that if he could not become a general, he would become a Zen abbot.

As a result, after graduating from elementary school, he entered the priesthood at the age of eleven at Kokubun-ji in Aichi Prefecture under the priest Hattori Zenrei. Every night Zenrei would teach the young Shibayama to read Chinese characters phonetically, without worrying about their meanings (just as the young Seki Seisetsu had learned). If the young boy became sleepy or restless, the lessons would stop. By the following year, Shibayama was making use of these lessons, reading poems.

In 1908, at the age of fourteen, Shibayama went to Kyoto and entered Manshō-ji. He also officially left the Shibayama household and began studying Zen through the chief priest at Reiun-in, a subtemple of Myōshin-ji. The following spring he entered high school and did not return home during school vacations, instead spending his free time cleaning and working at Reiun-in and Manshō-ji.

Upon his graduation from senior high school in 1914, Shibayama be-

BRIDGES OF ZEN

Shibayama Zenkei (1894–1974)
and Fukushima Keidō (b. 1933)

Brought along for a hundred
years to be a bridge
Directly pointing to the field of
the heart:
this is the site of enlightenment
The 84,000 dharmas of peace
and bliss
Can be taken up right here.[1]

Figure 24. Shibayama

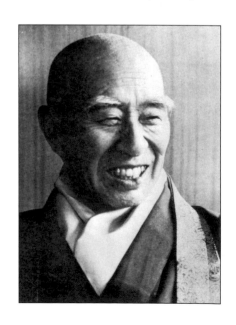

gan studying at Hanazono University, a school affiliated with the Rinzai Zen sect in Kyoto. However, as his studies progressed, he found he could not blindly follow the Buddhist path put before him, and he became increasingly interested in Christianity, eventually transferring to a Christian university. Shibayama planned to join a Christian movement led by Kagawa Toyohiko, which advocated helping the less privileged by living among them, but he changed his plans because of his frail health and his mother's pleas not to leave the priesthood. Shibayama also began to embrace Dr. Ludwig Zamenhof's advocacy of a world with a single language, and he began studying Esperanto, eventually becoming a leading Esperanto scholar in Japan. However, this type of ideology was considered dangerous in those days, and Shibayama's name appeared on the blacklist of the secret police.

One day while still pursuing various spiritual paths, Shibayama went to a lecture given by the Zen Master Mamiya Eishū (see chap. 6), who explained that it would be nice to be able to cover the whole world in leather and be able to walk anywhere without dirtying or hurting one's feet. But since this would be extremely difficult, it was better to cover the soles of one's own feet with leather. Moved by the idea of training oneself instead of idealistically trying to change the whole world, Shibayama entered the Nanzen-ji *sōdō* in 1916. Years later when Shibayama began giving Zen lectures, he also used Eishū's story, and today his disciple Fukushima Keidō uses the same story when lecturing in the United States. Many Zen temples in Japan have a sign that says, "*shōkokyakka*" ("Look under your feet"); seven hundred years ago a disciple asked the Zen Master Sankō, "What is the essence of Zen?" Master Sankō replied, "*shōkokyakka*."

Shibayama's Master at Nanzen-ji was Kōno Mukai (1864–1935),[4] a strict teacher whose determination and single-mindedness Shibayama discussed in an essay on Zen:

> My master, the late Rev. Mukai Kōno, was the Chief Abbot of Nanzenji Temple. While in his novitiate, he devoted himself for several years to sitting in meditation so fervently that all his colleagues were struck with admiration. At last he succeeded in reaching the state of overcoming all distinctions and consciousness. He had reached the high state, "He walks, but he does not know he is walking. He sees but he does not see." One day, while walking in the compound of the temple where he was studying, he did not see there was a pond in his way. He kept on walking into the pond, just as if he was striding on the solid earth. He returned to consciousness by a loud cry of other people, and found himself standing in the pond with the lower half of his body soaked in water. On the border of the pond, his colleagues were extending a bamboo rod and yelling to him to grasp it in order to be dragged out of the water....."To such an extent I had myself sat and meditated," were the words of my master.[5]

Kōno's determination as a monk was later reflected in his severity as a teacher; as Shibayama recalled:

> I had already spent three years at the monastery and was in the abyss of darkness. I did not know how to proceed, where to go or what to do. There is an occasion in the *sesshin* (the intensive week-long training period at the monastery) when every monk has to go to the Master's room for *sanzen* which is the occasion for a monk to show his Zen ability to his teacher in private. (It

is totally different from logical or philosophical discussion, or questions and answers.) I struck the bell of sanzen *and stepped into the Master's room feeling like a lamb dragged to a slaughter house, for I did not have anything to say. In a fix, I instantly raised my hand and exclaimed, "Truth pervading the whole universe!" The Master, with piercing eyes, stood up and drove me out of the room of* sanzen *, saying, "You good-for-nothing monk! You had better return to college!" I shall never forget the pain I had at this Master's rebuke.[6]*

After ten years studying under Kōno Rōshi at Nanzen-ji, Shibayama completed his monastic training and received Kōno's certification. He then decided to continue his academic career while also serving as chief priest at the Jishi-in, a subtemple of Nanzen-ji.

In July 1930 Shibayama published an Esperanto translation of the Ten Oxherding Pictures. In 1937 he began teaching at the Rinzai sect's Hanazono University and at his former high school. Two years later, through a matchmaker, he met Yamashita Yoshio, an English teacher at a local women's school, and they were married in a traditional Buddhist ceremony. In 1940 Shibayama took a position at Ōtani University, succeeding D. T. Suzuki as a lecturer on Zen studies. Takayama Rōshi, a disciple of Shibayama and current Zen Master of Nanzen-ji, recalled that in the late 1950s when he was wrestling with a difficult decision as a monk, Shibayama told him to keep thinking about his decision, saying, "For me also, when I became a lecturer at Ōtani Daigaku [university] for Suzuki, it was extremely difficult to get the baggage off the ground. But it is not manly to shift the burden to another."[7]

The noted Zen scholar Yanagida Seizan of Hanazono University remembered Shibayama as "an academically liberal scholar with a wide range of friends and associates including artists such as Jikihara Gyokusei, people in English literature, etc. He quickly met his wife and aimed at a new life."[8] However, Shibayama's scholarly life was disrupted by the war, which was having a devastating effect on Japanese universities. During the last stages of the war, students were rounded up to work in the war plants, so colleges and universities were left empty. To encourage the students, faculty members sometimes went to the factories. Seeing students covered in oil and dust, Shibayama wept at the loss of their adolescence and opportunity to study.[9]

When Yanagida first met Shibayama he was a special cadet who had no particular plans except to "die for my country."[10] Shibayama told him that the war would continue for a few months but that defeat was inevitable. After the defeat, only Zen and Japanese culture could survive, so he should study to restore it. "It was an extremely natural talk, but at that time I only stared blankly at the Rōshi's face and couldn't believe it. At this time no one was thinking of Japan's defeat, and other monks were teaching that it was Zen to die for one's country." Shibayama then suggested, "Go to Ōtani Daigaku. Suzuki-sensei is there, even now it is not too late." With the Rōshi's words, my course was decided."[11] Yanagida was to become a leading philosopher of Zen.

In 1945 Shibayama's wife and child died. Up to this point Shibayama, now fifty-one years old, had assumed his life would be spent as a Zen priest and scholar/teacher. However, the death of his wife and child drastically changed the situation. Zen Masters, unlike Zen priests, maintain celibate lives, but despite some opposition from within the Nanzen-ji sect due to the

Figure 25. Nanzen-ji

fact that he had been married, Shibayama was allowed to become a Zen Master.

In June 1948 Shibayama retired from the Jishi-in and accepted the position of Zen Master at Nanzen-ji (FIG. 25). Despite his new duties running the Nanzen-ji *sōdō*, Shibayama continued his academic pursuits, publishing *Rinzai Zen no seikaku* (The Character of Rinzai Zen) in September 1951 and maintaining his teaching duties at Hanazono University. In December of 1954 he traveled to Burma to attend the World Buddhist Studies Meeting, and during his journey he made a pilgrimage to Buddhist sites in India. Prior to his departure he collected all the monks in his charge in the *hondō* and told them:

> *This time I'm leaving on a Buddhist pilgrimage to India, but I am accustomed to this idea. There was Myōe Shonin [1173–1232] in the Kamakura period [1185–1333] and Eisai Zenshi [1141–1215], who traveled twice in the T'ang-Sung periods. Shonin's plan was to journey to the western region as far as India, but this was abandoned due to political events there; Shonin's attempt was ended. He had followed Shaka's path diligently, as is recorded in many books—"This far today, up to such and such place tomorrow"—but in the end had to abandon his plans. Then Shonin fervently put his feet in the water on the coast of Kii province and said, "This sea is connected to Shaka's country." His deep emotion is said to have grown. Fortunately today, my own plans can be carried out.[12]*

In 1959 Shibayama was appointed *Kanchō* of the Nanzen-ji sect at the age of sixty-five, and the following year he retired from university teaching.

Shibayama was extremely concerned about the spiritual education and development of lay followers, once asking, "Isn't our function to raise the consciousness of the faithful with true Buddhist teachings?"[13] He oversaw the training of a lay group, the Kōrin-kai, which met at Nanzen-ji, and also gave lectures to the general public, both expounding Zen teachings and promoting multicultural awareness. In a lecture given in the early 1960s at the Society for International Cultural Relations (Kokusai Bunka Shinkōkai) in Kyoto, he tried to explain the differences between Eastern and Western religion:

> *The English word "religion" is translated shūkyō in Japanese. I am told that the word "religion" etymologically comes from a Latin word which means "to bind together" and implies that religion consists in the relegation between God who is the Creator and human beings who are the created. Thus faith becomes important in religion, because religation occurs in the correlation of those who believe and Him who is believed in. It seems, therefore, that there is a strong character of the salvation by faith and that a human being means "one that is to be saved."*
>
> *The essential character of Buddhism is quite different....It has no sense of binding together and, therefore, in itself does not contain the element of faith. ...In Buddhism the word kiye is used as a term corresponding to "faith" in the West. Kiye means "to return to the fundamental truth and trust wholeheartedly in it." This shows that the character of self-reliance forms the main current in Buddhism, and the ultimate goal or purpose of shūkyō is to reach "gedatsu" (deliverance from worldly passions) or "satori" (spiritual awakening) rather than "salvation."[14]*

Ten years later, in his preface to *A Flower Does Not Talk*, a collection of Zen essays translated into English and published in 1970, Shibayama again stated:

> We should not too easily conclude that there is just one Truth, and that East and West are after all the same. If, however, we are awakened to our true humanity, we will realize that at the bottom of all the differences, there is the fountainhead which is the basis for the happiness of all mankind.[15]

On October 10, 1964, D. T. Suzuki visited Shibayama at his retirement house, the Koun-an, at Nanzen-ji. The two friends enjoyed a lunch together and afterward did some calligraphy. Using Shibayama's brush, Suzuki wrote a large character *myō* (wondrous), next to which Shibayama added the inscription "making fire in water," (PLATE 80). The forceful brushwork of Suzuki with its rough, open tips, streaks of "flying white," and extreme diagonals cutting across the composition is balanced by Shibayama's softer, rounded characters, the first of which, "fire," takes on the anthropomorphic shape of a face. The effect is a fascinating juxtaposition of calligraphic styles as well as a visual representation of a cherished friendship—the aging Suzuki, still dynamic at the end of his life, and Shibayama, who was beginning to make his full mark as a Zen Master. Only a few months after the *myō* calligraphy was done, Suzuki returned to Nanzen-ji and convinced Shibayama to embark on the first of what would eventually be eight trips to the United States.

In 1965, however, Shibayama was still apprehensive about the whole situation, despite Suzuki's encouragement. The night before he was sched-

Plate 80. Shibayama Zenkei (1894–1974)
and D. T. Suzuki (1869–1966),
MYŌ
Ink on paper
Fukushima Rōshi Collection

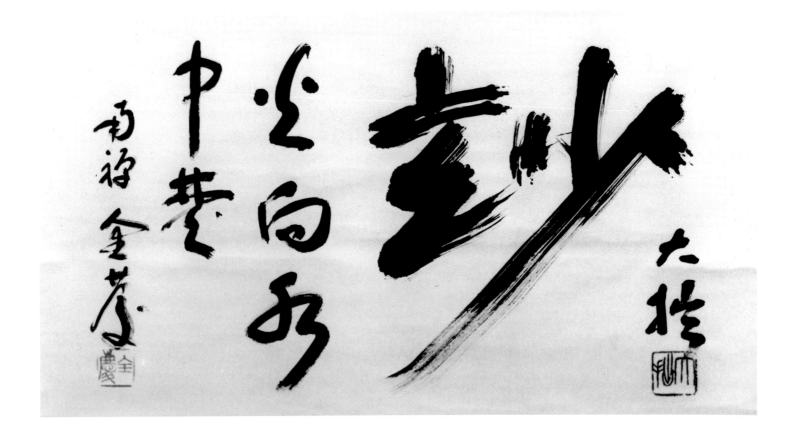

uled to depart, Shibayama called a young monk named Fukushima into his room and handed him a sealed box. "I think it is impossible, but in the one in ten thousand chance that it happens, open this box. Inside is my will."[16] That Shibayama had planned so thoroughly and was viewing the trip in such monumental terms surprised the young monk. The next morning, before Shibayama left the temple, the president of the *honzan* (sect headquarters) came to see him off; to have an active *Kanchō* travel abroad was still rare at the time. In front of the *hondō* the temple monks gathered and recited one volume of the *Hannya shingyō* (*Heart Sutra*), praying for a safe and pleasant journey.

The first stop on the lecture tour was the University of Hawaii, and by the end of the Hawaiian visit the impact on Shibayama was becoming clear, "This trip will continue for two and a half months; I think it will somewhat change this monk," he noted.[17] The tour continued on, making stops at Claremont, Carlton, and Earlham colleges, Atlanta University, Duke University, Colgate, and Westhampton University. His lectures included "The Characteristics of Zen," "Freedom in Zen," "Training in Zen," and "The Ideal Image of Man in Zen."[18] By the halfway point of the tour, Shibayama was becoming increasingly comfortable and adjusted to American life. When he was asked by an American if he would return to the United States, Shibayama said, "Today going to America is like going to Osaka."[19] He drank some tea and laughed. Building on Suzuki's foundation, a second bridge of Zen and Japanese culture had been established.

Meanwhile, back in Japan the president of the *honzan* and other organizations were making plans for a homecoming reception for Shibayama. Originally the Rōshi had believed that this would be his last trip abroad, so he decided to visit Europe as well. When Shibayama was informed in Paris that a welcome-home party was being planned, he replied, "Today, the world is getting smaller, it's only been about three months since we left for America. This reception is nonsense."[20] Shibayama's transformation from his do-or-die attitude prior to his departure to his casual outlook on traveling was complete.

Since he could not avoid the welcoming party, Shibayama went and entertained the crowd with stories about America. One of the guests that evening was the Zen Master Furukawa Taikō (1872–1968), head of Myōshin-ji, who was ninety-four. Upon hearing Shibayama Rōshi's descriptions of his journey, Taikō became very enthusiastic and decided that he too wanted to visit the United States. Taikō said he would learn two English words every day. This made Shibayama feel even better about his trip, and Taikō actually did make a visit to Los Angeles Zen Center before he died. Despite the fact that Shibayama had protested the idea of the reception even in the taxi on the way to it, after the party Shibayama told one of his disciples, "Good party."

Shibayama had a personal appreciation for art, befriending *haiga* and literati artists and creating his own works. In particular, he held great respect for the Edo-period Zen Master Hakuin Ekaku as well as special admiration for Hakuin's paintings and calligraphy, of which he had a small collection. In *A Flower Does Not Talk*, Shibayama provided detailed commentary on Hakuin's *Zazen wasan* (Song of Zazen), a short text meant to propagate Zen to the general public in a manner easier to understand than traditional Zen texts. This was one of the efforts Hakuin made to promote an understanding

of Zen to people of all social classes, backgrounds, and walks of life, utilizing every means available to convey basic Zen teachings. Beyond writing numerous texts, Hakuin also had produced a huge number of ink paintings and calligraphies depicting not only traditional Zen and Buddhist subject matter, but also Japanese folk themes and aspects of everyday life with which he believed he could reach a general audience with his Zen teaching. Shibayama wrote of Hakuin:

> *His paintings and calligraphy strongly appeal directly to the eye and heart with unusual strength and inspiration that seems to emanate from the work. Apart from their great artistic appeal, his comments added to the paintings often well express the spirit of Zen. They are not mere moral teachings or humorous remarks, but point directly to the fact of religious experience of Zen Enlightenment, and illustrate Zen spirituality.[21]*

In his own calligraphic works, Shibayama was most influenced stylistically by the works of Jiun Sonja, whose terse, blunt style of brushwork he highly admired. In many of Shibayama's works the aesthetic similarities become evident, particularly the dynamic use of "flying white" and the almost agitated energy of the brush as it dances across the composition, leaving the surface with gestural energy resulting in broad open tips of the brushstrokes. Shibayama once explained how he achieved this similarity to Jiun's brushwork; "Since I was young I have liked the calligraphy of Jiun Sonja, so in order to create that style of characters I had to cut the brush."[22] Thus, after the age of sixty-five Shibayama would cut off the soft, flexible tip of the brush (considered by most artists to be the most important part) with a sharp knife and work instead with the short, stubby remainder. Although he first cut his brushes in private, by the age of seventy he was cutting them in front of his assistants, but he never let anyone cut them for him. This blunt style of calligraphy is evident in a single-line scroll that reads, "Mountain is mountain, water is water" (PLATE 81). Here the first and third characters are the word for "mountain" (山) and thus their shapes reveal their pictographic origins. The fourth character is "water," (水) but the second "water" character is represented not by another "water" character, but instead by a dot at the bottom of the scroll due to the lack of space.[23]

When Shibayama wrote this phrase, his disciple Fukushima assisted him. Fukushima recalls, "When he ran out of space, he said, 'Ahh, I blew it.' So he put the brush down and planned to throw it away." But Fukushima suggested putting a dot (chobo), representing a repeat mark, there.[24] Shibayama asked him, "How do you read it?" Fukushima replied, "You don't have to read it as 'Mountain is mountain, water is. . . .' I read it as 'Mountain is mountain, water is chobo.' Shibayama seemed satisfied and said, 'Oh, that is interesting. And there is only one in the world like it.'"[25] He then gave the work to Fukushima.

Shibayama often borrowed phrases from kōan for his calligraphic inscriptions. Two such cases are a short wooden stick on which he inscribed, "shattered into a hundred pieces" (PLATE 82), and a teabowl on which he wrote, "one, two, three" (PLATE 83).

The phrase on the stick comes from case 13 in the *Hekiganroku*, "Pa Ling's Snow in a Silver Bowl," in which a monk asks Pa Ling, "What is the school of Kanadeva?" Pa Ling replies, "Piling snow in a silver bowl."

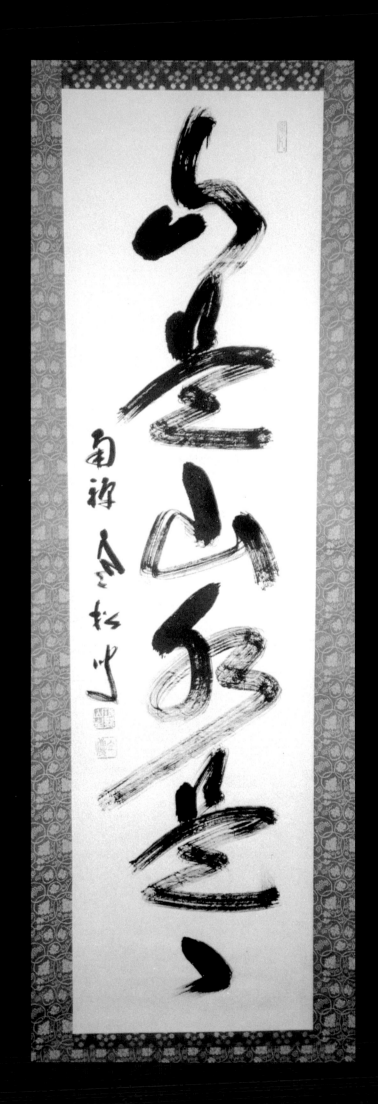

Plate 81. Shibayama
MOUNTAIN AND WATER
Ink on paper
Fukushima Rōshi Collection

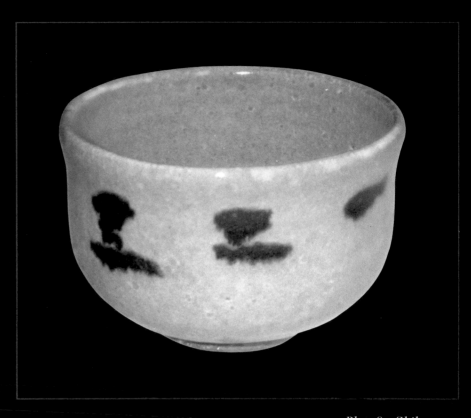

Plate 83. Shibayama
INSCRIBED TEABOWL
Glaze on ceramic
Fukushima Rōshi Collection

Plate 82. Shibayama
SHORT STICK
Ink on wood, 47.5 x 4 cm.
Fukushima Rōshi Collection

Kanadeva was the Fifteenth Patriarch in India who felt that the Buddhist teaching was in trouble, so he met with heretics who challenged the Buddhist doctrine. In these disputes, the winner would hold a red banner over the defeated. The general punishment for heretics was to have their hands cut off, but Kanadeva ended this practice and required only that the defeated heretics shave their heads and follow the Buddhist path. As a result, the school of Kanadeva thrived.

Later in the *kōan* the monk Hsueh Tou added a verse that ends:

> *Beneath the red flag, arouse the pure wind.*
> *Shattered in a hundred fragments.*
> *Having struck, I'll say I've already hit it.*
> *Just cut off your heads and arms, and I'll speak a phrase for you.* [26]

The idea of shattering something into a hundred pieces is appropriate for the short stick that Zen Masters often carry during lectures and during *kōan* interviews with students, which can be employed to strike a student if a particularly bad answer is given. Ultimately, these *kōan* sessions are meant to help the students release their Zen mind, also implied by the idea of "shattering into pieces." At the top of the stick Shibayama has signed his name; the three larger characters below are the actual inscription.

The relatively simple phrase "one, two, three" on the teabowl comes from case 21 of the *Hekiganroku*. A monk asked Chih Men, "How is it when the lotus flower has not yet emerged from the water?" Chih Men said, "A lotus flower." The monk said, "What about after it has emerged from the water?" Men said, "Lotus leaves." [27] The textual note following Chih Men's first reply, "A lotus flower," says, "One, two, three, four, five, six, seven. He stumps everyone on earth." [28] "One, two, three . . ." merely expresses that something is simply the way it is without need for distinctions of what, why, where, or who, as similarly conveyed in the image of *Crows* by Nantenbō (PLATE 2, page 23).

The simplicity of the bowl and calligraphy underlies this idea. The strokes of the characters, which read from right to left across the surface of the bowl, are simple, terse, and open-ended. In the case of the "two" (二) and "three" (三), the strokes of glaze even run together, blurring the visual distinction even more. Shibayama has completed the piece with a *kaō* (signature-cypher) to the lower left of the "three" character.

In his teachings, Shibayama fully understood the irony between the vast amount of written materials about Zen and the belief that words and letters are unnecessary. He himself felt that there were three methods for dealing with the question "What is Zen?"

First, the direct method: presenting one's own Zen experience, directly and without compromise no matter to whom it is directed. Responses given by past Zen Masters to this question have included loud roars, the raising of a fan, and a blow with a staff. Second: the indirect method of presentation, which can be subdivided into two parts—symbolic and conceptual. The symbolic method is artistic; it conveys the content of *satori*, which reflects one's own experience through symbols, which are different from realistic pictures. As Shibayama explained:

> *The latter [conceptual method], even if it depicts the objective fact faithfully,*
> *is nothing more than a skeleton or a conception. It lacks the very life which*

forms the content. On the other hand, a symbol has the characteristics of representing vividly the inner life, even if the form of presentation is entirely different. In particular, we may say that with regard to abstract content there is no other way to represent it by symbols. For these reasons, the inner life of Zen is often presented by poems and paintings.[29]

The third, or conceptual, method explains Zen intellectually and promotes understanding through rational thought.

This is the most convenient method for the purpose of understanding the contents and the structure of Zen as general knowledge. As such, however, it is not Zen itself. With regard to the original meaning of Zen, it has the defect of seeing only the superficial outline of Zen, and therefore it may be said to be the farthest from the truth. Nonetheless, if knowledge is the first step to seeking truth for human beings, I think this method is not meaningless.[30]

In January 1970 Shibayama's Zen teachings to Americans penetrated new depths. That year twenty-five students at Hamilton College in New York spent three weeks in intense Zen study, based on the monastic *sesshin* intense training periods. Students spent the first week reading assigned texts on Zen, but during the next two weeks they participated in the first student *sesshin* conducted by Shibayama. The schedule included three hours of *zazen* and Zen lectures (*teishō*) on the *Mumonkan* by Shibayama every morning. The afternoon was devoted to personal study and private interviews with the Master. Students participated in another two hours of *zazen* in the evening; during this period they lived in dormitories and were not allowed to leave campus. Despite the rigorous schedule, there were no dropouts during the three weeks.

The response to the student *sesshin*, and particularly the Zen lectures, encouraged Shibayama to produce *teishō* in written form. With the help of Dr. Kenneth Morgan, Shibayama agreed to write *Zen Comments on the Mumonkan*, a translation of the classic Zen *kōan* collection with Shibayama's *teishō* on each of the forty-eight *kōan*. He spent three years working on the manuscript, often writing late into the night. The text was finally completed in January 1973, and when Shibayama received the published copy in May 1974, he said, "It turned out nicely. This will be the greatest work of my life. I am grateful to all who helped me to complete it."[31]

Shortly after publication of *Zen Comments on the Mumonkan*, Shibayama was taken ill and moved to a Kyoto hospital; he died on August 29, 1974. Shibayama had led an unusual life as a Zen Master, reflecting the changes in the world. He had been married, had a child, was a scholar and teacher, survived the devastation of the Second World War, traveled the world, and enthusiastically taught Zen to Americans. All of this became part of his Zen life, and it was this experience that he gave back through his writings, lectures, paintings, calligraphy, and personal interactions with monks and lay people. He wrote, "Zen Masters may express their Zen experience by talking, by writing, by painting, by a sudden blow, or in many other ways. It is an iron-clad rule in Zen always to read the teaching, however it may be expressed, from within, based on the experiential fact, and never to try to reach the experiential fact by following any particular form of expression."[32] His final poem, which utilizes the same motif of filling the well with snow that Mokurai used in his death poem, was:

Carrying snow and filling the well,
I have lived for eighty-one years.
Truly there is nothing special —
I sleep with limbs outstretched.[33]

FUKUSHIMA KEIDŌ

In the spring of 1969, on his fifth trip to the United States, Shibayama brought along his disciple Fukushima Keidō, then thirty-six years old, to assist him. "My first visit was in 1969 to Claremont. I was able to clearly see the Zen scene at that time. This was a very exciting era when hippies were taking LSD as an enlightenment experience. It was called 'Hippie Zen.' My Master, who was over seventy years of age, told me to go check out Hippie Zen. I went to Hollywood to see them. During the day I didn't see many hippies. In the evening, there were many along the street. When I got out of the car, I was surrounded by them. I was wearing a black robe and shaved head. 'You must be a hippie too, where are you from?' one of them asked. 'I am the patriarch of the hippies,' I said. One of them said, 'Oh, you must be a Japanese monk.' Of course, I said it as a joke, but the fact that they knew from that statement shows a connection. That is how American Zen first appeared to the public. During the 1970s and 1980s, many of the curious elements died out, and many Japanese Zen centers emerged."[34]

Fukushima Keidō had entered Hōfuku-ji in Okayama at the age of fourteen under Okada Kidō Rōshi of the Tōfuku-ji lineage. When Fukushima was twelve years old, his older sister died, and at age thirteen his grandmother, who had raised them, passed away. During his studies in classical Chinese, his teacher taught him the belief that if one person becomes a monk, his or her whole family will be reborn in the Buddhist paradise. "So I decided to become a monk so that my sister and grandmother would go to paradise. I had to study more Buddhism before I understood that becoming a monk was not just for the sake of family, but for the whole world."[35]

Because the family knew Okada Rōshi personally, young Fukushima cut off all normal family relationships (*shukke*) and went to study with him. Okada was known as a very strict teacher and therefore was very effective in conveying the basics of Buddhism. At this time, all young monks had to attend school until high school, so Fukushima divided his time between the temple and middle school.

There were five novices at the temple, and because of their youth they had no direct teaching from Okada Rōshi and no *kōan* study. Instead, once a week Okada would give a *teishō* to the five young monks. Fukushima recalled, "I always looked forward to the stories, although I didn't always understand them. He was a very good speaker."[36] While being initiated into Zen study and training, the young monks still had to continue their regular schoolwork, and occasionally this led to new lessons in Zen.

When I had just entered the temple in junior high, I was preparing the fire for the bath. I was also studying for a chemistry test, so I had my book with me. Rōshi Okada got very angry at me for doing this. He said, "When you are choking the fire, choke the fire. Why are you reading?" "I have a test." Then Rōshi

Figure 26. Fukushima standing by his calligraphy FUSHIKI, *Spencer Museum, University of Kansas*

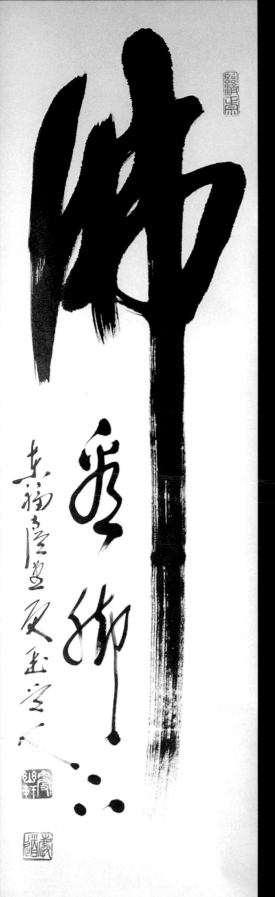

Plate 84. Fukushima Keidō (b. 1933
BUDDH
Ink on paper, 116 x 32.9 cm
Private Collectio

Plate 85. *Fukushima*
BUDDHA (*detail*)

Okada was no longer mad; he got interested and said, "Oh, chemistry. Okay, I'll give you a question. Let's say there are three powders. Salt, sugar, and sodium bicarbonate. How are you going to tell them apart?" So I thought as hard as I could about what I had learned in class. Rōshi was in the bath while I was thinking about this. When Rōshi got out, he asked me if I had figured it out yet. I said I did not know. He said, "You taste them." I didn't realize it at the time, but I know now that it was a very good Zen teaching.[37]

During these early years Fukushima began his appreciation of ink painting. Hōfuku-ji is famous as the temple where the painter-monk Sesshū Tōyō (1420–1506) spent his early years. As a result, the temple houses some of the artist's works that had an immediate impact on Fukushima.

From the age of fourteen I grew up looking at the works of Sesshū. I remember very clearly the moment when I saw Sesshū's painting for the first time. We were expecting a special guest, and only when a guest would come was a painting by Sesshū exhibited. Therefore my Master took the scroll out of the storage room and carefully hung it in the tokonoma. *My Master said, "This is a National Treasure by Sesshū." I thought, "If this is all, then I can paint this by myself too." That was because at that time, I didn't understand the depth of Sesshū's painting yet. After studying Zen and training, I gradually understood the depth of Sesshū's painting. I also understood the beauty of space in his painting, so as I grew up and lived surrounded by Sesshū's work I began to understand painting.*[38]

Although Fukushima does not paint images himself, he is a highly skilled and accomplished calligrapher, and the idea of "the beauty of space" is equally apparent in his calligraphic works. In a scroll that reads, "Buddha, watch your feet" (PLATE 84), the large "Buddha" character dominates the space with its powerful horizontal and vertical gestures, culminating in the final long vertical stroke, which sweeps down the paper, breaking into streaks of "flying white." To the left, in small script, Fukushima wrote the inscription, "Watch your feet," the final character of which has been reduced to three dots of ink.

The compositional balance in this work is important. At the top, the large character fills the space completely, but below, its long vertical stroke is offset by the three-character inscription, which is tucked neatly under the left side of the "Buddha" character. Although "Buddha" is rather angular, tight, and sharp, the small characters reveal a more rounded, looser structure. The juxtaposition between the rich, dark ink and the interrelated but always different patches of negative space within the characters is particularly strong (PLATE 85). Fukushima enhances the vertical thrust of the space by elongating the final stroke of the second character in the inscription as it leads to the final character, reduced to the three dots. These two characters are further visually linked by the heavy dot of ink that is suspended from the long vertical stroke immediately above them. It is this type of spatial juxtaposition that makes calligraphy a particularly exciting visual art. The beauty, as Fukushima learned when viewing Sesshū's brushwork, is not merely in what ink traces the brush leaves behind, but in the empty spaces created by the brush.

The fame of Sesshū provided Hōfuku-ji not only with great works of

art but also with a story of Sesshū and the rat. According to legend, Sesshū liked to paint so much that he didn't do anything else at the temple: no chanting, just painting. His Master decided that this was not good, so he sat him on the wood floor and tied him to a pillar in the Chanting Hall. When the Master returned to check on him, he found Sesshū crying and a large rat next to him. The Master assumed that Sesshū was crying because the rat bit him, so he went to shoo the rat away. But the rat didn't move. Upon closer inspection he realized the rat wasn't real. Sesshū had cried so much, he was able to paint a rat with his toe using his tears. The Master was very impressed with Sesshū's ability, and from that point he recognized his genius and allowed Sesshū to concentrate on his painting.

Because of this association, Zen Masters of Hōfuku-ji continued to paint images of rats. Rōshi Okada was no exception, and Fukushima and the other young monks would often assist him. Okada would use three different brushes to paint a mouse. For the face and body he used a thick brush, for the eyes and tail a smaller brush, and for the whiskers the finest brush. As he painted, he would ask for the next brush, which the young monks would hand to him. Requests from lay followers for these paintings were numerous, especially during the year of the rat, and as a result Okada and the young monks were kept busy. Fukushima Rōshi recalled one humorous incident:

> During the day the temple was busy, so painting would be left for the evening and night. By then we would be very tired, but we still had to assist. When the bell rang and we had to go help, the youngest monk would complain and would be half asleep while handing him the brushes. Sometimes he would mistake the order of the brushes and hand him the wrong one. Okada Rōshi did not get mad, but said, "Hey," and called him over. He then took each brush and explained what each brush was used to paint. As he did this, he painted a mouse face on the little monk. He told the little monk not to wash it off until morning.[39]

During Fukushima's third year of high school, Shibayama Rōshi came to lecture at Hōfuku-ji; Shibayama and Okada were both disciples of Kōno Rōshi, Shibayama being the senior disciple. At this time Shibayama and Okada began discussing which college Fukushima should attend. Shibayama suggested Ōtani University in Kyoto, where he himself had lectured. The president of the university, Dr. Yamaguchi, was a well-known scholar of Indian Buddhism, so following Shibayama's advice, Fukushima began studies in Indian Buddhism. Eventually, in graduate school Fukushima began studying Chinese Buddhism and Zen.

> After I began graduate school I became very fond of my studies. I thought of becoming a scholar and I had no idea that I would become a Zen Master. In graduate school I worked on the Rinzairoku [Record of Rinzai] for my master's thesis. I understood by reading this record that to truly understand it, I would have to practice it. So when I finished this graduate study, I decided to enter a training monastery. I knew I would have to train for at least three years in the monastery, even if I wanted to become a scholar. I decided to enter Shibayama's monastery, Nanzen-ji.[40]

Going to Nanzen-ji provided Fukushima with another view of a Zen Master. Although both disciples of Kōno Rōshi, Shibayama and Okada were vastly different personalities.

Until my third year of high school, my only idea of a Zen Master had been Okada Rōshi, but once Rōshi Shibayama had come to visit, and I saw how Okada respected him so much. I was very impressed. Their personalities were totally different. Okada was very severe, Shibayama was very elegant; I respected both of them. In the beginning of one's training one needs a more severe master. But to become a complete, full-fledged Zen Master it is important to not only have the strict side, but also the gentle side, especially when teaching lay people. But even Rōshi Shibayama was very severe during kōan study. I was very fortunate to begin with a strict master and then a gentle master. If it had been the other way, I would not have gotten the basics down.[41]

Fukushima trained under Shibayama at Nanzen-ji for ten and a half years. Like Shibayama many years earlier, Fukushima still perceived himself as a scholar, and this attachment to his intellect initially hindered his Zen training. Generally, monks enter the monastery after four years in college, but Fukushima had also spent five years in graduate school, so his attachment was even stronger. While Zen does not deny the importance of the intellect, at a certain point in training it is important for these ties to be broken. During his first year of *kōan* study, Fukushima relied on his thorough knowledge of the *Rinzairoku*.

I thought to myself that good answers were to be found throughout these records. But good answers do not come by just picking them out of these books. By the end of my second year, I finally became aware of that. But up until then I would just bring answers from this text. Shibayama would say, "This is from the Rinzairoku, *these are not your own words. You know this is a difficult thing, you're really smart aren't you? You should maybe quit and just go back to the university." He was just being sarcastic.*

During my third year he didn't even explain it to me, he just kept saying, "Be a fool." At first I thought to myself, how can you become a fool after studying so much...? Every time I went to him, whatever I told him, he replied, "Try to be a fool." For a half a year, he told me to be a fool, so I decided, maybe I should become a fool. After one year, I decided, I will just be a fool. During the most intense sesshin of the year in the first week of December, I finally decided to let go and become a fool. That is when I had my first Zen experience. I am very grateful to him for persevering and telling me to be a fool. As for some of my fellow monks who entered when I did, he told them the opposite, he told them to study more.[42]

Although his attachment to his intellect hindered Fukushima's first three years of training, once he transcended it, his progress was rapid. During his seventh year, he began the final phase of his *kōan* study with Shibayama. However, a request came from Tōkai-ji, a temple in Tokyo, for a resident priest. The temple was of the Daitoku-ji sect, and it is one of the temples from which the head abbots for Daitoku-ji are chosen. Although it is not a training monastery, the resident priest for this temple has to be a Zen Master. Fukushima was almost finished with his training, so Shibayama recommended him to Tōkai-ji. But to go there he would also need the permission of his first master, Okada. So Shibayama asked Okada to visit Nanzen-ji.

One day Okada appeared at Nanzen-ji, and when Shibayama told him about the Tōkai-ji's request and his recommendation of Fukushima, Okada was very surprised. He protested that Fukushima hadn't finished his *kōan* study, and Shibayama replied that he was within a year of finishing.

Okada was even more surprised at Fukushima's rapid progress. After the meeting, Fukushima accompanied Okada to Kyoto Station. In the car Okada told him about what had been transpiring, and that he had refused the offer for two reasons: first, because Tōkai-ji was not a training monastery, and second because he did not want Fukushima to leave the Tōfuku-ji sect because he hoped Fukushima would eventually become *Kanchō* of the sect. Because Okada had refused the idea so strongly, Shibayama acquiesced.

Next, Tōkai-ji made a direct request to Okada at Hōfuku-ji. Okada was very clear in his replies. "No matter how many times you come here from Tokyo, when I say no, I mean no. He will become the successor of his home temple, Hōfuku-ji." Tōkai-ji eventually found a Zen Master from another monastery. "At that time Rōshi Okada told me, 'When I see you now, you are almost exactly like Rōshi Shibayama.' That was the result of my complete faith in Shibayama, I respected him completely."[43]

While training with Shibayama, Fukushima often assisted his Master while doing calligraphy and became extremely fond of Shibayama's style of brushwork. In fact, while Shibayama cut his brushes to make them short and stubby, Fukushima now has his horsehair brushes custom-made to re-create the effect. Although a Zen Master's calligraphy is a personal and individual expression of his Zen mind, the consciously adopted visual influences from one Master to another are often apparent.

We have already seen Shibayama write "Mountain is mountain, water is . . ." Fukushima also wrote out the first part of this phrase (PLATE 86). However, in contrast to the gesturally sweeping quality of Shibayama's work, Fukushima uses a much more pronounced, blocky style, enhancing the solidity and powerful presence of the mountains. Like Shibayama, Fukushima alters the way in which he writes the two "mountain" (山) characters. The first reveals a triangular shape more reflective of it pictographic origin [山]. The second example has been squared off, creating a more massive effect. Again, the juxtaposition of the triangular and rectangular negative spaces set against the heavy application of ink, broken by streaks of "flying white," is visually striking. In contrast to Shibayama, Fukushima has rounded almost all of the tips on his characters, while Shibayama left almost all of his open in continuous gestures.

In 1968 Fukushima completed his *kōan* training, and the following year accompanied Shibayama to the United States for the first time. That year Shibayama also decided that he wanted to travel by ship, but because of the time and distance, it was decided that they would travel by plane from Japan to Hawaii and by ship from Hawaii to California. Upon boarding the ship, Shibayama gazed at the night sky and was in good spirits. Shibayama asked Fukushima to wake him a little before eight o'clock the next morning so they could have breakfast. The next morning, however, the group (Shibayama, Fukushima, and a translator) awoke seasick. After being given some medicine by the ship's doctor, they went to breakfast, where Shibayama announced, "No more riding on boats." After breakfast they went up on deck and took pictures (FIG. 27). Fukushima recalled that they were told that walking briskly around the deck would ease their illness, "so in front of the foreigners enjoying their sunbathing, the three of us looked like a flock of geese. In the eyes of the foreigners it must have looked strange, but Rōshi was extremely delighted. Later, while visiting Santa Barbara and even Claremont, he told the story of the flight of geese on the boat deck over and over."[44]

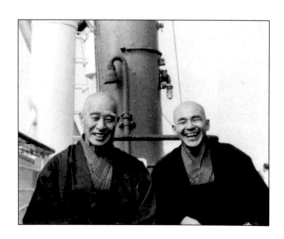

Figure 27. Shibayama (left) and Fukushima on board a ship, 1969

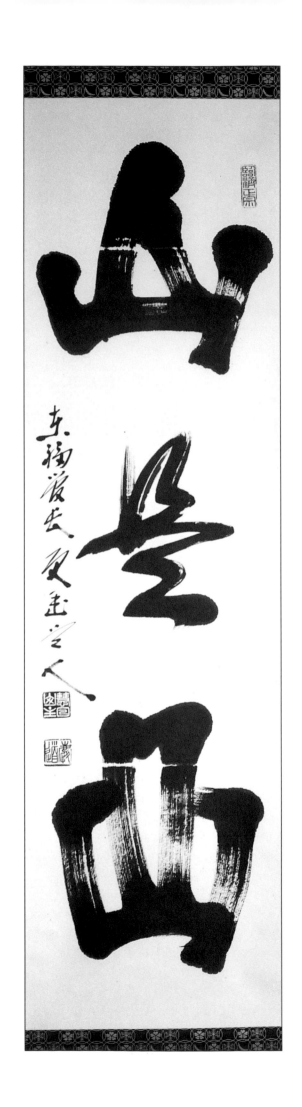

Plate 86. *Fukushima*
MOUNTAIN IS MOUNTAIN
Ink on paper, 122.4 x 34 cm.
Chikusei Collection

In 1970 Fukushima returned to his home temple, Hōfuku-ji in Okayama, and assisted Okada Rōshi with temple duties. In 1973 he went to Claremont College in California for a year as a guest lecturer on Zen. This had been Shibayama's idea, but Okada agreed that it might be good training. Shibayama's trips abroad had changed him dramatically; according to Fukushima, he never spoke of *angya* (pilgrimage) in Japan, only *angya* in the world. So the trip would serve as a type of modern *angya*. Fukushima received one hundred dollars per month plus room and board; Shibayama also sent him three hundred thousand yen so he could return via Europe.

During his year at Claremont, Fukushima held meditation sessions followed by a Zen lecture given in English once a week. In the beginning it took Fukushima two or three nights to prepare each talk, including one Zen story. Eventually, as the year progressed, he could write his lecture in only one night.

During his free time, he attended classes in the religion department, concentrating on the Old and New Testaments. Many people asked him, "What is Zen?" And he often asked them, "Where is your God?" but no one could give a satisfactory answer. Eventually, a Dominican nun, who was studying at the graduate school and had joined the sitting sessions, took Fukushima to a Catholic monastery in the mountains on a Saturday afternoon to join a retreat. "I sat in the chapel while the monks were praying. One time as I sat there, the monks chanted in Latin. When I heard that chanting, I realized, 'Here is God for them.' After that experience, I never asked 'Where is your God?' again."

Fukushima believes that during his year at Claremont his ideas and personality changed. "Unconsciously I became more open. For instance, everyone has his or her own ideas about the world, religion, life. That year I had a big change; it was a good experience for me to stay in the United States. My duties were just to teach Zen meditation, so I concentrated on teaching. For instance, by learning which Zen stories are most effective for Americans, I concentrated on how to teach Zen to Americans. Even now, my ideas of teaching Zen come from that time. Even in Japan, my ideas of opening outward are apparent; I encourage Japanese young people to leave Japan and look at their own country from outside."[45]

By 1973 Americans were studying Zen more earnestly and carefully than the hippies in the 1960s. D. T. Suzuki was read seriously, and there was a much deeper awareness of Zen. When Fukushima returned to Okayama in February 1974 as vice resident priest assisting Okada Rōshi, there were no other monks in training, just young disciples, and Fukushima spent most of his time cleaning the temple. However, in April, three American college graduates came to Hōfuku-ji, asking to become disciples. Although they did not remain at the temple permanently, they became Fukushima's first American followers.

At the end of 1978 the Tōfuku-ji sect began requesting that Fukushima go to Tōfuku-ji monastery in Kyoto to serve as Zen Master, but Okada, still wanting Fukushima to serve as his successor at Hōfuku-ji, said no for a year and a half. Persistently, Tōfuku-ji made four requests. Finally, in January 1980, the new *Kanchō* of the sect and six high-ranking priests of Tōfuku-ji visited Hōfuku-ji. Rōshi Okada told Fukushima the priests were coming with requests but that he still wanted to say no. Fukushima had to agree with his Master. When the official delegation of seven priests arrived

at Hōfuku-ji wearing long purple robes (a sign of high rank), Okada, in regular robes, again said no. Okada asked them to be seated, but the *Kanchō* said, "Until you answer yes, we will not sit down." Fukushima was sitting at the entrance of the room. Because the request was now so strong, Okada had to reconsider; he said he could not answer that day but would answer later. The seven priests then sat down. That afternoon, Okada Rōshi told Fukushima that he would have to go to Tōfuku-ji (FIG. 28).

Upon Fukushima's arrival at the Tōfuku-ji *sōdō* on October 10, 1980, there were no monks, only three cats. Fukushima told one of his American disciples that he had no pupils, so the American went to Japan to train at the monastery. Then three Japanese monks entered the temple that fall (monks traditionally enter temples twice a year, once in the fall and once in the spring). The American actually had more experience in Zen, so he supervised the first training session that fall. By spring, nine more monks entered the Tōfuku-ji *sōdō*. By 1987 there were twenty-five.

As Zen Master of a prestigious monastery such as Tōfuku-ji, Fukushima began receiving many requests for examples of his brushwork. In January 1994 he started counting the number of requests he had received, and when he reached three thousand, he stopped counting. He usually sets aside five or ten days a month to concentrate only on writing calligraphy.

One of the most requested and appreciated subjects brushed by Zen Masters is the *ensō*. Although it is interpreted in many ways—as representing the universe, or the void, for example—Zen Masters have often playfully negated this type of intellectualizing by suggesting instead that the circles may just as easily represent the moon, or even a rice cake. In his richly brushed *ensō* (PLATE 87), Fukushima simply asks, "What is this?," leaving the viewer to ponder the spiritual or commonplace possibilities.[46] Fukushima's Master Shibayama had written:

> *Zen priests often draw a circle with one stroke of the brush. The empty circle of course symbolizes the spiritual world. A Zen priest thought that even this drawing of an empty circle was an impurity, and added an inscription, "Never a ring on a circle!" He thus tried to show the transcending character of truth. Is there any other way to symbolize so cleverly the idea of "One is equal to All"?[47]*

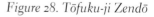
Figure 28. Tōfuku-ji Zendō

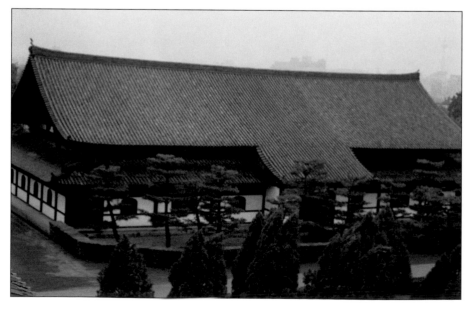

Plate 87. *Fukushima*
ENSŌ: WHAT IS THIS?
Ink on paper
Fukushima Rōshi Collection

Shibayama had a personal appreciation for *ensō*, and in 1969 he wrote the text for the book *Zenga no ensō*, which featured *ensō* brushed by Zen Masters over the centuries. When Shibayama was first approached about doing the book, his only request was that the book should not merely reproduce the *ensō* but also provide the calligraphic commentary accompanying each *ensō*. He believed that the teachings given by Zen Masters in their inscriptions was of the utmost importance, and that therefore the image of the circle should not be indiscriminantly reproduced without the text. To this end he also said that an *ensō* without an inscription was like "flat beer."[48]

Although the *ensō* has become highly symbolic in Zen, it is important to remember that its round shape is not absolute. Thus, Fukushima has also occasionally brushed other shapes, including triangles, and has added the inscription, "Even this is a circle," in English, as a means of breaking through both the language barrier and barriers of preconceived ideas and assumptions.

In another scroll, Fukushima placed a triangle at the top and then wrote, "Every day is a fine day," from case 6 of the *Hekiganroku* (PLATE 88). In this *kōan* the Master Unmon asks an assembly to tell him not about the days before the fifteenth of the month, but the days after the fifteenth of the month. When no one can reply, he answers, "Every day is a fine day." Visually, the triangle is enhanced by the shapes of the characters in the inscription below, which dance playfully. The two characters for "day" (日) that begin and end the inscription have been transformed from their traditional square shape into triangles; this playful manipulation of shapes is heightened by the fact that the character was originally transformed from an ideograph for "sun," which was a circle with a dot inside [☉]. The second character is a repeat mark represented by two dots, thus writing "day day," meaning "every day." The fourth character is "fine" (好), and here too

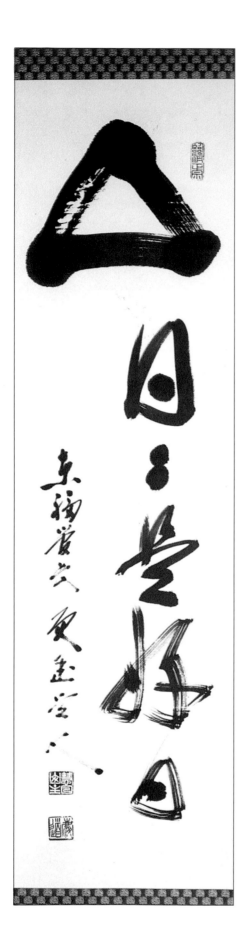

Plate 88. Fukushima
EVERY DAY IS A FINE DAY
Ink on paper, 119 x 32.5 cm.
Hōsei-an Collection

Fukushima has altered the left side of the character into another triangle. Although the manipulation of character shapes has a long tradition in Japanese art, it is not always a conscious decision by the artist; often the rhythm of the calligraphic gesture produces it. Fukushima explains, "Calligraphy is done not with the head or the hand, but through the whole body, thus the characteristic rhythm. . . . I do not think of trying to make something beautiful; it must be done naturally."[49]

In 1983 the president of Pomona College in California visited Tōfuku-ji and discussed establishing a special connection between the temple and the university. More requests came for Fukushima to visit Claremont for one year, six months, even three months, but Fukushima was increasingly busy with temple duties. He continued to decline requests to visit the United States until 1989.

In that year the Spencer Museum at the University of Kansas organized the exhibition "The Art of Zen: Paintings and Calligraphy by Japanese Zen Monks, 1600–1925." As part of the public programming, the museum decided to try to have an "artist in residence" to help promote an understanding of the works. However, in the case of Zen painting, an artist in residence means a Zen Master. Eventually, Fukushima was contacted and invited to spend ten days at the University of Kansas giving Zen lectures and introductions to Zen meditation. By this time, the Tōfuku-ji *sōdō* was running smoothly and Fukushima believed the time was right to return to the United States. In addition, he agreed to give demonstrations of Zen brushwork, something which is not done in Japan (see FIG. 5, page 15).

> *Until I received this request, I had never thought of giving a demonstration of calligraphy. If I were to give a lecture, I would only need my notes, but to give a calligraphy demonstration I need a great deal of preparation. Because 1989 was my first demonstration, I brought a very large inkstone. In Japan at the airport I had to pay for overweight luggage. At that time I thought this would be my first and last calligraphy demonstration. When I stayed in Kansas for ten days, there were fourteen events, among which were four calligraphy demonstrations. During the question-and-answer period there were many good questions about Japanese culture, so I realized the meaning of the demonstration; instead of static calligraphy, it is living, dynamic moving art.*[50]

During this visit to the University of Kansas, Fukushima presented the Spencer Museum with a large hanging scroll reading, "Fushiki" (FIG. 26; see page 162 for explanation).

Whenever Fukushima gives a calligraphy demonstration in the United States, he begins the session with a brief Zen talk to help introduce Americans to the ideas and concepts of Zen, and also to introduce them to aspects of his own Zen experience. Beyond the personal and Zen anecdotes, the phrases that Fukushima then writes during the demonstration are also used to convey specific Zen teachings. For instance, on a large scroll he wrote, "No host or guest" (PLATE 89), a phrase from a poem by the Zen Master and founder of Daitoku-ji, Daitō Kokushi (1282–1337). Buddhism often utilizes the image of host and guest, but Daitō's poem was written upon experiencing enlightenment.

> *Now broken through Yunmen's barrier.*
> *Release everywhere—east, west, north, south.*

In at morning, out in the evening, both host and guest are gone.
Moving my head, my eyebrows, stirs up a pure wind.[51]

Daitō refers to penetrating through Unmon's barrier to the freedom of enlightenment; it is this enlightened state that distinguishes the art of Zen Masters from professional calligraphers.

In the calligraphy of a Zen Master, the right Zen mind must be contained. Therefore, there is also calligraphy in which the art is not very good. That is proof that the Master has not done much calligraphy. But one can still see the Zen mind there. This is a characteristic of Zen calligraphy. In some cases the person has expressed his Zen mind by drawing only one line; after I had explained this at one university, I was asked, "Looking at your calligraphy, where is your Zen mind?" Actually, from the point of picking up the brush, everything is Zen mind, it is not in only one point. The total thing is Zen mind.[52]

Stylistically, the calligraphy in this scroll bears a strong resemblance to Fukushima's Master Shibayama. There is a continuous, lucid rhythm of strokes, the tips are left open, and one can see a general sweeping quality of the brush reminiscent of Shibayama's work.

In 1991 Fukushima fulfilled Okada Rōshi's hopes and was elected *Kanchō* of the Tōfuku-ji sect, a position that he accepted under the condition that he be able to continue his annual visits to the United States. In 1996 his term was renewed. As a result, he supervises 370 subtemples in the Tōfuku-ji sect. Despite these administrative duties, through the availability of technology—Fax, phones, and express mail—he is able to travel and still run the temple. Once again Zen has been able to adapt to modern currents and utilize them to their best advantage. However, Fukushima is quick to point out that in some cases technology has not been beneficial to Zen training. In particular, he was astonished to discover an American Zen teacher using the telephone as a means of conducting *dokusan*, the private interviews between master and student during *kōan* training, and calling it "dokuphone."

Plate 89. Fukushima
NO HOST OR GUEST
Ink on paper
Collection of Mishō-ji,
a temple of the Tōfuku-ji sect

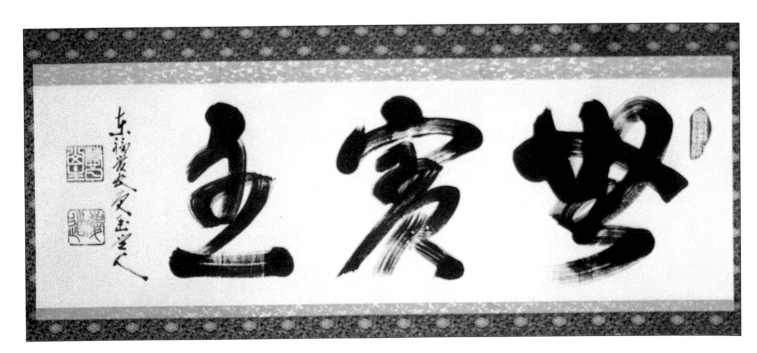

Despite these setbacks, Fukushima believes that great progress in the understanding of Zen has been made in the past thirty years. This is due to the increased number of books on Zen that are now available, initiated by the efforts and work of D. T. Suzuki; the greater interest in Japanese culture; the shrinking of the world thanks to technology; and the expanding outlook of people now eager to understand different approaches to life and spirituality. In the 1960s Shibayama Rōshi brought his Zen experience to Americans through books, lectures, and introductions to meditation. Fukushima Rōshi continues this tradition, now adding demonstrations of Zen brushwork to provide a visual expression of Zen mind.

Through his lectures and calligraphy demonstrations, Fukushima introduces Americans to the experience and teachings of Zen. However, realizing that cultural understanding is an exchange, he also adapts to his audience as revealed in another scroll of an *ensō*, but here inscribed in English, "Watch Touch and Bite" (PLATE 90). He comments, "One reason Westerners are becoming interested in Zen is because of an awareness that through becoming attached to words and letters, there grows within one a need to transcend that attachment."[53]

Fukushima not only uses English here instead of traditional Sino-Japanese, but also updates and adds a new dimension to the highly interpreted and appreciated *ensō*. No longer asking the viewer, "What is this?," now Fukushima solicits the audience to take an even more active role, utilizing a variety of senses, each more physically involved than the last, thus deepening the viewer's experience. Although often viewed as a meditative, calm, and passive religion, Zen vigorously encourages activity. Hakuin strongly believed in meditation within activity even more than silent, seated meditation, and this is what Fukushima suggests in this scroll.

Fukushima is fascinated by bridges. Although he visits America to convey his Zen teachings, he also encourages his audiences to participate and to understand Zen as an active vital force in modern Japanese and world culture. He recalls that in the late 1960s and early 1970s, American students tended to ask whether Christianity or Buddhism was better. Now they ask what the differences are between Christianity and Buddhism. Fukushima sees this as progress. "Eastern and Western cultures originally had many differences; this is okay, we have to study the differences. When you study, naturally you will find many good points. I emphasize these points because this is real *bunkakōryū* [meeting, merging of cultures]. Bridges are important." He himself, and his ink traces, have now become Zen bridges between Japan and the West.

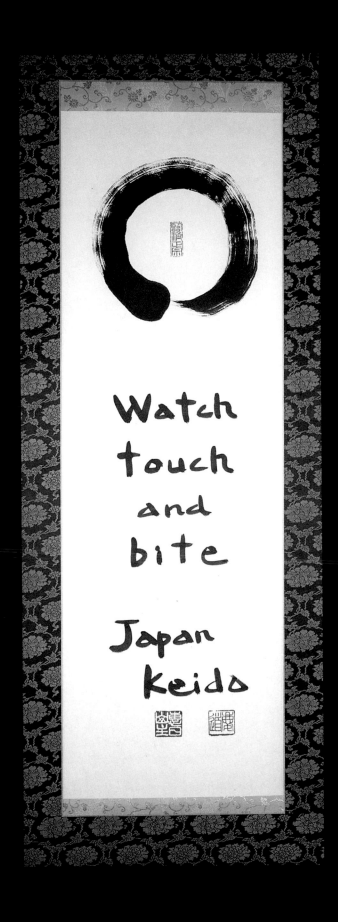

EPILOGUE

— STEPHEN ADDISS

IT HAS NOW BEEN TEN YEARS since I wrote *The Art of Zen*, presenting painting and calligraphy by Zen Masters from 1600 to 1925;[1] one of my hopes at that time was that other scholars would continue to study Zen art and exhibit it to the public. Being asked by Audrey Yoshiko Seo to contribute a chapter plus an epilogue to this volume has given me special pleasure, since I believe that through her diligent research she has brought forth some important insights into the Zen experience.

The twentieth century has seen many changes in the world of Zen, including the greatly increased participation of lay people, Zen as a basis for philosophy in Western terms, and the export of Zen to America and Europe. However, the core of Zen teaching from Master to pupil in monasteries, without which the tradition would falter, has continued unabated in Japan. This inner core is celebrated in this book and exhibition, through works of art created by leading Zen monks and nuns over the past one hundred years.

Zen and art have long interacted, and the works shown here of Masters from Nantenbō to Fukushima demonstrate that this interaction has remained strong and vibrant throughout the twentieth century. Yet the exact connection between Zen and art is never easy to define. On one hand, the Zen influence in Japanese ink painting and calligraphy, as well as tea, Noh drama, haiku, and martial arts, has long been clear. On the other hand, much of what has been described as "Zen," especially in this country, has tenuous connections at best. Where, then, is the specifically Zen quality in works of art?

There can be several definitions of Zen painting and calligraphy, ranging from works in traditionally Zen-influenced styles to works with a specific Zen theme. Therefore a calligraphy in a bold and powerfully simple style, or an ink portrait of Daruma, might be considered "Zen art" no matter who the calligrapher or painter might be. In chapter 3 we learn that the Zen Master Mokurai admired how a visiting artist "straightforwardly used his brush to empty out his conscious self and reach true concentration, manifesting the authority of a lion-lord. Indeed, attaining the singleness of art is not something an ordinary person can do, and is quite admirable." Nevertheless, the Zen Master Shibayama Zenkei wrote:

> When one puts his soul and body into his work, often he will be in a state of samadhi [no-mind] where he forgets himself and transcends the distinction of subject and object. Such unity has its own value and beauty and may justly be admired. But it is limited in most cases to a particular aspect of one's work, which is psychologically or technically separated from the rest of his life. One will be in that samadhi only when he is engaged in that particular work, and his unity may be gone once he comes out of it. The vital point is that his samadhi is not based on a fundamental awakening which will completely change his personality and life.[2]

Therefore, another definition is simpler: Zen art consists of works done by enlightened Zen monks and lay people, whatever the material or style, with a special focus upon works done by Zen Masters.[3]

Under this definition, landscapes or "four gentlemen" paintings that follow literati traditions, as well as haiku paintings, can be considered Zen art if done by Zen artists; the focus shifts from the style or subject to the maker of the work. This seems appropriate, since the core of Zen has remained the individual who realizes his or her enlightenment; the works

themselves become a visual record of personal expression and teaching. But the greater problem remains: how is enlightenment expressed in art?

The major Sōtō sect Master Dōgen at one point in his voluminous writings discussed art, taking the well-known saying that "a painting of a rice-cake does not satisfy hunger" as a point of departure. Referring to a famous Zen *kōan* about the "original face," he wrote:

> *Know that a painted rice-cake is your face after your parents were born, your face before your parents were born. Thus, a painting of a rice-cake, made of rice-flour, is neither born nor unborn. Since this is so, it is the moment of realization....Painted rice-cakes, which are usually understood as words and letters useless for realization, are not different from mountains and waters, which are regarded as actual expressions of the Buddha's enlightenment....all Buddhas are painted Buddhas, and all painted Buddhas are actual Buddhas....Unsurpassed enlightenment is a painting. The entire phenomenal universe and the empty sky are nothing but a painting....if you say a painting is not real, then the myriad things are not real. If the myriad things are not real, then the Buddha-dharma is not real. As Buddha-dharma is real, a painted rice-cake is real. . . . things beyond measure are actualized in a painting....Those who experience great awakening upon hearing the sound of bamboo, whether they are snakes or dragons, are all paintings. . . . Because the entire world and all phenomena are a painting, human existence appears from a painting, and Buddha ancestors are actualized from a painting.[4]*

This passage establishes the unity of painting and the Buddha-nature. As noted in chapter 3, a further statement was made by Yūzen Gentatsu when he wrote that the act of Zen painting requires the protracted experience of meditation. His comment helps to establish an understanding of where the specifically Zen values in a painting or calligraphy may lie:

> *To make a painting requires a lot of zazen.*

But if meditation is vital, what then of subject, style, composition, brushwork, and other matters of artistic technique? Fukushima Rōshi in conversation commented that when he looks at scrolls by Zen Masters, he enjoys the degree of enlightenment he can sense in them, although he realizes that some brushwork is technically superior to others. He most appreciates the works that combine both what he calls "Zen mind" and artistic values, but it is the first of these that is most important to him.[5]

Can this "Zen mind" within a painting or calligraphy be defined? It might seem useful if there were some way to demonstrate it, and some efforts have been made in this direction by the scholar and Zen layman Terayama Katsujō, who took measurements of the ink particles in completed ink paintings and calligraphy. Using an electron microscope, he magnified fifty thousand times small sections of signatures by the Zen layman Yamaoka Tesshū (1836–1888), finding that the particles were much more "solid, dynamic, and alive" in his calligraphy after enlightenment.[6] The photographs taken through the microscope reveal a more dense patterning of ink in Tesshū's later works, but it is not yet clear how far this method will prove useful in examining other Zen scrolls.

It may be that some kind of testing such as that done by Terayama can be helpful in determining the authenticity, internal energy, and even possi-

bly the "life breath" within a work of art. However, like Zen itself, art is best sensed and communicated through direct involvement, through empathy, and through practice. Intense viewing of paintings and calligraphy has the potential to convey a form of experience that goes beyond words; that is why Zen Masters, especially in their final years, have created so many works to give to their followers. But in all the arts, it is personal experience that matters most; this opportunity for experience is available for each one of us when we encounter Zen painting and calligraphy. As noted in chapter 7, Shibayama wrote that Zen Masters can express their experience by painting, but viewers must read the teaching from within, based on experience.[7]

This book and the exhibition that it accompanies offer a unique opportunity to explore and experience the works of Masters who have not only kept Zen painting and calligraphy robust and vigorous throughout the twentieth century, but who have also added new subjects, new styles, new humor, and a banquet of personal variations upon traditional themes. Furthermore, the transmission of Zen from one generation to the next is visually apparent in the works illustrated here. Comparing the art of such monks as Nantenbō and Deiryū, Shōun and Gempō, Yūzen and Mokurai, and Shibayama and Fukushima makes clear that the traditional Master-pupil relationship that sustains Zen has not faltered despite the changes and dislocations that have taken place in Japanese society over the past hundred years. And yet each Master has brought his or her own distinct individuality to the art, as is clearly displayed by the scrolls and objects reproduced here.

It has long been believed in East Asia that the flexible brush upon paper or silk reveals the full personality of the artist who wields it. The works in this volume display the inner character of monks and nuns who have given their lives to the study, practice, and teaching of Zen. Both individual and universal, these works constitute a form of teaching that remains vital for us in a different culture, half a world away. Above all, they express directly that for every one of us, the enlightenment of our "original face" is right here, right now.

1. Shibayama Zenkei, *Zen Comments on the Mumonkan* (New York: Harper and Row, 1974), p. 159.
2. Robert Bellah, *Tokugawa Religion* (New York: Free Press, 1957), p. 51.
3. Masahide Bitō, "Thought and Religion, 1550–1700," in John Whitney Hall, ed., *The Cambridge History of Japan*, vol. 4, *Early Modern Japan* (Cambridge: Cambridge University Press, 1991), p. 378.
4. Joseph Kitagawa, *Religion in Japanese History* (New York: Columbia University Press, 1966), p. 202.
5. He reduced the number of temples from 539 to 80. However, in 1870, a new official increased the number to 135.
6. Martin Collcutt, "Buddhism: the Threat of Eradication," in Marius B. Jansen and Gilbert Rozman, eds., *Japan in Transition: From Tokugawa to Meiji* (Princeton, N.J.: Princeton University Press, 1986), pp. 158–59.
7. Ibid., p. 159.
8. Ibid., p. 161.
9. Kitagawa, *Religion in Japanese History*, p. 226.
10. Ibid., p. 227.
11. Ibid., p. 230.
12. H. Byron Earhart, *Religion in the Japanese Experience* (Belmont, Calif. : Dickenson Publishing, 1974), p. 216.
13. Ibid.
14. Seikō Hirata, "Zen Buddhist Attitudes to War," in James W. Heisig and John C. Maraldo, eds., *Rude Awakenings: Zen, the Kyoto School, and the Question of Nationalism* (Honolulu: University of Hawaii Press, 1994), pp. 3–4.
15. Quoted in Robert H. Sharf, "The Zen of Japanese Nationalism," in Donald S. Lopez, ed., *Curators of the Buddha* (Chicago: University of Chicago Press, 1995), p. 114.
16. See Brian Victoria, *Zen at War* (New York: Weatherhill, 1997), pp. 91–93.
17. Hirata, "Zen Buddhist Attitudes to War," p. 10.
18. Earhart, *Religion in the Japanese Experience*, p. 216.
19. Ibid., p. 217.
20. Kitagawa, *Religion in Japanese History*, p. 290.
21. Ibid.
22. Heinrich Dumoulin, *Zen Buddhism in the Twentieth Century* (New York: Weatherhill, 1992), p. 12.
23. The third main sect in Zen is Ōbaku, which was introduced to Japan in the seventeenth century by Chinese monks after the fall of the Ming dynasty. See Stephen Addiss, *Obaku: Zen Painting and Calligraphy* (Lawrence, Kans.: Spencer Museum of Art, 1978).
24. Dōgen is the founder of the Japanese Sōtō sect.
25. See chap. 5, note 2, and the bibliography.
26. Dumoulin, *Zen Buddhism in the Twentieth Century*, p. 36.
27. See Shin'ichi Hisamatsu, *Zen and the Fine Arts* (Tokyo: Kodansha International, 1971).
28. Sharf, "The Zen of Japanese Nationalism," p. 141.
29. Information in this section on monastic practice was culled from T. Griffin Foulk, "The Zen Institution in Modern Japan," in Kenneth Kraft, ed., *Zen: Tradition and Transition* (New York: Grove Press, 1988).
30. The fifteen Rinzai head temples are Buttsu-ji, Daitoku-ji, Eigen-ji, Engaku-ji, Hōkō-ji, Kenchō-ji, Kennin-ji, Kōgaku-ji, Kokutai-ji, Kōshō-ji, Myōshin-ji, Nanzen-ji, Shōkoku-ji, Tenryū-ji, and Tōfuku-ji. Statistics from Foulk, "The Zen Institution," p. 158.
31. Ibid.
32. In the Rinzai sect, Kōshō-ji does not have its own monastery.
33. Foulk, "The Zen Institution," p. 165.
34. Shibayama, *Zen Comments*, pp. 100–101.

NOTES

35. Philip B. Yampolsky, *Zen Master Hakuin* (New York: Columbia University Press, 1971), pp. 33–34.

36. Adapted from Eshin Nishimura, "Zen Monastic Life and Its Culture," in *Zen no shiki* (Tokyo: Kōsei Deppansha, 1988).

37. Fukushima Keidō, from his guest lecture for the "Beyond Words" seminar, University of Richmond, Spring 1994.

38 . See Alice Rae Yelen, "Looking at Zen Art," in *Zenga: Brushstrokes of Enlightenment* (New Orleans: New Orleans Museum of Art, 1990), for a detailed discussion of artistic materials and techniques used in *zenga*.

CHAPTER 1: USHERING ZEN INTO THE TWENTIETH CENTURY

1. Nakahara Tōjū, *Nantenbō angya roku* (Tokyo: Heika Shuppansha, 1984), pp. 23–24. Adapted by Akizuki Ryōmin from the original (Tokyo: Osakaya Goshoten, 1921).

2. By Japanese count, which considers a baby to be one year old at birth.

3. Awakawa Yasuichi, "Edo-jidai Rinzai kōsō bokuseki no tokushoku," *Kinsei zenrin bokuseki* (Kyoto: Shibunkaku, 1974), II, p. 3.

4. See Alexandra Munroe, "To Challenge the Mid-Summer Sun: The Gitai Group," in *Japanese Art after 1945: Scream against the Sky* (New York: Harry N. Abrams, 1994), p. 94.

5. Nakahara, *Nantenbō angya roku*, p. 20.

6. Ibid., p. 34.

7. Ibid., p. 68.

8. Ibid., p. 90.

9. Ibid., p. 134.

10. Ibid., p. 144.

11. Ibid., p. 145.

12. Ibid., p. 165.

13. Ibid., p. 275.

14. David Pollack, *The Fracture of Meaning: Japan's Synthesis of China from the Eighth through the Eighteenth Centuries* (Princeton: Princeton University Press, 1986), p. 129 (as translated and quoted from Takakusu Junjirō and Watanabe Kaigyoku, eds., *Taishō shinshū daizokyū*) (Tokyo: Daizō Shuppan K.K., 1924–1932), 80:503c.

15. Horie Tomohiko, *Bokuseki*, Nihon no bijutsu series, no. 5 (Tokyo: Shibundō, 1966), p. 13.

16. Nakahara, *Nantenbō*, p. 369.

17. Ibid., p. 335.

18. Heinrich Dumoulin, *Zen Buddhism: A History—India and China*, trans. James W. Heisig and Paul Knitter (New York: Macmillan, 1988), p. 99.

19. Nakahara, *Nantenbō*, p. 358.

20. See Morohashi Tetsu-ji, *Dai kanwa-jiten* (Tokyo: Daishuten shoten, 1984), vol. 13, entry for *ningen*.

21. Translation by Yoshiaki Shimizu and John Rosenfield as published in *Masters of Japanese Calligraphy, Eighth-Nineteenth Century* (New York: Japan House Gallery and Asia Society Galleries, 1985), p. 90.

22. According to a Mr. Yamada, who helped Nantenbō when he wrote the large characters, as quoted in *Bokubi* 14, p. 7.

23. Munroe, "To Challenge the Mid-Summer Sun," p. 94.

24. Stephen Addiss, *The Art of Zen* (New York: Harry N. Abrams, 1989), p. 11.

25. For an example, see Kazuaki Tanahashi, *Penetrating Laughter: Hakuin's Zen and Art* (Woodstock, N. Y. : Overlook Press, 1984), p. 120.

26 . See, for an example, Stephen Addiss, *The Art of Zen*, p. 156.

27. Nakahara, *Nantenbō*, p. 349.

28. Jan Fontein and Money Hickman, *Zen Painting and Calligraphy* (Boston: Museum of Fine Arts, 1970), pp. 113–18; see chap. 7 for a further explanation.

29. Miyeko Murase, *Jewel Rivers: Japanese Art from the Burke Collection* (Richmond: Virginia Museum of Fine Arts, 1994), p. 55.

30. One disciple's view of the Master can be seen in Deiryū's portrait of Nantenbō in chapter 3, Plate 13, as contrasted with Nantenbō's portraits of his own visage (plates 14 and 15).

31. Katsuki Sekida, *Two Zen Classics: Mumonkan and Hekiganroku* (New York: Weatherhill, 1977), pp. 213–14.

32. Shibayama Zenkei, *Zenga no ensō* (Tokyo: Shunshūsha, 1969), p. 8.

33. Heinrich Dumoulin, *A History of Zen Buddhism*, trans. Paul Peachey (Boston: Beacon Press, 1963), p. 108.

34. For an example, see Stephen Addiss, *Haiga: Takebe Sōchō and the Haiku-Painting Tradition* (Richmond, Va.: Marsh Art Gallery, University of Richmond, and the University of Hawaii Press, 1995), pp. 122–23.

CHAPTER 2: THE TRANSMISSION OF ZEN ART AND TRAINING

1 . From *Deiryū ihō* (Kyoto: Empuku Sōdō, 1980), p. 130.

2 . See chap. 4 for information on Yamamoto Gempō.

3. Biographical information on Deiryū is found in Shun'ō Fukushima and Shōshun Katō, *Zenga no sekai* (Kyoto and Tokyo: Tankosha, 1978), and Kembu Kishida, *Hōmyaku gendai zen sho retsudan* (Kyoto: Chūgai Nipponsha, 1973).

4. *Deiryū ihō*, p. 75. I would like to thank Natsuko Oda for her invaluable help with many of the anecdotes used in this chapter.

5. Ibid., pp. 63–64. Wang Hsi-chih (309–365) was perhaps China's most famous calligrapher, and his work is often used as a model by calligraphers.

6. Ibid.

7. Ibid., p. 163.

8. Ibid., pp. 151–52.

9. Translation by Stephen Addiss.

10. See Matthew Welch, *The Painting and Calligraphy of the Japanese Zen Priest Tōjū Zenchū, Alias Nantenbō (1839–1925)* (Ann Arbor, Mich.: University Microfilms, 1995), pp. 193–97.

11. *Deiryū ihō*, p. 169, recollection of Masahiro Yoshida.

12. For a detailed description of how the character for "dragon" can be written and calligraphically modified, see Stephen Addiss, *How to Look at Japanese Art* (New York: Harry N. Abrams, 1996), p. 92.

13. Katsuki Sekida, *Two Zen Classics: Mumonken and Hekiganroku* (New York: Weatherhill, 1977), p. 312.

14. The date is also sometimes given as 1921.

15. Kōzuki Tessō trained at Empuku-ji under Sōhan Gempō (Shōun), whom he assisted in the renovation of several temple buildings. In 1918 Kōzuki received *inka* from Shōun and was appointed abbot of Empuku-ji. He traveled to various Buddhist sites in India and China, and in 1923 was appointed president of the Rinzaishū Daigaku (Rinzai-Sect University). At the age of fifty he was elected abbot of the Myōshin-ji sect. During his last years he built a Zen center for foreigners and encouraged university students to become more interested in Zen Buddhism.

16. *Deiryūkutsu goroku* (Kyoto: Empuku Sōdō, 1980), p. 1. This and other translations from the same work are by Stephen Addiss.

17. The term "no gate" or "no barrier" (*mumon*) can refer to the Zen text *Mumonkan*. It also refers to the fact that although the path of Zen is said to be "gateless," the practitioner must still break through and transcend ordinary, dualistic thinking.

18. *Deiryū ihō*, pp. 102–3.

19. *Deiryūkutsu goroku*, pp. 94–95.

20. *Deiryū ihō*, p. 99.

21. Ibid., p. 100.

22. Ibid., p. 128.

23. See John Stevens, *Zenga: Brushstrokes of Enlightenment* (New Orleans: New Orleans Museum of Art, 1990), p. 137.

24. See Addiss, *The Art of Zen*, p. 200.

25. *Deiryū ihō*, p. 131.

26. Ibid., pp. 102–3, recollection of Hitomi Sōchu.

27. Ibid., pp. 90–91.

28. Ibid.

29. Ibid., pp. 156–58.

30. Ibid., pp. 152–55.

31. *Deiryūkutsu goroku*, p. 24

32. *Deiryūkutsu goroku*, p. 24. "Old Pine" refers to Nantenbō. The service was performed by Deiryū and Kōzuki Tessō.

33. *Deiryūkutsu goroku*, p. 30

34. Ibid., p. 37.

35. *Deiryū ihō*, pp. 169–70.

36. Takuan Sōhō, *The Unfettered Mind: Writings of the Zen Master to the Sword Master*, trans. William Scott Wilson (Tokyo: Kodansha International, 1986), p. 19.

37. *Deiryū ihō*, p. 81.

38. Ibid., p. 165, recollection of Hideo Mori.

39. This expression is given in an 1189 anthology of Rinzai tradition, *Arrayed Lamps of the Zen School Merged in Essence*. After a Zen monk is finally enlightened, he exclaims that studying with a former teacher was "like a mosquito trying to bite an iron bull." See Kazuaki Tanahashi, ed., *Moon in a Dewdrop: Writings of Zen Master Dogen* (New York: North Point Press, 1985), pp. 80–81.

40. *Deiryū ihō*, pp. 120–21.

41. Ibid., p. 127.

42. *Deiryūkutsu goroku*, p. 96.

43. Ibid., p. 97.

44. Fukushima and Katō, *Zenga no sekai*, p. 191. A *nabe* is a Japanese casserole.

45. *Deiryū ihō*, pp. 120–21.

46. Ibid., p. 168.

47. Ibid., pp. 76–77.

48. Ibid., p. 63.

CHAPTER 3: RESTORING ZEN AND TAKING IT FORWARD

1. Shun'ō Fukushima and Shōshun Katō, *Zenga no sekai* (Kyoto and Tokyo: Tankosha, 1978), p. 169. Excerpts from other letters from Sōseki to the monks can be found in *Zen Haiku: Poems and Letters of Natsume Sōseki*, translated and edited by Sōiku Shigematsu (New York: Weatherhill, 1994).

2. Kembu Kishida, *Hōmyaku gendai zen sho retsudan* (Kyoto: Chūgai Nipponsha, 1973), p. 425.

3. Yūzen Gentatsu, *Sanshōroku* (Kurume: Bairin-ji, 1941), pp. 5–6

4. Izan Soan became a monk at the age of nine under Sensō Soei at Tenki-ji in Ichinose-mura, Ishitsu-gun. At twenty he went to Zuiryū-ji in Gifu to study under Inzan Ien. He trained there for seven years and was then sent to serve as attendant to Sekkan Shōju at Daisen-ji in Bishū (Aichi), from whom he eventually received his certification. In 1824 he returned to Tenki-ji as head of the temple, retiring in 1849 at the age of sixty-two. In the spring of 1852 Izan moved to Mampuku-ji in Uchino-mura, Enshū (Shizuoka) and then the following year to Myōshin-ji in Kyoto. In the spring of 1862, upon his retirement from Myōshin-ji, he returned to Mampuku-ji to supervise temple renovations made possible by a lay follower, Yokota Fumai. Izan fell ill in 1864 while lecturing on the *Hekiganroku* at Tōkō-ji in Tsuboi-mura, and died there on May 16, 1864, at the age of seventy-seven.

5. Yūzen *Sanshōroku*, p. 29.

6. Kishida, *Hōmyaku*, p. 426.

7. Ibid., p. 427.

8. Suigan became a monk under Manzan Kai of Fukusen-ji in Kamae, Bungo. Later he trained under Shunno Zen'etsu at Eiho-ji near Nagoya, and eventually he received his certification. After Shunno's death, Suigan went to Seigen-ji in Ōmi near Lake Biwa, and then to Hōun-in in western Kyoto, where he remained

for fifteen years. In 1864, upon the death of Izan Soan, Suigan succeeded him at Mampuku-ji in Uchino-mura. The training hall was eventually closed, so he took his pupils to Tōun-ji in Hamamatsu. In 1867 he moved to Eigen-ji and renovated the temple. He was also responsible for the reconstruction of many other temples including Samiyō-ji, Jisen-ji, and Jikō-ji. He died on June 1, 1874, at the age of sixty-five.

9. Yūzen, *Sanshōroku*, p. 6.

10. Ibid., pp. 6–7.

11. Gōten Dōkai became a monk under Morin at Zenryu-ji in Owari. At the age of sixteen, he went to Higo to train under Sozan Genkyō at Kenshō-ji, receiving certification from him eighteen years later. In 1848 he became head of Tafuku-ji in Usuki, Bungo, and stayed there for twenty years. When Sozan died at Tokugen-ji in 1868, Gōten replaced him. In 1871 Gōten moved to Myōshin-ji and was appointed head abbot. He died on February 3, 1891, at the age of seventy-eight.

12. Mugaku Bun'eki is also known as Seki Mugaku. He became a monk under Tangen at Seitai-ji, and then began traveling at the age of sixteen. At twenty he began training under Gessan Kokyō of Kokusei-ji in Bizen, then under Keiin of Gyokushō-ji in Izumo. He then moved to Bairin-ji to train under Sozan Genkyō and, upon Sozan's death, continued training under Sozan's successor, Razan. He received certification from Razan. In 1867 he became head of Bairin-ji, and in 1874 was appointed head abbot of Myōshin-ji. His appointment was renewed in 1878, 1885, and 1896. In 1875 the newly formed Kyōbushō (Ministry of Education) appointed Mugaku superintendent of all nine Zen sects. In 1878 he was appointed head of all Buddhist and Shinto sects. In 1879 he retired from Bairin-ji and moved to Zuigen-ji in Owari. He died on October 31, 1897, at Myoshin-ji. Bairin-ji is the temple where Nantenbō trained under Razan Genma and achieved his first enlightenment after sitting on a plank board over a well.

13. Kishida, *Hōmyaku*, p. 428.

14. Yūzen, *Sanshōroku*, p. 3.

15. Ibid., p. 9.

16. Ibid., pp. 13–14.

17. Ibid., p. 14.

18. Ibid., p. 13.

19. Ibid., p. 11.

20. Ibid., p. 24. The udon made at Saifu Kankōbyō was beaten from very pure Japanese flour and was noted for its tenderness; Yūzen was very fond of this udon.

21. Ibid., p. 32.

22. Ibid., pp. 35–36.

23. Ibid., p. 16.

24. Ibid., pp. 14–15.

25. Ibid., p. 15.

26. Helmut Brinker and Hiroshi Kanazawa, *Zen: Masters of Meditation in Images and Writings* (Zurich: Artibus Asiae Publishers, 1996), p. 182.

27. Yūzen, *Sanshōroku*, p. 16.

28. Ibid., p. 17.

29. Ibid., p. 31.

30. See Audrey Seo, "The Flight of Cranes: A Pair of Six-Panel Screens by Soga Shōhaku," in *Orientations* 27, no. 22 (December 1996), pp. 28–36, for a discussion of cranes in Chinese and Japanese art and culture.

31. Sōiku Shigematsu, trans., *A Zen Forest: Sayings of the Masters* (New York: Weatherhill, 1981), p. 45.

32. Translation by Jonathan Chaves, who notes that the phrase "on all four sides" derives from a passage from the *Monograph on Music and History of the [Liu] Sung Dynasty* [A. D. 420–479]: "The sage ruler is established at the center; his ministers and artisans encircle him on all four sides. "

33. Yūzen, *Sanshōroku*, p. 25.

34. During the Muromachi (1333–1573) and Momoyama (1573–1600) periods, the administrative and cultural center of Zen was largely based in the five "Gozan" temples and Daitoku-ji in Kyoto. However, during the Edo period (1600–1868),

the revitalization of Zen and Zen training under Hakuin Ekaku (1685–1769) caused Myōshin-ji's role to increase.

35. Yūzen, *Sanshōroku*, p. 39.

36. Ibid., p. 7.

37. Yūzen, *Sanshōroku*, p. 39.

38. Ibid.

39. Ibid., p. 8.

40. Kishida, *Hōmyaku*, p. 431.

41. Yūzen, *Sanshōroku*, pp. 37–38.

42. Kishida, *Hōmyaku*, p. 431. Some sources give Yūzen's death date as 1917.

43. Biographical information on Mokurai is given in Tōshin Itō, *Mokurai Zenshi* (Kyoto: Kennin-ji, 1979), and in the *nenpu* (yearly record) contained in Ōura Kandō, ed., *Mokurai Zenshi ihō* (Kyoto: Hyakka-en, 1969), pp. 134–46. I would like to thank Stephen Addiss for his help with material on Mokurai.

44. Kandō, *Mokurai*, p. 20.

45. Ranryō Gishū served as abbot of Rinsen-ji, a temple in the Daitoku-ji line. In 1853 he was appointed ninety-third abbot of Sōfuku-ji.

46. Quoted in Itō, *Mokurai Zenshi*, p. 6.

47. Tairyū became a monk at the age of seventeen under Shōin at Jiun-ji in Okada. He subsequently trained under Settan Shōhaku at Zuiryū-ji and then Shōgen-ji for a total of nineteen years. He served as head of Daitai-ji for several years and in the spring of 1808 moved back to Shōgen-ji to supervise the *sōdō*, remaining there for over ten years.

48. Gisan became a monk at the age of eleven under Nanrei at Chōfuku-ji in Takahama, Fukui. At seventeen he went on pilgrimage to visit Zen teachers, eventually continuing his training at twenty-two under Taisen Shizen at Sōgen-ji in Bizen. Ten years later he received Taisen's *dharma* transmission. In 1868 he became head of the *sōdō* at Nanshū-ji in Sakai Izumi (Osaka). Later he was appointed *Kanchō* of Myōshin-ji and then eventually supervised the training hall at Daitoku-ji, becoming the first Zen Master to introduce the Hakuin tradition to Daitoku-ji. He established the training halls at Tenryū-ji, Myōshin-ji, and Engaku-ji.

49. Kandō, *Mokurai*, pp. 126-7.

50. Yūzen, *Sanshōroku*, p. 40.

51. Chōsō became a monk under Eiō of Sugetsu-ji, a subtemple of Myōshin-ji. At the age of eighteen he practiced under Banrei Gen'i of Zuiryū-ji in Mino. He then trained under Shōzen Zengai at Sōkei-in in Iyo (Ehime) and received his certification of enlightenment. He continued his training under Kasan Zenryō of Chōfuku-ji in Mino and also received his certification. In 1871 he became the head of Yūkō-ji on Hirado island, Hizen (Saga). He wrote the *Tōken fuko*, an explanation of Buddhism, in response to the anti-Buddhist sentiments of the period. After serving at Tenzui-ji in Osaka from 1883–1887, he moved back to Yūkō-ji, and then retired in 1890 at Tenkei-ji. He died in 1903 at the age of seventy-three.

52. All current Japanese Rinzai monks trace their Zen training lineages back to Hakuin through either Inzan Ien (1751–1814) or Takujū Kōsen (1760–1833), both disciples of Hakuin's pupil Gasan Jitō (1727–1797). The teachings in both the Inzan and Takujū lines are similar; for example, *kōan* training was basically standardized in both traditions. The major difference is in the use of *jakugo*, or "capping phrases." Upon the successful completion of a *kōan*, the student will bring to his Master one or two lines of prose or verse. The phrase should reflect and summarize the importance of the *kōan* that has just been mastered. Zen Masters of the Inzan line use *jakugo* for most but not all *kōan*, the Takujū lines use them for all *kōan*.

53. From Mokurai's *Angō mitsurei*, vol. 1, as quoted in *Mokurai Zenshi*, p. 8.

54. *Mokurai zenwa*, quoted by Kembu Kishida, "Mokurai Sōen," in Ito, *Mokurai Zenshi*, pp. 21–22.

55. The syllable count in this haiku is 5-7-7 rather than the standard 5-7-5.

56. Itō, *Mokurai Zenshi*, p. 8.

57. Takeda Mokurai, *Zenki* (Tokyo: Heigo Shuppansha, 1915), pp. 147–48.

58. Interview with Fukushima Keidō, March 1996.

59. Takeda Mokurai, *Zen no sakkatsu* (Tokyo: Seikōkan Shoten, 1931), p. 287.

60. Thomas Cleary, ed., *Teachings of Zen* (Boston: Shambhala Publications, 1998), p. 30.

61. Both translations by Norman Waddell.

62. Itō, *Mokurai Zenshi*, p. 27.

63. Hidaka Tetsuō (1791–1871) was born in Nagasaki and entered Shuntoku-ji at the age of ten after the death of his father. He studied painting under Ishizaki Yūshi (1768–1846), a Nagasaki scholar-artist, and Chiang Chia-p'u (1744–after 1839), a Chinese painter who visited Nagasaki. Tetsuō specialized in orchid paintings, and his approach to painting orchids, which he is said to have received in a dream, is recorded in the book *Tetsuō Ranchikufu*. He took his name Tetsuō from two men he greatly admired, the orchid painter Tesshū Tokusai (d. 1366) and his Zen Master Ken-ō (dates unknown).

64. *Nanga* is the Japanese version of the scholar-painter tradition from China.

65. Kandō, *Mokurai*, pp. 77–79.

66. Mokurai, *Zenki*, pp. 145–46.

67. Kandō, *Mokurai*, p. 126.

68. Itō, *Mokurai Zenshi*, p. 18, translation by Norman Waddell. The first line refers to the seeming futility of the bodhisattva working to save others.

CHAPTER 4: LARGE MONASTIC CENTER VERSUS SMALL RURAL TEMPLE

1. Sōhan Gempō, *Dokuge-shū*, vol. 2 (Kyoto: Shingetsu Tessō, 1928), p. 20. Translations from this poetry collection are by Stephen Addiss.

2. Biographical information on Shōun is found in Shun'ō Fukushima and Shōshun Katō, *Zenga no sekai* (Kyoto and Tokyo: Tankosha, 1978), pp. 175–177, and Kembu Kishida, *Hōmyaku gendai zen sho retsudan* (Kyoto: Chūgai Nipponsha, 1973), pp. 377–82.

3. Kasan trained under Sekiō Sōmin at Empuku-ji and after Sekiō's death moved to Tokugen-ji in Nagoya to train under Sozan Genkyō (1799–1868), from whom he eventually received *inka*. Kasan became head of Chōfuku-ji in Iyo and then was asked to supervise the training hall at Empuku-ji. In 1881 he moved to Sōkei-ji in Tokyo, but he returned to Empuku-ji a year later. In 1883 he traveled to China to observe Chinese Buddhist practices. Upon his return to Empuku-ji, he reported to his monks that the Chinese monks maintained the Buddhist precepts rigorously; he then banned the drinking of alcohol in the temple. He was appointed abbot of Daitoku-ji in 1891 and died two years later.

4. Matthew Welch, *The Painting and Calligraphy of the Japanese Zen Priest Tōjū Zenchū, Alias Nantenbō (1839–1925)* (Ann Arbor: University Microfilms, 1995), p. 39.

5. Ikkyū Sojun (1394–1481) spent much of his life as a wandering monk, outside traditional monastic circles; however, he was violently opposed to anything that threatened the pure nature of Zen, including aristocratic influences and those willing to sell Zen for the financial benefit of their temple. He sympathized with the common people and tried to make Zen approachable and understandable for everyone. To this extent, he is credited with popularizing *kanahōgo*, the writing of Zen phrases in colloquial Japanese.

6. Translation by J. Thomas Rimer and Stephen Addiss. The last line, *yume no ukihashi*, is a reference to *The Tale of Genji*. Shōun has also made a pun with the word *hashi* meaning both "chopsticks" and "bridge."

7. The term *Gozan* was used to distinguish five of the most important Zen temples as centers of Zen activities. The Gozan have changed over the years, but primarily those of Kyoto have been Tenryū-ji, Shōkoku-ji, Kennin-ji, Tōfuku-ji, and Manju-ji.

8. Kishida, *Hōmyaku*, p. 380.

9. Ibid.

10. *Dokuge-shū*, vol. 2, p. 30. The term "cross over" is used in Buddhism for enlightenment.

11. Kishida, *Hōmyaku*, p. 381.
12. *Dokuge-shū*, vol. 2, p. 40.
13. Sōgo Takayi, *Gempō Rōshi* (Tokyo: Ōkura Shuppan Kabushi Kaisha, 1963), pp. 206–7.
14. Kishida, *Hōmyaku*, p. 378.
15. *Dokuge-shū*, vol. 2, p. 28.
16. Kishida, *Hōmyaku*, p. 382.
17. Interview with Fukushima Keidō, March 1996.
18. Daishin Gito (1656–1730), Hakuin Ekaku (1685–1769), and Tōrei Enji (1721–1792) were three prominent Zen Masters of the Edo period.
19. Translation by Jonathan Chaves.
20. Benkichi Tamaki, *Kaisō Yamamoto Gempō* (Tokyo: Harukisha, 1970), p. 48.
21. Ibid., p. 52.
22. Translation by Kinuko Jambor.
23. Tamaki, *Kaisō*, p. 215.
24. Kishida, *Hōmyaku*, p. 382.
25. There is no evidence to prove this account of abandonment. According to Gempō's nephew, Okamoto Tsutamu, the legend is false, and Gempō was originally born to the Okamoto family. However, this too has not been proven. Biographical information about Zen Masters is often embellished or blurred slightly in order to reveal Zen teachings or Zen aspects of the Master's life. This tradition of hagiographic accounts goes back to Chinese Zen. Biographical information on Yamamoto Gempō has been culled from *Gempō Rōshi* by Sōgo Takagi (Tokyo: Ōkura Shuppan Kabushi Kaisha, 1963), *Yamamoto Gempō Rōshi ten* (Mishima City: Nakayama Kaisha, 1982), *Kaisō Yamamoto Gempō* by Benkichi Tamaki (Tokyo: Harukisha, 1970) and *Hōmyaku gendai zen sho retsudan* by Kembu Kishida (Kyoto: Chōgai Nipponsha 1973), pp. 410–18.
26. Takagi, *Gempō Rōshi*, p. 3.
27. Ibid., p. 4.
28. The thousand-mile pilgrimage route on the island of Shikoku is one of the most famous routes in Japan and is known as the "Pilgrimage to the Eighty-eight Sacred Places of Shikoku." It is believed that Kōbō Daishi (774–835), founder of the Shingon sect of Buddhism, originally made this pilgrimage in the ninth century.
29. Takagi, *Gempō Rōshi*, p. 15.
30. *Yamamoto Gempō Rōshi ten*, p. 46.
31. Kyūhō began his training under Shinno at Hōfuku-ji in Okayama, and continued under Razan at Bairin-ji in Kurume, and Gizan at Sōgen-ji in Okayama. He became resident priest at Hōfuku-ji at the age of thirty-two but continued his training under Kaishū Sotō at Tōfuku-ji, and after Kaishū's death, with Kyōdō Etan, from whom he received *inka* in 1880. In 1883 he became abbot of Tōfuku-ji.
32. Takagi, *Gempō Rōshi*, p. 37.
33. Ibid., p. 41.
34. Ibid., p. 46.
35. Ibid., p. 48.
36. Ibid., p. 50.
37. Ibid., p. 54.
38. Kishida, *Hōmyaku*, p. 414.
39. Ibid., p. 415.
40. Sochū Suzuki, "Shi kan," in *Yamamoto Gempō Rōshi ten*, p. 46
41. Ibid.
42. Takagi, *Gempō Rōshi*, p. 63.
43. Tamaki, *Kaisō*, p. 221.
44. Takagi, *Gempō Rōshi*, p. 100.
45. Toen Fujiwara, *Zen no meisō retsuden* (Tokyo: Kosei Deppansha, 1990), p. 155.
46. Tōrei Enji (1721–1792) was Hakuin's main disciple; he was installed as Zen Master of Ryūtaku-ji in 1760 and oversaw the renovation of the temple and its reconstruction when it was later destroyed by fire.
47. Kishida, *Hōmyaku*, p. 417.

48. Sōen Nakagawa, *Endless Vow: The Zen Path of Sōen Nakagawa*, compiled and translated by Kazuaki Tanahashi and Roko Sherry Shayat (Boston & London: Shambhala Publications, 1996), p. 13.

49. Ibid., p. 64.

50. Yamamoto Gempō, *Mumonkan teishō* (Lectures on the Mumonkan) (Tokyo: Daihō Rinkaku, 1978), p. 16. Gempō here is discussing the *Mu kōan*; translation by Stephen Addiss.

51. Takagi, *Gempō Rōshi*, p. 7.

52. Ibid., p. 185.

53. Ibid.

54. Ibid., p. 187.

55. *Yamamoto Gempō Rōshi ten*, p. 49.

56. Takagi, *Gempō Rōshi*, p. 95.

57. See Robert G. Henricks, *The Poetry of Han-shan* (Albany: SUNY Press, 1990), p. 32, for complete poem and notes on the Chinese origin of the phrase.

58. Suzuki, "Shi kan," p. 44.

59. Ibid.

60. Tamaki, *Kaisō*, pp. 28–29.

61. Suzuki, "Shi kan," p. 47.

62. Tamaki, *Kaisō*, p. 151. Translation by Norman Waddell.

63. Fujiwara, *Zen*, p. 155.

64. Nakagawa, *Endless Vow*, p. 116.

65. Takagi, *Gempō Rōshi*, p. 115.

66. Nakagawa, *Endless Vow*, p. 140.

67. Tamaki, *Kaisō*, p. 183.

68. Nakagawa, *Endless Vow*, p. 138.

69. Tamaki, *Kaisō*, p. 193.

CHAPTER 5: THREE SŌTŌ ZEN RESPONSES TO THE TWENTIETH CENTURY

1. Dōgen is often considered the greatest figure in Japanese Zen, although his importance was probably matched by the later Rinzai Master Hakuin Ekaku (1685–1768). For a more complex view of his importance in Sōtō tradition, see William M. Bodiford, *Sōtō Zen in Medieval Japan* (Honolulu: Kuroda Institute and University of Hawaii Press, 1993).

2. A number of Dōgen's writings have been translated into English, including in such books as: Yūho Yokoi, *Zen Master Dōgen: An Introduction with Selected Writings* (New York and Tokyo: Weatherhill, 1976); Reihō Matsunaga, *A Primer of Sōtō Zen: A Translation of Dōgen's Shōbōgenzō Zuimonki* (Honolulu: University of Hawaii Press, 1971); Kazuaki Tanahashi, ed., *Moon in a Dewdrop: Writings of Zen Master Dōgen* (San Francisco: North Point Press, 1985); Thomas Cleary, trans., *Shōbōgenzō; Zen Essays by Dōgen* (Honolulu: University of Hawaii Press, 1986): Francis H. Cook, *Sounds of Valley Streams; Enlightenment in Dōgen's Zen, Translation of Nine Essays from the Shōbōgenzō* (Albany: SUNY Press, 1989); Steven Heine, *A Blade of Grass: Japanese Poetry and Aesthetics in Dōgen Zen* [including Dōgen's *Sanshō dōei*] (New York: Peter Lang, 1989); Hee-jin Kim, trans., *Flowers of Emptiness: Selections from Dōgen's Shōbōgenzō* (Lewiston, N.Y.: Edward Mellan Press, 1985); Takashi J. Kodera, *Dōgen's Formative Years in China* [including Dōgen's *Hōkyō-ki*] (London: Routledge & Kegan Paul, 1979); Reihō Matsunaga, *Introduction to Hukanzazengi* (Tokyo: Seshinshobō, 1956); Nishiyama, Kōsen and John Stevens, trans., *Shōbōgenzō* vols. 1, 2, 3, and 4 (Tokyo: Nakayama Shobō, 1975, 1977, 1983, and 1983); Yūhō Yokoi, *The Shōbōgenzō* [one-volume and five-volume editions] (Tokyo: Sankibo Buddhist Bookstore, 1986); and various translations by Norman Waddell and Masao Abe of Dōgen's writings in *Eastern Buddhist*. For further discussion, see also Carl Bielefeldt, *Dōgen's Manuals of Zen Meditation* (Berkeley: University of California Press, 1988).

3. Masunaga, *A Primer of Sōtō Zen*, pp. 96–97.

4. Yokoi, *Zen Master Dōgen*, p. 46.

5. Ibid., p. 50.

6. Ibid., pp. 46–47.

7. Translation by Stephen Addiss.

8. Yokoi, *Zen Master Dōgen*, pp. 39 and 61.

9. The most reliable biography of Bokuzan is given in *Sōtōshū jinmei jiten* (Sōtō Sect Biographical Dictionary) (Tokyo: Kokusho Kankōkai, 1977), pp. 63–64.

10. Translation by Jonathan Chaves, who also provided the information on Li Kung-tso.

11. These stories are given in a Chinese *kōan* compendium translated by Thomas Cleary as *The Book of Serenity* (Hudson, N.Y.: Lindisfarne Press, 1990), pp. 206 and 211.

12. Translated from Dōgen's *Shōbōgenzō* by Thomas Cleary in *Rational Zen: The Mind of Dōgen Zenji* (Boston and London: Shambhala, 1995), p. 100.

13. Ibid., p. 398.

14. Ibid., pp. 400 and 399.

15. Translation from John Daido Loori, *Two Arrows Meeting in Mid-Air* (Boston and Rutland: Charles E. Tuttle, 1994), pp. 17–18, where this *kōan* is presented and discussed.

16. From Dōgen's *Eihei Kōroku*, translated by Thomas Cleary, *Rational Zen*, p. 59.

17. All translations of Santōka haiku given here are by Stephen Addiss unless otherwise noted.

18. Santōka's biography and translations of 372 of his haiku are presented by John Stevens in *Mountain Tasting: Zen Haiku by Santōka Taneda* (New York: Weatherhill, 1980), a book recommended to all lovers of poetry.

19. A thorough *nempu* (yearly record) of Santōka is given in *Santōka ibokushū* (Collection of Remaining Works by Santōka) (Tokyo: Shibunkaku, 1993), pp. 199–208.

20. By the end of the nineteenth century, haiku (also called *hokku* and *haikai*) had a long history in Japan, although they were still considered a more modern form of verse than the classical five-line *tanka*. Because the rules of haiku are simple—three lines of five/seven/five syllables, with a seasonal reference—it became an art for ordinary people rather than the aristocracy. The greatest historical master of haiku, Matsuo Bashō (1644–1694), had established the aesthetics of the form as close observation of nature, including human nature, in order to see the ordinary as extraordinary. The strong influence of Zen that appears in Bashō's haiku was not always fully absorbed by later poets, but the ability of the finest masters to suggest a moment of perception, even a hint of enlightenment, within a short verse about the everyday world has been close to the "right here, right now" attitude of Zen.

21. Santōka's journals have been published several times, including by Shun'yōdō, Tokyo, in eight volumes; translations given here and on the following pages are by Stephen Addiss.

22. Quoted by Kōnoike Rakusai, "Santōka iboku tanbō" (Searching for Santōka's Remaining Works), *Santōka ibokushū*, p. 181.

23. See Sakaki Bakuzan, "Santōka no sho o oshimu"(Evaluating Santōka's Calligraphy), *Sumi* no. 42 (May 1983), pp. 62–64.

24. See Stephen Addiss, *The Art of Zen* (New York: Harry N. Abrams, 1989), pp. 94–99.

25. This was first written as a dissertation by Paula Arai, *Zen Nuns: Living Treasures of Japanese Buddhism* (Ann Arbor, Mich.: University Microfilms 1993); the current book is being published by Oxford University Press in 1998.

26. Kojima Kendō, *Fune ni kizamu* (Carved in a Boat) (Tokyo: Josei Bukkyō-sha, 1985), pp. 172–73.

27. Comments of Arisaga Tainin, based upon the translation of Paula Arai, *Women Living Zen: Japanese Sōtō Buddhist Nuns* (New York and London: Oxford University Press, 1998), chap. 3.

28. Ibid.

29. Ibid., translated by Paula Arai.

30. Ibid.

31. Ibid.

32. Kojima, *Fune ni kizamu*, pp. 156–57.

33. See ibid., p. 157.

34. These and the following comments by Tsuneda Sen'ei were recorded by Stephen Addiss and Audrey Yoshiko Seo during an interview on November 9, 1995, at the Lumbini-en in Toyama.

35. This refers to a period when the Buddha practiced asceticism in the mountains, eating only a handful of grain every day; there are many statues extant of the "Starving Buddha," resembling a skeleton, with all his ribs showing.

CHAPTER 6: APPROACHES TO TRAINING AND ART
 DURING SOCIAL UPHEAVALS

1. Biographical material on Rozan is found in Shun'ō Fukushima and Katō Shōshun, *Zenga no sekai* (Kyoto and Tokyo: Tankōsha, 1978), and Kembu Kishida, *Hōmyaku gendai zen sho retsudan* (Kyoto: Chōgai Nipponsha, 1973).

2. Kishida, *Hōmyaku*, p. 399.

3. A pupil of Gasan Jitō, who was a disciple of Hakuin, Takujū was the founder of one of the two main lines of Rinzai teaching in the Hakuin tradition.

4. Ikkyū Sōjun, "Skeletons," from *Wild Ways: Zen Poems of Ikkyū*, trans. John Stevens (Boston & London: Shambhala Publications, 1995), pp. 107–9.

5. From *Ono no Komachi: Poems, Stories, Nō Plays*, trans. Roy. E. Teele, Nicholas J. Teele, and H. Rebecca Teele (New York: Garland Publishers, 1993), p. 36.

6. Ibid.

7. Kishida, *Hōmyaku*, p. 400.

8. Biographical information on Eishū is found in Fukushima and Katō, *Zenga no sekai*, pp. 186–88.

9. The *nenbutsu* is a vow made to Amida Buddha by followers of the Pure Land Buddhist sect. Believers chant *Namu Amida Butsu* (Praise Amida Buddha) repeatedly. In return, Amida Buddha will take them at the time of death to his Pure Land, the Western Paradise.

10. Mamiya Eishū, *Zen no zuihitsu* (Tokyo: Bukkyō Nen Kansha, 1937), pp. 266–67.

11. Ibid., pp. 30–33.

12. Mamiya Eishū, *Rinzairoku* (Tokyo: Shinkō Shuppansha, 1930), pp. 128–29. For information on the nun-artist Rengetsu, see John Stevens, trans., *Lotus Moon: The Poetry of the Buddhist Nun Rengetsu* (New York: Weatherhill Inklings, 1994).

13. Eishū, *Rinzairoku*, p 55.

14. Eishū, *Zen no zuihitsu*, pp. 317–18.

15. Eishū, *Rinzairoku*, pp. 12–14.

16. Eishū, *Zen no zuihitsu*, pp. 268–72.

17. Ibid., p. 266.

18. Kishida, *Hōmyaku*, p. 230.

19. Tanchū Terayama, "Onjun ni shite kiu kattatsu," *Zen Graphic* 9 (Fall 1989: special issue on Seki Seisetsu), p. 11.

20. Kishida, *Hōmyaku*, pp. 231–32.

21. Terayama, "Onjun," p. 12.

22. Kōshō Shimizu, "Ryūnen-san ni tsuketa," *Zen Graphic* 9 (Fall 1989), p. 24.

23. Seki Bokuō, "Ummei o kaeta sendai no hito koto," *Zen Graphic* 9 (Fall 1989), p. 20.

24. Ibid.

25. Kishida, *Hōmyaku*, p. 232.

26. Fukushima and Katō, *Zenga no sekai*, p. 190.

27. Nishiyama Kōsen and John Stevens, *A Complete English Translation of Dōgen Zenji's Shōbōgenzō* (The Eye and Treasury of the True Law), vol. 2 (Tokyo: Nakayama Shobō, 1977), pp. 146ff, as given in Helmut Brinker and Hiroshi Kanazawa, *Zen: Masters of Meditation in Images and Writing*, (trans. Andreas Leisinger) (Zurich: Artibus Asiae Publishers, 1996), p. 43.

28. Seki Bokuō, "Ummei," p. 20.

29. Kishida, *Hōmyaku*, pp. 232–33.

30. Terayama, "Onjun," p. 15.

31. Kishida, *Hōmyaku*, p. 233.

32. Ibid., p. 234.

33. See Stephen Addiss, *Haiga: Takebe Sōchō and the Haiku-Painting Tradition* (Richmond, Va.: Marsh Art Gallery, University of Richmond, and the University of Hawaii Press, 1995).

34. Ghosts of jealous women played pivotal roles in the eleventh-century novel *The Tale of Genji*.

35. See *Japanese Ghosts and Demons*, ed. by Stephen Addiss (New York: Braziller, 1985).

36. Victoria, *Zen at War*, p. 113. The cover of *Bushidō no kōyō* depicts Momotarō, the boy warrior from Japanese children's tales, standing triumphantly on top of two demons representing Winston Churchill and Theodore Roosevelt.

37. Terayama, "Onjun," p. 15.

38. Seki Bokuō, p. 20.

CHAPTER 7: BRIDGES OF ZEN

1. "The Bridge," in *A Tune beyond the Clouds: Zen Teachings from Old China*, trans. and ed. by J. C. Cleary (Berkeley, Calif.: Asian Humanities Press, 1990), p. 123.

2. Fukushima Keidō, "Shibayama Rōshi to Amerika," in *Zen Graphic* 8 (Summer 1989), p. 46.

3. "Shibayama Rōshi arubamu," in *Zen Graphic* 8 (Summer 1989), p. 12.

4. Kōno Mukai (also pronounced Bukai) was also known as Nanshinken; he was born in Aichi and entered the priesthood at the age of nine under Ranshū Bun'i at Ishiba-ji in Shiga Prefecture. He then studied under Tairyū at Shogen-ji in Ibuka, Gifu. After graduating from the newly established Hanazono University in Kyoto, Kōno trained under Dokutan Sōsan at Eiho-ji for ten years, eventually receiving his certification. He became abbot of Chōfuku-ji in Ehime in 1894 and was elected head of the Nanzen-ji sect in 1910.

5. Shibayama Zenkei, "An Outline of Zen," in *Anthology of Zen*, ed. by William A. Briggs (New York: Grove Press, 1961), pp. 197–98.

6. Shibayama Zenkei, *Zen Comments on the Mumonkan*, (New York: Harper and Row, 1974), p. 46.

7. Taigan Takayama, "Shijun no hito," in *Zen Graphic* 8 (Summer 1989), p. 27.

8. Seizan Yanagida, "Kanshōken Shibayama Zenkei Rōshi no gakumon," in *Zen Graphic* 8 (Summer 1989), p. 16.

9. Ibid.

10. Ibid.

11. Ibid.

12. Takayama, "Shijun," p. 26.

13. Ibid.

14. Shibayama, "An Outline of Zen," pp. 195–96. Shibayama does note that there are certain sects within Buddhism that promote salvation through faith, but Zen is not one of them.

15. Shibayama Zenkei, *A Flower Does Not Talk* (Rutland, Vt., and Tokyo: Charles E. Tuttle Company, 1988) p. 6.

16. Fukushima, "Shibayama Rōshi to Amerika," p. 46.

17. Ibid.

18. "The Characteristics of Zen," and "Training in Zen," can be found in *A Flower Does Not Talk*.

19. Fukushima, "Shibayama Rōshi to Amerika," p. 47.

20. Interview with Fukushima Keidō, Tōfuku-ji, May 1997.

21. Shibayama, *A Flower Does Not Talk*, p. 73.

22. Fukushima Keidō, "Dokutoku no sei to dō no myō," in *Zen Graphic* 8 (Summer 1989), p. 32.

23. The Sōtō master Dōgen wrote in his *Mountains and Waters Sutra*, "An ancient Buddha said, 'Mountains are mountains, waters are waters.' These words do not

mean that mountains are mountains; they mean mountains are mountains." Translated by Arnold Kotler and Kazuaki Tanahashi in *Moon in a Dewdrop: Writings of Zen Master Dogen*, ed. Kazuaki Tanahashi (New York: North Point Press, 1985), p. 107.

24. Fukushima Keidō, "Dokutoku," p. 32. Fukushima has commented, "You can see it was written later, not as part of the original movement."

25. Ibid.

26. Thomas Cleary and J. C. Cleary, trans., *The Blue Cliff Record* (Boston & London: Shambhala Publications, 1992), p. 91.

27. Ibid.,p. 139.

28. Ibid.

29. Shibayama, "An Outline of Zen," p. 199.

30. Ibid., pp. 200–201.

31. Sumiko Kudō, "Shibayama Zenkei, 1904–1974," *Eastern Buddhist* 8, no. 1 (Kyoto: Ōtani University, (May 1975), p. 154.

32. Shibayama, *Zen Comments on the Mumonkan*, p. 199.

33. Kudō, "Shibayama Zenkei," p. 149.

34. From a lecture by Fukushima Keidō for the "Beyond Words" seminar at the University of Richmond, Spring 1994

35. Interview with Fukushima Keidō, March 1997, Richmond, Va.

36. Ibid.

37. Interview with Fukushima Keidō, May 1997, Tōfuku-ji, Kyoto.

38. Fukushima Keidō, from the introduction to his calligraphy demonstration, University of Richmond, March 1996.

39. Interview with Fukushima Keidō, May 1997, Tōfuku-ji.

40. Interview with Fukushima Keidō, March 1997, Richmond, Va.

41. Ibid.

42. Ibid.

43. Ibid.

44. Fukushima, "Shibayama to Amerika," p. 47.

45. Interview with Fukushima Keidō, May 1997, Tōfuku-ji.

46. The phrase "What is this?" appears in cases 17 and 51 of the *Hekiganroku*.

47. Shibayama, "An Outline of Zen," p. 200.

48. Shibayama Zenkei, *Zenga no ensō* (Tokyo: Shunshūsha, 1969), p. 7.

49. Fukushima Keidō, from the introduction to his calligraphy demonstration, University of Richmond, March 1996.

50. Ibid.

51. From Shibayama Zenkei, "One-Word Gates: Ro, Kan, Jaku, Kan," translated by Gaynor Sekimori in *Cha No Yu Quarterly*, no. 50 (1987).

52. Fukushima Keidō, from the introduction to his calligraphy demonstration, University of Richmond, March 1996.

53. Fukushima Keidō, from his guest lecture for the "Beyond Words" seminar, University of Richmond, Spring 1994.

EPILOGUE

1. Stephen Addiss, *The Art of Zen: Painting and Calligraphy by Japanese Monks, 1600–1925* (New York: Harry N. Abrams, 1989).

2. Shibayama Zenkei, *Zen Comments on the Mumonkan* (San Francisco: Harper and Row, 1974), p. 74.

3. This definition is in accord with other accepted divisions in Japanese art, such as "Kanō" or "Tosa" paintings being those created by artists of the Kanō or Tosa schools.

4. Kazuaki Tanahashi, ed., *Moon in a Dewdrop: Writings of Zen Master Dogen* (San Francisco: North Point Press, 1985), pp. 134–39.

5. From a conversation in March 1997.

6. See Terayama Katsujō, *Zen and the Art of Calligraphy*, trans. John Stevens (London: Routledge & Kegan Paul, 1983), p. 13.

7. See Shibayama, *Zen Comments*, p. 199.

BIBLIOGRAPHY

Addiss, Stephen. *The Art of Zen: Paintings and Calligraphy by Japanese Monks, 1600–1925.* New York: Harry N. Abrams, 1989.

——. *Haiga: Takebe Sōchō and the Haiku-Painting Tradition.* Richmond, Va.: Marsh Art Gallery, University of Richmond, and the University of Hawaii Press, 1995.

——. *Zenga and Nanga.* New Orleans: New Orleans Museum of Art, 1976.

Addiss, Stephen, with Audrey Yoshiko Seo. *How to Look at Japanese Art.* New York: Harry N. Abrams, 1996.

Aiken, Robert. *A Zen Wave: Bashō's Haiku and Zen.* New York: Weatherhill, 1978.

Arai, Paula. *Women Living Zen: Japanese Sōtō Buddhist Nuns.* New York and London: Oxford University Press, 1998.

——. *Zen Nuns: Living Treasures of Japanese Buddhism* Ann Arbor, Mich.: University Microfilms, 1993.

Awakawa, Yasuichi. *Zenga no kokoro* (The Heart of Zenga). Tokyo: Yūkonsha, 1970.

——. *Zen Painting.* Tokyo: Kodansha International, 1970.

Barnet, Sylvan, and William Burto. *Zen Paintings.* Tokyo: Kodansha International, 1982.

Bielefeldt, Carl. *Dōgen's Manuals of Zen Meditation.* Berkeley: University of California Press, 1988.

Bodiford, William M. *Sōtō Zen in Medieval Japan.* Honolulu: Kuroda Institute and University of Hawaii Press, 1993.

Bokubi (Ink Beauty), no. 14 (Kyoto, 1952). Includes Nantenbō.

Brasch, Kurt. *Zenga.* Tokyo: Japanisch-Deutsche Gesselshaft, 1961.

Brinker, Helmut. *Zen in the Art of Painting.* London: Arcana, 1987.

Brinker, Helmut, and Hiroshi Kanazawa. *Zen: Masters of Meditation in Images and Writings.* Zurich: Artibus Asiae Publishers, 1996.

Cleary, Thomas, trans., *The Book of Serenity.* Hudson, N.Y.: Lindisfarne Press, 1990.

——. *Shōbōgenzō: Zen Essays by Dōgen.* Honolulu: University of Hawaii Press, 1986.

Cleary, Thomas, trans. and ed. *Teachings of Zen.* Boston & London: Shambhala Publications, 1998.

Cleary, Thomas, and J. C. Cleary, trans., *The Blue Cliff Record.* Boston & London: Shambhala Publications, 1992.

Collcutt, Martin. "Buddhism: The Threat of Eradication." In *Japan in Transition: From Tokugawa to Meiji,* edited by Marius B. Jansen and Gilbert Rozman. Princeton, N.J.: Princeton University Press, 1986.

Cook, Francis H. *Sounds of Valley Streams: Enlightenment in Dōgen's Zen, Translation of Nine Essays from the Shōbōgenzō.* Albany: SUNY Press, 1989.

Daitoku-ji bokuseki zenshū (Collection of Daitoku-ji Monk Ink Traces), vol. 3. Tokyo: Mainichi Shinbunsha, 1986.

Deiryū ihō. (Recollections of Deiryū). Kyoto: Empuku Sōdō, 1980.

Deiryūkutsu goroku (Writings of Deiryū). Kyoto: Empuku Sōdō, 1980

Dumoulin, Heinrich. *A History of Zen Buddhism,* translated by Paul Peachey. Boston: Beacon Press, 1963.

——. *Zen Buddhism: A History—India and China,* translated by James W. Heisig and Paul Knitter. New York: Macmillan, 1988.

——. *Zen Buddhism: A History—Japan,* translated by James W. Heisig and Paul Knitter. New York: Macmillan, 1990.

——. *Zen Buddhism in the Twentieth Century.* New York: Weatherhill, 1992.

Fields, Rick. *How the Swans Came to the Lake: A Narrative History of Buddhism in America.* Boston & London: Shambhala Publications, 1992.

Fontein, Jan, and Money Hickman. *Zen Painting and Calligraphy*. Boston: Museum of Fine Arts, 1970.

Foster, Nelson, and Jack Shoemaker, eds. *The Roaring Stream: A New Zen Reader*. Hopewell, N.J.: Ecco Press, 1996.

Fujiwara Tōen. *Zen no meisō retsuden* (Biographies of Famous Zen Monks). Tokyo: Kōsei Deppansha, 1990.

Fukushima Keidō. *Furi-maindo* (Free Mind). Tokyo: Tokyo Shuppan, 1995.

———. *Zen wa mu no shūkyō* (Zen Is the Religion of *Mu*). Tokyo: Hakujūsha, 1994.

Fukushima Shun'ō and Shōshun Katō. *Zenga no sekai* (The World of Zen). Kyoto and Tokyo: Tankosha, 1978

Furukawa Taikō. *Yakushin Nihon to shin daijō-bukkyō* (Rapidly Advancing Japan and the New Mahayana Buddhism). Tokyo: Chūō Bukkyōsha, 1937.

Heine, Steven. *A Blade of Grass: Japanese Poetry and Aesthetics in Dōgen Zen*. New York: Peter Lang, 1989.

Hisamatsu, Shin'ichi. *Zen and the Fine Arts*. Tokyo: Kodansha International, 1971.

Horie Tomohiko. *Bokuseki* (Ink Traces). *Nihon no bijutsu* series, no. 5. Tokyo: Shibundō, 1966.

Irokawa Daikichi. *The Culture of the Meiji Period*, translation edited by Marius B. Jansen. Princeton N.J.: Princeton University Press, 1985.

Itō Tōshin. *Mokurai Zenshi*. Kyoto: Kennin-ji, 1979.

Kapleau, Philip. *The Three Pillars of Zen*. New York: Harper and Row, 1966.

Kashiwahara Yūsen and Sonoda Kōyū, eds., *Shapers of Japanese Buddhism*. Tokyo: Kōsei Publishing, 1994.

Kasumi Bunshō. *Unsui no isshō* (The Life of a Training Monk). Kyoto: Senshin Kōgei, 1977.

———. *Zen ni ikiru kessō: Nantenbō* (Born to Zen: the Leading Master Nantenbō). Tokyo: Shunshūsha, 1963.

Katō Shōshun. *Hyakunin no zensō* (One Hundred Zen Monks). Kyoto and Tokyo: Tankōsha, 1973.

Kim, Hee-jin, trans., *Flowers of Emptiness: Selections from Dōgen's Shōbōgenzō*. Lewiston, N.Y.: Edward Mellan Press, 1985.

Kinsei kōsō ibokushū (High Monk Ink Traces of Recent Eras). Kyoto: Art-sha Shuppan, 1976.

Kinsei zenrin bokuseki (Zen Ink Traces of Recent Eras). 3 vols. Kyoto: Shibunkaku, 1974.

Kishida Kembu. *Hōmyaku gendai zen sho retsudan* (Pulse of the Law: Modern Zen Biographies). Kyoto: Chūgai Nipponsha, 1973.

Kishida Kinuo. *Kikutsu no tan: kindai zensō no sei to shi* (Individuals of the Devil's Cave: The Lives and Deaths of Modern Zen Monks). Tokyo: Tankōsha, 1994.

Kodera, Takashi J. *Dōgen's Formative Years in China*. London: Routledge & Kegan Paul, 1979.

Kojima, Kendō. *Fune ni kizamu* (Carved in a Boat). Tokyo: Josei Bukkyō-sha, 1985.

Kōsō ibokushū (Collected Works by Lofty Monks), 12 vols. Tokyo: Hakurinsha, 1930.

Kraft, Kenneth, ed. *Zen: Tradition and Transition*. New York: Grove Press, 1988.

Loori, John Daido. *Two Arrows Meeting in Mid-Air*. Boston and Rutland: Charles E. Tuttle, 1994.

Mamiya Eishū. *Hekiganroku kōwa* (Lectures on the *Hekiganroku*). Tokyo: Kinryūdō, 1935.

———. *Koku no hone* (Bones of Emptiness). Tokyo: Shunshūsha, 1928.

———. *Rinzairoku* (The Record of Rinzai). Tokyo: Shinkō Shuppansha, 1930.

———. *Shōki to Zenki* (Opportunities in Business and Zen). Osaka: Taizandō Shoten, 1925.

———. *Zendō zokuwa* (Stories of the Zen Road). Tokyo: Kaiwa Shoin, 1914.

———. *Zen'en yawa* (Night Garden Zen Talks). Tokyo: Shinkō Deppansha, 1935.

———. *Zen no zuihitsu* (Zen Jottings). Tokyo: Bukkyō Nenkansha, 1937.

———. *Zen to wa kore-ja?* (What Is Zen?). Tokyo: Taiyōsha, 1938.

———. *Zenwa tanbankan* (Traveling Zen Talks). Tokyo: Heiken Deppansha, 1923.

Mamiya Eishū, ed., *Dai'e Fukaku Zenshi sho* (Writings of Dai'e Fukaku). Tokyo: Bukkyō Nenkansha, 1935.

Meiji no zensō (Meiji Era Zen Monks). Kyoto: Zen Bunka Kenkyūjō, 1981.

Miura, Isshū, and Ruth Fuller Sasaki. *Zen Dust*. New York: Harcourt, Brace, 1966.

Moog, Eike. *Handbuch japanischer Priester mit Bedeutung fur Schrift und Malerie* (Dictionary of Japanese Priests with Significance for Calligraphy and Painting). Cologne: Galerie Eike Moog, 1995.

Mori Taikyō. *Kinko Zenrin sōdan* (Recent Zen Master Biographies). Zōkei Shoin, 1919.

Morohashi Tetsuji. *Dai kanwa-jiten* (Large Character Dictionary). Tokyo: Daishuten Shoten, 1984.

Munroe, Alexandra. *Japanese Art after 1945: Scream against the Sky*. New York: Harry N. Abrams, 1994.

Murakami, Shigeyoshi. *Japanese Religion in the Modern Century*. Tokyo: University of Tokyo Press, 1980.

Nakagawa Sōen. *Endless Vow: The Zen Path of Soen Nakagawa*, edited and translated by Kazuaki Tanahashi and Roko Sherry Shayat. Boston & London: Shambhala Publications, 1996.

Nakahara Tōjū. Akuratsu sanmai (Craftiness and Concentration). Tokyo: Seibundō, 1921.

———. *Dokugo chūshingyō* (Poisonous Words Commentary on the Heart Sutra). Tokyo: Hōbunsha, 1973.

———. *Hakugankutsu goroku* (Writings by Hakugankutsu). Nishinomiya: Kaisei-ji-sō, 1922.

———. *Ikkatsu zen* (One-Shout Zen). Tokyo: Osaka Yagō Shoten, 1916.

———. *Nantenbō angyaroku* (Nantenbō's Pilgrimages, 1915). Tokyo: Heika Shuppansha, 1967 (reprint).

———. *Nantenbō zenwa* (Collected Zen Sayings of Nantenbō, 1915). Reprinted as *Nantenbō zenwa shū*.Tokyo: Kokusho Kankōsha, 1978.

———. *Zen no kyokuchi* (Zen Perfection). Tokyo: Chūei Shuppan, 1928.

Nantenbō ibokuten (Exhibition of Nantenbō Ink Traces). Nishinomiya: Mainichi Shinbunsha, 1978.

Natsume Sōseki. *Zen Haiku: Poems and Letters of Natsume Sōseki*, translated and edited by Sōiku Shigematsu. New York: Weatherhill, 1994.

Nishiyama Kosen and John Stevens, trans. *Shōbōgenzō*, vols.1–4. Tokyo: Nakayama Shobō, 1975, 1977, 1983, and 1983.

Ōmori Sōgen and Terayama Katsujō. *Zen and the Art of Calligraphy*, translated by John Stevens. London: Routledge & Kegan Paul, 1983.

Ōura Kandō, ed. *Mokurai Zenshi ihō*. Kyoto: Hyakka-en, 1969.

Pollack, David. *The Fracture of Meaning: Japan's Synthesis of China from the Eighth through the Eighteenth Centuries*. Princeton: Princeton University Press, 1986.

Reihō Matsunaga. *Introduction to Hukanzazengi*. Tokyo: Seshinshobō, 1956.

Reihō Matsunaga, trans. *A Primer of Sōtō Zen: A Translation of Dōgen's Shōbōgenzō Zuimonki*. Honolulu: University of Hawaii Press, 1971.

Reps, Paul, ed. *Zen Flesh, Zen Bones*. New York: Doubleday, 1989.

Sanshōken iseki (Remaining Works of Sanshōken [Yuzen Gentatsu]). Kurume: Bairin-ji, 1965.

Santōka ibokushū (Collection of Remaining Works by Santōka). Tokyo: Shibunkaku, 1993.

Sasaki, Ruth Fuller, trans. *The Record of Lin-chi*. Kyoto: Institute for Zen Studies, 1975.

Satō, Koji, and Sosei Kuzunishi. *The Zen Life*. New York: Weatherhill, 1972.

Sekida, Katsuki, trans. *Two Zen Classics: Mumonkan and Hekiganroku*. New York: Weatherhill, 1977.

Seki Seisetsu. *Bushidō no kōyō* (The Promotion of Bushidō). Kyoto: Kendō Shoin, 1942.

Seo, Audrey Yoshiko. *Painting-Calligraphy Interactions in the Zen Art of Hakuin Ekaku 1685–1769*. Ann Arbor, Mich.: University Microfilms, 1997.

Shaku Sōen. *Zen for Americans*. New York: Barnes and Noble, 1993.

Sharf, Robert H. "The Zen of Japanese Nationalism." In *Curators of the Buddha: The Study of Buddhism under Colonialism*, edited by Donald S. Lopez, Jr. Chicago: University of Chicago Press, 1995.

Shibayama Zenkei. *A Flower Does Not Talk*. Rutland, Vt., and Tokyo: Charles E. Tuttle, 1988.

——. "One Word Gates: Ro-Kan-Jaku, Kan" In *Cha No Yu Quarterly*, no. 50, 1987.

——. *On Zazen Wasan*, translated by Sumiko Kudō. Kyoto: privately printed 1967.

——. "An Outline of Zen." In *Anthology of Zen*, edited by William A. Briggs. New York: Grove Press, 1961.

——. *Zen Comments on the Mumonkan*. New York: Harper and Row, 1974.

——. *Zenga no ensō* (Zen Ensō Paintings). Tokyo: Shunshūsha, 1969.

——. *Zenshin zenwa* (Zen Mind, Zen Words). Tokyo: Shunshūsha, 1974.

Shibayama Zenkei, ed. *Zenrin kushū* (Forest of Zen Phrases). Tokyo: Kichūdō, 1972.

Shibayama Zenkei and Jikihara Gyokusei. *Kōko fugetsu shu* (Beauties of Rivers and Lakes Collection). Osaka: Sōgensha, 1969.

Shigematsu, Sōiku, trans. *A Zen Forest: Sayings of the Masters*. New York: Weatherhill, 1981.

Shimizu, Yoshiaki and John Rosenfield. *Masters of Japanese Calligraphy Eighth-Nineteenth Century*. New York: Japan House Gallery and Asia Society Galleries, 1985.

Sōhan Gempō, *Dokuge-shū* (Poison Flower Collection, 2 vols.) Kyoto: Shingetsu Tessō, 1928.

Sōtōshū jinmei jiten (Sōtō Sect Biographical Dictionary). Tokyo: Kokusho Kankōkai, 1977.

Stevens, John. *Mountain Tasting: Zen Haiku by Santōka Taneda*. New York: Weatherhill, 1980.

——. *Sacred Calligraphy of the East*, 3rd ed. Boston & London: Shambhala publications, 1995.

——. *Zenga: Brushstrokes of Enlightenment*. New Orleans: New Orleans Museum of Art, 1990.

Stone, Jackie. "A Vast and Grave Task: Interwar Buddhist Studies as an Expression of Japan's Envisioned Global Role." In *Culture and Identity: Japanese Intellectuals during the Interwar Years*, edited by J. Thomas Rimer. Princeton, N.J.: Princeton University Press, `1990.

Sumi, no. 42 (May 1983). Special issue on Santōka.

Sumiko Kudō. "Shibayama Zenkei, 1904–1974." *Eastern Buddhist* 8, no. 1 (May 1975).

Suzuki, D. T. *Essays in Zen Buddhism*. New York: Grove Press, 1949.

——. *Living by Zen*. New York: Samuel Weiser, 1972.

——. *Manual of Zen Buddhism.* New York: Grove Press, 1960.

——. *The Training of the Zen Buddhist Monk.* New York: University Books, 1959.

——. *Zen and Japanese Culture.* Princeton NJ: Princeton University Press, 1970.

——. *Zen Buddhism.* New York: Doubleday, 1956.

Takagi Sōgo. *Gempō Rōshi.* Tokyo: Ōkura Shuppan Kabushi Kaisha, 1963.

Tamaki Benkichi. *Gempō Rōshi* (Zen Master Gempō). Tokyo: Daisō Deppan, 1963.

——. *Kaisō Yamamoto Gempō* (Lofty Monk Yamamoto Gempō). Tokyo: Harukisha, 1970.

Takeda Mokurai, *Mokurai Zenshi ibokushū* (Collection of Works by Moukurai Zenshi), Nagasaki: Showadō, 1979.

——. *Mokurai zenwa* (Mokurai's Zen Talks). Tokyo: Chūgai Nippōnsha, 1979.

——. *Zenki* (Zen Opportunities). Tokyo: Heigo Shuppansha, 1915.

——. *Zen no sakkatsu* (Zen Killing and Reviving). Tokyo: Seikōkan Shoten, 1931.

Takeda Mokurai. *Zoku Mokurai zenwa* (Mokurai's Zen Talks, second series). Tokyo: Sekibunsha, 1907.

Takeuchi Naoji. *Kinsei no zenrin bijutsu* (Zen Art of Recent Eras). Tokyo: Shibundō, 1972.

Takuan Sōhō. *The Unfettered Mind: Writings of the Zen Master to the Sword Master,* translated by William Scott Wilson. Tokyo: Kodansha International, 1986.

Tanahashi, Kazuaki, ed. *Moon in a Dewdrop: Writings of Zen Master Dōgen.* San Francisco: North Point Press, 1985.

Ueda, Makoto. *Bashō and His Interpreters.* Stanford, Calif.: Stanford University Press, 1991.

Victoria, Brian. *Zen at War.* New York: Weatherhill, 1997.

Welch, Matthew. *The Painting and Calligraphy of the Japanese Zen Priest Tōjū Zenchū, Alias Nantenbō (1839–1925).* Ann Arbor, Mich.: University Microfilms, 1995.

Yamamoto Gempō. *Mumonkan teishō* (Lectures on the *Mumonkan*). Tokyo: Daihō Rinkaku, 1960.

Yamamoto Gempō Rōshi no iboku (Remaining Works by Yamamoto Gempō). Tokyo: Tanaka Onkodō, 1991.

Yamamoto Gempō Rōshi ten (Exhibition of Works by Yamamoto Gempō). Mishima: Nakayama Kaisha, 1982.

Yanagida Seigan and Katō Shōshun. *Ensō.* Tokyo: Mainichi Shinbun, 1986.

Yokoi, Yūhō. *The Shōbōgenzō.* Tokyo: Sankibo Buddhist Bookstore, 1986.

——. *Zen Master Dōgen: An Introduction with Selected Writings.* New York and Tokyo: Weatherhill, 1976.

Yūzen Gentatsu. *Sanshōroku* (The Writings of Sanshōken). Kurume: Bairin-ji, 1941.

Zen bunka. Kyoto: Zen Bunka Kenkyūjo, 1955–present.

Zen Graphic 6 (on Gempō, 1988), 8 (on Shibayama, 1989), 9 (on Seisetsu, 1989), and 19 (on Yūzen, 1992).

Zen no shiki (The Seasons of Zen). Tokyo: Kōsei Deppansha, 1988.

INDEX

— HILARY T. SEO, M.L.S.